Plains Indian Rock Art

P9-AGQ-307

9 MAR 2006
1 JUL 2006
07 APR 2007

North Valley Public Library
Stevensville, MT 59870

DEMCO

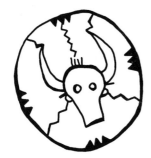

A Samuel and Althea Stroum Book

Plains Indian Rock Art

JAMES D. KEYSER AND MICHAEL A. KLASSEN

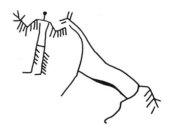

University of Washington Press
Seattle and London

UBC Press
Vancouver and Toronto

This book is published with the assistance of a grant from the Stroum Book Fund, established through the generosity of Samuel and Althea Stroum.

Copyright © 2001 by the University of Washington Press

Printed in Canada by Friesens Corporation, Altona, Manitoba

Designed by Audrey Meyer and Dennis Martin

This book is published simultaneously in the United States and Canada by the University of Washington Press, PO Box 50096, Seattle, WA 98145, and UBC Press, 2029 West Mall, Vancouver, BC v6t 1z2.

All rights reserved. No part of this publication may be reproduced or transmitted in any form or by any means, electronic or mechanical, including photocopy, recording, or any information storage or retrieval system, without permission in writing from the publisher.

Except where noted, all drawings are by James D. Keyser. Source materials for the drawings include photographs, original site tracings, and other published illustrations.

Unless otherwise specified in the captions, all photographs are by the authors.

The paper used in this publication is acid-free. It meets the minimum requirements of American National Standard for Information Sciences—Permanence of Paper for Printed Library Materials, ANSI z39.48-1984.

Library of Congress Cataloging-in-Publication Data

Keyser, James D.

Plains Indian rock art / James D. Keyser and Michael A. Klassen.

p. cm.

Includes bibliographical references and index.

ISBN 0-295-98094-x (pbk. : alk. paper)

1. Indians of North America—Great Plains—Antiquities. 2. Petroglyphs—Great Plains. 3. Rock paintings—Great Plains. 4. Great Plains—Antiquities. I. Klassen, Michael. II. Title.

E78.G73K49 2001

978´.01—dc21 00-051178

National Library of Canada Cataloguing in Publication Data

Keyser, James D.

Plains Indian rock art

Includes bibliographical references and index.

ISBN 0-7748-0857-8

1. Indian Art—Great Plains. 2. Indians of North America—Great Plains—Antiquities. 3. Petroglyphs—Great Plains. 4. Rock paintings—Great Plains. 5. Great Plains—Antiquities. I. Klassen, Michael. II. Title.

E78.G73K49 2001

709´.01´1308997078 C2001-910471-5

Contents

Authors' Note on Names

The Great Plains of North America stretches from west Texas to the prairie provinces of Canada, and petroglyphs and pictographs are scattered throughout this vast landscape. We have chosen in this book to focus on the rock art from the northern half of the Great Plains, at sites from northern Colorado to Alberta and from the Rockies to the western Dakotas. This northwestern Plains region is the land of the Cheyenne and the Blackfeet, the Crow and the Sioux—the high plains of popular imagination and dramatic western history. It is also home to some of the most famous rock art sites and best-known rock art traditions. Comparatively little is known about rock art of the southern Plains, but preliminary studies suggest it may rival its northern counterpart in significance and variety. Although we know the northern Plains rock art best, we believe that the descriptions and interpretations in this book can be applied equally to much in the southern region. As more is learned about southern Plains rock art, this information can be incorporated into a synthesis spanning the entire Great Plains.

Throughout this book, we refer to numerous Native groups by their most commonly known names. In many cases, these names were given to the groups by outsiders. Nowadays, many Native groups prefer to be known by names of their own choosing, based on their own language. For example, the people commonly known as the Gros Ventres prefer to be called the A'ani. Although we recognize and respect the names chosen by each group, we have chosen to retain the names familiar to most of our readers.

When multiple spellings occur for a group's common name, we use the variation preferred in their country of residence. However, the spelling of common names for several groups that live in both Canada and the United States may differ on opposite sides of the border. For instance, the people known in Canada as Blackfoot are known in the States as Blackfeet. Likewise, the Peigan and Kootenay of Canada are the Piegan and Kutenai of the United States. When this disparity occurs, we have chosen the common American spelling.

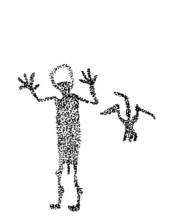

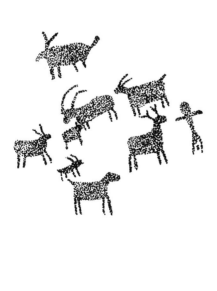

Preface

As professional archaeologists, we are involved with many aspects of archaeological research and management on a daily basis. But it is rock art—a minor sideline for most archaeologists—which truly fascinates us. James Keyser has had a lifelong interest in the subject; he saw his first pictographs as a young boy. A decade later, he began pursuing formal rock art study, despite the warning of professors that little of importance could be learned from the subject—and he has never regretted his decision. Michael Klassen first learned of rock art in his first archaeology job. This led him to a stint as a park employee at a major rock art site, then to conduct a rock art research survey, and later to a graduate school program to study Plains rock art. Significantly, both authors conducted extensive research projects at Alberta's Writing-on-Stone Provincial Park—probably the most complex cluster of Northwestern Plains rock art sites— although their work was separated by more than fifteen years. We first met at Writing-on-Stone, and our shared enthusiasm for that place and its rock art inspired this book.

Our enthusiasm for rock art is also shared by many others. Public visitation at interpreted rock art sites is higher than ever before—not only at world-famous sites in Europe and Australia, but at dozens of sites across the United States and Canada. Newspapers and magazines often publish articles reporting rock art discoveries from Europe,

South America, and every other corner of the globe. Rock art books are the best sellers of popular archaeology and dozens are available. Amateur rock art interest groups, Internet web pages, and dozens of volunteer rock art projects conducted by universities and government agencies introduce thousands of people to pictographs and petroglyphs every year.

Why is this level of interest so high? The images themselves often show a striking mastery of form and execution that belies their outward simplicity. They are also frequently enigmatic and generally very old, hinting at an ancient, mysterious past. But most important, they connect us directly to the beliefs and cultures of the aboriginal peoples who first discovered and populated this continent. While bones tell us what animals they ate, and arrow or spear points tell us how they killed them, and potsherds show how they cooked them, these artifacts relate almost nothing about how people worshipped, the way they perceived their environment, the ceremonies they conducted, or their feelings about their place in the world.

Rock art reveals all these things, for it is one of the rare archaeological artifacts whose form, structure, and location derives almost solely from the inner mind of its maker. The result is an almost limitless variety of images throughout the landscape that represent a nearly infinite variety of ideas, experiences,

and perceptions. Yet by recognizing the relationships between images, we can begin to see patterns in depiction. These patterns, viewed in the context of the cultures that produced them and the landscape in which they are found, help illuminate for us the meaning and significance of the rock art.

In this book, we have tried to portray the beauty and variety of Northwestern Plains rock art, and to introduce readers to the fascinating stories that lie behind the images. But our decision to write this book goes beyond our aesthetic and academic interests. Rock art is one of the most vulnerable of all archaeological resources, and is threatened daily with damage or destruction from thoughtless vandalism and ongoing development. We feel a personal and professional responsibility to ensure the protection and conservation of rock art sites. Although popularizing rock art may lead to increased site impacts, we also feel the benefits far outweigh the risks. By fostering a better

understanding and appreciation of its cultural and historical significance, we stand the best chance of promoting the protection of rock art.

We recognize the special significance that rock art continues to have in the traditional culture of Plains Indians. Many Native people regard rock art sites as sacred places and consider pictographs and petroglyphs as links to the spirit world. Rock art is thus far more than an archaeological resource to be classified and managed, or an artwork to be admired— it is part of a living culture and a sacred heritage that must be honored. Although in this book we have chosen to view rock art from an archaeological perspective, we have tried to do so with respect and sensitivity to traditional viewpoints. By sharing our understanding and appreciation of rock art with a wide audience, we hope to encourage greater awareness and respect for this legacy among society as a whole.

Acknowledgments

In researching and writing this book, we relied extensively on the research and fieldwork of numerous professional and amateur colleagues. We could not have undertaken a work of this scope without their cooperation and assistance. Many of our professional colleagues provided us with unpublished information, photographs, site records, and hard-to-find publications. They also guided us to new sites and provided countless personal observations of sites, areas, and even entire traditions. We are equally grateful to the Plains tribal members who openly shared their knowledge and traditions about rock art and rock art sites, providing us a deeper understanding of the place of rock art in traditional Native culture. We are also indebted to the many rock art enthusiasts across the Plains who led us to numerous unrecorded or inaccessible sites. Many friends and relatives volunteered their time to assist us with our field research.

Foremost among our professional colleagues who deserve thanks are Mavis Greer and John Greer, who opened their personal rock art archives for Keyser's three-day visit to their Missouri residence, guided visits to more than a dozen sites, and contributed many photographs and site forms to our research effort. We thank our many other colleagues who willingly shared information, guided us to sites, offered suggestions, and provided assistance. Special thanks go to Larry Loendorf, Jack Brink, Linea Sundstrom, Martin Magne, Stu Conner, John Dormaar, Danny Walker, Lawrence Halmrast, Jim Stewart, and Mike Beckes. We also wish to thank Walt Allen, Mike Andrews, Alva Bair, Mike Bies, Keo Boreson, Ted Brasser, Craig Bromley, John Brumley, Tony Buchner, Phillip Minthorn Cash Cash, Fred Chapman, Christopher Chippindale, Carl Davis, Ken Feyhl, Julie Francis, Lynn Fredlund, Carlos Germann, Joe Horse Capture, Elaine Howard, Tim Jones, Halcyon LaPointe, Brent Larson, Dan Leen, Tom Lewis, Carling Malouf, Rick McClure, Ron McCoy, Carolynne Merrell, Sandi Morris, Richard Newton, Linda Olson, Leo Pard, John Park, Kevin Peters, Jacquie Peterson, Maureen Rollans, Alan Schroedl, Sara Scott, Gary Smith, Larry Stach, Doug Stockton, Paul Taçon, Joe Tainter, Mike Turney, Alice Tratebas, James Wettstaed, John Whitehurst, David Whitley, and Eldon Yellowhorn. We acknowledge the often significant part each played in the completion of this work.

Over the years, many landowners freely granted us permission to visit sites on their lands; we greatly appreciate their cooperation and would like particularly to acknowledge the hospitality and assistance of Fred DesRosier, Frank Duer, Larry Mackillop, Elmer and Edna Penrose, Jim Posey, the Reese family, and Claire Tempero. Land managers at many of the sites on public lands also deserve credit

for their assistance. We are grateful to the past and present park staff at Writing-on-Stone Provincial Park, especially Chief Park Ranger Bob Ward, Janet Hawkwood, Bonnie Moffet, and former Chief Park Ranger Fred M. (Scotty) Shearer, and his wife Nancy Shearer.

We also thank several museums and archives and their curatorial staff for access to study collections and for permission to publish photographs of robe and ledger drawings. These include Ernest Klay and Daniel Kessler, Bernisches Historisches Museum; Margot Reid, Canadian Museum of Civilization; Renate Wente-Lukas, Deutsches Ledermuseum, Offenbach-am-Main; Eastern Montana College Library Archives; Susan Kooyman, Gerald Conaty, and Hugh Dempsey, Glenbow Museum and Archives; Wolfgang Haberland and Corrina Raddatz, Hamburgisches Museum für Völkerkunde; Hans Lang, Indianer Museum der Stadt Zürich; Nancy Merz, Jesuit Missouri Province Archives, St. Louis; Evan Maurer, The Minneapolis Institute of Arts; Montana Historical Society Archives; Baretta Due, National Museum of Denmark; Joan Damkjar, Provincial Museum of Alberta; Arni Brownstone, Royal Ontario Museum; and Candace Greene, Smithsonian Institution, Washington, D.C.

Karen McNamee and Paula Sindberg provided support, research assistance, and a place to live during Keyser's writing sabbatical in England. Without Jim Daley's permission to use the copy machine at Masefield Ltd., London, we would not have been able to complete many of the illustrations in the book. Klassen wishes to acknowledge the insights of Joan Vastokas, which helped shape a number of chapters in this book. The encouragement, assistance, and critical comments of Marty Magne deserve special recognition. And finally, a special thanks goes to Jack Brink, who was responsible for bringing the two of us together for the first time at Writing-on-Stone in 1993—a meeting that ultimately led to this book.

James D. Keyser and Michael A. Klassen
January 2001

Part I / Introduction and Background

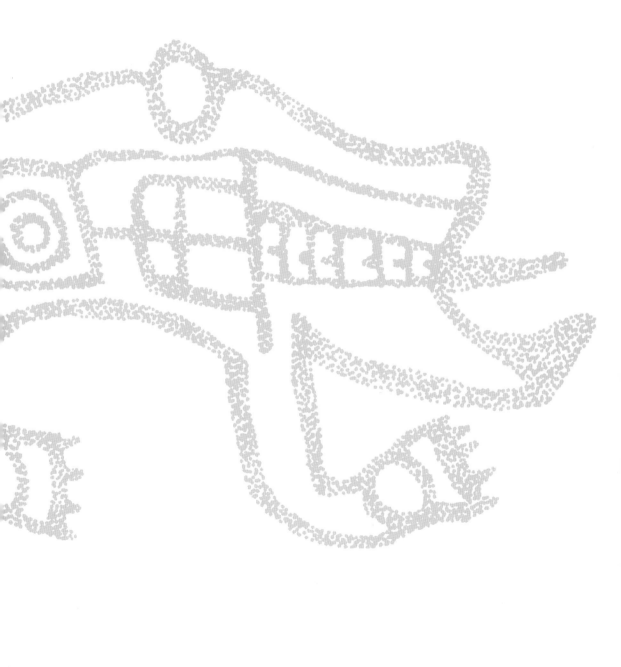

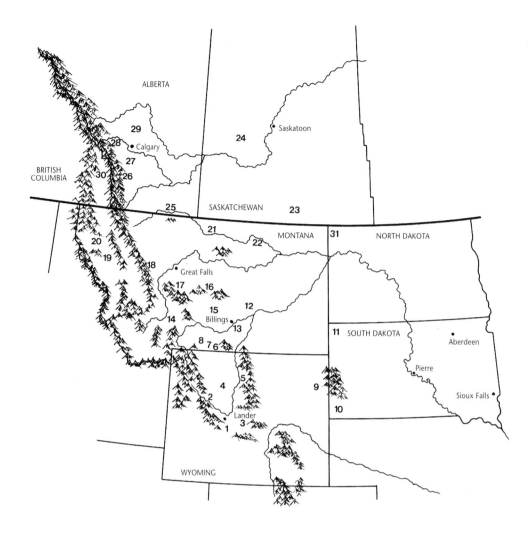

Map 1.1. The Northwestern Plains: Major Rock Art Sites

1. Little Popo Agie River
2. Dinwoody Lakes
3. Castle Gardens
4. Legend Rock
5. Medicine Lodge Creek
6. Petroglyph Canyon
7. Valley of the Shields
8. Joliet
9. Whoopup Canyon
10. Red Canyon (Southern Black Hills)

11. North Cave Hills
12. Castle Butte
13. Pictograph Cave
14. Missouri Headwaters
15. Musselshell River
16. Judith River
17. Smith River
18. Gibson Dam (Sun River)
19. Flathead Lake
20. Kila
21. Wahkpa Chu'gn

22. Sleeping Buffalo
23. St. Victor
24. Herschel
25. Writing-on-Stone (and Verdigris Coulee)
26. Zephyr Creek
27. Okotoks Erratic
28. Grotto Canyon
29. Crossfield Coulee
30. Columbia Lake
31. Writing Rock

1 / Introduction to Rock Art

For thousands of years, Northwestern Plains Indians carved and painted images on cliffs, rock outcrops, and boulders throughout the region—images with which Native people recorded their visions and chronicled their history. Often found in the spectacular settings of these peoples' most sacred places, rock carvings and paintings represent the intimate connection between Native people and their spirit world. These images are a remarkable artistic accomplishment and a lasting cultural legacy of the Plains Indians. More than 1200 rock art sites have been recorded across the plains of Alberta, Saskatchewan, Montana, Wyoming, and the Dakotas (Map 1.1), and the images at these sites span the last 5000 years, with some possibly dating to the end of the Ice Age (ca. 10,000 B.C.). An expression of the spiritual and social lives of these ancient artists, rock art offers a fascinating glimpse into Native culture and history from the earliest occupation of the New World to the early 1900s.

Northwestern Plains rock art has captured the interest of Euro-Americans from the time of the earliest explorers in the region, which attests to both its abundance and its artistic beauty. Lewis and Clark provided the first written record of this art, but many other explorers, soldiers, traders, artists, and missionaries sketched rock art sites and collected examples of robe and ledger drawings. Early anthropologists also recorded sites and

obtained information about the more recent designs from knowledgeable tribal elders (Wissler 1912, 1913; Mallery 1893). These early studies have proved invaluable for studying several rock art traditions, but most sites predate the occupation of this region by historically known groups; thus, much of the rock art is known only from its archaeological context.

The numerous articles and scientific monographs about Plains sites and styles, most written since the 1960s, form the most diverse body of rock art literature for any region of North America. Some works are broadly based syntheses of known data (Renaud 1936; Conner and Conner 1971; Wellmann 1979a; Keyser 1990), but even the most recent of these studies omits the four least-known rock art traditions and relies on incomplete data for three others. In the 1990s alone, hundreds of new sites have been described and interpreted in dozens of new publications. While researching this book, we consulted more than 200 written sources ranging from Ph.D. dissertations to single-site summaries written by local amateur researchers; we incorporated additional information from almost 100 other sites that have yet to be described in the literature (Map 1.2).

Despite this richly documented record, the public remains relatively unaware of and uninformed about much Northwestern Plains rock art. A few famous sites are visited by

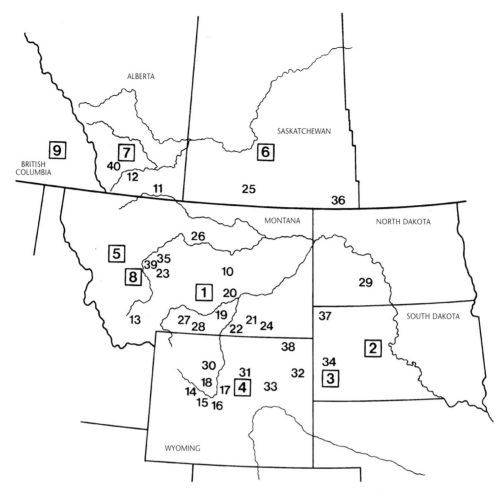

Map 1.2. The Northwestern Plains: Locations of Major Rock Art Study Projects

Boxed numbers indicate regional studies

1. *Conner 1962, Conner and Conner 1971*
2. *Over 1941, Sundstrom 1993*
3. *Sundstrom 1984, 1990*
4. *Renaud 1936*
5. *Keyser 1992, Keyser and Knight 1976*
6. *Dewdney 1963*
7. *Brink 1981, Klassen 1994a*
8. *Greer 1995*
9. *Corner 1968*
10. *Secrist 1960*
11. *Dewdney 1964, Keyser 1977a, Brink 1979, Magne and Klassen 1991, Klassen 1995*

12. *Leechman, Hess, and Fowler 1958*
13. *Jasmann 1962*
14. *Sowers 1939, 1940*
15. *Gebhard 1969*
16. *Gebhard and Cahn 1951*
17. *Gebhard 1954, Walker 1992*
18. *Tipps and Schroedl 1985*
19. *Mulloy 1956*
20. *Conner 1980*
21. *Conner 1984, 1989a*
22. *Fredlund 1993*
23. *Keyser 1979a*
24. *Johnson 1976*
25. *Jones and Jones 1982*
26. *Conner 1989b*
27. *Loendorf 1984, Loendorf and Porsche 1985, Loendorf et al.*

1990
28. *Loendorf 1990*
29. *Loendorf and Porsche 1987*
30. *Walker and Francis 1989, Francis et al. 1993, Francis 1994*
31. *Gebhard et al. 1987, Renaud 1963, Sowers 1941, 1964*
32. *Tratebas 1993*
33. *Schuster 1987*
34. *Sundstrom 1987, 1989*
35. *Greer and Greer 1994a, 1995a, 1996*
36. *Wintemberg 1939*
37. *Keyser 1984, 1987*
38. *Buckles 1964*
39. *Shumate 1960*
40. *Keyser 1978; Brink 1980*

thousands of tourists each year, but information at these sites can vary greatly in quality and accuracy; sometimes it even suggests that rock art is a complete mystery. All too often the public receives the impression that this art's origin and meaning are lost, and any interpretation of these images is therefore purely speculative. Inaccurate statements by professional researchers concerning its chronology (cf. Grant 1983:49) also lead to false impressions of the antiquity and significance of these images. Some sites have even been subjected to absurd "interpretation": the work of Pre-Columbian Chinese cartographers, Celtic scribes, or Spanish bankers recording their transactions.

Rock art sites in fact chronicle the long histories, the hunting ceremonies, and the religions of the region's diverse Native peoples. They reveal their relationships with the spirit world and record their interactions with traditional enemies and the earliest Europeans, Americans, and Canadians who explored and later colonized the area. Although some rock art conveys only enigmatic messages from an unknown past, many sites can be dated or attributed to a specific group or culture. Some rock art can even be read almost like a simple sentence. Unfortunately, ignorance of this rich cultural record has led to

thoughtless vandalism and the defacing of many sites with graffiti. At some sites petroglyphs and pictographs have been removed and stolen, or destroyed in the attempt. A few sites, like Ludlow Cave in South Dakota, have been entirely destroyed.

This book is intended to help interested persons learn about and appreciate the origins, diversity, significance, and beauty of Northwestern Plains rock art. We hope first to provide the reader with a general overview of this art, and further, that this effort will lead to increased public appreciation and concern for this treasure from the past.

Petroglyphs and Pictographs

Rock art includes both engravings, or petroglyphs, made by cutting into the rock surface, and paintings, or pictographs, made by coating the rock surface with pigment. A wide variety of techniques was used to make each type.

Incising and pecking were the most common methods for making Northwestern

Pecked, incised, and scratched petroglyphs cover this panel in the North Cave Hills. The pecked horse and rider (top left center) and pecked horse hoofprint (bottom left center) are unusual.

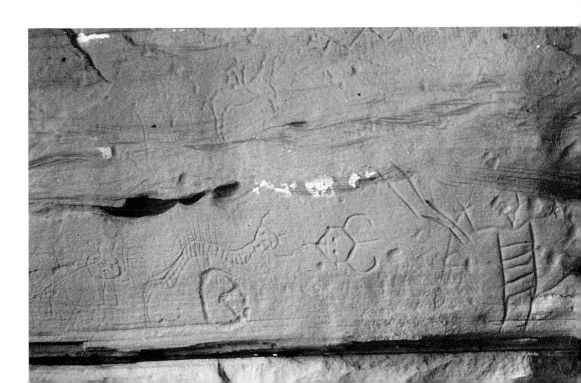

Plains petroglyphs. Incised petroglyphs were originally cut into the soft sandstones of the region by bone, antler, or stone flake tools to produce sharp, deep U-shaped or V-shaped grooves. After the introduction of metal to Plains cultures in the early postcontact era, knives and other sharp iron tools were also used to incise petroglyphs. Although most incised petroglyphs were probably drawn freehand, some nearly perfectly circular shields suggest that an aboriginal thong-and-pin compass was occasionally used. Sometimes a well-executed design is paired with a similar but coarse and uneven scratched or incised version, suggesting that a rough sketch may have been executed before the finished carving.

Pecked petroglyphs were made by direct and indirect percussion. Direct percussion involves repeatedly striking the rock surface with a piece of harder stone to produce a shallow pit, which was then gradually enlarged to form a complete design. Indirect percussion, whereby a small chisel stone is positioned against the rock surface and then struck with a hammerstone, provides more accurate control of the pecking and was probably used to produce the more carefully made pecked designs. Pecking occurs throughout the region on harder sandstone surfaces and also on granite and quartzite glacial erratic boulders scattered across the Plains north of the Missouri River.

Scratched petroglyphs occur frequently on the Northwestern Plains. These were made by lightly incising the rock surface with a sharp stone or bone flake or metal tool. Unlike incised petroglyphs, which are carved by repeated strokes along the same line, most scratched petroglyphs were made with a single stroke. The freshly made scratches were highly visible to the artists, as the scored line contrasted sharply with the darker surface of the weathered rock. Weathering eventually renders many scratches nearly invisible except under optimum lighting conditions.

A few petroglyphs are abraded—rubbed into the naturally rough cliff surface with a harder stone to create an artificially smoothed and flattened area, which contrasts with the natural surface texture. Large pecked designs, such as hoofprints and oversized animals, were sometimes refined by abrading within their outline, but a few designs were formed solely by abrasion. Finally, a few designs at some sites were made by drilling into the sandstone surface small pits arranged in lines to form figures.

Petroglyph techniques are frequently combined on the same panel or even on the same figure. Often new petroglyphs in different techniques were added to a panel by different artists at a later time. In many instances, an artist used multiple techniques to make a single figure, but sometimes the original design was modified by a later artist using another technique. The most frequent multiple-technique petroglyphs are pecked figures with incised features such as eyes, mouth, heartline, fingers, legs, or horns/antlers. Many pecked designs also have abraded parts, and a few Historic period figures were first scratched and then abraded. Incising and scratching sometimes occur together deliberately, but a few very carefully incised figures have somewhat carelessly executed scratched features that appear to be later additions. One design at Writing-on-Stone is an incised human partially pecked out by a later artist.

Northwestern Plains pictographs are most often red, but yellow, orange, blue-green, black, and white pictographs are also known. Most pictographs were painted using a single color, and polychrome paintings are very rare. The most notable polychromes are the Great Turtle Shield and other shields at Castle Gardens, Wyoming, and painted shields in the Valley of the Shields, southern Montana.

Pictograph pigments were made from various minerals. Iron oxides (hematite and limonite), often found in clay deposits, yielded

reds ranging from bright vermilion to dull reddish brown, and also yellow. Often called red and yellow ochre, these minerals were sometimes baked to intensify their color. Some orange pigments were made directly from powdered ironstone or other naturally occurring iron-rich rocks. Ash-rich clays and diatomaceous earth yielded white pigment, copper oxides produced blue-green colors, and charcoal made black pigments.

To make a pigment suitable for painting, the crushed mineral was mixed with water or an organic binding agent to form a paste or liquid. Ethnographic descriptions and archaeological work from other areas of North America document such binding agents as blood, eggs, animal fat, plant juice, or urine. As yet, little analysis of Northwestern Plains pigments has been undertaken to identify possible binding agents.

Most pigments were applied to the rock surface using fingers and brushes. Northwestern Plains pictographs are most often finger painted, as indicated by finger-width lines on many figures. Some paintings show fine lines of relatively evenly applied pigment that indicate the use of small brushes made from animal hair, feathers, porous bone fragments, or frayed twigs. Twig and bone brushes are well documented in the Plains ethnographic record. In some cases, both finger and brush painting were used on the same figure. Other designs show a characteristic waxy texture and somewhat spotty paint application, indicating that they were drawn with an ochre "crayon"—a lump of pigment with a greasy consistency, perhaps from being mixed with animal fat. Some black and reddish-orange designs were drawn with a piece of charcoal or a raw lump of ironstone, much like using chalk on a blackboard. These have a similarly spotty appearance, but lack the texture of "crayoned" drawings.

Handprints at sites along the Rocky Mountain front ranges in Alberta, Montana, and Wyoming were made by dipping the hand

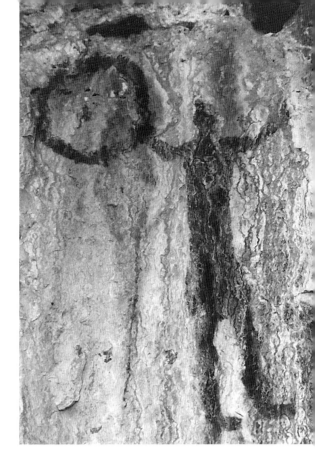

The finger-width lines of the hoop and the block-body human figure at Grassi Lakes, Alberta, are characteristic of finger-painted pictographs.

in paint and then pressing it against the rock surface. Paint was also spattered, smeared, and blown onto some sites to produce designs. Paint spatters or smears measuring several meters across are common at some central Montana and western Alberta sites. Blowing paint through a tube or spitting it directly from the mouth was used to make negative handprints at a few Wyoming sites and two Montana pictographs. To make such designs, the hand is held against the cliff, and paint is blown around it so that when it is lifted, an unpainted hand-shaped area remains.

How pigments can survive on exposed cliff faces has long been the subject of scientific debate. Early scholars, presuming that pigments would fade rapidly, argued that all

of these paintings were made during the last few hundred years. Some even reported that they would not last beyond a few more decades. We now know that most rock paintings are not rapidly disappearing. While there is evidence that some designs on sandstone cliffs are fading, some sandstone surfaces retain pictographs quite well. One site at Writing-on-Stone looks as vivid in a photograph taken today as it does in one taken in 1897. At a central Montana site, a painting of a shield-bearing warrior using an atlatl remains distinct and readily visible, even though it may be more than 1700 years old. Other paintings at two sites have been dated to between 800 and 900 years ago using scientific methods.

Research has demonstrated why these paintings are so durable (Taylor et al. 1974, 1975). When freshly applied, the pigment stains the rock surface and seeps into microscopic pores by capillary action. By this means, it becomes part of the rock. Mineral deposits coating many cliff surfaces further preserve these paintings. Rainwater, washing over the surface of the stone or seeping through microscopic cracks and pores, leaches naturally occurring minerals—calcium carbonate, aluminum silicate, or other water soluble minerals—out of the rock. As the water evaporates on the cliff surface, it precipitates the mineral as a thin, transparent film over the pigments. Microscopic thin-section studies show that staining, leaching, and precipitation have made the prehistoric pigment part of the rock surface, thus protecting it from rapid weathering and preserving it for hundreds of years. In areas with extensive water seepage, however, mineral deposits may eventually become so thick that they form an opaque, whitish film that obscures pictographs, which explains why some may eventually fade from view. In fact, at a few sites, prehistoric artists painted new designs over those more ancient ones partially obscured by precipitated minerals, and thus provided evidence of the relative ages for these designs.

Descriptive Terms

The appearance or form of rock art images is often described in the archaeological literature by a variety of technical terms unfamiliar to many readers. Here we have attempted to keep the use of jargon to a minimum, but the specialized nature of the subject requires some technical terms.

"Anthropomorph" and "zoomorph" derive from the Greek root words *anthropos,* "man"; *-zoon,* "animal"; and *morphe,* "form." Thus, anthropomorphs have human form, and zoomorphs have animal form. Many researchers use these terms, as we do, when they are unsure if the original artist intended a specific figure to represent an actual human (or animal) or merely the concept of humanness, or even the personification of a spirit or other nonliving thing. We use the terms "human," "human figure," "animal," and "animal figure" in this book when fine distinctions of meaning are not required.

The best Northwestern Plains anthropomorphic examples are the petroglyphs of the Dinwoody tradition, often drawn with bizarre combinations of human and animal attributes (fig. 1.1), and also the Foothills Abstract tradition pictographs showing mazelike figures with limited human or animal features. A mazelike design with clearly depicted human arms and hands is considered anthropomorphic, while a painted face that most closely resembles a bear is zoomorphic. Some authors use the term "therianthrope" for such combined figures, but here they are categorized as either anthropomorphic or zoomorphic, depending on their primary attributes.

Sometimes, as with the maze figure at Audrey's Overhang in Montana, the distinction is difficult to make. Painted on the ceiling of a small, low rockshelter, the figure lacks an obvious vertical or horizontal orientation, as the observer must lie on his back to see it. Partially obscured by a light coating of mineral precipitate, the figure was originally

identified as anthropomorphic because of vague similarities to a maze figure with two arms at another site (Keyser 1977b). In that and subsequent publications, the figure was shown in a vertical orientation. However, a recent reexamination of this site, together with the discovery of nearby sites showing bears in various degrees of abstraction, strongly suggests that the Audrey's Overhang figure is a very abstracted bear (fig. 1.2), in a horizontal posture, with the two limbs ending in short claws.

Representational images depict real objects—humans, animals, weapons, tipis, plants, celestial bodies, and so on (fig. 1.3). They may range from naturalistic to abstract or stylized. These terms are more suitable for comparing relative categories rather than for the rigid classification of images.

Anthropomorphs illustrate the variation from naturalistic to abstracted images very well. Naturalistic examples are portrayed much as humans actually appear in the world. Some show realistic facial features, body proportions, and extremities, while others are simple outline or stick figures with varying degrees of anatomical detail. More abstracted anthropomorphs, such as V-neck humans and some Dinwoody anthropomorphs, show imagined elements and details (power rays, internal structures, V-neck) or internal organs or structures not visible in nature. The most abstracted images, such as numerous Dinwoody and Foothills Abstract anthropomorphs, are barely recognizable as representations of humans. Often their identification hinges solely on our ability to recognize eyes, arms, or other anatomical features.

Nonrepresentational images, on the other hand, do not occur in nature. They may take a variety of geometric, abstract, and amorphous shapes, including geometric designs, spirals, vertical marks and grooves, mazes, and so on (fig. 1.4). Geometric shapes may be rectilinear, composed of straight lines, or curvilinear, composed of curving lines, or a combination

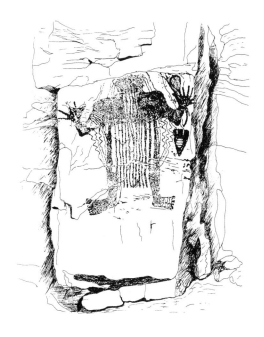

1.1 Dinwoody tradition rock art is characterized by bizarre anthropomorphs, often with interior body decorations (note left foot with interior spiral). Associated items of material culture include bow, rattle(?), and large projectile point. (Drawing courtesy of Linda Olson)

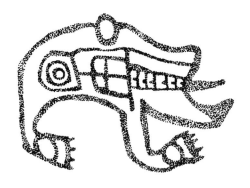

1.2 Abstract bear, Audrey's Overhang.

Anthropomorphs	Zoomorphs	Material Culture

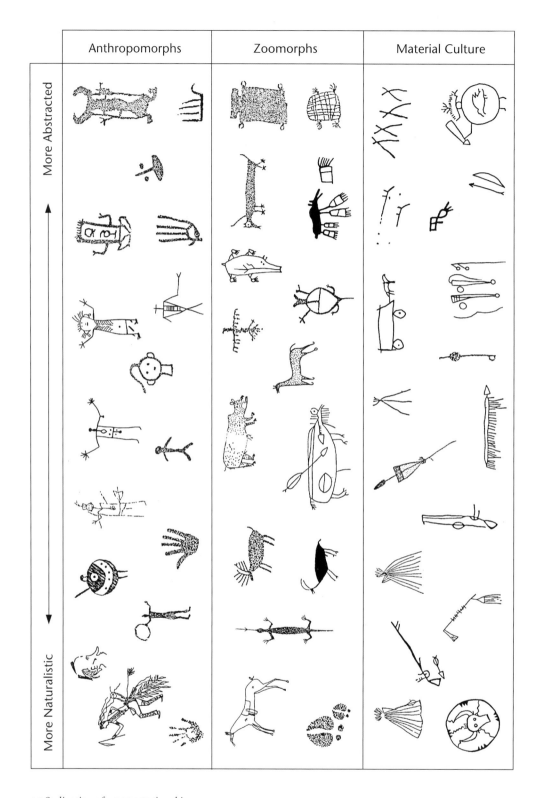

1.3 Stylization of representational images

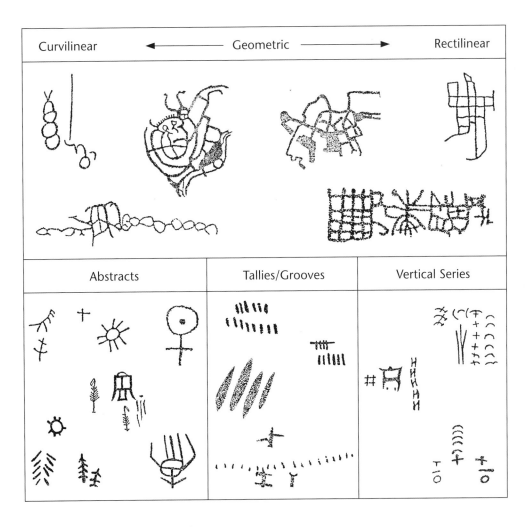

| Curvilinear | ← Geometric → | Rectilinear |

| Abstracts | Tallies/Grooves | Vertical Series |

1.4 Stylization of nonrepresentational images

of both. Many nonrepresentational images are now completely inexplicable, or it may be that we simply do not recognize what objects they represent. Some nonrepresentational images, however, clearly symbolize a concept or an idea rather than represent an object. For instance, some groups of vertical marks appear to have been used for counts of things or as ritual mnemonic devices. Other designs are pictographic or ideographic symbols. Still others apparently depict entoptic phenomena or phosphenes (not to be confused with visions or hallucinations)—the electrical images experienced in the brain during altered states of consciousness, such as shamanic trances.

No Northwestern Plains rock art tradition is composed exclusively of either representational or nonrepresentational forms. However, some traditions are classified by their predominant forms. Northwestern Plains traditions that tend to be almost entirely nonrepresentational include Pecked Abstract and Vertical series, while the Early Hunting, Ceremonial, and Biographic traditions tend to be composed primarily of representational images. Other traditions fall somewhere in between.

Northwestern Plains representational traditions also vary from very naturalistic to highly abstracted. The Biographic, Early

Hunting, En Toto Pecked, and Columbia Plateau traditions tend toward more naturalistic images, while Dinwoody and Foothills Abstract traditions are significantly more abstracted.

The terms "conventionalized" and "schematic" relate to the form of individual images. For example, the V-neck human motif in the Ceremonial tradition has been standardized or conventionalized in such a way that it almost always consists of a rectilinear-outline body, arms held to the side and bent at the elbow, and a V-shaped shoulder area. Schematization refers to the reduction of a representational image to only those pictorial features necessary for it to be recognized. For example, both V-neck and "stick-figure" humans are schematized depictions of a human being (fig. 1.5). The latter, however, is more schematized than the former: everything except the very

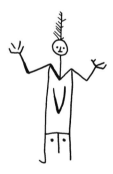

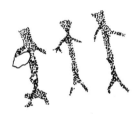

1.5 Human portrayals range from very simple, schematized stick figures to the highly conventionalized V-neck figures.

basic elements of a human—arms, legs, torso, and head—has been omitted. Schematization allows the rapid, conventionalized depiction of specific subject matter in such a way that it is easily recognized and repeated by all those producing images of a specific tradition.

Subject matter refers to the types of things depicted in representational rock art. Human and animal figures comprise the most common categories of representational subject matter. Much Northwestern Plains rock art also frequently illustrates items of material culture—that is, the tools, clothing, and other human-made objects. Such items are most often shown being used by human figures, but others may be drawn as isolated images or as the primary subjects. Only three traditions—Early Hunting, Ceremonial, and Biographic—depict items of material culture in significant numbers. The Dinwoody and Columbia Plateau traditions show a very few such objects, and the remaining traditions show almost none.

Finally, the compositional relationships of images may be described as solitary, juxtaposed, or integrated. Integrated compositions consist of a group of images either directly linked or depicted in a state of clearly intentional interaction. For example, a horse and rider attacking a pedestrian figure shooting arrows or bullets is an integrated scene. On the Northwestern Plains, Biographic and Early Hunting tradition rock art characteristically show integrated scenes. Juxtaposed compositions, on the other hand, consist of formally and spatially associated motifs in a clustered arrangement, but depicted without any obvious evidence of direct interaction. For example, a stickman, stick animal, and series of tally marks grouped together to commemorate a successful vision form a juxtaposed composition. Columbia Plateau, Ceremonial, En Toto Pecked, and Foothills Abstract tradition art frequently show juxtaposed compositions. Finally, solitary compositions consist of separate individual images that

display no evidence of intentional juxtapositioning or integration—such as a lone shield-bearing warrior, or the bear's face at Bear Mask Cave. Although solitary images can occur in any tradition, they are most common in the Pecked Abstract, Dinwoody, and Ceremonial traditions.

Styles and Traditions

When seen from a regional perspective, the Northwestern Plains presents a confusing array of rock art images carved and painted over a period of several thousand years. Understanding this vast body of art is often quite difficult—frequently the variation at a single site, or group of related sites, is nearly as great as that of the region as a whole. For instance, Kibbey Canyon shows simple red-painted, stick-figure humans on the same panel with abstract spirit figures and a shield-bearing warrior using an atlatl, while V-neck humans with headdresses, earrings, and heartlines are chalked in black charcoal on the roof of a small, nearby rockshelter. Pecked petroglyphs at Legend Rock include herd scenes of small animals overlaid by almost life-sized anthropomorphs with strangely patterned bodies. Close by are groups of small pecked humans and other scratched compositions of horses and riders. Writing-on-Stone, Pictograph Cave, the North Cave Hills, Craven Canyon, Twin Creek, Recognition Rock, and Castle Gardens are just a few of the other sites displaying similar collections of such obviously different kinds of rock art.

In order to classify this art into units that can be easily described and compared with one another and with similar rock art units in other areas and periods, we use the terms "rock art tradition" and "rock art style." As used in this book, traditions and styles are descriptive, organizational units based on traits shared by a group of images. These traits include (1) characteristic subject matter; (2) the forms used to illustrate these subjects;

(3) the compositional relationships typically noted between them; and to a lesser extent, (4) the technique used to produce the designs; and (5) the specific landscape setting in which they are found. Taken together, these criteria produce an overall distinctness of expression that enables us to recognize a characteristic pattern of depiction for each rock art style or tradition. Each style is generally restricted to a specific time and place, and in many cases may indicate a specific cultural or ethnic group. Traditions, on the other hand, consist of a set of related styles for which a spatial, temporal, and cultural continuity can be demonstrated (Schaafsma 1985; Sundstrom 1990). On this basis, we can construct a general framework to help determine when, why, how, and sometimes even by whom the art was made.

For example, we can distinguish between the red painted pictographs of the Columbia Plateau and Foothills Abstract traditions. These traditions contain some of the same designs, including stick-figure and block-body humans and simple animals and geometric figures, but each tradition uses them in significantly different numbers and arranges them in different structured relationships. Furthermore, in each tradition these shared designs are associated with characteristic motifs (tally marks in Columbia Plateau art; handprints and mazelike figures in Foothills Abstract art) that are rare or entirely absent in the other tradition. The traditions also show differences in site setting. Columbia Plateau art is typically painted in isolated locations, difficult of access and with commanding views of the surrounding terrain. These locations suggest that the rock art was an individual effort. In contrast, Foothills Abstract sites, though isolated, are usually easy to reach, and many appear to have served some sort of public function.

Traditions cannot be separated into perfectly distinct entities, however, because some if not all of their defining criteria vary continuously over space and time, as motifs,

subject matter, compositional structures, and techniques increase or decrease in popularity. Geographic groups of artists often favor some forms and compositions over others, thereby giving the art of a particular tradition distinctly local flavors, much like regional dialects in a language. Such variants may constitute styles within the tradition. Furthermore, some blending almost always occurs among traditions that are geographically and temporally associated. Artists may even have borrowed designs from sites seen during travel to distant places, or from much older styles and traditions, thereby bridging large gaps in space and time. This blending does not preclude defining specific traditions and styles, since precise boundaries in any multidimensional classification scheme dealing with such a flexible subject are always somewhat arbitrarily fixed.

Rock art traditions are not necessarily restricted to specific cultural groups or even related groups speaking similar languages. For instance, the Columbia Plateau tradition was carved and painted by both Kutenai and Salish speakers in Montana and by Sahaptian speakers farther west in Idaho, yet their art is so similar as to be nearly indistinguishable. The Biographic tradition was carved and painted by groups representing numerous Northwestern Plains language families (and several others on the central and southern Plains). The Biographic tradition as a whole shares characteristics widely understood by many different groups, yet certain differences in Biographic rock art, noted from area to area, may correspond to tribal groups, and thus constitute ethnic or regional styles within a larger tradition. Similar situations likely existed with Hoofprint, Ceremonial, Early Hunting, Pecked Abstract, and other traditions produced by members of several groups.

On the other hand, more than one art tradition can also coexist within a single cultural group, with each usually made for different functional purposes. The Historic

period Salish used two representational traditions and one nonrepresentational. Columbia Plateau tradition rock art was made for religious purposes at vision quest locations, Biographic tradition art was drawn in several media to document a warrior's status; and nonrepresentational geometric art was used for painted or beadwork decorations on clothing, moccasins, parfleches, and other items. Similarly, among the Historic Wind River Shoshone, warriors drew Biographic art, shamans pecked Dinwoody tradition motifs, and women decorated clothing with geometric painted, quilled, or beaded designs.

Rock art traditions may be broadly or narrowly defined, depending on the orientation of the researcher and the current state of site description. For example, we identify the Early Hunting tradition, but note significant temporal variations within it at Whoopup Canyon, a major complex of dozens of related sites (Tratebas 1993). Whether these same temporal variants can be identified in similar nearby sites in the Black Hills has not yet been demonstrated. Spatial variations occur between the Whoopup Canyon and other Black Hills sites and those in the Wind River basin (where some hints of temporal variations that may or may not correspond to those at Whoopup also occur). Similarly, temporal and spatial variation are beginning to be documented within the Dinwoody, Foothills Abstract, and Ceremonial traditions.

Rock art traditions related in content and expression, and sharing some spatial and temporal continuity, constitute a macrotradition. On the Northwestern Plains, at least four such macrotraditions are represented: the Western Archaic, Eastern Woodlands, Northwestern Plains , and Northwest Montane. The similarities among traditions that make up these macrotraditions may simply be the result of the movement of ideas among groups who share general modes of cultural/ecological adaptation. This appears to be the case with the general similarities between

the several traditions throughout the Northwestern Plains, Great Basin, and Colorado Plateau, which compose the Western Archaic macro-tradition. In other situations, the similarities might represent the migration of people. For example, it is likely that the historically documented immigration of Siouan- and Algonkian-speaking groups introduced the Hoofprint tradition, representing the Eastern Woodlands macrotradition, to the Northwestern Plains.

In still other cases, the relationships among traditions are best explained as evolutionary change through time, with a single parent tradition slowly developing into a slightly different one, or branching into several related ones. A combination of these processes seems to best characterize the relationships among the Ceremonial, Biographic, Robe and Ledger art, and Vertical Series traditions, which together form the Northwestern Plains macrotradition. This macrotradition is based on the similar geographic distribution, shared formal characteristics, and apparent cultural relationships of the four traditions.

In the end, we have organized Northwestern Plains rock art (and the closely related Robe and Ledger art) into eleven distinct traditions. Most of these traditions closely correspond to styles previously defined by various researchers, although sometimes these styles have been given multiple names, and in some cases a full description of their characteristics has never been published. In each chapter, we have included a summary of the distinguishing characteristics that help to define that tradition. It has also been necessary to assign new names for several traditions in order to incorporate recently reported sites and greater variation than was previously known. For example, the Foothills Abstract tradition was created in order to incorporate both Central Montana Abstract style sites (Keyser 1979a) and many newly documented sites with similar rock art in Alberta and north central Montana. We have attempted to use the best known and least ambiguous names when two or more occur for the same tradition.

For descriptive convenience, we often include several temporal and spatial variants within a single tradition. We recognize, however, that it may be possible to define these variants as distinct styles within each tradition, and future efforts may even split a tradition into two or more distinct entities when more complete data are available, or if someone wishes to pursue different research questions. This process of splitting and defining new traditions (and styles) has occurred continuously over the past several decades; various researchers have separated the Biographic, Central Montana Abstract (Foothills Abstract), En Toto Pecked, and Vertical Series entities (Conner and Conner 1971; Conner 1980; Keyser 1979a; Loendorf 1984; Loendorf and Porsche 1985; Sundstrom 1987) from the general stylistic descriptions of earlier researchers (e.g., Malouf 1961; Conner 1962a; Conner and Conner 1971). As our knowledge and understanding of Northwestern Plains rock art expands and evolves, so too will the sophistication and consistency of its description and organization.

2 / Dating Rock Art

Reliably determining the age of petroglyphs and pictographs has always been a challenge. Rock art images rarely occur in dated archaeological contexts, such as a buried soil layer. Nor has radiocarbon dating been applied to rock art until recently, with the development of techniques to date the tiny amounts of organic material sometimes found in pigments or incorporated into carvings. Without reliable dates, determining temporal and cultural relationships between sites and images is often nearly impossible, and tracing the development of styles through time and across regions is difficult.

Nevertheless, unlike rock art in other areas of North America, much Northwestern Plains rock art has been dated with relative certainty, even in the earliest studies, through the presence of historical or European items drawn at many sites. Images of horses, guns, and other items of obvious non-Native origin have been reliably dated to the Historic period at more than 150 sites. Some rock art can even be separated into Protohistoric, early Historic, and late Historic periods, based on the known earliest dates for introduction of some of these items, their relative frequency, and certain patterns of stylistic evolution (Dewdney 1964; Conner 1980; Keyser 1977a, 1979b, 1987a; Klassen 1995).

Nonetheless, more than 90 percent of Northwestern Plains rock art is prehistoric. Until recently these sites could only be relatively dated by chronologies based on differential weathering and superpositioning (Gebhard and Cahn 1950; Buckles 1964; Sundstrom 1990; Keyser 1987b). Although these schemes provided reasonably good tradition sequences in several areas, many authors tended to be conservative in their estimates of rock art preservation, and as a result the true age of much of this rock art was not recognized; recent studies have shown that these early chronologies are often seriously foreshortened.

The 1990s have seen the development of new dating techniques and a flowering of new efforts to date Northwestern Plains rock art. Some of this work has been very successful in providing evidence for rock art of greater antiquity than anyone had previously suspected. At first, efforts were made to locate sites where rock art extended down to or below the ground surface, and the associated sediments were excavated in the hope of finding either rock art manufacturing tools in a datable context, or datable archaeological deposits actually overlying designs. Recently, new techniques that allow direct absolute dating of petroglyphs and pictographs have been experimented with in the area, and in the last few years, tentative radiocarbon and cation ratio dates have been obtained on designs at more than a dozen sites.

In general, Northwestern Plains rock art can be dated using six major kinds of evi-

dence: (1) association with dated archaeological deposits; (2) association with dated portable artifacts or art; (3) portrayal of datable subject matter; (4) superimposition of designs; (5) patination and weathering; and (6) chronometric methods. Most of these methods are relative dating techniques, in that they only show one image to be older or younger than another. On the other hand, chronometric methods such as radiocarbon dating are absolute dating techniques, which provide an approximate age in years before the present for a specific image.

Association with Dated Archaeological Deposits

Occasionally the lower part of a rock art panel, or a piece that has broken off and fallen to the ground, is found buried in sediments containing dated archaeological materials. Such circumstances imply that the rock art must be older than the dated materials burying it. Incorporation of rock art into an archaeological context is relatively uncommon, although several instances are known on the Northwestern Plains. One Dinwoody tradition petroglyph at Legend Rock was found partially buried by an occupation level dating to A.D. 50 (Walker and Francis 1989). Others cases involve boulders in southwestern Saskatchewan,

where Late Prehistoric period artifact-bearing deposits were covering cupule petroglyphs and burying some black pictographs (Steinbring and Buchner 1993). These situations provide a minimum date for the rock art, but a maximum age cannot be determined.

Dated archaeological deposits below a rock art panel sometimes contain tools or other artifacts directly associated with the images. At both Writing-on-Stone (Brink 1979) and the Valley of the Shields in south-central Montana (Loendorf 1988, 1990), tools used to make the images were found beneath rock art panels. One bone carving tool at Writing-on-Stone was dated to approximately 725 B.C., but it could not be directly linked to a specific petroglyph. At Valley of the Shields, however, recovered tools link the production of several large shield-bearing figures to a date of about A.D. 1100. At the Simanton petroglyph boulder in northern Montana, ceremonial offerings relating to the boulder were dated to the Late Prehistoric period (Park 1990), providing a minimum date for use of the site after the motifs were carved.

Well-drawn horses, along with the small shield with identifiable designs, date this North Cave Hills panel to the late Historic period, between A.D. 1800 and 1850.

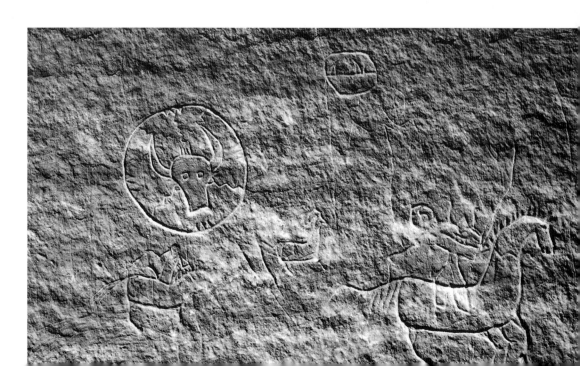

Association with Dated Portable Art

In some cases, aboriginal artists created the same designs on both rock art panels and portable objects that can be dated. Several such Northwestern Plains examples are known. Many Columbia Plateau tradition pictographs in western and central Montana and western Alberta consist of simple dots and lines that are nearly identical to similar paintings found on a cylindrical stone in a British Columbia occupation site dated to more than two thousand years old (Copp 1980). Clearly, some of these pictographs could be of similar age. A petroglyph face associated with the Hoofprint tradition at the St. Victor

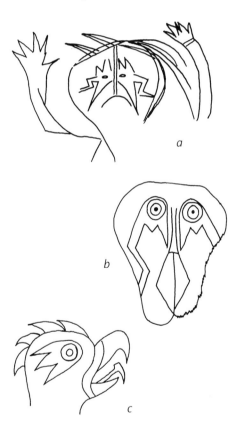

2.1 Southern Cult imagery often shows the "forked eye" motif: a, incised rock art from Black Hills; b, conch shell maskette from North Dakota; c, pottery design from Alabama.

site in Saskatchewan is almost identical to faces carved on ceremonial items in the Late Prehistoric period Devils Lake–Sourisford Burial complex (Jones and Jones 1982). Since the portable art from this complex dates between A.D. 900 and 1400, the St. Victor face is probably of a similar age. This association is strengthened by the occurrence of a Devils Lake–Sourisford type catlinite pipe left as an offering at another Hoofprint boulder, the Simanton site, only 100 miles (160 km) south in Montana. In the Black Hills of South Dakota, a few painted and incised sites show forked eye and bellowing bison motifs almost identical to images carved on catlinite tablets and pottery from Oneota culture sites in Iowa and eastern South Dakota (fig. 2.1). These cultures participated in the Southern Cult ceremonial complex between approximately A.D. 1300 and 1800 (Sundstrom 1990). Sundstrom makes a good case that these designs are the product of Late Prehistoric period Siouan speaking peoples who migrated into the Black Hills area from the Oneota culture.

Dated portable objects from the post-contact period can also be used for dating. Early explorers, traders, missionaries, and military men often collected painted robes, decorated shirts, and ledger drawings from Northwestern Plains Indians. Several hundred of these items have survived in museums, archives, and private collections. The oldest examples were painted in the late 1700s; the latest were collected after 1900; and many are securely dated to a specific decade or even year. The images on many of these objects are clearly similar to rock art designs, and as a group, they chronicle developments in style and drawing technique (fig. 2.2). By comparing dated drawings and paintings to similar rock art examples, researchers have been able to date numerous rock art images to specific periods that may span only a few decades (Conner and Conner 1971; Conner 1980; Keyser 1987a; Keyser and Cowdrey 2000).

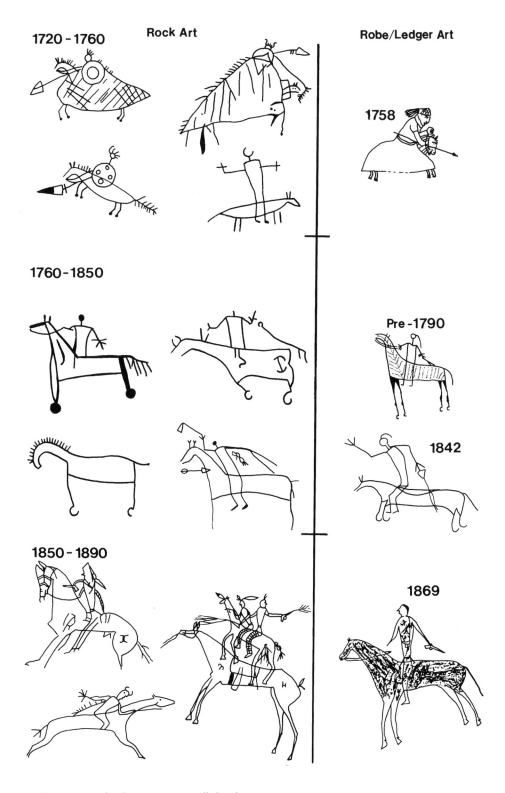

Rock Art · **Robe/Ledger Art**

1720 - 1760

1758

1760 - 1850

Pre - 1790

1842

1850 - 1890

1869

*2.2 Comparison of rock art images to well-dated
Robe and Ledger art drawings.*

Portrayal of Datable Subject Matter

Images of atlatls (throwing sticks used to propel stone-tipped darts), large body shields, and bows and arrows are relatively reliable prehistoric time markers. Before the bow and arrow, hunting weaponry consisted of spears or atlatls and darts. Atlatl petroglyphs are carved at several Early Hunting tradition sites, and a painted shield-bearing figure at Kibbey Canyon is also shown using one. The presence of atlatls and the absence of bows and arrows in the Early Hunting tradition dates these sites to about A.D. 500, before the introduction of the bow onto the Northwestern Plains. The bows and arrows shown at more than one hundred sites date them to the last 1500 years. Two types of bow may be further restricted temporally. The bow-spear—a longbow with a large spear point affixed to one end—is only associated with prehistoric shield-bearing and V-neck warriors at Writing-on-Stone, Pictograph Cave, and an eastern Wyoming site. Shorter, recurved bows are shown with numerous historic warriors but have yet to be found in prehistoric drawings.

Figures holding large body shields in front of their torsos generally indicate a Late Prehistoric date. Although one shield-bearing figure wields an atlatl, and a few are shown with horses or guns, they are most commonly associated with bows, bow-spears, or spears characteristic of the Late Prehistoric. Body shields, introduced into the region during prehistoric times, were abandoned at the beginning of the Historic period, soon after the horse made them impractical.

Northwestern Plains rock art also shows thousands of items first introduced into the area between approximately 1650 and 1830. They include horses (some with brands), guns, metal hatchets, military accouterments, boats, wagons, Euro-Americans, and buildings. For many of these items, the specific dates of their arrival and subsequent spread across the region has been determined by careful ethnohistoric research (Map 2.1). For instance, the first horses were introduced onto the Northwestern Plains about 1690 by the Shoshone, who obtained animals stolen from the Spanish settlements in New Mexico from their Ute kinsmen (Haines 1938; Ewers 1955). Through trade and raiding, horses spread rapidly northeastward, reaching southern

The large body shields and bow-spears associated with these shield-bearing warriors at Writing-on-Stone date them to the Late Prehistoric period.

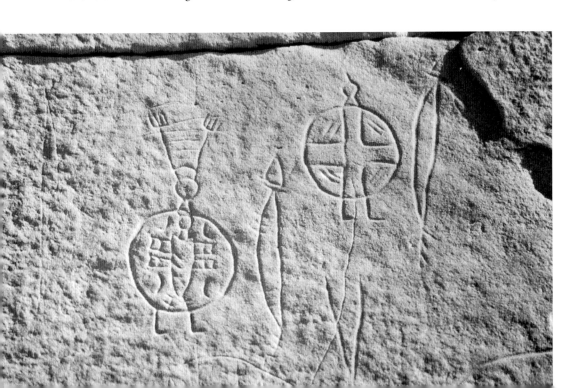

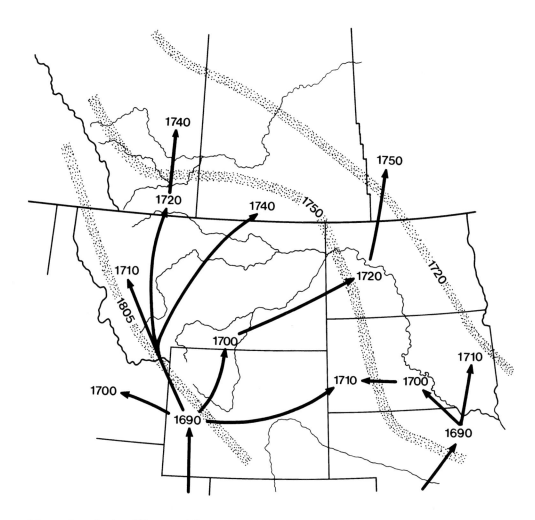

Map 2.1. Introduction of Horses and Guns
onto the Northwestern Plains

Routes of diffusion of horses
Extent of diffusion of guns

For more than a century, the diffusion of horses and
guns produced a shifting dynamic that had as many
as ten tribes competing to be the region's most
powerful. Primary sources for this map are Haines
(1938) and Secoy (1953).

Alberta and North Dakota by about 1730. French and English trappers traded guns to the Plains Cree in the Great Lakes and Hudson Bay regions. Guns reached the northeastern edge of the Plains about 1700 and then spread rapidly southwestward, so that by 1775 nearly all Plains groups had some (Secoy 1953). Other items can also be dated in a similar way. For example, for a very brief period after horses arrived, leather horse armor was used in battle. Boats first came up the Missouri River with Lewis and Clark in 1804; wagons first entered the region after 1830; and the first forts and trading posts, erected around 1800, had become common across the region by 1850.

With these and other dating clues it is sometimes even possible to reliably date postcontact rock art on the Northwestern Plains within a twenty-five-year span. For example, Explorer's Petroglyph north of Billings, Montana, apparently shows Clark's return expedition down the Yellowstone in 1806 (Cramer 1974). The branded horses at Joliet and a hanging scene at Writing-on-Stone probably date between 1860 and 1885, and combat scenes showing horsemen fighting pedestrian warriors at Writing-on-Stone and in the North Cave Hills can be dated between 1725 and 1750 by the presence of body shields, horse armor, and the absence of guns. A panel of Crow "Hot Dancers" at Joliet (fig. 2.3) can be dated between 1875, when the Crow adopted this dance, and 1890, when almost identical scenes were drawn in Crow ledger art (Keyser and Cowdrey 2000).

Superimposition of Designs

Though a superimposed image is unquestionably the most recent, such images provide only limited chronological information, because the underlying design may have been made anywhere from an hour to thousands of years earlier. On the other hand, if a number of stylistically distinct motifs are consistently superimposed in the same order at a number of different sites, then a generalized chronology for a region's rock art can be developed, since the relative ages of each tradition can be shown. A regional chronology based on superimpositioning requires substantial supporting evidence, including differential patination and the analysis of several sites, to be considered accurate: the more sites involved, the more reliable the chronology. On the Northwestern Plains, superimpositionings are frequent and have been used in several

2.3 Crow "Hot Dancers." a, rock art dancers at Joliet; b, 1887 ledger drawing by Custer's Crow scout, Curley; c, 1882 ledger drawing by Above, a Crow warrior.

areas to propose general chronologies (Gebhard and Cahn 1950; Buckles 1964; Sundstrom 1990; Loendorf et al. 1990). Keyser (1987b) also provides a good example of a proposed chronology based on superimposed images at a site in the North Cave Hills. These chronologies are still tentative, but the many known examples of superimpositioning will likely be combined with other forms of dating evidence to clarify relationships between styles and traditions.

Patination and Weathering

Many Northwestern Plains petroglyphs were made by pecking or incising images through a dark patina often found on sandstone in the region. This patina, called desert or rock varnish, is a thin, dark coating of manganese and iron oxides formed on rock surfaces in arid or semiarid climates by manganese-oxidizing bacteria. When a petroglyph is pecked or carved through the varnish, it exposes the lighter colored stone beneath and creates a dramatic negative image—a light petroglyph against a dark background. If conditions for varnish development still exist after the petroglyph is made, the rock varnish slowly reappears on the newly exposed surfaces. Over time the design may become so repatinated that it becomes essentially the same color as the unaltered rock face.

Experimental techniques developed in recent years suggest that it may be possible to date rock varnish in certain circumstances to provide a minimum absolute age for the underlying petroglyph (see Chronometric Dating, below), but these specialized techniques are costly. Even in the absence of absolute dates, however, patination can provide relative dating clues, because the rate of varnish formation is so slow that petroglyphs cut into the same surface at different times will show different amounts of repatination. Since the rates of varnish formation vary widely from surface to surface,

This shield-bearing warrior at Medicine Lodge Creek, Wyoming, was made by pecking through a patina of dark-colored desert varnish, revealing the light-colored sandstone underneath.

patination can only be used to relatively date different petroglyphs on the same panel.

Variations in the degree of weathering of different designs are often used in conjunction with patination studies. Variation in weathering can also be applied to pictographs, which patination affects differently from petroglyphs. Weathering involves chemical or physical breakdown of the rock surface or deposition of mineral precipitates leached from some other part of the rock. Often such weathering causes faded pictographs or worn petroglyphs, in clear contrast to younger, newer-looking images on the same or adjacent surfaces. Again, because weathering rates vary from surface to surface, differential weathering

is most reliable when applied to different images on the same panel. Sometimes weathering caused portions of a rock panel to fall off after images were made, creating a new rock surface that cuts across the older panel. Any designs drawn on the new surface are therefore younger than those drawn on the original surface.

If certain motifs or traditions at many different sites consistently appear older on the basis of relative weathering and repatination, a generalized chronology for these motifs can be developed. Both patination and weathering have been used throughout the region in various attempts to arrange traditions in their proper relative chronology. These methods are often combined with other dating evidence, such as superimpositioning and the depiction of datable objects, to develop regional chronologies. Probably the most thorough example of a chronology developed in this way is that of Sundstrom (1990) in her work on southern Black Hills rock art.

Chronometric Dating

The 1990s have seen experimentation with two chronometric methods for directly dating rock art images: accelerator mass spectrometry (AMS) radiocarbon dating and cation ratio (CR) dating (Francis et al. 1993). Radiocarbon dating (or carbon 14 dating) measures the radioactive decay of the unstable carbon isotope (14_C) relative to its stable isotope (12_C) in organic materials. Living organisms absorb the unstable isotope during their lifetimes, but this intake stops at death, when the radioactive breakdown of 14_C into 12_C begins. Given the known radioactive half-life of carbon, measurement of the ratio of these isotopes found in an organic archaeological object produces a date for the death of the living organism.

Traditional radiocarbon dating requires relatively large amounts of organic material.

As AMS dating requires only very small quantities of organic material (often far less than a single gram) to obtain radiocarbon dates, it has been used on both pictographs and petroglyphs. The charcoal-based pigments of black pictographs offer the best potential for AMS dating, but other organics, including plant fibers and organic binding agents (blood, animal fat, egg yolk) found in pictograph pigment can be used. For petroglyphs, AMS dating has been used on organic matter such as lichens, fungi, bacteria, or microscopic charcoal flecks trapped on the surface of the petroglyph by the subsequent formation of rock varnish. To date, only a single pictograph and approximately twenty petroglyphs at several different sites in the region have been dated by AMS methods (Francis et al. 1993; Tratebas 1993; Chaffee et al. 1994).

CR dating measures the slow leaching of potassium and calcium out of rock varnish. The ratio of these elements to titanium (which does not leach) decreases at a consistent rate through time. When both AMS radiocarbon dates and cation ratios are obtained from a number of the same petroglyphs, the rate of cation leaching in a local area can be determined. Other cation ratios from petroglyphs which have not been radiocarbon dated can then be compared to this rate to determine their age. At present, only local leaching rates for single sites or closely associated groups of sites have been determined, because the rate of cation leaching appears to vary widely owing to local climatic conditions. The CR dating technique is still in the early stages of development, and the resultant dates are preliminary. Nonetheless, some CR dates have suggested a far greater antiquity for Northwestern Plains rock art than was previously believed possible. Further work with CR techniques will undoubtedly lead to greater control of its reliability, and comparisons with dates obtained by other methods will strengthen regional chronologies. On the Northwestern Plains, petroglyphs at sites in the Bighorn

Basin in Montana and Wyoming and at Whoopup Canyon have been dated by CR analysis (Tratebas 1993; Francis et al. 1993; Francis 1994).

As this book was nearing completion, newly published reports began to question the reliability and validity of past AMS radiocarbon dating of petroglyph rock varnish (Dorn 1996, 1997, 1998; Beck et al. 1998). A key finding of recent research indicates that rock coatings (i.e., desert varnish, silica skins) are not "closed systems" that only trap organic material originating from the time shortly after the petroglyph was made. Instead, the organic matter in rock coatings may include contaminants that originated long before or long after the petroglyph was made. These older and younger organic contaminants may be deposited by natural weathering processes, or they may originate with organisms living on the rock surface.

As AMS dating relies on small amounts of organic material trapped beneath rock coatings on petroglyphs, the possibility of contamination makes the use of this technique unreliable and problematic. For any particular sample, it is not yet possible to ascertain if it is contaminated, nor is it possible to correct for contaminants that might cause the date to be in error. Therefore, Dorn (1996:11) cautions that his previous varnish dates, including both AMS radiocarbon dates and CR dates calibrated to AMS dates, cannot be accepted uncritically. These concerns do not necessarily directly invalidate CR dating, which remains a valid means of assessing the relative ages of petroglyphs—rather, they question the assignment of "absolute" ages for CR dates when they are linked to AMS radiocarbon varnish dates.

Concerns with AMS dating are significant here, as the chronologies of several rock art traditions described in this book are partially based on these dates. Although we should not ignore the many AMS dates obtained for Northwestern Plains rock art—some or all of them may be correct, and a few are supported by independent age controls—we must also acknowledge the likelihood that some reported dates are wrong. Dorn, who is responsible for most of the varnish dates so far obtained for Northwestern Plains petroglyphs, notes that some sites have independent age controls, and he hopes that further work will ultimately refine rock varnish dating to such an extent that researchers will be able to correct for contamination and thus identify accurate AMS dates.

Until that time, we must support AMS dates with other dating evidence available for rock art sites and traditions. In discussing the three Northwestern Plains rock art traditions that have been dated extensively using AMS radiocarbon and CR dating methods—Early Hunting, Dinwoody, En Toto Pecked (chapters 6, 8, and 9)—we discuss the reliability of the dates and carefully assess them in the context of other dating evidence.

Superimpositioning at a North Cave Hills Site

Superimposition of rock art images occurs when an artist paints or carves designs over already existing ones. Whether intentional or accidental, these occurrences are important for establishing a relative rock art chronology. When supported by other evidence, such as datable subject matter, superimpositioning is an even more powerful dating clue.

One of the best examples of such superimpositioning occurs at a site in the North Cave Hills of South Dakota (Keyser 1987b). Here, more than forty recognizable figures are carved across a large panel on a broad, south-facing cliff (fig. 2.4). At first glance, the panel seems a bewildering jumble of randomly placed images. Closer examination reveals that these figures in fact represent three distinct rock art traditions successively superimposed from top to bottom of the panel. The excellent visibility of the motifs indicates that this superimpositioning was intentional—perhaps the later artists hoped to capture some of the power thought to exist in the earlier images.

The earliest carvings, on the panel's upper third, are six figures of the Ceremonial tradition. They display classic Ceremonial motifs—shield-bearing warriors and V-neck humans, one holding a bow. Elsewhere, Northwestern Plains shield-bearing warriors have been dated as early as A.D. 1100. This precedent and the absence of historic weap-

onry suggest that these petroglyphs were carved during the Late Prehistoric period. The highest images are out of reach from the present ground surface, suggesting that considerable erosion has occurred since they were carved. This is supported by the fact that the lower portion of one of the shield-bearing warriors has been rubbed away, perhaps by bison standing on much higher ground.

Scattered across the middle third of the panel are nineteen Hoofprint tradition petroglyphs centered around a bison cow and calf composition more than 7 feet (2 m) long and 4 feet (1 m) high. These figures cover almost a fourth of the panel surface. They are superimposed on the lower torso and legs of three Ceremonial tradition V-neck humans. The bison cow (whose humped hindquarters, upraised tail, and trailing placenta suggest a calving posture) and her calf both have carved hoofprints representing feet. Around and across this dynamic scene are additional hoofprints, bird tracks, and bison.

All the Hoofprint tradition glyphs are within reach from the present ground surface, though they would have been easier to carve had the ground been slightly higher. Their various superimpositions indicate at least three and probably more Hoofprint tradition carving episodes. All but one of these figures occur lower than the Ceremonial motifs. The exception is a bird track at the top right of the panel, which can still be reached from a

hummock directly below it. The lower placement of the Hoofprint tradition motifs and the superimposition of the largest bison on V-neck humans demonstrates that they postdate those of the Ceremonial tradition. Although the Hoofprint tradition began in the Late Prehistoric and extended into the Historic period, the absence of horses' hoofprints suggests that these petroglyphs were carved before A.D. 1750.

The most recent images are five figures, including two humans and weapons, at the panel's bottom. They are loosely grouped into what may be a coup-counting scene similar to those found in the largely Historic period's Biographic tradition. The larger human figure is directly superimposed on the hanging placenta of the large Hoofprint tradition bison cow. An arrow superimposed over its right horn high on the panel suggests that the artist used the same hummock as the person drawing the highest Hoofprint tradition bird track. These images are situated between knee and chest height of an adult standing in front of the panel. This low position and the superimpositioning indicates that they represent the latest carving episode.

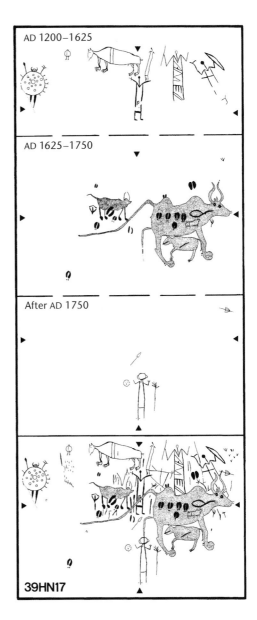

2.4 *Superimpositioning of motifs at a North Cave Hills site.*

3 / Interpreting Rock Art

In traditional Plains Indian beliefs, much rock art originates in the spirit world. Oral traditions often describe petroglyphs and pictographs as "writings" of spirit beings—images that, shifting and changing over time, communicate messages from the spirit realm to living people. In this traditional world view, everything in life reflects a celestial order, and objects and beings possess sacred powers. Events are seen as repetitions of mythic precedents taking place in cyclic time, and human actions repeat those of the spirit ancestors.

In contrast, the scientific or historic conception of the world views objects and people independent of the cosmos. Time is a linear progression, in which each event is uniquely related to the historical past, and current cultural conditions are explained as the result of a series of actions taken by human beings. Based on this view, archaeologists identify rock art as the creation of people at various times in the chronological past.

The dichotomy between sacred and historical views does not imply that one is better than or contradictory to the other. From the chosen perspective of the viewer, each is a valid way of interpreting the images, each serves a different cultural purpose, and both views often coexist within a single culture (Vastokas 1990).

Too often, rock art researchers have misunderstood or dismissed traditional explana-tions because they did not fit scientific models. From our viewpoint, traditional explanations offer valuable insights into the meaning and function of the images—in many ways they can be understood as metaphors of how non-Western cultures relate to their world (Whitley 1994a). These sacred interpretations, when understood in terms of their cultural context, often provide information available nowhere else. Thus, wherever possible, we have attempted in this book to employ traditional explanations of rock art as a source of anthropological insight.

Early Academic Investigations

Formal academic study of rock art has generally fallen to anthropology, beginning with the publication of Garrick Mallery's "Picture Writing of the American Indians" (1893). Probably because most petroglyphs and pictographs are of prehistoric age and associated with Indian cultures, archaeologists quickly adopted the subject, and for the first half of the twentieth century published numerous works on rock art throughout the Northwestern Plains and adjacent areas (Buker 1937; Gould 1900; Leechman, Hess, and Fowler 1955; Malouf 1961; Mulloy 1958; Over 1941; Renaud 1936; Smith 1908, 1923; Sowers 1939, 1941; Steward 1929; Wintemberg 1939). These early studies tended to be primarily descriptive, and the most sophisticated of them

merely described the rock art in terms of styles or placed it into general chronological and cultural frameworks.

Despite their early fascination, most archaeologists were reluctant to investigate these images in detail. Many felt that rock art interpretation was beyond the abilities of their methods and theories, because intangible aspects of cultures, such as religion and artistic meaning, were not preserved in the archaeological record like arrowheads and housepits. They believed that understanding the meaning of rock art images required direct cultural and historical information about them—information that was not readily accessible, if at all. Then, in the early 1950s, radiocarbon and tree ring dating were developed, allowing archaeologists to precisely date many types of archaeological sites—but not pictographs or petroglyphs. Armed with these new chronometric methods that could provide dates for most site types, archaeology rapidly lost interest in rock art, which could not be placed into a specific time period. As a result, efforts to record and interpret rock art fell largely to nonarchaeologists who were fascinated with this cultural legacy but not constrained by prevailing archaeological ideas (e.g., Conner 1962a, 1964; Conner and Conner 1971; Fowler 1950; Gebhard 1951, 1963, 1969; Gebhard and Cahn 1950; Grant 1967; Habgood 1967; Wellmann 1979a). Although many of these studies produced valuable insights into the rock art record, some suffered from speculative interpretations.

By the late 1970s archaeologists once again began to study rock art, and recent advances in dating techniques, recording and analytical methods, and theoretical approaches have created new opportunities for bringing its interpretation into the mainstream of archaeology. Some of these new approaches borrow theories from other disciplines, and others incorporate a wide variety of external evidence from archaeology, oral traditions, historical records, ethnographic observations, and material culture that can be linked to the images. Analysis of all aspects of the images, including their technique, subject matter, form, composition, and style, has also advanced (Vastokas 1987). Finally, many researchers now recognize the importance of investigating the contextual relationship of rock art images to ritual and landscape.

Analysis and interpretation of rock art is now undertaken using many approaches, including descriptive studies, stylistic analyses, universal regularities, ethnographic analogies, iconographical analyses, and investigations of cultural and physical contexts. Since we refer to these approaches throughout the book, we discuss each in more detail below.

Descriptive Studies

Early rock art investigations were broadly based surveys that documented site locations and recorded the images by photographs or drawings. The earliest (e.g., Sowers 1939, 1941; Renaud 1937; Over 1941; Dewdney 1964; Conner and Conner 1971) are invaluable records of many sites now damaged or destroyed. Even today, the highest priority for many Northwestern Plains rock art studies is documenting sites before they are lost to natural deterioration or human disturbance. Many such surveys also include descriptive studies of the images, but only rarely attempt any significant degree of interpretation. At most, they document different types of subject matter and classify these images into types or styles which are believed to represent chronological developments. Although many descriptive studies are intended to be objective classification schemes, the identification of subject matter can involve a degree of subjectivity.

Recent important descriptive studies include those of Keyser (1977a), Loendorf and Porsche (1985), and Gebhard et al. (1987). Such studies are very useful for determining the geographic distributions of various designs

and investigating the potential relationships of rock art across regions. The identification of subject matter also can provide valuable clues for dating and other anthropological research. Known dates for the introduction of items of non-Native manufacture provide a framework for determining the age of the rock art that pictures them. Equally important are illustrations of such things as shields, medicine bundles, clothing, weaponry, and headdresses. These objects are rarely preserved in the archaeological record and only occasionally known from historic collections. Illustrations of these items expand our knowledge of both the temporal and geographic range of their use, and when combined with animals and humans in action scenes, they illustrate hunting, warfare, and other practices that may otherwise be known only from archaeological remains or early historic writing (Sundstrom 1989; Keyser 1979b). These illustrations represent the artists' own visualizations of actual events, and are often the only pictorial records available from a time before photography.

Other descriptive approaches treat individual rock art images as discrete artifacts that can be measured, quantified, and categorized in "nonstylistic" classification schemes (Schaafsma 1985). In one of the most extreme forms of this approach, human figures at Writing-on-Stone were broken down into their constituent parts or attributes (such as bent arms or headdresses) and then these attributes were tabulated and analyzed by computer so that the statistical associations (e.g., ratio of bent arms to headdresses) could be determined (Magne and Klassen 1991). Although this study demonstrated relationships among human types, the approach is unable to provide insight into the function or meaning of images.

Chronology and Style

To place rock art into a culture-historical sequence, and to better understand its

geographic distribution and temporal development, many archaeologists have focused their research on the concept of style. Archaeologists have traditionally considered style as a set of traits or characteristics, with limited geographical and temporal distribution, diagnostic of a particular cultural complex (Sundstrom 1990); they did not attempt any interpretation of function or meaning (Schaafsma 1985). Despite recent advances in scientific dating methods, it remains impossible or impractical to obtain absolute dates for many images. Therefore, the vast majority of rock art must still be relatively dated by arranging broadly defined styles and traditions into a generalized regional chronology.

Relative dating on the basis of style involves two basic assumptions: two images that share significant formal similarities are in the same style; and if the age of one is known, then we can infer that the second image is of a similar age. Stylistic analysis can be applied both within and among sites. By identifying and dating a series of styles in a single region, chronological developments and geographical trends can be determined, which can be helpful in understanding the relationship of rock art variation to cultural sequences. For this reason, much previous research on Northwestern Plains rock art has concentrated on the concept of style (Francis 1991; Francis et al. 1993; Gebhard et al. 1987; Gebhard and Cahn 1950; Greer 1995; Greer and Greer 1994a, 1995a; Keyser 1984, 1990; Loendorf and Porsche 1985; Sundstrom 1990).

While some styles may be restricted to a single culture or ethnic group, others cut across cultural and geographical boundaries. Styles can also be identified for a variety of cultural levels, including individual artists (fig. 3.1), an ethnic group, or an entire region. Since the level of differentiation depends entirely on the defining criteria, the past result for Northwestern Plains art has been a series of proposed styles that are not readily

comparable. Even so, by organizing rock art into geographical, temporal and cultural units, stylistic classification does provide a starting point from which interpretation may proceed. Without stylistic analysis, describing and interpreting the multitude of images and great variation that exists in Northwestern Plains rock art would be nearly impossible.

Neuropsychological Universals

Direct sources of external information about the function and meaning of rock art are often very limited or entirely absent, particularly in prehistoric contexts. To overcome this deficiency, some researchers focus on theoretical approaches that assume that certain recognizable regularities underlie all pictorial imagery. These regularities are thought to reflect universal behavioral traits shared by all humans, both past and present. For example, since all humans share the same basic neurological equipment—our brains and senses—and this equipment functions in the same way for everyone, certain neuropsychological universals may exist that predetermine the form of some types of images. In other words, human brains respond to various sensory inputs in a similar fashion, so regularities in these responses may lead to regularities in behavior, including artistic expression.

A good example of this neuropsychological approach involves the concept of entoptic phenomena (Lewis-Williams and Dowson 1988). Simply put, entoptic phenomena are the phosphenes or flashes of light and color "seen" in the brain during altered states of consciousness or trances. They are sometimes induced by psychoactive drugs, fatigue, sensory deprivation, trauma, hyperventilation, and rhythmic actions. Phosphenes appear as glowing, shimmering, and moving images taking the shape of grids, zigzags, dots, spirals, nested curves, and branching patterns. In common terms, such images are known as "seeing stars," as from a sharp blow to the head. Since these entoptic phenomena are generated by the nervous system, anyone who enters an altered state of consciousness will likely perceive them, regardless of their cultural background. This is why Australian Aborigines, American psychotherapists, and South African Bushmen all report seeing similar images.

If we assume that the human nervous system has remained essentially unchanged for thousands of years, then it seems likely that humans have experienced entoptic phenomena throughout our past. Rock art images depicting grids, zigzags, spirals, and other geometric shapes are found all over the world, and some researchers believe that they are representations of entoptic phenomena visualized by individuals during trances. They propose that shamans induced these trances, and afterwards recorded their visualizations as rock art. Although not all rock art can be explained this way, Sundstrom (1990) makes a good case that the Pecked Abstract tradition of rock art reflects such entoptic phenomena; the wavy lines and geometric patterns characteristic of some Dinwoody tradition art may also be of similar origin.

Semiotics and Pictography

Another theoretical approach proposes that all humans structure language in much the same way. Some researchers consider that all rock art is a system of visual communication similar to a language, and they suggest that it can be understood in linguistic or semiotic terms. In a semiotic system, each image is a sign with a symbolic meaning, and these signs are combined into recognizable patterns using certain rules. By identifying recurring signs and studying their patterns of association, we can gain some idea of how the system works and what it means. Without information about the meaning of the signs themselves, however, semiotics cannot provide direct evidence of what the images communicate.

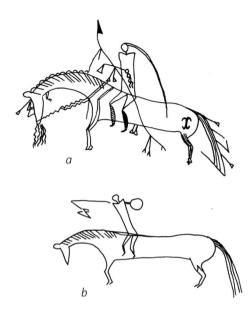

3.1 Close stylistic similarities between these two rock art horses suggest they may have been drawn by the same Crow artist: a, Joliet; b, Castle Butte.

Semiotics assumes that all pictorial images are organized on the same basis as verbal language, but many researchers remain unconvinced. Semiotics in the context of Northwestern Plains rock art has been explored by Sundstrom (1990).

A related theory holds that some rock art operates as a simple writing system, such as pictography or ideography. Such a system uses conventionalized symbols, each with a specific meaning, which can be understood in the same way by all who use it. In a pictographic system, pictograms are recognizable pictures of things as they appear in the world. Ideographic systems, in contrast, use ideograms where the form of each symbol has an abstract relationship to real things. For example, a stick-figure human, which means "man," is a pictogram, while the common symbol for "woman"—a circle with a cross attached beneath—is an ideogram. In addition to abstract portrayals of real things, ideograms also may symbolize ideas and concepts that cannot be represented pictorially—such as the

idea of "stop" represented by a red hexagon. Many early writing systems employ a combination of pictograms and ideograms.

A number of simple and easily repeatable pictograms or ideograms form a vocabulary or lexicon. Following certain rules of grammar or syntax, these symbols are arranged in a sequence to convey information. As pictographic systems use readily recognizable symbols, they can often be loosely translated by people outside the culture which produced them. Ideographic systems, on the other hand, are nearly impossible to decipher without some prior knowledge of what each symbol represents. Nonetheless, the grammar used by the system can sometimes be independently recognized in both cases. Several studies have shown that some Northwestern Plains rock art, particularly that of the Biographic and Vertical Series traditions, incorporates elements of both pictographic and ideographic systems (Keyser 1987a; Klassen 1998a; Sundstrom 1987, 1990).

Analogy and Iconography

Although direct information about rock art is rarely available, sources of external evidence provide useful information for the interpretation of these images. Some historical accounts and ethnographic observations provide direct evidence of aboriginal use of sites, record traditional explanations for images, and indicate relationships between rock art and other aspects of Native culture.

Most historic and ethnographic accounts relevant to Northwestern Plains rock art date from the late nineteenth century, long after most of it was made. Yet these sources can often be employed effectively for interpretive purposes through ethnographic analogy—using what is directly known for one situation to explain another similar situation that lacks direct information. For example, we know from ethnographic and historic sources that the Blackfeet used an image of a bird with

zigzags trailing from its wings to represent Thunderbird. Ethnographic analogy permits us to infer that a similar image at a rock art site in Blackfeet territory also represents Thunderbird. This is an example of the direct historical approach, the strongest ethnographic analogy. Direct historical analogies have been used to suggest that some Columbia Plateau tradition rock art records dreams from the vision quest ritual, and that rock art with strong similarities in form and subject matter to hide paintings of several Historic period Plains tribes served biographic purposes similar to the painted robes.

A weaker ethnographic analogy involves applying a known situation to an unknown one in the absence of a direct historical relationship. An example of this type of general analogy would be the suggestion that since shamans in Siberia used images of skeletons to depict their transformations, then similar skeletal imagery in Northwestern Plains rock art might also depict shamanistic transformations. Although much less certain, general analogies are useful so long as the ethnographic record and comparison to archaeological and other data are systematically applied to evaluate their credibility. Finally, all forms of analogy are strongest for the recent past and become weaker the farther back in time they are applied. However, when no evidence for a radical historical discontinuity can be demonstrated, it is often plausible to suggest that the same cultural mechanisms known from ethnographically documented groups also operated in the past.

Another important approach to interpreting rock art involves iconographical analysis, which combines the formal analysis of images with the extensive use of external sources and ethnographic analogy (Panofsky 1955; Vastokas and Vastokas 1973). With this approach, several levels of meaning can be derived from representational images. The first level considers the form and subject matter of images. This involves recognizing images as

representations of real objects (humans, animals, and tools) and events (hunting or fighting), and then describing various motifs on the basis of both their conventionalized form and identification. For example, a human figure with a characteristic rectilinear outline body and V-shaped shoulder area can be described as the V-neck human motif (see fig. 1.5). Correct identification of motifs often requires a degree of familiarity with the traditional objects and events of the culture responsible for the images.

At the next level of meaning, motifs and compositions are interpreted in direct reference to cultural traditions. For example, a composition featuring two V-neck human motifs in conflict can be interpreted to represent a warrior counting coup on an enemy; another motif showing a large bird trailing lightning bolts from its wings represents Thunderbird (fig. 3.2). These motifs represent specific traditions and stories from within a culture; their correct iconographic analysis requires a close familiarity with the history, social organization, and traditions of

3.2 Analogy with other Plains Indian images helps to identify this pictograph at Writing-on-Stone as Thunderbird, and to recognize details such as the zigzag lightning streaks trailing from its wings, the hailstones covering its body, and the thunder or wind symbol it carries in its beak.

that culture, obtained from oral traditions, ethnographic literature, and historic sources.

The deepest level of meaning involves recognizing how motifs express underlying cultural principles or beliefs. This level of analysis considers symbolic meanings so deep as to have been unconscious, perhaps even to the artist—and involves interpretation in a broad historical and cultural context. For instance, continued analysis of the Thunderbird motif would reveal its intrinsic meaning—its significance as a component of the earth-sky dualism in Plains Indian beliefs. In this way, iconographical analysis helps reveal a culture's characteristic philosophy or world view as it is manifested in pictorial expressions.

This comprehensive approach has shown promise for the interpretation of much Northwestern Plains rock art. For example, the rock art of the Black Hills (Sundstrom 1990) and Writing-on-Stone (Klassen 1995, 1998a) has been explored from the perspective of iconographical analysis. Sundstrom (1995) has also made a persuasive case for the relationship of some Hoofprint tradition rock art to Sioux mythology. Likewise, Loendorf (1994) has used Shoshone mythology and oral traditions to identify a motif in Dinwoody rock art as the spirit being known as Water Ghost Woman.

Functional Analysis

Functional analysis of rock art also employs external sources and analogy. Some authors have suggested that two distinct modes of expression exist in native North American pictorial traditions, each serving a different function. These iconic and narrative modes (Vastokas 1990) are characterized by different formal qualities. Iconic images are static, symmetrical, detailed motifs found alone or in small juxtaposed groups. They represent sacred themes, such as mythological beings and medicine visions. In contrast, narrative images are active, asymmetrical, schematic motifs found in small as well as large, complex, integrated scenes, which depict specific historical and mythical events and stories.

On the Northwestern Plains, both iconic and narrative imagery have been identified in ethnographically and historically documented representational painting. For instance, many animals and birds painted on tipis and shields are considered iconic images. Ethnographic sources indicate that such images were used to represent the guardian spirits, seen in visions, that gave the owners of the tipis and shields their medicine powers. Conversely, the complex depictions of battles, horse raids, and hunts found on hide paintings and ledger drawings are narrative images. Ethnographic sources indicate that these scenes recorded a warrior's most significant lifetime accomplishments, such as war honors and brave deeds.

As both types of imagery have been documented for nearly every Plains group, it seems likely that both modes of expression are also found within Plains rock art traditions. By ethnographic analogy, we can infer that rock art images similar in form to tipi paintings and war records probably served equivalent iconic and narrative functions. Thus, a detailed symmetrical animal carved alone on a rock face probably served a ceremonial or sacred function, while a group of active, interacting human figures probably served a narrative biographic function.

On the Northwestern Plains, the Ceremonial and Biographic traditions have been largely defined on the basis of a suite of formal attributes related to the function of the images (Keyser 1977a). As iconic and narrative imagery use distinct forms and compositions, the Ceremonial tradition has been described as an iconic mode of expression, while the Biographic tradition is an example of the narrative mode (Klassen 1995, 1998a). In other words, the stylistic differences between these rock art traditions arise more from differences

in their function than as a result of their temporal, geographical, or ethnic origin.

Overall, studies employing external sources, analogy, iconography, and functional analysis often offer much greater interpretive range and potential than those relying solely on the examination of internal evidence.

Contextual Approaches

Contextual studies seek to understand the role of rock art in cultural activities, and the relationship of rock art sites to the landscape in which they are found (Molyneaux 1977; Taçon 1990; Vastokas 1992; Klassen 1998a, 1998b). In this view, individual images had a specific role and meaning in a particular cultural and physical context. For instance, the purpose and meaning of certain ritual activities may help us gain insight into rock art's meaning. In aboriginal societies, many pictorial expressions were produced and used as parts of rituals and ceremonies. Indeed, the process of making rock art may often have been more important than the images themselves (Sundstrom 1990; Vastokas 1992).

The relationship of rock art to shamanism illuminates the value of cultural context. Shamans possess special powers to transform themselves into spirit beings and journey into the spirit world. In their travels, shamans gain knowledge and participate in activities that are unavailable to ordinary humans. To transform themselves, shamans often participate in elaborate rituals involving animal costumes and ceremonial objects, eventually entering a trance in which they are transported into the spirit realm. As many Plains groups had shamans or medicine men, many strange Northwestern Plains rock art motifs— depictions of supernatural creatures, combination human/animal beings, auras, halos, "power lines," and "X-ray" views of humans and animals—may have been made as part of shamanistic rituals (Barry 1991; Greer and Greer 1994a, 1995c).

The vision quest provides another good example of ritual imagery. A warrior often painted images of his vision on his shield and tipi, a ritual that transferred the medicine power to these objects. Similarly, some groups commemorated vision quests by rock art done at the isolated quest locations. Many Ceremonial and Columbia Plateau tradition petroglyphs and paintings are located at such

This pronghorn antelope petroglyph at Verdigris Coulee is characteristic of iconic images representing a spirit being seen in a vision or a shaman's trance.

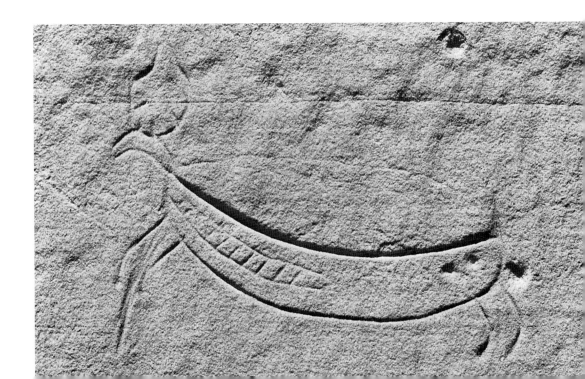

sites (Keyser 1992; Klassen 1995)—a clear indication of the close relationship of ritual and rock art to the landscape.

Although aboriginal cultures viewed nature as being charged with spiritual energy, this energy was often concentrated in specific natural features, including strangely shaped rocks, large glacial erratic boulders, narrow canyons, and isolated mountain peaks. Many unusual or impressive Northwestern Plains landscapes held special spiritual or sacred values for Plains people. According to tradition, individuals are able to tap into the power of these sacred places through rituals, ceremonies, and rock art (Taçon 1990). Indeed, many rock art sites are located in awe-inspiring sacred landscapes with sweeping vistas and impressive features. The concentration of unusual geologic features and high vantage points, along with the looming presence of the Sweetgrass Hills, made Writing-on-Stone a focal point

At Crowsnest Pass, Alberta, a tributary of the Oldman River rushes out of a deep cave. Awe-inspiring features like this were considered sacred by Native people, and are frequently the location of rock art sites.

for sacred activities and rock art (Klassen 1995, 1998a).

Native people were also struck by the awesome beauty and mysterious nature of places like Writing-on-Stone, Castle Gardens, the Cave Hills, Pryor Mountains, Dinwoody Lakes, and the Black Hills. At these places, the powers of the spirit world were manifested in the landscape itself, which acted as potent inspiration for sacred rituals and ceremonies. The ethnographic, archaeological, and historic records are replete with references to visions, offerings, and burials at such places. Ultimately, understanding these images in their overall cultural and physical context may produce the greatest appreciation of the rich treasure of Northwestern Plains rock art.

Spirit Images, Sacred Places

Traditional explanations, which approach the rock art from a religious rather than anthropological perspective, remind us that many rock art sites still function as sacred places within today's Native communities. But the preceding pages also suggest that the anthropological analysis of rock art can go far beyond straightforward description to include interpretation of the function and meaning of

At Writing-on-Stone, Alberta, the combination of strangely-shaped hoodoos, steep cliffs, narrow canyons, and the looming presence of the Sweetgrass Hills creates a potent landscape where medicine powers are concentrated.

these images for their artist creators. To be effective, such interpretation must rely on careful assessment of data, consideration of traditional explanations, familiarity with the vast archaeological, ethnographic, and historical literature of the region, and recognized anthropological methods and theories. Interpretations that are internally coherent and best correspond to all available data remain well within the acceptable limits of academic inquiry. This scientific credibility sets these anthropological interpretations apart from fantasy "explanations" that suggest this art was made by Chinese explorers, Celtic monks, or lost Egyptian travelers (Keyser 1992).

In the chapters that follow we attempt to summarize the most current scientific data for the region, and to utilize the interpretive value of archaeological, ethnographical, and traditional explanations. Our interpretations are not intended as final explanations for all Northwestern Plains rock art. By relying on a variety of different types of evidence, different researchers have arrived at startlingly different conclusions about the same rock art (e.g., Sundstrom 1990; Tratebas 1993; Gebhard and Cahn 1950; Francis et al. 1993; Loendorf 1994; Keyser 1977a; Klassen 1998a), and new data result from nearly every rock art project. These differences are a large part of what makes archaeology, and the study of rock art, so fascinating. We hope our interpretations provide the reader with a starting point for understanding and appreciating Northwestern Plains rock art—one of the most important historical and cultural legacies of the people that have inhabited the region for the last 12,000 years.

"All Kinds of Spirits Dwell Up There"

The people used to go there for visions, to the place where there are paintings on the rocks. When a fellow went there in the old times, he used to talk to the spirits about the future. . . . Those [supernatural] beings gave the people colored objects [red ochre] which they called *nameeta*. And they drew on the stone wall whatever they wanted with this *nameeta*. The spirits told them how long they would live and what they would do. They would help them during their lives and in battle. —Wife of Tatley (name not recorded), 1926

A young man would go and spend a night near these places. . . . If a fellow did have something appear to him he would never tell others about it. He would keep it to himself. If he told, he would die soon after. —Tatley (Qalsahluhlat, or Three-Pipe-Stems), 1926

With these words, two elderly Kutenai from British Columbia described the spiritual significance of Columbia Plateau rock art (Barbeau 1960: 207, 211). Although Tatley and his wife were referring specifically to several sites in southeastern British Columbia, similar stories can be found across the Northwestern Plains.

The interpretive value of traditional explanations is readily apparent for rock art of the Columbia Plateau tradition. Tatley's wife uses the term *nameeta*, which closely parallels the word *nupeeka* used by other Kutenai to indicate supernatural power in general (Malouf and White 1953)—an indication that pictographs and spirit powers were closely associated in Kutenai cosmology. Receiving nameeta in the form of red ochre metaphorically describes how the spirits inspired the creation of pictographs. More importantly, the accounts of Tatley and his wife clearly demonstrate the strong link between pictographs and the vision quest—a ritual that formed the core of Columbia Plateau religion.

Among the Kutenai and Salish groups who occupied the mountains on the western edge of the Northwestern Plains, the vision quest was the means by which a person acquired a spirit helper to ensure success in life. In this ritual, a man or woman sought a guardian spirit by retreating to a secluded, sacred place to fast and pray. The supplicant hoped that a spirit would appear in a dream or vision, and would provide sacred items, songs, and rituals to use in daily life. Spirits of animals, birds, mythical beings, and the sun and stars served as guardians to assist in hunting, fishing, love, warfare, and gambling. The association between a vision and success in later life was of primary importance; the anthropologist Verne Ray (1939) remarked: "Perhaps nowhere in America did the guardian spirit concept play so great a role as among the Salishan groups of the Plateau."

To commemorate a successful vision or give thanks to the spirit world, the supplicant then painted pictographs of the guardian spirit or other dream subjects (fig. 3.3). For later visitors, the presence of paintings was thought to indicate a very sacred place where powerful spirits dwelled. Baptiste Mathias, another elderly Kutenai, attributed pictographs at Painted Rocks on Flathead Lake to spirit beings, who painted there long ago so that people would go to that place to obtain spirit power (Malouf and White 1953).

The words of Lasso Stasso, an elderly Flathead Lake Kutenai, make clear the power of these ancient images: "Up there is a little circle of stones where we would lay. All kinds of spirits dwell up there, like birds, animals, rocks, everything. Coyote spoke to me up there one night. . . . Deer gave me the power to hunt . . . [and] fawn gave me gambling power" (Malouf and White 1952).

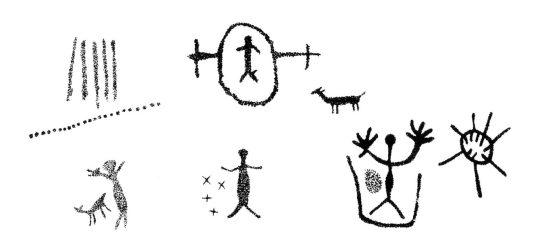

3.3 *Vision imagery, consisting of juxtaposed compositions of humans, animals, tally marks, dots, and circles, characterize the Columbia Plateau tradition.*

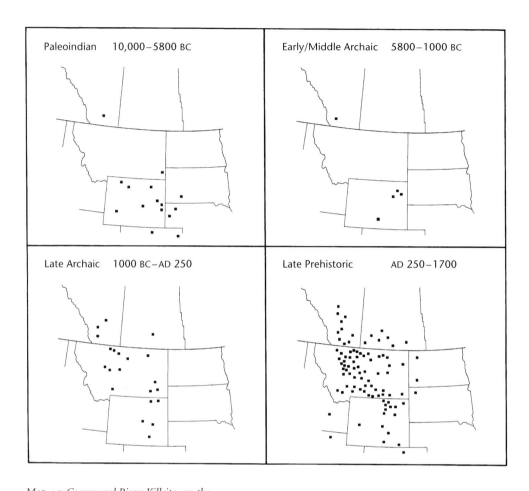

*Map 4.1. Communal Bison Killsites on the
Northwestern Plains*

4 / The Area and Its History

The Northwestern Plains is a vast land of extremes and stark contrasts with an incredible diversity of landscapes and climates. It encompasses the northwestern third of the North American Great Plains (see Map 1.1). Extending south from the aspen parklands of central Alberta and Saskatchewan to the South Platte River in northeastern Colorado, the area is bounded on the west by the Rocky Mountains and on the east by the tall grass prairies along the Missouri River in North and South Dakota. Often misconceived as a great flat, monotonous prairie, this land ranges from lush green hills to desiccated badlands, and from snowcapped mountain peaks to endless stretches of rolling grasslands.

The rugged eastern slopes of the Rocky Mountains define the area's western boundary. Rolling foothills lie along the flanks of the Rockies, while more than fifteen major outlying mountain ranges lie farther to the east. These ranges occur throughout the western half of the region, generally paralleling the northwest-southeast trend of the Rockies. Peaks taller than 10,000 feet (3000 m) rise in the Beartooth, Wind River, Absaroka, Bighorn, Medicine Bow, and Crazy mountains. Between these outlying ranges lie large intermontane basins, varying from the verdant Bighole and Smith River valleys to the near-desert environments of the Bighorn Basin and Red Desert.

Isolated hills and low mountains are also scattered across the plains, including Wood Mountain and the Cypress Hills in Saskatchewan and Alberta, the Sweetgrass Hills, Bearpaw Mountains, and Judith Mountains of north-central Montana, and the Black Hills of western South Dakota on the eastern margin of this area. Rising abruptly from the surrounding plains, these outliers often ascend more than 3000 feet (900 m) in only a few miles, and form landmarks visible for great distances.

In the southwestern portion of the Northwestern Plains lie the highly dissected pine parklands. Stretching south from Montana's Musselshell River to Cheyenne, Wyoming, and east from the Bighorn Mountains to the Black Hills, this area consists of luxuriant grassland basins separated by broken buttes and rolling hills sparsely forested with ponderosa pine and juniper. These basins, together with topographic features such as the Chalk Buttes, Wolf Mountains, Cave Hills, Pine Bluffs, and Hartville Uplift, form a complex mosaic of interconnected but diverse ecosystems and microclimates.

Much of the Northwestern Plains, however, is characterized by flat or gently rolling prairie grasslands. The level prairies extending throughout southern Alberta and Saskatchewan, across northeastern Montana and western North Dakota, and into north-

central South Dakota result from the great Pleistocene continental glaciers that advanced across this area between 15,000 and 100,000 years ago. Their relentless grinding action wore away the soft rocks of the region, blanketing much of the prairies with extensive glacial till sediments or ground moraines. The glaciers also carried many large rocks and boulders from the mountains, depositing them as isolated glacial erratics across the prairies. Meltwater from the retreating ice sheets carved deep channels into the plains, creating the coulees and dry valleys that now meander across much of the prairies. For example, the now-dry Etzikom, Forty Mile, and Verdigris coulees in southern Alberta once drained huge volumes of glacial meltwater into the Milk River.

Major rivers in the region have also carved deep, meandering valleys across the prairies. Highly dissected, barren badlands, like those at Drumheller, Alberta, and Badlands National Park southeast of the Black Hills, often border long sections of river valleys. Characterized by sharp ridges and rounded outcrops of exposed clay and sandstone, the many-hued rock layers are often eroded into strange spires and columns called hoodoos. Colorful local names, such as Makoshika (Dakota Sioux for "bad land") and Hells Half Acre, provide a bleak but accurate assessment of the inhospitable nature of these badland areas.

The Northwestern Plains has a harsh continental climate characterized by long, cold winters and hot, dry summers. Temperature extremes are greater here than anywhere on the North American continent south of the Arctic, with winter lows occasionally reaching −50 degrees F (−45° C) and summer highs often soaring to 115 degrees F (45° C). In addition, temperatures on the Northwestern Plains often change radically over the span of a day or two. The warm Chinook winds, which frequently blow off the Rockies in the winter and spring, can dramatically raise temperatures in only a few hours, often quickly

melting away midwinter snowdrifts. During a 1916 Chinook, the temperature at Browning, Montana, rose 100 degrees F (from −56° to +44°) in 24 hours—the American record for the greatest temperature change in a one day period—while during another such event in 1980 the temperature at Great Falls, Montana rose 47 degrees F (from −32° to +15°) in just seven minutes—the most rapid temperature change in U.S. history.

Annual precipitation on the Northwestern Plains averages about 24 inches (600 mm) per year, but this total varies widely from year to year and place to place. Some springs are so wet that river valleys experience severe flooding, while prolonged drought, like that of the 1930s, can last for years. Paleoclimatic evidence indicates that such droughts have been cyclical throughout prehistory. The highest monthly precipitation generally falls in June, but short, heavy downpours associated with violent thunderstorms, which occasionally spawn tornadoes, occur routinely during most of the summer. Although winter snowfall is usually low outside the mountain ranges, snow has been recorded every month of the year. Blizzards bringing high winds, deep snow drifts, and subzero temperatures occur regularly from late September to early May. A warm, sunny spring or autumn afternoon can easily give way to snow the next day.

Several major rivers flow through most parts of this region. From north to south, four main river systems—the South Saskatchewan, Missouri, Yellowstone, and Platte—drain most of the area. The South Saskatchewan drains northward into Hudson Bay, while the remaining systems drain south into the Gulf of Mexico. Tributaries of these systems, such as the Red Deer, Bow, Oldman, Milk, Marias, Musselshell, Bighorn, Powder, and Little Missouri, are major rivers in their own right. Numerous smaller rivers and streams also drain the area, and springs emerge in many places where underground aquifers reach the surface. Countless ponds and temporary

sloughs dot the plains, particularly in spring along the northern edge of the prairies. Large natural lakes are few and often alkaline, such as Pakowki Lake in southern Alberta.

Northwestern Plains vegetation ranges from alpine to semidesert. Dense forests of pine and fir cloak the mountain ranges and higher hills, while bunchgrass, sagebrush, greasewood, and cactus sparsely vegetate the desertlike badlands and intermontane basins. Stands of cottonwoods and poplars line many of the river valleys, while aspen parklands border the boreal forests on the north. The region's predominant vegetation, however, is the wide variety of grasses that carpet the rolling plains, river valleys, and wetter intermontane basins. More than anything else, the Northwestern Plains is grass country—ideal habitat for herds of grazing animals, and for thousands of years, the best bison range in North America.

Twelve thousand years ago, at the end of the Pleistocene, herds of mammoths, horses, and camels shared this area, but even then, several now-extinct forms of giant bison predominated. Of these large Pleistocene herd animals, only the descendants of the giant bison survived, eventually evolving into the smaller modern bison. Interestingly, the native horses of North America went extinct thousands of years ago and were not reintroduced to the Plains until the 1700s, with the arrival of Europeans. Until their near extinction in the late 1800s, bison were the predominant big game animals of the Northwestern Plains. At the beginning of the nineteenth century, more than half of the estimated thirty million bison in North America lived in this region.

Elk, mule deer, pronghorn antelope, and bighorn sheep were the other big game animals common on the Plains throughout the past. Major predators included the grizzly bear and wolf (both now extinct on the Plains and rare in the adjoining areas), along with cougars, coyotes, and foxes. Smaller mammals include otters, weasels, beavers, hares, and porcupines. Eagles, hawks, owls, songbirds, and shorebirds also make the prairies their home, while prairie chickens and grouse are common. Perhaps the most abundant and important bird species, however, are the millions of ducks and geese that breed in the thousands of prairie potholes and migrate through the area every spring and fall. The semiarid climate of the Northwestern Plains also provides suitable habitat for many reptiles, including short-horned lizards and prairie rattlesnakes.

The area's geology is relatively simple, except along the western margins, where mountain-building and faulting have created a jumble of rock layers of many different ages. These rocks include a wide variety of stone types used by prehistoric makers of stone tools, but more important to our interests are the sandstones and limestones that underlie most of the region. Thick layers of sandstone, originally laid down by prehistoric rivers, rim major river valleys and cap buttes and mesas. Limestone deposits, formed beneath ancient seas, have been carved into deep gorges and thousands of rockshelters in the foothills and mountains. These ancient stone surfaces provided an ideal rock art canvas and countless opportunities for the Native people of the Northwestern Plains to create this art. Petroglyphs could be easily carved into the soft sandstones, while smooth limestone faces were ideal for painting pictographs.

Archaeological History

The archaeological history of the Northwestern Plains spans more than ten millennia, from the earliest arrival of humans on the continent to the beginning of the modern era. Archaeologists have subdivided this vast time span into five main eras: the Paleoindian, Archaic (further subdivided into the Early, Middle, and Late Archaic), Late Prehistoric, Protohistoric, and Historic periods (fig. 4.1).

In some chronologies, the Archaic period is known as the Early and Middle Prehistoric periods. Each period is primarily defined on the basis of the types of artifacts present in the archaeological record, and the onset of each period is marked by the arrival of a major new tool technology. For example, the Late Prehistoric Period begins when small side-notched stone projectile points first appear in the archaeological record, an event that represents the introduction of the bow and arrow.

Within each period, archaeological cultures are also recognizable, each represented by sites where a particular assemblage, or combination, of tool types is found. Assemblages distinguish sites of one archaeological culture from another. Studying changes in assemblages occurring over time helps trace the appearance of innovations, changes in subsistence activities, diffusion of technologies, and sometimes even the movements of peoples. In some cases, different archaeological cultures may reflect different ethnic groups, but in other cases they represent broad subsistence strategies and technologies shared by several groups.

Paleoindian Period (10,000 to 5800 B.C.)

Archaeological evidence indicates that the first inhabitants of the Northwestern Plains arrived from Asia about 10,000 B.C., soon after the retreat of the continental ice sheets of the Wisconsin glaciation. Due to the cold and dry postglacial climate, an open steppe extended across the northern reaches of the Plains, while a vast spruce forest stretched far to the south. After crossing the Bering Land Bridge, the earliest immigrants moved south along the Rocky Mountains and onto the Plains, where they encountered a virgin wilderness filled with herds of mammoths, horses, camels, elk, caribou, and giant bison.

These first people, named after their characteristic Clovis fluted spear points, followed the herds across the Plains, killing and butchering big game animals at killsites and camping in nearby sheltered locations. Small numbers of Clovis spear points have been found throughout the area, and archaeological evidence indicates that Clovis hunters directed significant energy toward killing mammoths. Contemporary with the latest Clovis people, and lasting for the next three thousand years, were many other groups of Paleoindian hunters. Known to archaeologists by the names of their characteristic lanceolate spear points, these groups include the Goshen, Folsom, Cody, Hell Gap, and Agate Basin cultures. Typical sites associated with these cultures are communal kills where they trapped and slaughtered the large herd animals (Map 4.1).

Mammoths and many other large mammals eventually became extinct, and during the latter part of the period Paleoindian groups primarily hunted several forms of now extinct bison. Many occupation and killsites of these groups have been found across the Northwestern Plains, with examples occurring from the parklands of central Alberta south to the Platte River drainage, and from the Rocky Mountains to the Black Hills.

For nearly half a century, Northwestern Plains archaeological research has largely focused on these Paleoindian groups, and much is known about their technologies and lifestyles. From the artifacts they left behind, we know that they were incredibly successful hunters, with elaborate systems designed to trap and kill every available big game species. To trap game, they constructed wooden corrals or used natural features such as arroyos and sand dunes, and in some cases even nets. A mountain sheep trapping net found in northwestern Wyoming has been dated to more than 6800 B.C. (Frison 1991). Some sites show meat caches that suggest hunting was undertaken in early winter and the carcasses frozen for use throughout the cold season.

These groups created a wide range of flaked stone spear points; the stone-working skills of

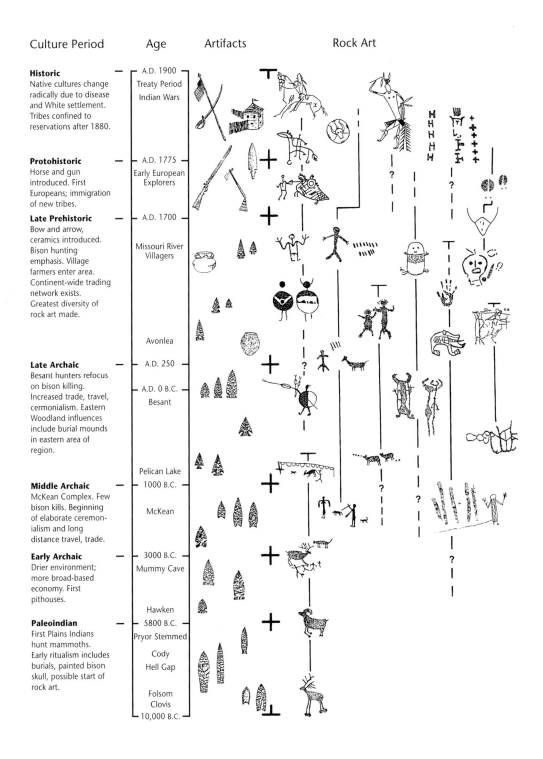

4.1 A Generalized Chronology of Northwestern Plains Cultures with Associated Artifacts and Rock Art Traditions

several of these cultures are perhaps the finest ever known on the Northwestern Plains, and among the best worldwide. Stone quarrying operations were conducted in some of the highest, most rugged mountains in the area, and some workshop sites suggest that production focused exclusively on manufacturing especially fine implements.

In addition to spear points, Paleoindian tool assemblages contain stone and bone tools for scraping, chopping, cutting, and many other tasks. Sharp-pointed engraving and boring tools were used extensively to work bone, ivory, and wood, and attest to a high degree of craftsmanship. Eyed bone needles for sewing leather garments, delicately incised bone gaming pieces, and ivory and antler tools also illustrate other aspects of the material life of these people. As for habitations, evidence from several sites indicates the use of small surface structures, probably tents made of sewn hides, with leveled dirt floors.

We also know that these people had well-developed rituals and ceremonies. Clovis burials, presumably of high-status individuals, include caches of extraordinarily well-crafted stone items clearly intended as funerary offerings. Often these tools are smeared with red ochre. A central post in the Jones-Miller bison killsite in northeastern Colorado may have been a so-called shaman post similar to those used throughout Northwestern Plains prehistory and even into the Historic period. Associated with it was shaman's paraphernalia, including a flute and a miniature projectile point. A site on the Oklahoma plains has recently produced a bison skull painted with red zigzag designs. Rock art may also have been part of this ritual behavior. At Whoopup Canyon in eastern Wyoming, more than a dozen panels of Early Hunting tradition petroglyphs have been tentatively dated to the Paleoindian period, with one communal hunt scene dated to as early as 9300 B.C. (Tratebas 1993). If these dates can be supported by additional evidence or research,

they will be some of the earliest dates for rock art in North America.

Early Archaic Period (5800 to 3000 B.C.)

Toward the end of the Paleoindian period, a number of cultural groups began to occupy caves, rockshelters, and open sites in the Rocky Mountain foothills and major outlying ranges such as the Bighorn. Contemporaries of the better-known Paleoindian bison-hunting groups, these people practiced a broader-based subsistence strategy oriented toward hunting smaller mammals and collecting plant foods. One notable addition to their tool kit was milling stones for processing plant foods. Although clearly related to the bison-hunting cultures, these groups may have begun to adopt a foraging economy, owing in part to the gradual drying of the climate.

About 5800 B.C., these mountain-adapted groups gave rise to the next major Northwestern Plains cultural tradition, the Mummy Cave complex of the Early Archaic period. These Early Archaic cultural groups are recognized in the archaeological record by a shift from the lanceolate and stemmed Paleoindian points to large side-notched types such as Hawken and Bitterroot. The change in point type seems to reflect the introduction of a new weapons system—the atlatl and dart spear.

These Early Archaic groups lived in caves and rockshelters in the foothills of nearly every mountain range on or adjacent to the Plains. So few large and open occupation sites are known from this period that it appears they made less use of the open plains than did their predecessors. This shift in settlement pattern may have arisen partly as a response to the increasingly dry conditions that culminated in the Altithermal—a region-wide period of drought or near-drought conditions that began in approximately 6000 B.C. This dry period saw the expansion of the shortgrass prairies, and the reduction of carrying capacity for many Plains mammals including bison.

A few communal bison kills, such as the Black Hills Hawken sites and the earliest levels of Alberta's Head-Smashed-In buffalo jump, indicate that these groups communally hunted bison when sufficient herds were available. Environmental conditions, however, probably prevented their hunting bison to the extent noted for the Paleoindian groups. The subsistence economy focused on the killing of smaller big game (deer, pronghorn, mountain sheep), small game (from rabbits to rodents), and the collecting of a wide variety of plant foods, including seeds, berries, and roots.

Expanding upon the generalized foraging economy of the mountain-adapted Paleoindians, Mummy Cave complex groups perfected the grinding tools, cordage, and cache pits first noted in terminal Paleoindian times, and added basketry and a variety of small animal trapping devices to their tool assemblages. Bone and stone tool technology declined from the artistry of the Paleoindian cultures, but bone awls, punches, and other tools were produced, and needle-sharp projectile points were still effective killing instruments. True circular to oval-shaped pithouses, several feet deep and containing interior walls, central posts, hearths, and cache pits, began to appear at the end of the Early Archaic. Although these early pithouses are now restricted to west-central Wyoming, they will likely be found elsewhere in the region.

The only rock art dated to the Early Archaic is a continuation of the Early Hunting tradition petroglyphs first noted in Paleoindian period. The florescence of this tradition, with an apparent focus on the shamanistic rituals associated with hunting scenes, may be in part a result of the deteriorating environment and the increased effort needed to successfully hunt these smaller big game animals.

Middle Archaic Period (3000 to 1000 B.C.)

The Middle Archaic period on the Northwestern Plains is largely synonymous with the McKean complex, a loosely related group of local populations who utilized the characteristic McKean and Duncan/Hanna projectile points. McKean complex sites occur throughout the Northwestern Plains, and McKean and Duncan points have a wider distribution in the area than any point type since Paleoindian times. The Middle Archaic climate was characterized by a gradual cooling trend with increasing rainfall, and forests expanded southward.

In the northern portion of the region, the Oxbow complex first appears near the end of the Early Archaic, and continues into the Middle Archaic, where it is contemporaneous with McKean. Although exhibiting broad similarities in technology and subsistence, the Oxbow and McKean complexes are sufficiently different that some feel they were distinct ethnic entities; McKean cultures eventually displaced Oxbow people from the Plains. Middle Archaic points made by these cultures were undoubtedly used with atlatl and darts, since atlatl weights have been recovered from these sites.

The appearance of the McKean complex across the Plains is quite rapid, and forms a distinctive break in the cultural sequence. The number of sites increased dramatically, and evidence suggests that the McKean economy was extremely broad-based—enough so that these groups could occupy much of the open plains and intermontane basin areas that had been all but abandoned during the Early Archaic. To do this, Middle Archaic people increased their emphasis on plant foods, and many sites include milling stones and extensive evidence of charred seeds and other plant remains. Various types of plant fiber cordage and even evidence of eating grasshoppers and ants occur in dry cave deposits of McKean age in the Bighorn Mountains.

Plant food preparation pits are another McKean hallmark. These deep excavated basins, often lined with flat stones and filled with fire-cracked rock, were usually cleaned out and reused several times as simple cooking

ovens, and probably also to warm a pithouse or small surface structure during cold weather. Big game hunting was also a major activity and included communal and individual hunting of bison, deer, antelope, and mountain sheep. Although bison were regularly taken, they are the focal point of only a few sites. Other sites demonstrate extensive communal hunting of deer and antelope. McKean gives the overall impression that local groups shared a general weapons technology but adapted to local conditions, exploiting a wide range of resources during a carefully scheduled seasonal round that took them across long distances and numerous ecosystems.

McKean sites are found from high-altitude rockshelters to the lowest elevations in the region along the Belle Fourche, South Saskatchewan, and Missouri rivers. Extensive sites occur in and around the broken, flat-topped buttes that characterize the eastern fringe of the Northwestern Plains. Pithouses at several sites indicate permanent winter dwellings, but the most common habitation structures are tipi rings—circles of stone boulders used to weigh down the hide coverings of the classic Plains tipi.

The relatively rapid spread of McKean technology across the plains and its incorporation into what must have been numerous groups with relatively well-defined territories (probably the equivalent of tribes) suggest that the Middle Archaic period saw increased region-wide trade and contact among different peoples. Increased ceremonialism in burial complexes and hunting rituals accompanied this cultural florescence. A collapsed pile of large mule deer antlers found at one McKean site in Wyoming indicates the communal ritual behavior of these hunters.

At the Majorville Cairn, a large medicine wheel in southern Alberta, long-term ceremonial use is indicated by both McKean and Oxbow points. In southwestern Saskatchewan, the Gray site, a Middle Archaic period Oxbow

burial, contained the remains of more than 300 individuals. The site yielded a wealth of grave goods including stone tools, shell gorgets and pendants, eagle claws, beads, and worked copper. Some of the shell and copper artifacts indicate trade networks that extended into the midwestern United States as far as the Great Lakes.

Although petroglyphs of the Early Hunting tradition are the only rock art dated to the Middle Archaic period, it is likely that some Columbia Plateau and possibly early Dinwoody, Pecked Abstract, and Foothills Abstract rock art was made during this period.

Late Archaic Period (1000 B.C. to A.D. 250)

The Late Archaic on the Northwestern Plains shows a marked increase in the number of sites over the preceding periods, and the initial return throughout much of the region to an economy dominated by bison hunting. At the beginning of the Late Archaic, the climate was similar to modern conditions, but toward the end of the period it had become somewhat wetter and cooler—a perfect environment for increasing bison herds. Corner-notched Pelican Lake dart points replace McKean technology at about 1000 B.C. The Besant complex, known by its characteristic large, side-notched dart points, appears contemporaneously with the latest Pelican Lake sites. Both Pelican Lake and Besant cultures persist into the Late Prehistoric period.

Although Late Archaic cultural groups hunted both large and small game and collected plant foods, most Pelican Lake and Besant sites indicate a strong focus on communal bison hunting. From central Alberta and Saskatchewan to the Laramie Basin of southeastern Wyoming, the predominant Late Archaic sites are bison kills and butchering areas (Map 4.1). These include jumps, corrals, and arroyo traps, often associated with extensive tipi ring campsites representing the butchering and processing areas. Many of the largest killsites were fall

season operations designed to stockpile meat for the coming winter, and involved systematic and highly coordinated butchering practices.

In particular, Besant killsites represent perhaps the most sophisticated bison-killing operations in Northwestern Plains history. Many of these sites are bison pounds with wooden corrals constructed to take optimum advantage of topographic features and bison behavior. Most incorporate wooden fence drive lanes, corral post supports, and constructed entrance ramps, which indicate a detailed knowledge of large animal behavior. Clearly, communal bison hunting was central to the lifeways of these Late Archaic period hunters, who moved their tipi villages across the open plains in order to follow the seasonal movements of the bison herds.

In the far southwestern part of the region, especially the intermontane basins south and west of the Beartooth, Pryor, and Bighorn mountains, Late Archaic cultures used projectile points and other tools similar to the Pelican Lake complex, but their overall artifact assemblages suggest broader based foraging economies. These hunters specialized in mountain sheep and mule deer procurement from the surrounding mountains, while rockshelter sites yield digging sticks, nets and snares, basketry, and milling stones similar to those of the earlier Archaic groups. A few Late Archaic pithouses are known in these sites, and basketry fragments resemble those from the Great Basin Fremont culture of Utah. Whether these sites represent people more closely related to Great Basin cultures or are a seasonal specialization of Plains-adapted hunters is not yet known.

The Late Archaic period was a time of increased travel, social differentiation, trade, and ceremonialism. A continent-wide trade network, reaching from the Atlantic and Gulf coasts to the Rocky Mountains, and west to the Pacific Ocean, linked Late Archaic cultures to groups across North America, including the Adena and Hopewell mound builders.

Pelican Lake burials across the region include hammered copper artifacts from the Great Lakes, Knife River flint from central North Dakota, and shells from the Pacific Coast. Obsidian in some graves comes from sources more than 400 miles (600 km) to the southwest. Large quantities of Knife River flint in the Muhlbach Besant Bison Trap may indicate travel to the quarry site or an extremely well-developed trade network. Some Besant groups were certainly middlemen in the trade network that brought Yellowstone obsidian and Knife River flint to the Hopewell burial mounds in Indiana and Ohio.

Ceremonialism is evident in burial practices and hunting rituals. Pelican Lake secondary burials and cremations were sprinkled with red ochre and placed in shallow pits covered with a low rock pile. Often the dead were interred with beads, gorgets, and pendants of bone and shell, perforated teeth and bird and bear claws, chipped stone items, and occasional pounded sheet-copper artifacts. The Highwood burial in Alberta yielded a necklace of ten perforated grizzly bear claws. Besant burials on the Northwestern Plains are little known, but related eastern North Dakota groups constructed low burial mounds, covering graves containing bison skulls and exotic artifacts obtained in long-distance trade. Hunting rituals are best demonstrated at the Besant Ruby bison pound, where a sophisticated roofed structure with interior walls and arrangements of bison skulls and other bones probably served as a shaman's structure.

Rock art dating from the Late Archaic includes the latest Early Hunting tradition petroglyphs, early Dinwoody glyphs, the earliest En Toto Pecked petroglyphs, and some Pecked Abstract tradition sites. Some Hoofprint, Foothills Abstract, and Columbia Plateau tradition sites also likely originated in this period. Except for the Early Hunting tradition, they all continued into the Late Prehistoric period.

Late Prehistoric Period (A.D. 250 to 1700)

The Late Prehistoric period on the North-western Plains is marked by the appearance of small, side-notched projectile points and pottery in the archaeological record. The small points reflect the introduction of the bow and arrow—a weapon that greatly increased the hunters' efficiency. Both the ceramic and bow and arrow technologies spread from neighboring areas.

Avonlea is the first region-wide cultural complex to rely exclusively on bows and arrows. Many Avonlea sites are large buffalo jumps containing thousands of small side-notched arrowheads. A communal pronghorn antelope killsite in Montana and tipi ring clusters across the Plains also include Avonlea assemblages. Avonlea points first occur in southern Alberta about A.D. 250, and then spread south and southeast until about 900 where they occur in the Beehive complex of south-central Montana and north-central Wyoming. Beehive complex sites include large quantities of ground stone, worked bone, shell artifacts, and occasional Woodlands pottery from the east. Dwellings were log and stone structures, probably topped with a hide tent. Although they focused on bison, the variety of faunal remains and plant processing tools suggests a more broad-based economy than that of Avonlea in the north. Besant culture also continued into this period, and some very small Besant-type projectile points indicate that these hunters also began to use the bow and arrow. Limited quantities of pottery occur at many Avonlea sites and some Besant sites.

The richness of Besant and Avonlea across the Northwestern Plain indicates that this was a time of unparalleled prosperity for the region's bison-hunting cultures. The climate was similar to today's, but characterized by short cycles when temperature and/or moisture fluctuated above and below the modern norm. This climate created a rich grassland able to support large numbers of bison, and both the herds and human populations expanded to such an extent that even intermontane basins and the Snake River Plain of southern Idaho were the scene of communal bison kills. The importance of communal bison hunting to these groups cannot be understated. Indeed, George Frison (1991) has asserted that a person can look successively northward from one Late Prehistoric period bison kill to the next, all the way from Ft. Collins, Colorado, to Calgary, Alberta—a distance of nearly 1000 miles or 1600 km (Map 4.1).

Between A.D. 800 and 1100, a series of groups using a variety of small arrow point types began to replace the Avonlea and Besant cultures on the Northwestern Plains. Pottery continued to be made and used by these peoples, and two tools—the grooved stone mall and the toothed hide flesher made from a bison's leg bone—are diagnostic of these Late Prehistoric cultures. Overall, relatively little is known about the origins of these cultures, but by about A.D. 1500, some can be recognized as the ancestors of historically known groups.

Around the same time, farming groups of the Middle Missouri and Late Woodlands traditions in the American Midwest began moving into South and North Dakota. The migration of these earthlodge village peoples onto the eastern fringe of the Northwestern Plains presaged tremendous changes that subsequently occurred in the region over the next one thousand years. The increased precipitation that made the Plains so fertile for bison also allowed the spread of agriculture, and these groups moved into the area to take advantage of river bottoms that could now support the farming of corn, beans, and squash. These people brought new horticultural products and artifacts, including finely made pottery, items of pipestone, and large quantities of exotic shell ornaments. They also became new partners for trading and victims for raids.

Earthlodge village sites north of the Black Hills and on the lower Yellowstone are more than 200 miles (320 km) from the nearest Missouri River villages, indicating that farming groups made significant incursions into the area to establish outposts. Fortifications and a heavy reliance on bison hunting at these sites indicate that this was no easy task, and these villages were occupied for only short periods. Other Missouri River village groups regularly visited the open plains for long bison-hunting and flint-quarrying expeditions. Evidence of these trips includes exotic ceramics and lithic materials in hunting camps and quarry workshops in the badlands and hills of western North and South Dakota. Some groups gave up farming entirely and moved out onto the open plains to become nomadic bison hunters.

During one of these periods of expansion after A.D. 1200, the Crow split off from the farming villages of the Hidatsa in central North Dakota and moved onto the Plains. Powder River tradition pottery in the Pine Parklands suggests that this split may have involved several small migrations over several hundred years, eventually producing the historically known Crow. In later centuries, other farming groups, including the Cheyenne, Assiniboin, and Lakota Sioux, broke away from the farming cultures and moved onto the Pains.

About the same time that Missouri River villagers were pushing into the region from the east, other identifiable cultures were becoming established in the northeast, west, and southwest. For the first time, these prehistoric cultures can be linked to known historic groups. In the north and east, Avonlea was replaced by Old Women's phase cultures. Associated with characteristic Saskatchewan Basin ceramics in campsites at major bison kills throughout southern Alberta, Saskatchewan, and extreme northern Montana, these cultures are generally believed to represent the ancestors of the Blackfeet and possibly the Gros Ventres.

In the south and west, small base-notched projectile points also began to appear around this time. These points are often associated with Intermountain tradition pottery and carved steatite vessels, and this complex of artifacts is generally linked to the Northern Shoshone. Although centered in the intermontane basins of northwestern Wyoming and southwestern Montana, the distribution of these diagnostic artifacts indicates the Shoshone moved onto the Plains from the Great Basin of northern Utah and southern Idaho and ranged widely across the area. Along the Rocky Mountains, the presence of other archaeological assemblages represents the movement of the Kutenai and Flathead peoples onto the Plains during the Late Prehistoric period. These groups occupied the bison-hunting territory along the east flanks of the Rockies from southern Alberta to the Missouri River headwaters in southwestern Montana.

By the end of the Late Prehistoric period, most historically known groups had become established on the Plains. As testified by the productive bison-hunting economy and the appearance of so many different ethnic groups, the Late Prehistoric period was a time of rich cultural development. Trade networks originating in the Late Archaic period reached their maximum extent and spanned the continent. Seashells came from the Pacific coast, and nephrite, obsidian, and soapstone from the western mountains. Ceramics, hammered copper items, catlinite tablets, pipestone, and conch shell masks came from as far away as the Mississippi River valley and the Great Lakes. Although rarely preserved in archaeological contexts, the movement of food and social innovations undoubtedly followed these same routes. Although the Missouri River villagers were the main brokers in this trade system, most Plains groups probably participated and benefited to some extent. Salish and Shoshonean groups provided

contacts with the groups in the Columbia Plateau, the Southwest, and Great Basin.

Warfare, an inevitable result of the territorial conquest that occurs when new groups move into an occupied area, was a regular but limited part of the Late Prehistoric period lifestyle. Fortifications surrounding many Middle Missouri villages, especially those located on frontiers, indicate that farming villages were frequent targets of raids. Occasional Late Prehistoric period graves of war casualties indicate that low intensity warfare occurred throughout the area. Late Prehistoric period rock art showing combat between shield-bearing warriors provides further evidence of limited warfare activities.

The Late Prehistoric period was a time of increased rock art production on the Northwestern Plains, with a complex interplay between several different traditions. Although the Early Hunting tradition had apparently died out, the Dinwoody, En Toto Pecked, Pecked Abstract, and Columbia Plateau traditions bridged the transition from the Archaic to Late Prehistoric periods. The Foothills Abstract tradition may also date in part to this time. Most important, several new rock art traditions developed and flourished. The Ceremonial tradition has its greatest expression in the latter half of this period, while the related Biographic tradition originated towards the end of the Late Prehistoric. Finally, the Hoofprint tradition expanded into the region from the east.

Protohistoric Period (A.D. 1700 to 1840)

The Protohistoric period spans the years from the first introduction of European trade goods, horses, and guns to the permanent arrival of Euro-Americans. The influence of European culture was felt on the Plains long before the first white man set foot on the prairies. At first only a few European trade items appeared, but horses and guns soon followed. Their introduction initiated a 250-year period of change, conflict, and accultura-tion that ultimately culminated in the demise of the buffalo-hunting cultures. By the mid-1800s, Euro-American society was permanently established on the Northwestern Plains, and the Native peoples had been largely relegated to reservations and reserves.

During the late seventeenth century, European goods were first introduced to the peoples of the Northwestern Plains through existing trade networks. Initially only a few items, such as metal knives, iron arrowheads (often manufactured from traded metal scraps), and glass beads found their way into Plains societies, causing few appreciable changes. Evidence from early Protohistoric period archaeological sites supports the notion of minimal culture change during this time. Bison-killing practices remained the same as in the Late Prehistoric period, and stone tool kits were simply augmented by the addition of occasional metal tools. Dogs and people continued to transport belongings, so tipis remained small, and long-distance movements of groups were slow and infrequent. Farming and seasonal hunting still occupied the village groups, and their role as middlemen in the trade networks was informal.

With the arrival of the horse and gun, however, changes occurred in every aspect of aboriginal life. Initially obtained from Spanish *rancherías* in northern Mexico and the American Southwest, the horse arrived on the Northwestern Plains through Shoshone traders in southern Idaho and southwestern Wyoming. By 1730 horses were known, though not yet common, throughout the region. Flintlock guns, traded by the French in the Great Lakes area and the English on Hudson Bay, reached the margins of the Northwestern Plains around 1725, and in the next two or three decades they spread across the region. By 1775, all Plains groups had horses and guns (see Map 2.1), and most were well on the way to becoming the equestrian cultures well known from the historic descriptions of the 1800s.

The archaeology of the Protohistoric period is poorly known, but some changes in material culture are recorded. Metal pots replaced pottery, and tipis became larger because the horse could carry more weight. Hunting patterns also shifted, and buffalo jumps and other communal hunting techniques were gradually abandoned in favor of individual hunting from horseback. Increased movements of groups occurred onto and across the Plains. The Cluny complex of southern Saskatchewan and Alberta, best represented by a fortified earthlodge village site on the Bow River, represents a short-lived intrusion of Middle Missouri farming people into the northernmost reaches of the Plains. The Cluny site includes typical Middle Missouri ceramics mixed with the bones of horses and a few pieces of metal. The movement of these village farmers may have been precipitated by Woodlands groups moving west owing to pressures from the Great Lakes fur trade.

The fur trade also encouraged the movement of several other groups onto the Northwestern Plains. Groups of Dene and Woodlands Cree moved south and west from the boreal forest, becoming the Sarcee and the Plains Cree. A group of Assiniboin moved west from the upper Mississippi region, eventually settling along the Bow River and becoming the Stoney. Finally, as a result of obtaining the horse, the Shoshone, Kutenai, Nez Perce, and Flathead traveled farther east onto the Plains to pursue the bison herds.

The movements of cultural groups led to increased territorial conflict, particularly after the horse arrived on the Plains. For a short period after 1700, the overall balance of military power shifted radically. Although warfare was known prehistorically, it was limited in nature and extent, and most groups participated equally. Because the Shoshone obtained horses first, their mounted raiders became feared throughout the region as the dreaded "Snakes," and they pushed far north

and east. Later, after the Plains Cree, Assiniboin, Gros Ventres, and Blackfeet possessed the gun, the balance shifted again, and the Shoshone were driven back southwestward. Eventually the Kutenai and Flathead were pushed completely off the Plains and back across the Rockies.

By the time the first European explorers and fur traders entered the Northwestern Plains, the distributions of Native groups closely approximated that of the later Historic period. The first Europeans to directly contact Plains Indians in the region were the La Vérendrye brothers, who traveled from southern Manitoba to winter with the Mandan along the Middle Missouri in 1742–43. During the second half of the eighteenth century, a number of Hudson's Bay Company fur traders ventured deep onto the northern Plains. In 1754, Anthony Henday journeyed to a Blackfeet or Gros Ventre camp in south-central Alberta, followed by Matthew Cocking, who reached southern Saskatchewan in 1776. In 1787, David Thompson wintered with the Piegan on the Bow River, followed by Peter Fidler, who reached the Oldman River in southern Alberta in 1792.

The first fur trade posts were established along the northern margins of the Plains by the late 1790s, including Fort Edmonton and Rocky Mountain House on the North Saskatchewan River. By the time Lewis and Clark crossed the Northwestern Plains on their way to the Pacific in 1804–6, fur traders were in regular contact with eastern and northern groups across the Northwestern Plains. Independent American traders and trappers followed Lewis and Clark to the upper Missouri, and the first trading posts on the Northwestern Plains proper were established on the South Saskatchewan around 1820 and the Missouri by about 1825.

By 1840, Euro-Americans were permanently established in small enclaves throughout the Northwestern Plains. Settlement of the area by Euro-Americans began the Historic period,

an era marked by warfare, decimation of the bison herds, and ultimately the signing of treaties and the settlement of the various Plains Indian groups onto reservations and reserves. With the end of the nomadic bison hunting lifestyle, the creation of rock art all but ceased.

Rock art chronicles the many changes to Native cultures that occurred during the Protohistoric and early Historic periods. While the Ceremonial tradition and some Dinwoody and Hoofprint rock art persisted, the Biographic tradition flourished in response to these changes. The Biographic tradition, depicting horse stealing, coup-counting, combat, and battle scenes, even influenced the structure of Columbia Plateau style art. Together with painted bison robes and the later ledger drawings, the Biographic tradition occurs more frequently and across a greater territory than any other Plains representational imagery. Finally, the Vertical Series tradition appears to be a late outgrowth of the Biographic tradition, reflecting a growing need for recording personal accomplishments and events.

INTERPRETING THE ART . . .

Medicine Rocks

Medicine rocks—the words conjure up images of a landscape alive with spiritual energy. In traditional Plains Indian belief, many impressive natural features—often those providing sweeping, panoramic views—are considered sacred or invested with "medicine power." In particular, medicine power is concentrated in striking geological formations, such as strangely shaped rocks and hoodoos, enormous glacial erratics, isolated mountain peaks, and deep narrow canyons. Almost without exception, rock art sites on the Northwestern Plains are associated with just such remarkable landscape features.

According to oral traditions, these features were either created by mythological figures or had their genesis under supernatural circumstances. The strange split-rock glacial erratics of southern Alberta were explained as the work of spirit beings or Naapi (Old Man), who created the world. Unusual sandstone outcrops were also revered by Native peoples as sacred medicine rocks inhabited by powerful spirits. Many Plains Indians made offerings to a boulder above the Milk River that was shaped like a buffalo bull lying down. Another medicine rock above the Marias River looked like a person turned to stone; it was the object of offerings and prayers for safety and long life. Grinnell (1962:263) described one sacred rock:

Down on the Milk River, east of the Sweet Grass Hills, is another medicine rock. It is shaped something like a man's body, and looks like a person sitting on top of the bluff. Whenever the Blackfeet pass this rock, they make presents to it. Sometimes, when they give it an article of clothing, they put it on the rock, "and then," as one of them said to me, "when you look at it, it seems more than ever like a person."

Isolated mountain peaks also figure prominently within the sacred geography of Plains cultures. Chief Mountain, Bear Butte, the Sweetgrass Hills, the Pryor Mountains, and the Black Hills are only a few of the powerful medicine places considered sacred by many different tribes. All these peaks rise high above the surrounding plains and provide vast panoramic vistas from their summits. In traditional terms, each is a sacred axis connecting the earth and sky worlds.

In Native cultures, these powerful locations emphasize the sacred relationships between nature, people, and spirits. Rituals and ceremonies—including the creation of rock art—reaffirm this connection with the sacred landscape. The most important of these rituals was the vision quest, through which individuals tapped the power of sacred places. Sacred peaks were particularly powerful vision-

questing locations, and those fasting on their summits often obtained strong medicine power. Others obtained their visions atop smaller hills, in rock shelters, or on high ledges with direct views to sacred summits or the rising sun.

A close relationship between rock art and sacred landscapes occurs across the Northwestern Plains, including the North Cave Hills, the Pryor Mountains, and Castle Gardens sites. Perhaps the primary example, however, is Writing-on-Stone, located along the Milk River in southern Alberta. Here, unusual geological features are found in great abundance—the Milk River valley is a steep-walled canyon, bounded by high cliffs and extensive outcrops of sandstone hoodoos eroded into fantastic shapes and hidden passageways. The effects of light and sound among these hoodoos, cliffs, and canyons lend an otherworldly air to Writing-on-Stone, and the sheer concentration of unusual features creates a landscape loaded with sacred meaning. The hoodoos are medicine rocks, while numerous caves, alcoves, and high vantage points provide an abundance of suitable vision quest locations. More important, the high cliffs offer spectacular views of the valley and the nearby Sweetgrass Hills—one of the most powerful locations within the sacred geography of the Blackfeet, and still used today for vision quests. Throughout history the Sweetgrass Hills undoubtedly acted as a spiritual magnet, drawing Native peoples from the entire surrounding region to this sacred place.

More rock art is found at Writing-on-Stone than at any other place on the Northwestern Plains. This concentration of rock art reflects the presence of a place charged with spiritual energy—it speaks to us of the intimate relationship between Native people, sacred landscapes, and medicine powers.

5 / Native Cultures of the Northwestern Plains

From the earliest days of European exploration, Plains Indians have been the most romanticized ideal of the North American Indian—proud mounted warriors in feathered bonnets, hunting buffalo and fighting the U.S. Cavalry. This fascination with Plains Indians, fed by the popular media from the time of frontier artists George Catlin and Charles Russell to recent movies like *Dances with Wolves,* is largely owing to the fact that these tribes coexisted with expanding Euro-American culture for more than a century and fought the military forces of the United States to a virtual standstill in the late 1800s. Yet, despite significant cultural traits shared by all groups, Northwestern Plains culture is not a homogeneous entity; at the time of contact with Europeans, more than twenty different tribes lived in or regularly visited the region (Map 5.1). These groups had languages, customs, traditions, and histories that in many ways made them as different from each other as the British are from the Polish or Norwegians are from Italians.

When the first Europeans arrived on the Northwestern Plains, the resident native groups occupied a vast territory more than three times the size of Great Britain. Their precise population (before European diseases decimated most groups) may never be known, but it numbered in the tens of thousands. Today descendants of these Native people live in cities and towns across the region, and they occupy numerous reservations and reserves in Wyoming, Montana, the Dakotas, and southern Saskatchewan and Alberta.

People of the Plains

At the time of contact with Europeans, resident Northwestern Plains tribes included representatives of six language families—Athapaskan, Algonkian, Siouan, Uto-Aztecan, Salishan, and Caddoan. In addition, groups speaking languages from three other families—Kutenaian, Kiowan, and Sahaptian—had used the area just before European contact or visited it seasonally after the adoption of the horse.

The two major language families were Algonkian and Siouan. Algonkian speakers included the Blackfeet, Plains Cree, Plains Ojibwa, and Gros Ventre in the north, and the Cheyenne and Arapaho farther south. Between these groups was a wedge of Siouan speakers including the Assiniboin, Stoney, Crow, Sioux, Mandan, Hidatsa, and Ponca. Unlike their nomadic cousins, the Mandan and Hidatsa were farmers, living in earthlodge villages along the upper Missouri where they grew corn, squash, and beans—only venturing periodically onto the open plains to hunt bison.

Far to the north were the Athapaskan-speaking Sarcee, allied with their Blackfeet neighbors. Caddoan speakers, more common

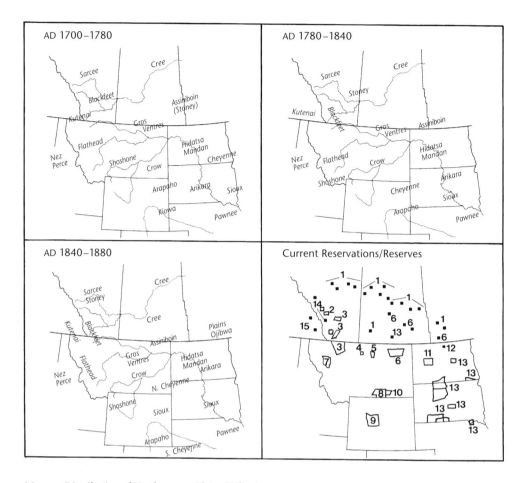

Map 5.1. *Distribution of Northwestern Plains Tribes in Protohistoric and Historic Periods*

Reservations and Reserves:
 1. *Plains Cree (numerous)*
 2. *Sarcee*
 3. *Blackfeet (including Blackfoot, Blood, Peigan)*
 4. *Plains Cree*
 5. *Gros Ventres*
 6. *Assiniboin (several)*
 7. *Flathead, Kutenai*
 8. *Crow*
 9. *Shoshone, Arapaho*
 10. *Northern Cheyenne*
 11. *Hidatsa, Mandan, Arikara*
 12. *Plains Ojibwa*
 13. *Sioux (several)*
 14. *Stoney*
 15. *Kutenai*

on the southern Plains, extended into the region as the Pawnee and Arikara. Uto-Aztecan speakers include the Bannock and Wind River Shoshone, who lived in southeastern Idaho and western Wyoming. Their cousins, the Comanche, had split off at some point in the 1600s and left Wyoming for the southern Plains. On the western edge of the region, the Salishan-speaking Flathead were residents of the intermontane valleys from the Rocky Mountains eastward to the headwaters of the Missouri River. Occasionally they were accompanied on their seasonal bison hunts by their Salishan-speaking cousins from the Pend d'Oreille, Coeur d'Alene, and Kalispel tribes.

In addition to the resident tribes, groups speaking Kiowan, Kutenaian, and Sahaptian languages also used the region. Kiowa oral history refers to a time when their ancestors lived in the broad valleys at the headwaters of the Missouri River in what is now central Montana, and they may have left the region only as late as A.D. 1500 (Schlesier 1994:310–15) to become a dominant group on the southern Plains. The Kutenai and the Sahaptian-speaking Nez Perce have somewhat similar histories. Although both groups now live in the Rocky Mountain region of the Columbia Plateau, their oral traditions and mythologies refer to a past time when they lived out on the western edge of the Alberta and Montana plains. During historic times, both groups made extended hunting trips to these same areas and participated to a significant extent in much of Plains culture.

Despite their distinct languages and traditions, Plains tribes shared many cultural traits. Foremost was bison hunting—a year-round occupation for the nomadic tribes, and an important source of food, clothing, and tools for the village farmers. Tipis and horse-drawn travois (pulled by dogs in prehistoric times) were also used by the nomads and seasonally by the villagers. All cultures emphasized status acquired through war honors, horse raiding, and membership in ranked societies. Vision quests, medicine bundles, and the Sun Dance were common features of religions. Their artwork employed distinctive geometric designs in beads and quills and war record drawings on robes and in ledgers.

Many similarities in economy and subsistence were responses to similar adaptations to the Plains environment. Similarities in social organization, religion, rituals, and status systems, on the other hand, indicate that widely shared and exchanged ideas and beliefs created a Plains-wide cultural system. In fact, Plains culture was so strong that groups immigrating into the area from any neighboring region quickly abandoned many of their former practices; after a few decades they were virtually indistinguishable from groups who had lived in the region for centuries. In this way the Cheyenne and Sioux went from being horticulturists of the Eastern Woodlands to being fully equestrian bison hunters in less than a century, just before 1800. Archaeological and ethnohistoric evidence indicates that similar transitions took place among the Shoshone, Crow, Comanche, Sarcee, Kiowa, and Apache at various times during the last 2,000 years. These commonalities allow a generalized overview of Plains Indian culture to focus on shared themes of government, religion, warfare, and bison hunting.

Plains culture is known from oral traditions, historical accounts, and ethnographic studies, but all of these sources primarily document life after the arrival of the horse. People have inhabited the Northwestern Plains for at least 12,000 years, but only the last 150 years of their history have been recorded by written documents. Oral traditions provide some evidence, but little direct historical information exists for the time before the horse, when the people had only dogs for transportation. Archaeological evidence, however, shows the deep roots of most cultural traits. Bison hunting, tipis, warfare, vision quests, shamans, and rock art, all with

histories spanning thousands of years, indicate that the basic economic and social organization of Plains culture was in place long before Europeans arrived.

Great changes occurred in Plains culture after the introduction of the horse and gun. Horse, or "elk dogs"—so named because they were as large as elk, but domesticated, like dogs—revolutionized transportation, trade, hunting, and warfare. The horse transformed concepts of wealth and status, and altered the significance of religious and warrior societies. It also led to increased contact and conflict between groups, resulting in much movement, migration, and territorial shifting. The gun was also responsible for radical changes in hunting, warfare, and trade.

Origins and Traditions

According to tradition, Native people believe they have always lived on the Plains. Placed into the world by the Sun, humans and all other living things derive their power from this celestial being. In the beginning, a transformer figure known by different names—Old Man to the Blackfeet, Coyote to the Crow—was sent down to the primeval world by the Sun. The transformer made the plains and valleys, raised the mountains and hills, created the land creatures, and, finally, made the people. He taught the people hunting and plant lore, but as he grew bored with his creations, he began to play tricks on them. These mean tricks and deeds invariably got him into trouble with the Sun, who punished him for his acts. By these stories, Plains Indians explain the origin of the world and the place and role of all things in it. Through this oral tradition, parents also taught their children moral lessons and reinforced cultural values central to the people's religious and social life.

Oral traditions form an invaluable source of insight into a way of life long before written history existed. The oldest of these oral histories preserves memories from before the horse—of ancient migrations and the deeds of legendary heroes. More recent stories recount the exploits of great warriors, of battles fought and hardships endured. Along with oral history, some Plains groups kept formal records known as winter counts. Originally painted on a bison hide as a linear series of year images spiraling counterclockwise from a central image, these were later drawn in ledger books or on muslin sheets. Each year the winter count keeper would add another image to represent a significant event that had characterized the preceding year. These images were the keeper's memory aids to assist in recounting a group's history. The longest of these documents stretches back into the 1600s. With oral histories and winter counts, Plains Indians maintained their history and acknowledged their place in the cosmos. As the following chapters show, they also used rock art as a means of relating to the cosmos and to record their history.

Religion, Ritual, and Ceremonies

Religion pervaded all aspects of Plains Indian life, and the ability to successfully undertake any activity derived from the powers of the spirit world. Ritual and ceremony provided the common foundation that linked people to each other and to the natural world. In Plains belief, all things have "medicine" power—animals, birds, natural features and phenomena are the earthly embodiments of spirit beings. Different spirits dominate the worlds of sky, earth, and water. Eagle and Thunderbird are powerful sky spirits, beaver and otter rule the water world, and bison and bear are potent earth spirits. Above all is the power of Sun.

Plains Indian religion had strong public and private aspects, both involving much ritual and ceremonialism. Personal rituals were the vision quest and the specialized training that a few individuals undertook

to become a shaman or medicine man. The vision quest ritual involved seeking a guardian spirit helper by fasting and praying in an isolated location, usually for four days and nights. During the quest, purification rituals, repetitive prayers, and self-torture brought contact with the spirit world in dreams or visions. In these visions, a guardian spirit helper taught the recipient certain ritual behaviors, songs, and prayers, and often revealed a talisman, which the supplicant later collected and kept in a personal medicine bundle. Medicine power came from a wide variety of supernatural beings in the form of imposing beasts, such as bison, bears, eagles, and hawks, and lesser animals, such as rabbits, mice, swallows, and chickadees, passed on their power in these dreams. Even butterflies, mosquitoes, and dragonflies possessed specific powers. Dragonfly was a particularly powerful warrior's guardian because it is so difficult to hit or catch, and it creates a concealing puff of dust when it flies near the ground—attributes especially advantageous in combat.

Although vision quests were most common among teenage boys seeking a guardian spirit, adult men and women could seek visions whenever a special situation called for the intercession of the spirit world. Not all young men were successful in their vision quests, and sometimes they had to resort to purchasing the power of an older retired warrior. Such purchases transferred the rituals, medicine bundles, and even protective shield designs associated with a spirit helper to the new owner. It was a widely practiced though less preferred alternative, and famous warriors are known to have received their guardian spirits in this way.

Shamans were holy men or occasionally women acknowledged to have received particularly strong powers in a vision. A shamanic vision could come at any time in life—the Cheyenne Black Elk received his vision at age nine—and shamans frequently had important visions throughout their lives.

With their special powers, shamans foretold the future, cured illness, and healed wounds. Shortly before the battle with Custer, Sitting Bull received a famous vision of dead soldiers falling into the Lakota camp. Healing of wounds was also very important in such militaristic societies; numerous stories tell of shaman-healers who successfully treated a wide variety of wounds and illnesses. Sometimes a particularly powerful individual had simultaneous roles as shaman, keeper of a sacred bundle, and even chief.

Public religious ceremonies, on the other hand, were important to strengthen group identity and maintain and revitalize the group's relationships with the spirit world. Each tribe had a main annual ceremony in which everyone participated. For most groups this was the Sun Dance, but the Mandan had the Okipa, while the Pawnee sacrificed a young woman war captive to the Morning Star. The annual Sun Dance was initiated by a woman who had made a vow to the Sun at a time of crisis. If her appeal was answered, she took on the costly and demanding role of leading the ceremony. In addition to elaborate rituals performed over many days, the Sun Dance involved self-torture rituals for young men, who gained group status and assistance from the spirit world.

Each group also conducted various bundle ceremonies and dances throughout the year. Bundle ceremonies involved rituals associated with maintaining the power and effectiveness of sacred objects whose powers had been revealed by supernatural beings. Medicine bundles held powers to predict the future, help warriors on the war path, or cure the sick. Bundles were known by descriptive names such as the Thunder Medicine Pipe of the Blackfeet, the Pawnee Star Bundle, the Sacred Buffalo Hat and Sacred Arrows of the Cheyenne, and the Teton Sioux Buffalo Calf Pipe. Bundle keepers were men held in exceptionally high regard who had received the songs and instructions for their bundles in dreams, or

from another bundle keeper. Among some groups, ownership or guardianship of bundles was transferred frequently in events usually marked by ceremony and participation by all or most of the group's adults. Dances, often a feature of bundle-transfer ceremonies, were also conducted to commemorate war exploits and the successful return of war parties. Such dances included the Buffalo Dance, Scalp Dance, and Grass (or Hot) Dance.

When life ended, Plains Indians believed that the spirit traveled to the spirit world, where the dead lived very much as they had before, inhabiting tipis, participating in daily activities, and hunting bison. The ways of the spirit world were confirmed by individuals who had traveled there in a dream or trance. Burial ceremonies prepared the dead for their journey to the spirit world. The deceased were painted and dressed in their finest clothes and then wrapped in a bison robe along with their most prized possessions. A man's favorite horse would often be sacrificed to accompany him to the spirit world. During a four-day mourning period, close relatives cut their hair, gashed their arms, and even cut off fingers. At the end of this period, a feast was held, the remaining possessions and horses of the deceased were given away, and the tipi abandoned or exchanged. In some cases, the body was buried, but more often it was left in a death lodge, placed on a scaffold made of poles, or set among the branches of a tree. Prominent chiefs or warriors were often placed at medicine rocks or other sacred places.

Political and Social Organization

Although more than a dozen distinct ethnic groups inhabited the Northwestern Plains, their territories were fluid and loosely defined. This reflected the loose political structure of Northwestern Plains tribes, each of which were composed of several autonomous, loosely affiliated bands (or villages, among the Missouri River farming groups). Although each tribe was united by language and common traditions, members gave their allegiance to their bands, from which they received their identity. The Teton Sioux, for example, counted seven distinct bands, and in the mid 1800s, the Piegan division of the Blackfeet named as many as fifteen. For much of the year, bands operated independently, only joining together for ceremonies, councils, and mutual defense.

Sometimes politically independent bands or tribes allied themselves in loose, long-term confederations, not for the purpose of acting as a coherent political unit but rather to establish peaceful cooperation and coexistence—a welcome occurrence in a region where warfare was a mainstay of economic and social relations. Probably the best such example is the Blackfeet confederacy, composed of the Piegan, Blood, and Blackfoot, but also including the Athapaskan-speaking Sarcee. Similar confederations occurred among seven Sioux tribes, between the Crow and Hidatsa, between the Flathead, Pend d'Oreille, and Kalispel, and between the Northern and Southern Cheyenne. Although the basis for most of these confederacies is a common or closely related language, the inclusion of the Sarcee into the Blackfeet confederacy and the exclusion of the Siouan-speaking Assiniboin from the Sioux alliance indicate that language was not the only factor. Many nations also made shorter alliances, but these were notoriously fragile and usually ended when leaders could not restrain young warriors eager to add more horses or scalps to their war record.

Leadership was democratic and nonhereditary. Bands were governed by charismatic individuals respected for their abilities, and who led by example. Group consensus was reached by councils of respected elders who qualified on the basis of their war records. At the summer gathering of the bands, the various band chiefs formed the council.

Neither chiefs nor the council exercised disciplinary power over band members; the only real coercive power was held by the men's warrior societies during the communal hunt. When violators attempted to kill bison before the entire group was prepared for the hunt, these policemen could punish them by flogging, destroying their tipis and other personal property, and in severe cases even by death. Otherwise a band chief and council could only resort to gossip, ridicule, or personal condemnation to quell arguments or conflicts between members. Members were free to change bands or form new ones at any time, and people frequently did so when they disagreed with a leader's decisions.

Plains groups traced descent either through the male (patrilineal) or female (matrilineal) line. Village farmers, including the Mandan, Hidatsa, Pawnee, and Arikara, were matrilineal and matrilocal—married couples lived in the woman's house with her relatives. This residence system was particularly important for continuity in land use and property distribution in a horticultural society. The Crow, because of their former life as village farmers, had matrilineal descent, but couples could reside with either the man's or woman's parents. Other than the Crow, the nomadic tribes were patrilineal, but residence among some groups was with the wife's family and among others with the husband's family.

Although monogamy usually prevailed, men of high status frequently had more than one wife, and occasionally as many as four or five. Multiple wives—often sisters—were considered necessary for the heavy workload that went along with a husband's high status and wealth. Their work included tanning numerous buffalo robes, care of ceremonial regalia, and cooking for guests. Female war captives were routinely kept as additional wives; their children were raised to replace warriors fallen in battle.

An important feature of Plains social organization was the presence of various associations or societies. Both men's and women's societies fulfilled social, religious, and military functions. These societies were generally ranked according to their relative importance, and membership conferred certain privileges and responsibilities. In some groups, membership was based on age, and an individual passed through a series of ranked societies over the course of a lifetime. In other cases, status and achievements in military and religious endeavors determined membership.

The nomadic groups lived year-round in tipis made of tanned buffalo hides that were often painted with sacred designs or scenes illustrating the war record of the owner. Before the horse, these lodges were 9 to 12 feet (3 to 4 m) in diameter, but later they became much larger, frequently exceeding 20 feet (6 m) in size. Originally, personal possessions were carried or loaded on small dog-drawn travois. Other than dwellings and clothing, the nomads had few material possessions. They kept only as many weapons, religious objects, cooking and eating utensils, and camp tools as they could easily carry from camp to camp. Simple bone and stone tools were often discarded before moving camp, as they could be easily replaced. Before European trade objects arrived, a few clay pots and bowls were used, but they were quickly replaced by metal pots. Later, the larger horse travois freed people from carrying burdens and allowed a significant increase in number and size of personal possessions that they could transport.

Villagers lived in large, semisubterranean earth lodges 40 to 80 feet (12 to 24 m) across. These structures had a level, packed earth floor about 2 feet (60 cm) below the ground surface. Four huge center posts and an outer ring of heavy posts supported crossbeams. Pole rafters spanned these beams, roofing all but the very center of the lodge. Posts leaning against the outer ring formed the structure's walls. The entire structure was covered with mats of woven willow branches and then covered with layers of firmly packed earth.

A door passage extended from one side, and the opening in the center of the roof provided a smoke hole which could be covered in inclement weather. Houses were furnished with sleeping platforms, storage pits, a family altar, and in later times some even had a corral space for favorite horses. With their sedentary life, villagers accumulated more belongings. Pottery was abundant, and carved bone and wooden objects included a wide variety of utensils, tools, toys, games, and ceremonial regalia not common in nomadic groups.

The Seasonal Round

The Plains Indians were first and foremost bison hunters, and much of their social and economic life revolved around this animal. Among the nomadic groups, the yearly cycle or seasonal round was largely dictated by the movements of the bison herds. In the fall and winter, small herds congregated in sheltered river valleys and in the foothills. During the spring and summer, however, the bison moved out onto the plains, eventually forming huge slowly migrating herds. During much of the seasonal round, bands moved frequently to follow the herds and to take advantage of various seasonally available food resources and trading opportunities.

The yearly cycle began in late fall, when individual bands established camps in timbered valleys, where they would remain sheltered from the wind and snow for the entire winter. If wood and shelter were limited, bands might even break into smaller, single-family groups to wait out the cold weather. Over the winter months, the people largely survived on dried foods such as pemmican, supplemented with small game and the occasional deer, elk, or bison. March was a difficult month, as food supplies were low, and the bison began to drift away from the valleys and onto the Plains. By April, the bands had left the winter camps and scattered across the prairies in pursuit of small bison herds.

During the spring months, they repaired clothes and tipis and made tools and other objects. In late spring, the bands would travel to favorite spots to collect roots and bulbs.

Beginning in June, when the bison bulls were in their prime, the bands began to come together for the summer bison hunt and the Sun Dance ceremony. Only when the bands congregated were there enough people to effectively operate communal bison kills. Before the horse, these kills involved elaborate drives to make the herd plunge over cliffs or gather in sophisticated corral systems. Most drives took place in autumn. After the horse, equestrian surrounds gradually became the favored technique, and they were generally conducted in the summer months. During the hunt, military societies ensured that no group or family acted independently to spoil the hunt for the larger group. The communal hunt provided fresh meat to support large groups as they worked together drying their winter meat supply and processing hides to trade or make into new clothing and tipis. Men used the thick hide of a bull buffalo's neck to construct their war shields.

The time of the communal bison hunt was also the Sun Dance season, high point of the religious and social year. In August, after several weeks of hunting, all the bands gathered, each occupying its traditional place in the great camp circle of tipis. During this several-week period, acquaintances were renewed, courtship flourished, marriages were arranged, and various other ceremonies were conducted. Games, races, storytelling, gossiping, and council discussion of important tribal issues dominated this most important time of year. The Sun Dance encampment was also the time for gathering berries and other plants for food and medicine.

After the Sun Dance, the great camp was dismantled, and the bands separated for the fall hunt. Bison cows were now in their prime, and the people collected more berries to dry and mix with dried meat to make pemmican.

In the fall, Plains hunters also took elk, deer, and antelope, and traveled to the mountains to hunt mountain sheep and mountain goats. Small game and birds were also killed, often for their skins and feathers to use in ceremonial regalia. Fall was also the time for trade and for trips to the camps and villages of neighboring tribes. In exchange for surplus bison hides and pemmican, the nomadic groups received exotic materials such as shell and obsidian, as well as agricultural products. By November, the bands had returned to their winter camps, and another yearly cycle began.

Among the sedentary farmers, bison hunting was a year-round activity near the village. Even so, communal summer hunts took large groups of villagers great distances west, to the badlands or Pine Parklands, for a period of several weeks each year. Although roots and berries were collected during gathering expeditions, the village cultures relied most heavily on corn, beans, and squash planted in the fertile river valleys near their villages. Despite living at the extreme northern limit for successful prehistoric agriculture, these groups often accumulated surpluses of vegetable foods which they traded to the nomadic hunting tribes.

The Northwestern Plains emphasis on bison hunting stretches back more than 10,000 years. The eighteenth-century arrival of the horse, however, caused major changes in the economic systems of all Plains groups for hunters and farmers alike. Horses increased the nomadic hunters' mobility and also provided transport for far more goods in the seasonal round than in earlier times. Hunting changed from pedestrian stalking of single animals and seasonal bison jumps to mounted chases where a single hunter could kill many animals in an afternoon. With increased killing ability and an expanding fur trade, bison robes became a form of currency. Among some groups, this led to the concentration of wealth by certain individuals—an unusual situation in the days before the horse.

Trade and travel also increased as more and different goods were available and transportation became easier.

Horses also changed the economic life of the village cultures. Buffalo hunts became easier and faster, and the Mandan, Hidatsa, Arikara, and Cheyenne also became expert traders who controlled the flow of European trade items to nomadic groups. During the earliest contact period, trading remained focused primarily at the Missouri River villages. Kettles, metal knives and axes, beads, cloth, guns, tobacco, and other products arrived here from sources to the east. Along with agricultural products, these objects were parceled out to nomadic groups from the west in exchange for horses, fine clothing with quillwork decoration, and bison products. For nearly a century, village tribes enjoyed their status as barons of the intertribal trade, and the first European trading posts in the region were started at or near their villages to fit into the already established system. The expansion of the fur trade, however, rapidly led to the founding of trading posts throughout Wyoming, Montana, and Alberta. By 1840, the effects of epidemic diseases on the settled farmers and the establishment of trading posts had moved much of the trade away from the villages.

The Role of Women

Women occupied a central and respected place in Plains cultures. Raising children was primarily their responsibility, and their work was essential to daily life. The majority of routine camp duties fell to women, who butchered most kills, gathered firewood, and cooked the food. Most utilitarian objects were made and owned by women. Women tanned the hides of bison, deer, and elk and used them to manufacture tipis, clothing, moccasins, and rawhide parfleches for carrying all manner of items. Many women were expert craft workers who made finely decorated robes, clothing,

moccasins, and parfleches, some of which were staples of intertribal trade. Every time the band moved, women dismantled, transported, and re-erected the family tipi. In many groups, women were also responsible for the daily care and ritual treatment of the men's most sacred possessions, including their shields and medicine bundles.

Women also gathered the many plants used for food and medicine. They gathered bulbs, roots, and berries in the spring and summer, and these were either eaten fresh or dried for winter consumption. They accounted for a large proportion of the people's diet, providing many vital nutrients. Much knowledge of medicinal plants also rested with women, who often administered remedies to the ill and injured. Among the village cultures, women were responsible for planting, tending, and harvesting crops.

Women had important social and religious functions in most tribes. At puberty, girls were secluded in a small menstrual tipi where they fasted and prayed under the supervision of an elder woman, who instructed the girls in a variety of tasks and roles. During this period, the girls often obtained a vision from the spirit world, which provided them with their medicine power. Some women's societies performed ceremonies designed to make crops prosper or lure bison herds, while others provided blessings for hunters and warriors. Women's societies also performed important roles in the Sun Dance and Scalp Dance. The most respected women were those who had received powerful visions and were acknowledged as shamans. Blessed with great healing abilities, these holy women often led ceremonial dances and purification rituals, and played key roles in the Sun Dance.

The Warrior Culture

In Northwestern Plains cultures men were hunters and warriors. Skilled hunters were able to provide for their extended families, and their generosity in distributing meat to the whole community was a recognized quality of a good leader. Even so, it was a man's success as a warrior that conferred the greatest status and respect upon an individual. Acquiring status involved a complex system of graded war honors, called coups, which were counted on the enemy during raids and battles. With war honors came membership in warriors' societies, wealth in horses, and eventually leadership in the community.

War colored nearly every aspect of Plains Indian life. Observers noted this preoccupation with warfare, from the first outside contacts with these people to the last horse raids of the 1880s. A warrior's training began at an early age, when boyhood play was designed to develop archery skills and speed and stamina for combat. Young boys also played many games involving mock combat, counting coup on meat-drying racks, or capturing green corn "horses" from fields guarded by their mothers and aunts. By his early teens, a boy had already participated in several hunts, allowing him to sharpen his skills with stalking and weapons, and soon thereafter, teenage boys undertook their vision quest.

Armed with their medicine power, young men went on their first war party, thereby embarking on a career of obtaining war honors. Although coups were ranked according to their relative difficulty, the ranking had little to do with the economic value of the deed, but rather depended upon its degree of danger. For instance, being the first to touch an opponent—whether alive or dead—was of greater note than to kill him. The highest honor may not have belonged to the person who shot an enemy, but rather to a bystander who raced to the dead body and touched it first. Some groups credited three and even four levels of coup to warriors touching the same fallen enemy one after another. Stealing a herd of horses brought less acclaim than taking a single prize horse from directly in

front of an enemy's tipi. A man who dismounted, approached his foe on foot, and snatched away his weapon was credited with the highest honor, even if his foe escaped to fight again another day. Even striking a woman or child was equivalent to fighting an enemy warrior.

To establish their war records, young warriors frequently set out on small-scale raids to enemy camps. Generally led by respected warriors, such parties consisted mostly of young men eager to improve their status and make names for themselves. In addition to counting coup, these raids were designed to capture weapons, medicine bundles, ceremonial objects, and in some cases even slaves. Raiding for horses later became the main focus. Occasionally, large-scale offensives would be mounted against enemies, leading to full-scale battles. These attacks were often motivated by revenge for a series of raids or killings, or by disputes over hunting and trading territories. Although raiding was fairly constant, larger battles were rare; despite the impression of constant war, casualties were relatively low.

To reaffirm war honors, coups were publicly reenacted or recounted at every important dance or ceremony, and images of successful raids were painted on robes, clothing, and tipis. Status was also reflected by leadership roles in military societies, and band chieftainship. Among the Crow, for instance, a man became chief only if he had counted the four main coups: first coup in a fight, stealing a horse picketed at its owner's tipi, taking away an opponent's weapon in hand-to-hand combat, and leading a successful war party. Wealth in horses and other captured objects was also important for maintaining status, as these could be given away as a sign of generosity. Finally, success in war was proof of a warrior's medicine power.

Although the primary motivation for raids and warfare was status, economic considerations also came into play. Captured battle axes, guns, powder, and ammunition were in high demand, and captured horses were an important medium for trade. Raiding was the main way to accumulate wealth in horses, which could be exchanged for many goods with neighboring groups. Large horse herds also enabled a man to kill more bison and support several wives, who processed the hides into robes for exchange at trading posts.

Art and decoration were also heavily influenced by war. Decorated shields, war shirts, and bundles represented the medicine that guaranteed a man's safety in war, and these were ornamented with enemy scalps and war trophies. Paintings celebrating a warrior's exploits also decorated his clothing, tools, and tipi, and these records also appear in an impressive body of rock art across the Northwestern Plains. Rock art war records at sacred locations reinforced the relationship of war honors to medicine powers.

The roots of Northwestern Plains warfare reach far back into history. Rock art made for at least the last thousand years shows warriors and their weapons, often composed in combat and battle scenes. Along the Missouri River as early as A.D. 1000, farming villages required stockadelike forts for defense against marauding nomads. Archaeological evidence from the Crow Creek village site in South Dakota shows that sometime shortly before 1400, nearly five hundred individuals were killed in an attack; many victims were scalped and mutilated, and some even showed earlier projectile-point and scalping wounds that had healed prior to death.

Warfare increased both in intensity and frequency during the Historic period due to the introduction of the horse and gun and the movement of more tribes into the region. Raiding quickly became the primary way to obtain horses, and expeditions in the early days ranged all the way to Mexico to capture animals. With horses, warfare and raids could be waged against more distant foes. Possession of horses also shifted the balance of power on

the Northwestern Plains in the early to middle 1700s (Map 2.1). After acquiring the animals from their Ute kinsmen, who were in contact with the Spanish *rancherías* in the southwest, the Plains Shoshone quickly became a military power and dominated much of the region for nearly two decades. Introduction of the gun, obtained from French, British, and American traders to the east, shifted the power back to groups such as the Blackfeet, Cheyenne, Sioux, and Crow.

By the late 1700s all the Plains groups had horses and guns and were actively involved in raiding and trading for more. During the next century, the Plains Indians developed a well-deserved reputation for their bravery and military skills. Ultimately, these abilities were proven necessary while fighting a lengthy war of resistance against the U.S. Cavalry—a war that flared sporadically from Texas to Montana for nearly thirty years.

Resistance and Renewal

The early Historic period saw the florescence of Plains Indian equestrian culture. With the permanent arrival of Europeans, however, this quickly began to change. Devastating epidemics of smallpox and other diseases swept through villages and camps, sometimes annihilating an entire band. The robe trade put heavy pressure on resources, eventually resulting in the near extinction of the bison. As more and more Euro-Americans entered the area, governments and Native peoples alike recognized that treaties were necessary, but for very different reasons. Governments desired the orderly and peaceful settlement of the western territories, while Indians saw the need to prevent the destruction of their way of life.

By the 1850s, the United States government had initiated the first treaties, but almost as soon as they were signed they were broken as miners and settlers swarmed into the West. In the United States, this led to a lengthy period of resistance and conflict, culminating in the

Battle of the Little Bighorn in 1876 and Chief Joseph's retreat a year later. In Canada, whisky traders and wolfers were involved in several minor skirmishes as well as the Cypress Hills Massacre of 1873, events which precipitated the formation of the North-West Mounted Police. The Mounties largely preceded settlement in the Canadian West, and their maintenance of law and order lessened the conflict in comparison to that in the United States. Nonetheless, the end result was much the same north and south of the border, and in both countries, most tribes had signed treaties by the 1870s, which set aside reservations and reserves (Map 5.1).

For a few years, Plains Indians attempted to carry on as before, but by the early 1880s the nomadic bison hunting culture had come to an end. The bison were nearly exterminated by a combination of Euro-American and Native hide hunters, and faced with starvation the tribes were confined to reservations following a quarter century of Indian wars. The late 1880s saw several last-ditch, and ultimately futile, attempts at resistance. The brief 1885 North-West Rebellion in Canada pitted several bands of Plains Cree and Metis against the combined forces of several Canadian militias and the Mounties, while the Ghost Dance revitalization movement across the western United States culminated in the Wounded Knee Massacre in late 1890.

The next decades saw the gradual decline of traditional Plains cultures and traditions, as the tribes increasingly came under the influence and control of missionaries and government officials. In place of the bison, cattle now grazed over much of the area, Euro-American settlement was booming, and lumbering, mining, railroading, and farming operations were beginning throughout the region. Cities and towns had grown up from the forts and mining camps that only fifty years before had replaced tipi camps and earthlodge villages. Although many groups attempted farming and ranching, their efforts

were often hampered by government meddling and racism. Many of the old traditions were lost as the elders passed away, and poverty and social problems became widespread. Children were often taken away from their families and communities and sent to boarding schools, where they were taught how to become more like white men and punished for speaking their own language. For a period, even the Sun Dance—once the central focus of Plains culture—was banned by the government.

In the early 1900s, anthropologists predicted the imminent death of Plains cultures, and they set about recording the traditions of the people before they were lost. Against overwhelming odds, however, Plains cultures have survived. Over the last several decades, Native groups have undergone revitalization, becoming more politically active, and taking greater control of their education and health. There is a renewed interest in traditional activities and values. With this renewal has come a resurgence of interest in artistic expression and spirituality, and rock art sites and sacred landscapes have once again become an important part of Plains culture. Rock art remains an enduring legacy of the history and culture of a living people.

War Bridles and Otter Bundles

Interpreting rock art requires a detailed familiarity with Plains Indian cultures. The careful study of ethnographic sources helps us identify the items depicted by the images and understand their significance in Plains culture.

In the Biographic rock art tradition, for instance, every detail counts; each image and element forms an integral part of the story. Most of the symbols represent real things, and most were readily identifiable to those living in the cultures that produced them. These pictorial details create a vocabulary of images that can be combined and organized into stories. The case of "war bridles" exemplifies

the value of careful reading of the ethnographic record.

At several Biographic rock art sites, horses are shown with three distinct varieties of decorated halters. The most common type consists of straight or wavy lines hanging from the lower jaw. Another type shows a ladderlike design dangling below the horse's jaw. A third type is represented by a comblike design, hanging below or suspended in front of the horse's nose (fig. 5.1). They were all once believed to represent scalps hung from a bridle, and the most common type probably does show war trophy scalps. Careful ethno-

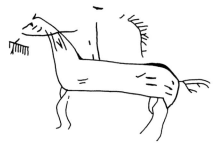

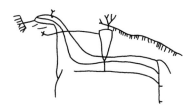

5.1 The objects hanging from the horses' noses in these Writing-on-Stone petroglyphs represent a special horse-medicine bundle used by the Blackfeet.

graphic research, however, reveals that the second type is a chain mail bit traded from the Spanish Southwest. The third type is a distinctive object with a very different significance (Keyser 1991).

In an early article about Blackfeet medicine bundles, Wissler (1912) illustrated a unique "war bridle." Consisting of feathers and small bags of horse medicine hanging from a beaded, leather-covered stick, this bundle hung from the bit or bridle of a war horse. Named literally "a thing to tie on the halter," the war bridle was part of a "Horse Medicine Cult" (Ewers 1955:277–78). According to elderly Blackfeet informants, a war bridle was made by a horse-medicine man and attached to the horse's bridle when the bundle owner went to war. It gave the horse strength, speed, and agility, and protected it from bullets.

Clearly, the third type of decorated rock art halter represents the war bridles described by Wissler and Ewers. Recognizing this detail increases our understanding of the images' meaning, as the war bridle bundle documents how medicine power gives status to a warrior. This war bridle image also allows us to identify Blackfeet rock art, since no other group commonly used a similar object.

Another example of how ethnography improves our understanding of Biographic rock art involves "war medicine bundles." Blackfeet war party leaders would often attach an animal skin (weasel, otter, beaver, wolf) to their clothing before taking part in a raid. These skin bundles represented the warrior's medicine power, which protected him and gave him courage. Only those with a powerful vision could wear such a bundle, and owning one brought with it the authority and prestige to lead war parties.

On several Blackfeet hide paintings, war medicine bundles are drawn as animal skins attached or adjacent to a warrior's body (fig. 5.2). On one robe, dating to the late 1800s, a warrior is shown six times wearing a weasel or

otter skin on his back. From ethnographic information, we know that the scenes represent the war record of a prominent warrior. The bundle documents his strong medicine power and indicates his leadership of six war parties (Brownstone 1993).

Some of the mounted warrior scenes on this painted robe bear such a remarkable likeness to a similar petroglyph at Writing-on-Stone (fig. 5.2) that the same artist may have

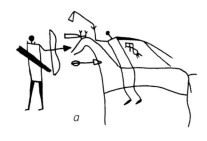

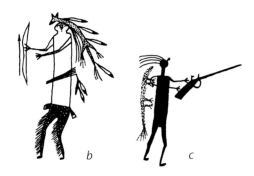

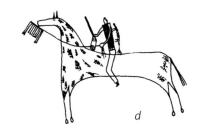

5.2 Animal-skin medicine bundles painted in robe art help us identify a similar design associated with a mounted warrior at Writing-on-Stone (a); b, Sioux robe dating about 1820; c, North Blackfoot robe dating from late 1800s; d, Blackfeet robe painted in 1892.

drawn both. Careful inspection of the rock art scene reveals a small object carved behind the back of the mounted warrior—almost certainly representing a war medicine bundle similar to those on the robe. Until recently, researchers had overlooked this small detail, and previous illustrations of the image even left it out.

Identification of this important detail supports the interpretation that this petroglyph records a Blackfeet warrior's coup. It also indicates he was the leader of a war party, protected by the strong medicine power of his guardian spirit. Identification of this one small detail leads to a greatly expanded understanding of the rock art scene as a whole.

Part II / Rock Art Traditions of the Northwestern Plains

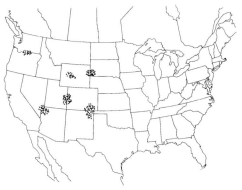

Map 6.1. Early Hunting Tradition Rock Art

above: Regional distribution. Large dots on regional map show extensive site complexes at Whoopup Canyon, Wyoming, and Red Canyon, South Dakota.

below: Continental distribution.

6 / Early Hunting Tradition

Carefully pecked into the dark sandstone cliffs across the southern third of the region, the petroglyphs of the Early Hunting tradition represent the most ancient examples of Northwestern Plains rock art. The oldest may date to just after the arrival of the area's first inhabitants, although these early dates are preliminary. Even so, most Early Hunting petroglyphs can be securely dated to the Archaic period. Primarily showing detailed

communal big game hunting scenes, these rock art panels likely served to instruct young men in the practice of the hunt (fig. 6.1).

Early Hunting rock art is distributed across a relatively limited area of the region. The largest concentration of Early Hunting tradition sites occurs in Whoopup Canyon, located in east-central Wyoming, where more than 100 separate panels are recorded. Major sites are found at Dinwoody, Legend Rock, Twin Creek, and Beaver Creek in the Wind River and Bighorn basins of west-central Wyoming. Other sites are found in the southern Black Hills of South Dakota.

Early Hunting tradition rock art consists entirely of pecked petroglyphs. Parts of these figures were directly hammered out with a hand-held stone, while details such as legs, hooves, and antlers were made by indirect percussion, using a hammerstone to strike a smaller, carefully placed chisel (fig. 6.2). Originally they were pecked on

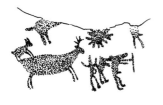

6.1 *Large hunting scene composition. Note loop-line at center and row of three "dancers" with snout masks, upper left.*

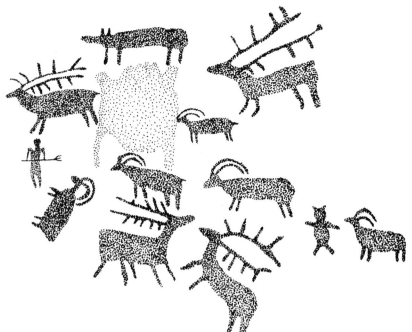

6.2 This site near Lander, Wyoming, shows pecked elk and mountain sheep superimposed by a Dinwoody tradition figure. Indirect percussion was likely used to make horns, antlers, and the hunter's three-pronged spear.

massive sandstone cliffs that flank small stream valleys and dry canyons throughout the region. Pecked through the red-brown or black desert varnish coating these cliffs, the images, originally much lighter than the unmarked surface, would have formed impressive galleries of highly visible rock art in these small, isolated canyons. Over time, desert varnish re-coated them, and many are now so faint and heavily patinated that they can only be seen under optimum lighting conditions. After centuries of erosion, some panels are now located up to 30 feet (10 m) above the present ground surface.

Previous Research

Early Hunting tradition sites were first recognized by archaeologists before World War II. Renaud (1936) and Over (1941) both noted some Whoopup Canyon sites, and

Renaud also found one site at Twin Creek. In his photographic record of the better-known Dinwoody petroglyphs, Sowers (1939) also recorded some Early Hunting sites. In the decade immediately following the war, David Gebhard conducted a pioneering Northwestern Plains rock art research program, visiting and recording numerous sites throughout western Wyoming (fig. 6.3). His publications (Gebhard and Cahn 1950; Gebhard 1951) represent a pivotal effort to define rock art styles and establish their chronological relationships.

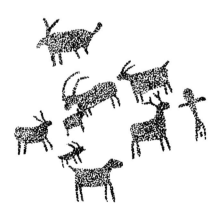

6.3 Early Hunting tradition site from the Dinwoody area of western Wyoming.

Using superimpositioning and differences in weathering, patination, and subject matter, Gebhard concluded that the petroglyphs he termed Early Hunting style were the oldest in the sequence at Dinwoody, predating both his Dinwoody style and later Plains or Late Hunting style. Although his chronology was notably foreshortened (as were most rock art chronologies before the advent of more precise dating in the 1980s), Gebhard's work paved the way for recognizing that Northwestern Plains rock art might have significant depth in time.

Some thirty years after Gebhard's initial research, Linea Sundstrom (1981, 1984, 1989, 1990, 1993) completed the first comprehensive recording of parts of Whoopup Canyon. In addition, she recorded fifteen South Dakota sites with rock art she named the Pecked Realistic style, but these petroglyphs appear to be a local variant of the Early Hunting tradition. At the same time, Gebhard (Gebhard et al. 1987) undertook a more extensive recording of thirty-three locations in Whoopup Canyon. Following these efforts, Tratebas (1993) began a comprehensive multiyear research program aimed at completely recording the rock art in Whoopup Canyon and dating it by means of the rock varnish found on many sites.

As yet only partially reported, Tratebas's research has provided evidence of the earliest dates for Northwestern Plains rock art, and it also suggests that the Early Hunting tradition is one of the longest-lived rock art traditions in western North America. Her work also identified several related but distinctive "patterns" or styles within the Early Hunting tradition, and several of these stylistic indicators are also present at the Wind River basin sites. Further research in the Black Hills, Yellowstone River drainage, and western Wyoming will undoubtedly locate additional sites and clarify the relationships among the styles identified by Tratebas.

The Rock Art

Descriptions of the Early Hunting tradition are incomplete because a large body of data for Whoopup Canyon (e.g., Gebhard et al. 1987; Tratebas 1993) is not readily available, and many of the western Wyoming sites have never been professionally recorded. The

These pecked deer, elk, and humans at Whoopup Canyon, Wyoming, are composed in scenes typical of the Early Hunting Tradition. Chalking not done by photographer; several figures not chalked are difficult to see.

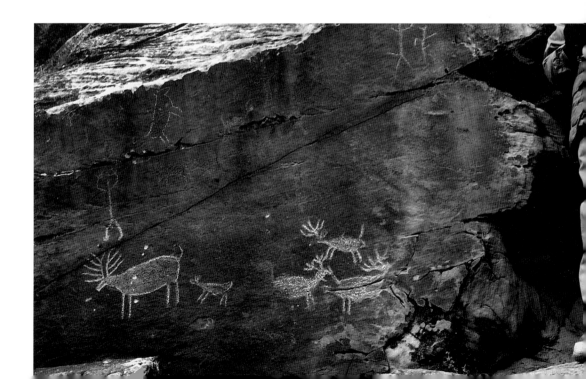

following basic descriptions and general trends for this tradition are based on both personal observations and available data.

Early Hunting tradition rock art consists predominantly of animal images, with fewer human figures and hunting paraphernalia. This subject matter is generally composed into elaborate hunting scenes. A great deal of formal variation exists in the Early Hunting tradition, and Tratebas (1993) has suggested that some of this variation may indicate the presence of several temporally or functionally separated styles (see below, Dating and Chronology).

Animal Figures

Between 70 and 80 percent of identifiable Early Hunting tradition petroglyphs show animal figures of at least ten different species: elk, deer, pronghorn antelope, mountain sheep, bison, rabbits, dogs, cougars, turtles, and snakes (fig. 6.4). Based on the partial records available from most sites, significant differences in the relative numbers of these species at Black Hills sites and Wind River Basin sites are apparent. In the Black Hills, antlered deer and elk greatly outnumber any other species. If figures lacking horns or antlers are also included (since deer and elk are the only large ungulates common to the region whose females and nonrutting males lack horns), then deer and elk account for almost two-thirds of all animals. Antelope and bison appear in far lesser numbers. Only four mountain sheep are recorded; even fewer turtles and rabbits occur; and only a single snake is depicted. Thirteen cougars and six dogs are also known (fig. 6.4). In the Wind River Basin sites, the ratio of animal species is quite different. Mountain sheep account for more than half of the depicted animals, while deer or elk with or without antlers account for less than 45 percent. Five dogs and one possible cougar are shown (fig. 6.2).

Although Early Hunting tradition animals are generally quite similar in form, they show a wide range of variation in specific details. Two different antler styles may depict elk (main beams with side tines) and deer (simple branching antlers), but this remains unproved. Some animals have ball-shaped hooves, while others have small, inverted, V-shaped cloven hooves. In addition to antlers, some cloven-hoofed animals are shown with open mouths, dewclaws, and ears. Although these types of animals were defined for Whoopup Canyon sites, they also occur at Black Hills sites. Ball-shaped feet and bent legs on some examples at Wind River Basin sites also suggest that these types occur in that area (fig. 6.5).

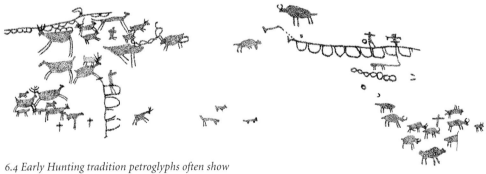

6.4 Early Hunting tradition petroglyphs often show animal herds associated with loop-lines, which appear to represent corrals, fences, or nets. Long-tailed animals in lower center are probably cougars; game animals include deer at left and bison at right.

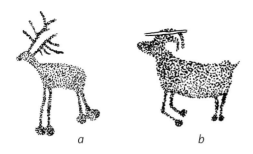

6.5 *"Ball feet" animals, like the elk (a), are an early style of the Early Hunting tradition at Whoopup Canyon in the Black Hills. The "ball feet" mountain sheep (b), pecked at a site near Lander, Wyoming, suggests that this early style may be regionwide.*

Early Hunting tradition animals often show movement, and differences in postures and leg positions probably represent running or leaping animals. Outstretched or bent legs and open mouths indicate running animals, while those in postures oriented at a significant angle upward from horizontal seem to be jumping or leaping. Some mountain sheep are shown nearly 90 degrees from horizontal, a realistic illustration of how well these animals negotiate steep cliffs and talus slopes.

Human Figures

Human figures occur far less frequently than animals, comprising fewer than 20 percent of all identifiable figures. Simple and unelaborated, they include round-body, oval-body, and stick figures. Some appear in profile; others are frontal. Most have relatively realistic proportions except that torsos are often unnaturally elongated. Both male and slightly more round-bodied female figures are shown. Some males are phallic, and others are assumed to be male because they are shown spearing game animals.

Many human figures hold weapons or hunting tools (fig. 6.2), while a few may be

wearing masks or headdresses, but many are unadorned and without elaboration. The majority are depicted in static poses, but a few seem to be animated as if running or dancing. Frequently humans are apparently engaged in hunting or ceremonial activities (fig. 6.3). Most common are figures shown driving or killing animals.

Material Culture

The material culture depicted in this tradition includes a variety of hunting tools, such as weapons, goads (herding sticks) or noisemakers, and loop-lines (fig. 6.4). Most tools are held or used by humans in hunting scenes, although a few are shown as isolated items or protruding from wounded animals. Hunting weapons include thrusting spears, staffs (which may be spears held at rest), atlatls, and curved sticks. One hunter at the Twin Creek site holds a tridentlike spear, suggesting that it may have been a specialized type of weapon (fig. 6.2). Atlatls show single finger loops and outsized oval or circular weights. Curved objects may represent throwing sticks or simple atlatl depictions.

Simple spiral-shaped objects held aloft or in front of humans may represent goads; humans appear to reach out and touch animals with them. They may represent some sort of whip or flail used to move animals into a trap, or perhaps noisemakers designed to frighten the animals into an ambush.

Loop-lines, restricted to a few sites in the Black Hills area, are long horizontal or vertical

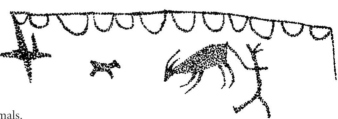

6.6 *Hunter and dog attack an animal at a loop-line net or fence strung between poles.*

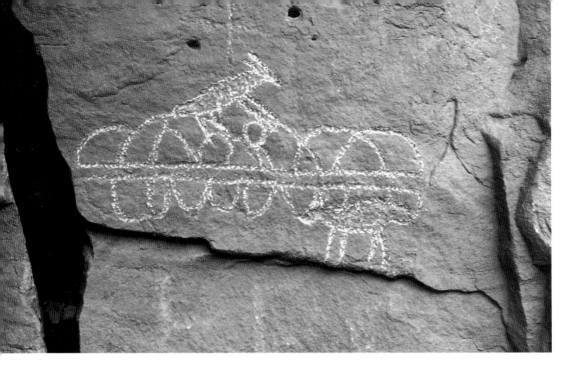

Animals caught in a loop-line net or corral at Whoopup Canyon, Wyoming. Chalking not done by photographer.

lines with semicircular loops along one side (fig. 6.4). Occasionally they are arranged in rectilinear or V shapes, suggesting corrals or drive lanes. Sometimes animals appear to be entangled in the loop-lines, as if caught in a net. Supporting this identification are drawings of one loop-line strung on poles and another showing two humans apparently stringing up or releasing a loop-line net (fig.

6.6). Loop-lines occur only with deer and antelope in the latest Early Hunting tradition styles. Since the motif is not found elsewhere, it may represent a localized elaboration within the broader artistic tradition.

Compositional Arrangements

Most animals are composed in loosely structured herds that include males, females, and juveniles of the same species, or groups of several different species (fig. 6.7). Occasionally animals are arranged as if walking single file,

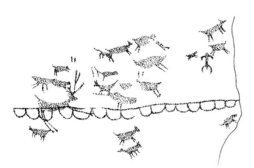

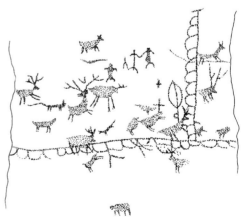

6.7 Early Hunting tradition scene composed of males, females, and juvenile animals. Hunters and loop-line fences also appear. Note atlatl on back of large buck deer in fence corner, lower right.

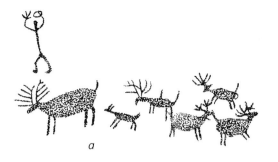
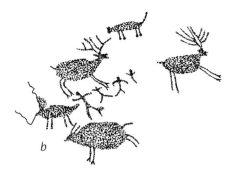

a

b

6.8 Hunters brandishing weapons, goads, or other items often run among the animals. Note cougar at top of scene (b).

and a very few exist as single, isolated figures. Early Hunting tradition animal herds at several Dinwoody sites show a marked preference for groupings of six or nine animals, but this trend has not been observed at other sites. Some groups of animals show evidence of more than one episode of petroglyph manufacture, as if a later artist added one or more figures to the panels. Certain panels clearly show several herds with differing degrees of weathering, indicating they were made at different times. In other instances, it appears that a later artist repecked a preexisting glyph to freshen its appearance. Often the former figure can be seen underlying the newer one—especially where the new pecking did not exactly follow the original figure.

Humans are often associated with animal herds in what appear to be hunting scenes. On several panels, hunters attack game animals with long spears, tridents, atlatls, and unidentified hoop-shaped and curved implements, or appear to prod them with spiral-shaped goads. In several scenes, unarmed humans stand or run among or alongside the animals just as drivers do to move game into a trap or toward waiting hunters (fig. 6.8). Sometimes these humans have upraised arms with outsized hands that show an uncanny resemblance to the antlers

of the deer on these panels. On some panels, dogs are also associated with the herds, as if they were pursuing the moving animals. On several panels, cougars are found slightly peripheral to the herds or hunting scene.

Some humans are composed in scenes that appear to represent ceremonial activities. These scenes generally show a row of phallic men wearing masks, horned headdresses or elaborate fringed costumes, and holding staffs. Two Black Hills sites include groups of three and four men costumed with "snout-headed" masks and holding long vertical staffs in front of them (fig. 6.1). Another group shows four men, each wearing a different mask or headdress, following a leader who holds curved sticks like those used by some hunters. Each man in all three groups is drawn with an erect penis. Individual humans dressed in fringed costumes include oval-bodied figures with a bird head or snout mask and a fringed or feathered skirt. In several instances, these

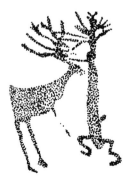

6.9 This dancing human locking antlers with a deer may portray a shamanic ritual.

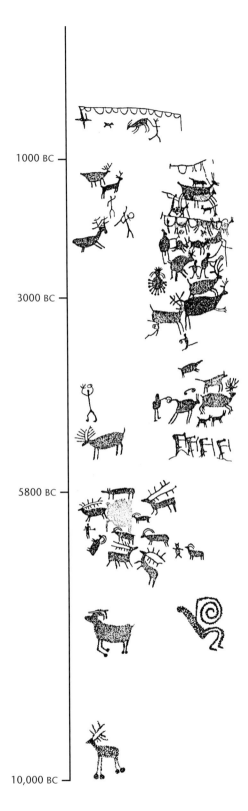

1000 BC

3000 BC

5800 BC

10,000 BC

6.10 Early Hunting Tradition General Chronology

costumed individuals are located just peripheral to a hunting scene. Although not yet fully recorded, similar groups of figures at the Twin Creek and Beaver Creek sites in the southern Wind River Basin may also represent dancers or ritual participants.

One intriguing ceremonial composition shows a tall human figure with an antler headdress whose curved legs suggest dancing or running (fig. 6.9). Although weathered, the figure appears to be locking antlers with a deer with conspicuously humanoid feet.

Dating and Chronology

Early Hunting tradition rock art on the Northwestern Plains is dated to the Archaic period (5800 to 500 B.C.) and it may even extend as far back as the Paleoindian Period (before 5800 B.C.) (fig. 6.10). Initially, Gebhard (Gebhard and Cahn 1950, 1954; Gebhard 1969), using a series of superimposed images and differences in weathering and patination, determined that this Early Hunting style was the oldest of three superimposed styles at the Dinwoody and Boysen Reservoir sites in the Wind River Basin (fig. 6.11). Although he felt (erroneously) that the overlying Dinwoody tradition was of Protohistoric age, he made no guess as to the actual age of the Early Hunting images. In her work in the Black Hills, Sundstrom (1981, 1984, 1990) used super-impositioning, relative weathering of sites, differences in patination, and characteristic weaponry to reach a similar conclusion. She placed the Early Hunting petroglyphs (her Pecked Realistic style) as the earliest in a relative chronology for the Black Hills. Unlike Gebhard, she inferred that the style dated to the Late Archaic period, predating A.D. 500, based on the presence of atlatls and spears and the absence of the bow and arrow (fig. 6.12).

With the advent of rock varnish dating techniques, Early Hunting tradition sites have been dated at Legend Rock, Whoopup Canyon, and the Black Rock site in southwest-

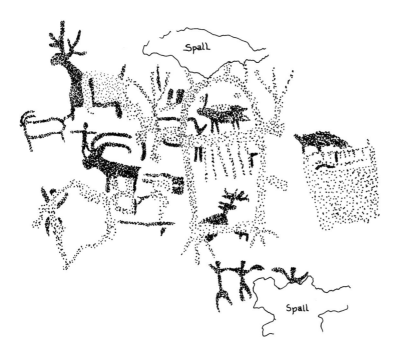

6.11 *An Early Hunting tradition panel at Dinwoody Lake is superimposed by a large Dinwoody tradition figure.*

ern Wyoming. At Legend Rock, Francis (1994) dated three separate animal figures that are similar to Early Hunting tradition motifs, using radiocarbon and cation ratio methods. She specifically selected these figures because they appeared to be the oldest, most varnished examples at the site. The four dates obtained for these figures range from 4055 to 3250 B.C. Although Francis argues that these are part of the Dinwoody tradition, her analysis does not account for the superimposition of Dinwoody figures over one of them, or the apparent gap of about 2000 years between these animals and the typical Dinwoody figures. Another outline animal and a human figure stylistically similar to the Early Hunting tradition at Legend Rock were dated to 1100 years ago, with the animal dated by AMS radiocarbon dating and the human by cation ratio method (Dorn 1995).

At Whoopup Canyon, Tratebas (1993) obtained a series of eleven radiocarbon and thirty-four cation ratio dates on panels containing Early Hunting tradition designs. Ranging from slightly more than 11,000 to about 2,400 years ago (9000 to 500 B.C.),

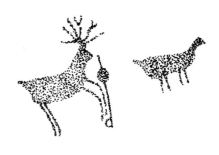

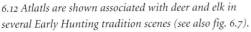

6.12 *Atlatls are shown associated with deer and elk in several Early Hunting tradition scenes (see also fig. 6.7).*

these dates provide tantalizing but controversial evidence that this Northwestern Plains rock art may have been made by Paleoindian people. Two of the radiocarbon and six of the cation ratio dates at Whoopup Canyon predate 7000 B.C., suggesting that this rock art tradition began in Paleoindian times. At the Black Rock site, a pecked panel of mountain sheep and elk figures was AMS dated to 11,500 years ago (Tratebas 1997).

The varnish dates for the Early Hunting tradition are the least well supported of any such dates on the Northwestern Plains. Moreover, the Whoopup Canyon dates have never been published or analyzed, and they are known only from the summary article by Tratebas (1993). The Legend Rock dates are well reported, but they were interpreted by the investigator to represent Dinwoody tradition rock art, despite a 2,000-year gap between them and the closest dates on indisputable Dinwoody motifs (Francis et al. 1993; Francis 1994). Although differences in varnish accumulation, weathering, and erosion, as well as superimpositioning at several sites, clearly show a relative chronology at Whoopup Canyon and Legend Rock with Early Hunting motifs as the oldest of several traditions, the early AMS dates themselves have very little independent support.

The only direct support for the validity of these very early dates is provided by an AMS radiocarbon date on a pecked outline bison at Legend Rock, and a stylistic analysis of the dated motifs at Whoopup Canyon. For the oldest dated figure at Legend Rock the authors note plentiful datable organic material and especially well-preserved charcoal (Francis et al. 1993), probably from a prehistoric artist filling the pecked bison outline with raw charcoal or a charcoal-based paint. The material was so plentiful that two dates could be obtained from the same sample, and microscopic examination indicated that any source of contamination was very unlikely. The two dates from this figure seem as

trustworthy as reasonably possible, and they fall between 5000 and 4500 B.C. At Whoopup Canyon, both the AMS radiocarbon dates and cation ratio dates are internally consistent and reflect independently derived stylistic differences in types of images. Thus, all dated examples of animals with ball feet are older than all cloven hoofed animals, even though the dates indicate that both span a relatively long period. A similar though less distinct stylistic difference is noted for the two main ways of showing humans (Tratebas 1993).

In particular, Tratebas's work shows that Early Hunting petroglyphs in Whoopup Canyon represent a series of five temporally distinguishable styles. The oldest shows left-facing, straight-legged, somewhat static elk with ball-shaped hooves; they are associated with stick humans whose upraised arms have outsized hands. The next style, characterized by leaping right-facing mountain sheep pursued by dogs, overlaps somewhat with the first style, and lasts considerably later (possibly terminating about 3000 B.C.). A third style, occurring contemporaneously with the sheep-hunting depictions, focuses on oval-body human figures shown in profile. Some of these humans are poorly integrated into deer-hunting scenes, while others show groups of humans participating in dances or shamanic initiations.

The final two styles are contemporaneous, but overlap only slightly with the mountain

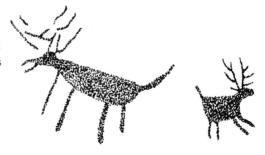

6.13 Elk are common in Early Hunting tradition sites. One style often is shown with an open mouth, like the animal at left.

sheep hunting and oval-body human styles. These latest styles show round-body humans well integrated into active hunting scenes composed almost exclusively of right-facing running deer pursued by hunters with dogs. Loop-lines occur as major components of both styles, and juvenile animals are included in herd scenes. These styles are also distinguished by the more elaborate anatomical details (cloven hooves, dewclaws, open mouths) shown on animals (figs. 6.8, 6.13). These final two styles are tentatively dated by AMS radiocarbon calibration from about 4000 to 500 B.C.

The styles described above show a gradual evolution within this tradition, at least at Whoopup Canyon sites, and no major gaps exist in the long chronology. The significance of the different styles within this long-lasting rock art tradition is not yet clear, nor is it obvious how other Black Hills sites or those in west-central Wyoming relate to these styles. A cursory examination of South Dakota panels shows figures that seem to fit two or three different Whoopup styles, and animals at some Wind River Basin sites also show similar ball feet and leg postures.

Two elk at Legend Rock, in west-central Wyoming, are classic Early Hunting tradition images. (Courtesy of Jim Stewart)

Distribution and Regional Relationships

About fifty Early Hunting tradition rock art sites have been recorded, most in the southern and western Black Hills and the Dinwoody area of the Wind River Basin (Map 6.1). The distribution of this tradition is poorly known, however, and important Early Hunting site complexes, such as those at Twin and Beaver creeks in the southern Wind River Basin, are known in the published literature by only two rough sketches and fewer than five photographs (Renaud 1936; Sowers 1940; Gebhard 1951; Hendry 1983). Therefore, it seems likely that many other Early Hunting sites have yet to be discovered or reported.

The records of some amateur researchers and the partial published records of sites at Boysen Reservoir and Legend Rock (Walker and Francis 1989; Walker 1992; Francis 1994) suggest that petroglyphs of this tradition may

be relatively common from west-central Wyoming right across to Whoopup Canyon and the western Black Hills. The distribution of this tradition may even extend northward into the Yellowstone River drainage in Montana.

Beyond the Northwestern Plains, petroglyphs showing big game hunting scenes occur across much of the western United States. Scenes somewhat similar to Early Hunting rock art are recorded from the Great Basin and southern Columbia Plateau, the Colorado Plateau, and on the southern Plains south of Denver (Map 6.1). In the western Great Basin these hunting scenes date as early as the Archaic Period, and the oldest show herds of mountain sheep and deer associated with hunting dogs (Grant et al. 1968; Heizer and Baumhoff 1962). Some Archaic period Columbia River petroglyphs also show hunters attacking herds of mountain sheep or deer with spears, atlatls, and hunting dogs (Keyser 1992, 1993). On the Colorado Plateau some Uncompahgre style sites with animal herds and hunters also date to the Archaic (Cole 1990), and finally, on the southwestern Plains of Colorado and northern New Mexico, hunting scenes showing mountain sheep and deer were recorded as some of the oldest rock art in the region (Renaud 1936:28–30). As these examples clearly show, Early Hunting tradition rock art of the Northwestern Plains appears to be part of a widespread pecked hunting scene tradition that occurs throughout most of the arid western United States.

Cultural Affiliations

Determining the identity of the artists responsible for the Archaic period Early Hunting tradition rock art is impossible with current information. Future excavation of some of the archaeological deposits associated with these sites may provide some clues, but even then it will be very difficult to associate the rock art with any single archaeological

entity over a span of possibly 9000 years. Across this part of the Northwestern Plains, more than a dozen archaeological complexes are defined for this time period. The economies of these cultures ranged from big game hunting (including extinct megafauna not pictured in the art) to broad-based foraging (with few communal hunts of the type pictured at these sites). Other groups, such as the McKean complex people, often hunted deer, elk, antelope, and even mountain sheep in what appear to be communal efforts. Some groups of McKean hunters could be responsible for the sites of the later styles in this tradition, but the earliest McKean sites date only to the Middle Archaic period, so they could not have carved the older styles.

Given the significant changes in technology and subsistence and settlement systems, and the likelihood of population movements into and out of this area during the long span of the Early Hunting tradition, it seems likely that members of several groups drew the figures. To assume a 9000-year culture group continuity, even in an area as restricted as the Black Hills, does not fit comfortably with the archaeological record as evidenced in sites so far found there. It seems likely that cultural groups, particular ceremonies, and even specific hunting methods changed during the span of this rock art tradition, but the rock art sites themselves seem to reflect a continuity in basic cultural institutions such as communal hunting and the role of shamans, which apparently changed only very gradually over a long period of time.

Thus, artistic concepts and themes concerning shamanism and communal hunting remained similar throughout the span of the Early Hunting tradition. In this scenario, later artists would have understood the general meaning of the earlier rock art and made new carvings in a slightly different style. Long-term reuse of religious sites in this fashion has been noted in many cultures, and some large rock art sites, such as those at Legend Rock,

California's Coso Range, and along the lower Columbia River seem to show similar traditions of reuse with minor, very gradual change in rock art styles (Grant et al. 1968; Francis 1994; Keyser 1992).

Interpretations

Determining how Early Hunting tradition petroglyphs functioned in the cultures that made them is complicated by the tradition's long time span and the existence of several different component styles. In her early work with Black Hills sites, Sundstrom (1981, 1984) was the first to explicitly propose that Early Hunting tradition rock art functioned as sympathetic hunting magic—made by hunters or special hunt shamans as a part of a ritual to ensure success in the hunt or to propitiate animal spirits afterward (fig. 6.14). At the time, the hunting magic hypothesis had been in vogue for the previous twenty-five years (Heizer and Baumhoff 1962; Grant et al. 1968) and had been applied to rock art across the western United States and even on other continents (including the famous cave paintings of France and Spain). More recently, however, there has been a general trend away from this explanation (see Whitley 1992a, 1992b, 1994a). Moreover, Whitley's (1994a, 1994b) shamanic model, which he has not yet formally applied to hunting-scene rock art outside the southwestern Great Basin, offers an alternative explanation for Early Hunting tradition petroglyphs. Sundstrom (1989, 1990, 1993) has also recently proposed that the art functioned not as sympathetic magic, but rather as a teaching aid in educating young members of a society in the hunting practices, traditions, and general belief systems of a group.

The case for Early Hunting tradition petroglyphs as sympathetic hunting magic stems from the unpredictable nature of hunting and the animistic basis for the religion of many pre-literate peoples. Prehistoric hunting was at best a chancy pursuit, and therefore hunters may have resorted to various ritual behaviors in attempting to control game animals and increase their hunting success. The concept of animism, which attributes a soul or spirit to all animate things, also characterizes many traditional Plains Indian religions; offerings or prayers to animal spirits by hunters both before and after hunts are widely recorded ethnographically (Hann et al. 2000). Some groups even had hunt shamans—religious practitioners who had acquired power over animals and were able to control them in communal hunting activities. The best documented of these were the antelope shaman of the various Great Basin Shoshone groups, and the Buffalo Runner from several Plains cultures, who had the ability to lead the bison herd into a corral or over a cliff. In this context, rock art may have been made as part of ritual hunting magic.

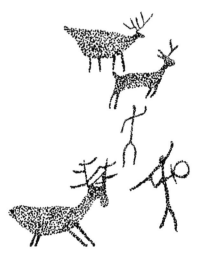

6.14 *Hunters often interact directly with animals in Early Hunting tradition compositions.*

There is some archaeological support for the hunting magic hypothesis at certain Great Basin sites, where rock art occurs at locations optimally suited for trapping game or ambushing it along well-used trails; some sites have associated rock structures thought to be hunting blinds or parts of trapping complexes. On the Northwestern Plains, however, no such association between rock art and hunting sites has been regularly noted, although archaeologists have identified a variety of structural remains and practices best explained as the result of rituals designed to ensure hunting success.

While some western North American rock art was very likely made by hunters using sympathetic magic to bring about hunting success or placate animal spirits, strong support for Early Hunting tradition rock art as primarily hunting magic does not exist. Most Early Hunting sites are located in possible hunting areas, but independent evidence (such as hunting blinds or associated kill and butchering sites) suggesting that these locations actually functioned as communal kill sites has not been identified, and many of these rock art sites would not be especially good killsites. The emphasis on big game (elk, deer, antelope, and mountain sheep) might suggest hunting magic, but in fact very few animals are shown wounded, and in some scenes a few figures are shown apparently escaping the hunters.

The realism and care with which these images are executed, and the overall details of the action, are also inconsistent with what would be expected in images made for sympathetic magic. In such art, the actual production and manipulation of the image, rather than the image itself (which may be crude and exaggerated), is most crucial to the desired result. Finally, the numerous depictions of tools and structures (goads, loop-lines) not directly related to the actual act of killing, and several panels that show activities other than hunting (dances, rituals),

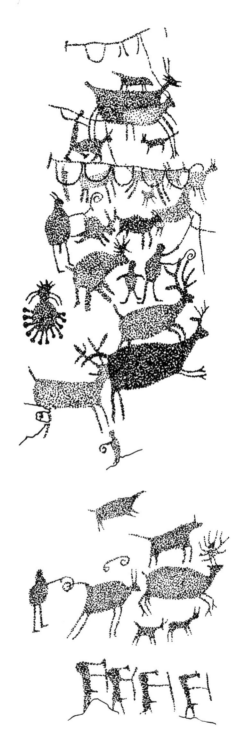

6.15 *This complex scene in Whoopup Canyon shows four figures using spiral-shaped "goads" and a hunter spearing an animal caught in the topmost loop-line. The row of four snouted figures at bottom may represent ritual dancers.*

suggest that there was far more to the ritual function of this art than mere sympathetic magic (fig. 6.15).

In response to various aspects of Great Basin rock art that did not seem to fit the prevailing hunting magic hypothesis, Whitley (1992a, 1992b, 1994b) has made a convincing case that Coso Range petroglyphs, including a number of mountain sheep hunting scenes, are in fact expressions of the acquisition of power by Shoshone rain shamans through vision quest experiences. He uses an extensive ethnographic record and neuropsychological models of trance experiences to suggest that shamans carved these petroglyphs as metaphors for their power. Although Whitley has not directly suggested that this explanation could account for Early Hunting tradition petroglyphs, it seems logical to explore this possibility. Of course, our first observation would be that these Early Hunting petroglyphs have no relationship to any ethnographically known group. In fact, their manufacture appears to have been discontinued long before ethnographically known groups in the Black Hills area moved into the region after A.D. 1500. Furthermore, no good evidence suggests that the groups who carved these scenes were in any way related to ethnographically known Great Basin or Columbia Plateau groups who carved generally similar petroglyphs until historic times. Thus, interpretations based on ethnographic analogy are very weak, and our comparison must be limited to formal and structural similarities between the Coso Range and the Early Hunting tradition petroglyphs.

Unfortunately, despite Sundstrom's (1981, 1984) initial suggestion, the petroglyphs of the two areas are not particularly similar. In general, Coso petroglyphs are not focused on animal herd hunting scenes. Instead, the great majority of Coso mountain sheep appear to have been made as individual figures at different times and presumably by different artists. These figures are often very large (some even larger than life size) and sometimes the

concept of the mountain sheep is simply expressed by a stylized front-view mountain sheep horn design that is often shown in recurrent sequences. Any actual hunting scenes tend to be schematic sketches showing a hunter and one or two bighorn sheep, or a sheep attacked by one or two dogs, rather than large, structured compositions. Furthermore, the dominant anthropomorphic form is not a hunter, but an outsized, patterned body figure that appears to represent a shaman in costume. Other motifs found commonly at Coso sites but either rarely or never at Early Hunting tradition sites include medicine bags, humans shooting one another, freestanding atlatls, projectile point drawings, oval and circular patterned "shield" designs, and a large group of various circular and curvilinear abstracts. Finally, superimposition of sheep, medicine bags, and patterned body shaman figures in various combinations characterizes the Coso sites (Wellmann 1979b), but this occurs only rarely at Early Hunting tradition sites. The only truly notable similarity is the occurrence in both traditions of game animals and hunters with weapons.

Several distinctly Coso motifs or artistic structures led Whitley to conclude that Coso rock art is shamanic. Specific items of costume (e.g., quail topknot headdress) and use of the spiral or concentric circle head form are known ethnographically to indicate a shaman, and the concept of "killing a bighorn" is a Shoshone metaphor for a rain shaman's trance. The characteristic abstract and patterned body designs, coupled with the repetition of the mountain sheep horn motif, and the characteristic superimpositioning in Coso art fit very well with the concepts of phosphenes, fragmentation, superimposition, and replication that characterize the neuropsychological model of shamanic art imagery. Early Hunting tradition art lacks the characteristic structural features and the focus on anthropomorphic shaman figures that is so distinctive of Coso rock art. Overall, Early

Hunting tradition rock art exhibits a far different structural pattern than the shamanic art of the Coso Range. If the Northwestern Plains Early Hunting scenes were some sort of metaphor for shamanism, then it was a completely different form than that in the Great Basin, and one for which there is no clear support from either ethnography or the neuropsychological model.

Nonetheless, several aspects of Early Hunting tradition rock art do suggest ritual themes possibly related to shamanism or indoctrination of a society's younger members into the traditions and communal hunting practices of the group. Some depictions can most reasonably be interpreted as shamanic activities. The hands of some humans in the earliest Whoopup Canyon style are remarkably antlerlike, and one scene clearly shows a human with erect phallus and antler headdress dancing with or interlocking antlers with a deer (or another elaborately deer-costumed human; fig. 6.9). These types of scenes suggest

a blending of animal and human identities similar to that which characterizes Plains Indian shamanism. Furthermore, costumed dancers with snout headdresses and arms held out as if to imitate deer legs suggest rituals that may have involved deer-head costumes and dance movements to mimic the game animals (fig. 6.16). Such dances would likely have been led by a hunt shaman. Possible initiation scenes may also represent shaman-led activities related to communal hunting. In some scenes, probable shaman figures also appear in postures or positions that suggest they are exercising control over the animals. One such figure, with outstretched antlerlike hands and dots radiating from his head, stands on the back of one animal, and another elaborately costumed figure appears to be directing a hunt (Tratebas 1993).

Finally, cougars integrated into several scenes are best explained in terms of a symbolic association with hunting (fig. 6.17). Cougars would not normally be involved in hunting activities, either as domesticated helpers (like dogs) or as post-hunt scavengers. However, deer are the preferred prey of cougars. Prehistoric hunters could not have

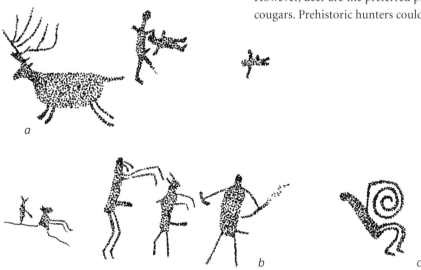

a

b

c

6.16 *Humans engage in a variety of ritual postures in Early Hunting tradition art. Note that the dancers in b have arms like a deer's legs and probably wear masks.*

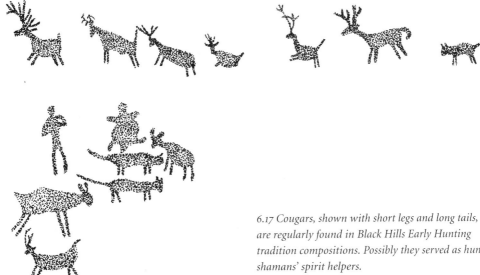

6.17 *Cougars, shown with short legs and long tails, are regularly found in Black Hills Early Hunting tradition compositions. Possibly they served as hunt shamans' spirit helpers.*

found a better natural symbol for deer-hunting prowess than the cougar. Thus it is reasonable to suggest that hunt shamans in the cultures that produced this rock art may well have considered the cougar as a special and powerful guardian spirit, and that the depiction of cougars in these scenes may be a metaphor for the shaman.

Certainly some Early Hunting rock art may relate to hunting shamans and their magic, yet many scenes are highly detailed, with numerous animals, hunters, weapons, loop-lines, and other hunting paraphernalia. If the rock art was merely metaphorical—as in Coso petroglyphs—we would expect more isolated, repeated, and superimposed imagery, and less emphasis on intricate hunting scenes with such realistic detail. In fact, the realism of many of these compositions is so great that they can be readily comprehended by anyone familiar with the process of conducting communal hunts. Finally, relatively small herds are structured to represent nursery herds—just the size and composition ideal for various types of communal hunting. Certainly prehistoric hunters would have recognized which behaviors—both human and animal—the scenes were intended to depict.

Yet the question remains: for what purpose were these realistic—almost narrative—scenes made? Sundstrom (1990) argues persuasively that they were intended as aids in teaching hunting and associated religious concepts to younger generations. The physical location of the sites in accessible areas, rather than hidden away in ritual or secret locations, implies that the rock art was intended for public viewing. Furthermore, the careful, detailed depiction of animal behavior, costumes, and weaponry contrasting to the relatively simply portrayals of those humans actually doing the driving or killing suggests an emphasis not on who, but on the what and how of the action. In this regard, illustrations of different animal species, dances and other rituals, shamans (or cougars) controlling the effort, and escaping animals would all serve as examples of behavior and actions relating to the hunt.

Early Hunting tradition petroglyphs may have been one way in which this cultural knowledge was passed through several hundred generations. These petroglyphs beautifully illustrate the behavior of animals, the actions of hunters, and the powers of shamans—and integrate them into a pictorial instruction manual for the communal hunt.

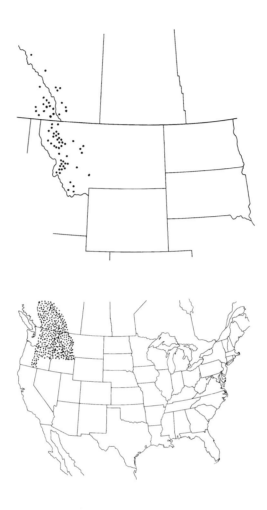

Map 7.1. Columbia Plateau Tradition Rock Art

above: Regional distribution

below: Continental distribution

7 / Columbia Plateau Tradition

The Columbia Plateau rock art tradition, best known from the interior plateau region of British Columbia, Washington, and western Montana, spills over the Continental Divide onto the western margins of the Northwestern Plains. In this area, a few dozen sites with Columbia Plateau pictographs are scattered along the slopes of the Rocky Mountains in the foothills and mountain valleys from southwestern Alberta through west-central Montana. Here, where the rugged mountains meet the open plains, generations of young Flathead and Kutenai men and women sought out these isolated locations to undertake their most important personal religious experience—the vision quest. Columbia Plateau rock art forms a painted record of these sacred dreams and spirit visions.

Columbia Plateau rock art consists of humans, animals, tally marks, and occasional geometric designs. These images are often arranged into simple but carefully structured compositions that symbolize the relationship among humans, animals, and the spirit world. Columbia Plateau sites range from small panels painted by a single artist, showing one or two simple figures associated with a few tally marks, to large gallerylike collections consisting of dozens of painted designs and representing the work of many individuals.

Almost all Columbia Plateau pictographs in this area are red ochre finger paintings, although yellow or black pigments were used for one or two figures at six sites. The only Columbia Plateau polychrome painting is a red and yellow figure at one Flathead Lake site. Only two sites contain petroglyphs—a large circle and zigzag design is lightly abraded over red pictographs at one Flathead River site, and several groups of pecked humans are found at a site in the foothills southwest of Calgary.

Most Columbia Plateau pictographs are painted on limestone or quartzite cliffs in mountain valleys, and a number of sites are found in or near narrow canyons. One site consists of petroglyphs pecked into a large quartzite glacial erratic set in open, rolling foothills. Sites are often found in out-of-the-way places quite difficult of access—getting to them often involves a steep climb or crossing a lake or river. Many site locations are the most isolated of any tradition in the region.

History of Research

The first reference to Columbia Plateau tradition rock art in our region was made in 1881 by the geologist George Dawson, who sketched some pictographs in a cave at Crowsnest Pass in southern Alberta (Leechman, Hess, and Fowler 1955). Almost thirty years later the pictographs at Painted Rocks on Flathead Lake in western Montana were first studied by a University of Montana biology professor (Elrod 1908). Over the next

These simple, juxtaposed human figures are pecked into a quartzite glacial erratic near Willow Creek, Alberta.

fifty years, several people visited and described the important Zephyr Creek site near the Highwood River, southwest of Calgary (Brink 1981; Leechman, Hess, and Fowler 1955), and a number of oral traditions concerning this site and others nearby were recorded in 1926 (Barbeau 1960).

In the early 1950s, the anthropologist Carling Malouf recognized that Columbia Plateau pictographs in the region were related to the vision quest (Malouf and White 1953; Malouf 1961). Malouf collected data from more than a dozen sites in Montana and interviewed native informants about the function of the pictographs. Around the same time, several Columbia Plateau sites in Alberta were briefly described (Leechman, Hess, and Fowler 1955). In the early 1960s, these sites were recorded by Selwyn Dewdney, and some were interpreted (Habgood 1967), while two more just west of the Divide in southeastern British Columbia were described (Corner 1968).

A systematic survey of western Montana in 1974 resulted in the identification of more than two dozen sites, and these pictographs were linked to rock art elsewhere on the Columbia Plateau (Keyser and Knight 1976). Since the late 1970s, archaeologists have continued to identify and record Columbia Plateau tradition rock art in Alberta and Montana (Brink 1980, 1981; Keyser 1978, 1981; Klassen 1994a; Werner 1981). Recently the rock art of western Montana and southeastern British Columbia was described as the Eastern Columbia Plateau style (McClure 1980; Keyser 1992), part of the larger, geographically widespread Columbia Plateau tradition.

The Rock Art

On the fringes of the Northwestern Plains, Columbia Plateau tradition rock art includes both representational and nonrepresentational designs. Representational images include simple human and animal figures; nonrepresentational images include tally marks and geometric designs. Events and activities are only rarely depicted, and compositions are generally simple, static and juxtaposed.

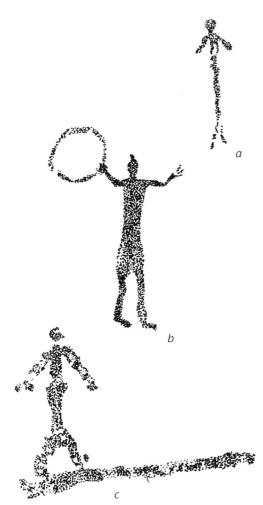

stick body. The sex of most figures is uncertain, but phalli identify a few as men, and breasts identify a woman in a Bitterroot Valley hunting scene. Shield-bearing warriors at two Bitterroot Valley sites are similar to those found across the Plains to the east; they probably belong to the Ceremonial rock art tradition.

Human figures are rarely depicted with clothing or material culture items. Headdresses appear on some figures, but the rayed arc headdress so common farther west on the Plateau is not found in the region. A block-body human at the Grassi Lakes site in southwestern Alberta is painted holding a circular hoop or drum, and a few humans hold weapons or ceremonial objects. At one site near Kila, three paintings show people in canoes, reflecting the importance of water transport for Columbia Plateau groups.

Depictions of material culture are rare in Columbia Plateau rock art. These human figures near Columbia Lake, British Columbia, hold long bows.

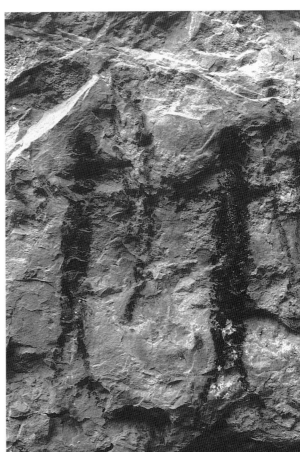

7.1 All of these characteristic Columbia Plateau stick-figure humans are from Alberta mountain and foothills sites; a is pecked; b and c are red pictographs.

Human Figures

Humans are painted at more than 70 percent of Columbia Plateau tradition sites in this region. The great majority are simple stick figures, although a few block-body and outline forms also occur (fig. 7.1). Arms of most stick figures are held at a downward angle, but several show upraised arms bent at the elbow. Their legs are usually a simple inverted V. A few include hands and feet, while heads are usually small featureless knobs set atop the

Animal Figures

Animals are slightly more numerous than humans, although they are found at fewer sites. Generally they are simple, solid-colored, block-body or stick-figure forms, but some outline forms also occur. A few, shown upside down or in a vertical position rather than the normal horizontal orientation, may indicate dead animals. Only about one-third of the animal figures can be identified as to species, and most of these represent large mammals including bison, deer, elk, moose, caribou, mountain sheep, and horses (fig. 7.2). Bison are usually shown as bulky, humpbacked forms, but two painted at a site near Kila are rendered with details including horns, humps, ears, tails, tongues, and hooves. These are among the most detailed, finely painted animal figures in Columbia Plateau rock art.

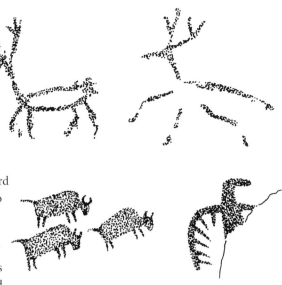

7.2 Columbia Plateau tradition animal figures are usually simple block-body or outline forms. These paintings are at various foothills sites east of the Rocky Mountains.

Deer and elk are the most common big game animals in these mountain valleys, and they can be identified at five sites. Although sometimes difficult to distinguish, buck deer and bull elk are recognizable by their antlers. A small elk herd at Grotto Canyon in southwestern Alberta includes two bulls with large sweeping antlers and several cows. Some have bodies painted with an unusual crosshatched pattern. A herd of deer or elk painted at Perma, on the Flathead River in Montana, consists only of females and fawns. A single

A bison painted upside down at Kila, Montana. Fine lines for leg, hooves, and horns indicate painting with a brush.

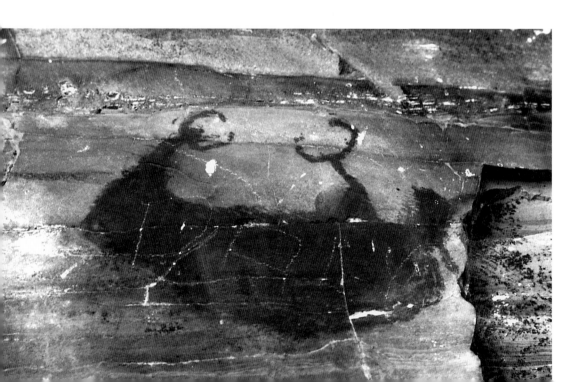

7.3 Red pictographs like those at DesRosier Rockshelter in the Smith River drainage are typical Columbia Plateau tradition vision images. Tally marks (upper right), rayed circles, and other geometric forms are common components of these compositions.

moose is depicted at one site, and an animal painted at the Grassi Lakes site appears to be a caribou. Two mountain sheep are easily identified by their swept-back horns.

In addition to ungulates, several dogs, birds, and a turtle are also depicted in this region. One dog, shown with a characteristic upraised tail, is part of a hunting scene similar to others on the Columbia Plateau. Several birds are depicted frontally, with outstretched wings and beak pointed to the side. These resemble other birds found elsewhere in the Columbia Plateau, and some may represent Thunderbird. The simple turtle is shown in plan view.

Horses are painted at three sites. At two sites they are shown with riders, and one also has a pedestrian human holding its rein. At a third site the horse is finely drawn, with flowing mane and tail and C-shaped hoofs, in a style resembling that commonly used to depict horses at Northwestern Plains sites such as Writing-on-Stone, far to the east.

Tally Marks

Tally marks—short vertical lines painted in an evenly spaced, horizontal series—are the most common design element in eastern Columbia Plateau rock art. In many cases, tally marks are associated with representational and geometric figures (fig. 7.3). Anywhere from two to more than twenty marks regularly occur in a series, although one group at the Cline River site in Alberta has fifty-four. Most sites have several separate series, and there are several sites with more than a dozen groups totaling more than one hundred marks. Although varying in size and spacing from one group to another, marks in any particular series are almost always well painted and consistent in length, thickness, and spacing.

Geometric Designs

Various geometric designs are a common feature of the Columbia Plateau tradition (figs. 7.3, 7.4), although for unknown reasons, they are less common at sites east of the Rocky Mountains. Geometric images are generally well-drawn and carefully executed, suggesting they are pre-planned, intentional designs. Geometrics include circles, rayed circles, ribbed figures, rakelike designs, zigzag lines, crosses, and dots. Dots and circles are fairly

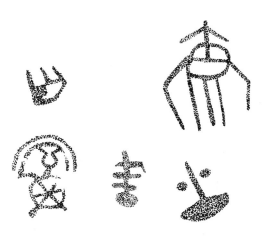

7.4 Columbia Plateau tradition art includes a variety of simple geometric designs.

common, while rakes, ribbed figures, and zigzags occur in fewer numbers. A circle with one or two trailing lines occurs at several sites. More complex geometric figures are composed of spoked or concentric circles or rectangles with appended lines. Several unidentifiable abstract designs are also present.

Compositional Arrangements

Compositions in the Columbia Plateau tradition are generally simple and static. Most involve small juxtaposed groupings of humans and animals, or small arrangements of geometric designs. Animals often occur in pairs or small "herds," while humans are occasionally found in groups of two or three. More commonly, a single human is closely associated with a single animal, or with a sunburst or other geometric design, in a static, juxtaposed composition.

Groups of humans and animals are sometimes arranged along an implied but undepicted ground line (fig. 7.5). Interaction between grouped humans and animals is rarely depicted, although action is implied or apparent in three hunting scenes, a combat scene, and three instances of humans riding. Some ceremonial activities may be shown. In several cases, lines connect humans with animals; one zigzag line connects a human to a bird.

Geometric designs may occur singly or in juxtaposed groupings. Human and animal figures are sometimes grouped together with a series of tally marks or a group of geometric designs. Groups of dots or circles in various arrangements are found at numerous sites, often associated with humans or animals.

Dating and Chronology

Direct dating of Columbia Plateau tradition rock art has yet to be undertaken in this region, but several lines of evidence enable us to estimate that this tradition extends from at least the Late Archaic to Historic periods (fig. 7.6).

Elsewhere Columbia Plateau pictographs date as early as 6000 B.C., and one portable pictograph from southern British Columbia was recovered from a site deposit dating about 2000 years ago. Across the Columbia Plateau, this pictorial tradition remained relatively unchanged over a long time span (Keyser

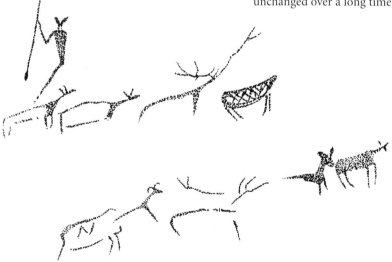

7.5 Herd scenes and hunters killing game were drawn as hunting magic in Columbia Plateau tradition rock art. Implied ground lines structure the composition of this herd and hunter scene at Grotto Canyon in Alberta.

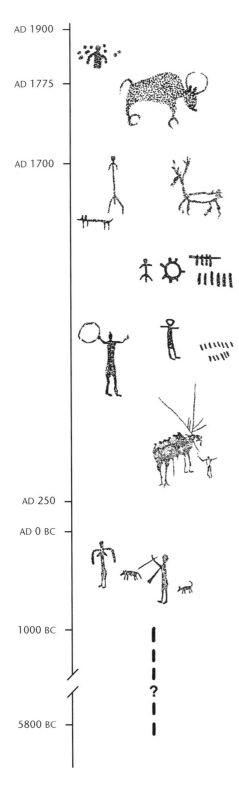

7.6 Columbia Plateau Tradition General Chronology

1992), which suggests that some of the Columbia Plateau pictographs on the periphery of the Plains also could be quite old. For example, a Bitterroot Valley hunting scene shows a hunter with a spear. Given the numerous bow and arrow scenes elsewhere on the Plateau, this pictograph could very well date to Late Archaic times (1000 B.C. to A.D. 250), before the bow was in use.

A few instances of superimposition or heavy weathering also support the idea that the tradition continued into the Late Prehistoric period. For example, a sun symbol and tally marks superimposed over a Foothills Abstract tradition maze design at a Smith River site indicates that the Columbia Plateau rock art is later than the Foothills Abstract rock art at this site, which would probably make it Late Prehistoric in age. Several Columbia Plateau pictograph sites in our region also show horses and therefore must date to postcontact times after the arrival of the horse around 1750. Nonetheless, depictions of historic trade objects are uncommon, and most sites undoubtedly originated during the Late Prehistoric period.

Distribution and Regional Relationships

The clear stylistic distinction between Columbia Plateau and typical Northwestern Plains rock art makes it relatively easy to identify Plateau-style sites that occur along the eastern flanks of the Rocky Mountains. To date, nearly twenty Columbia Plateau tradition sites have been recorded east of the Continental Divide in the area stretching from Jasper, Alberta, to Yellowstone Park in Montana (Map 7.1). These sites are considered to be part of the Eastern Columbia Plateau style of the Columbia Plateau tradition. Nearly fifty additional sites of this style are also found west of the Continental Divide in western Montana and southeastern British Columbia.

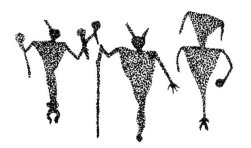

7.7 These unusual painted Columbia Plateau tradition human figures at Grotto Canyon are somewhat similar to petroglyphs on the Snake River near Lewiston, Idaho.

The largest sites in this region of Montana are found near Kila and at Painted Rocks on Flathead Lake, while several clusters of important sites are located west of Kalispell, on Flathead Lake, along the lower Flathead River, and in the southern Bitterroot Valley. A group of sites also occurs in the vicinity of Columbia Lake in British Columbia. East of the Divide, important sites include Zephyr Creek, Grassi Lakes, and Grotto Canyon, all located west of Calgary, Alberta. The widespread but scattered distribution of Columbia Plateau tradition sites along the Rocky Mountain front ranges and the generally scant archaeological survey in this region suggest that additional sites will be recognized here in the future.

Columbia Plateau tradition pictographs occurring on the western fringes of the Northwestern Plains are clearly part of a widespread rock art tradition that stretches from the Cascade Mountains of Oregon, Washington, and British Columbia to the eastern slopes of the Rocky Mountains (Keyser 1992). In terms of designs, composition, technique, and location, these sites more closely resemble those painted elsewhere on the Columbia Plateau than they do any style of rock art on the Plains (fig. 7.7). The bison at Kila, Painted Rocks, and Sourdough Cave are stylistically similar to bison painted at sites on the Columbia and Snake rivers in Washington and Idaho. The deer herd at Perma is almost identical in both style and composition to one painted at Kootenay Lake in southeastern British Columbia (fig. 7.8), and the hunting scenes are most similar to other Columbia Plateau sites. Overall, these animals are simpler than those of most Northwestern Plains rock art, and the numerous sunbursts, zigzags, dot groups, and other simple abstract designs are also more like rock art from the Columbia Plateau than from any other area.

Tally marks and simple stick figure humans and animals in small juxtaposed groups may be the most distinctive characteristics of the

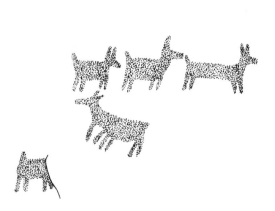

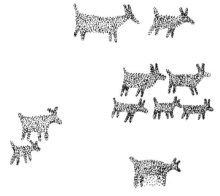

7.8 This deer herd painted at Perma on the lower Flathead River is a typical Columbia Plateau tradition composition.

Columbia Plateau tradition when compared to other Northwestern Plains styles. Painted tally marks in the quantities typically found at Eastern Columbia Plateau Style sites occur in no other Plains rock art tradition. Only a very few occur in Foothills Abstract rock art, and some of these may be additions to the sites by later Columbia Plateau artists. Simple front-view, stick-figure or block-body humans with arms held out horizontally or slightly downward also characterize Columbia Plateau rock art. Somewhat similar stick-figure humans are occasionally found in Foothills Abstract rock art, but often these lack arms or legs.

Despite the overlap in distribution along the foothills of the Rocky Mountains, few formal similarities occur between Columbia Plateau and Foothills Abstract rock art. For example, Columbia Plateau sites lack the complex, mazelike abstract designs, elaborate animal figures, and handprints characteristic of the Foothills Abstract tradition rock art. The influence on Columbia Plateau rock art by Late Prehistoric and Historic period Northwestern Plains rock art is also minimal. The outline V-neck humans, shield-bearing warriors, and other characteristic Ceremonial tradition motifs are rarely found at Columbia Plateau sites. However, shield-bearing warriors painted at two Bitterroot Valley sites and a classic vision quest scene at a southwestern Alberta site showing a typical V-neck figure joined to a Thunderbird clearly reveal that the Northwestern Plains Ceremonial tradition had a limited influence on the easternmost Columbia Plateau rock art. Likewise, a Flathead warrior's ledger drawings and a red finger-painted biographical scene at a site near Flathead Lake show some limited influences from the Biographic tradition (fig. 7.9).

Cultural Affiliations

Rock art throughout the Columbia Plateau is closely associated with Interior Salish groups. Columbia Plateau pictographs in our region were almost certainly painted by the Salishan-speaking Flathead and Pend d'Oreille, along with the Kutenai people. Informants from each of these groups have identified some of these sites as having been painted by their ancestors. In historic times, these three groups lived in the mountain valleys of western Montana and southeastern British Columbia. Separated from the Plains only by the Rockies, these groups made annual journeys, lasting from a few days to several months, across the mountains to hunt bison and raid for horses. The excellent bison-hunting territory from Lethbridge, Alberta, south to Great Falls, Montana, and in the Three Forks and Big Hole valleys east and south of Butte, Montana, was exploited by members of all three groups nearly every year.

Before the Historic period, the eastern slopes and foothills of the Rocky Mountains may have been occupied by the Flathead, Pend d'Oreille, and Kutenai on more than merely seasonal hunting expeditions; the annual return of these groups to the buffalo country may have been part of a long-established Plains existence. All three groups have strong oral traditions indicating that they permanently occupied the western fringes of the Northwestern Plains before they were pushed into the mountains by the expansion from the south and east of the more powerful Shoshone, Blackfeet, Plains Cree, and Crow. However, the restriction of Columbia Plateau pictographs to the eastern slopes of the Rocky Mountains suggests that the religious use and

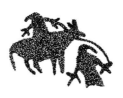

7.9 Horses and horse-raiding scenes at Columbia Plateau sites show the influence of Biographic tradition rock art.

primary occupation of the area by these groups focused on the large, broad, intermontane valleys such as Big Hole, Crowsnest Pass, and the Smith River and Bow River drainages, which form fingers of Plains-type ecosystems extending deep into the mountains.

Interpretations

Research has shown that most Columbia Plateau tradition pictographs in this region have a strong association with the vision quest (Keyser and Knight 1976; Keyser 1978, 1981, 1992; Klassen 1994a; Malouf and White 1953; Malouf 1961) while some pictographs were related to hunting rituals (Brink 1981; Keyser 1992; Hann et al. 2000).

Some rock art clearly depicts hunting-related imagery. One Bitterroot Valley site illustrates a classic Columbia Plateau hunting scene with a woman and a dog driving the quarry toward a spear-wielding hunter (fig. 7.10). Scenes at Zephyr Creek may also show men hunting deer, elk, or bison (Brink 1981). At Grotto Canyon, an anthropomorphic figure holding a spear or staff presides over an elk herd (fig. 7.5). Small herds of deer, elk, or bison also occur at several sites, and one nursery herd of elk or deer at Perma is a highly realistic portrayal of herd behavior (fig. 7.8).

All these depictions suggest that a hunting emphasis was intended for some Columbia Plateau rock art. Such herd and hunting scenes may have been used as sympathetic magic to try to control animal spirits, as teaching aids in instructing novice hunters, or to propitiate the spirits of killed animals and thank them for their cooperation in successful hunts (Hann et al. 2000). Some of them, such as the Grotto Canyon scene, may have been the work of hunt chiefs or shamans seeking special personal power to control game animals.

While hunting rituals were involved at some sites, most Columbia Plateau rock art was undoubtedly a product of the vision quest, a relationship relatively well documented in the ethnographic record (fig. 7.11). In our region, Kutenai and Flathead informants from both British Columbia and Montana remembered that people went on vision quests at rock art sites because they were sacred places where powerful spirits dwelled (Barbeau 1960; Malouf and White 1953; Malouf 1961; Teit 1928). Strong metaphysical powers were attributed to these places, and these powers could be transferred to people in dreams. Some Kutenai informants suggested that the spirits inspired the vision seekers to paint their dreams on the rocks. According to the Stoney (Plains neighbors of the Kutenai), the paintings were put there by the spirits themselves. The paintings were always changing, and if treated with respect could foretell the future for those who consulted them. Traditional Stoney explanations of these

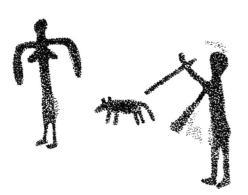

7.10 In this Bitterroot Valley hunting scene, the hunter uses a spear or atlatl, suggesting that the scene may date to earlier than the introduction of the bow and arrow.

paintings as the product of the spirit world can be understood as metaphorical references to the powers obtained by the Kutenai at these places (see Whitley 1994b). During visions and spirit journeys, the spirit world manifested itself through the dreamer—thus, paintings made by a vision seeker in a trancelike dream were said to be made by the spirits.

The specific significance of most Columbia Plateau rock art, including tally marks, geometric designs, and human/animal associations, can be understood from the perspective of the vision quest. On the Columbia Plateau, ethnographic informants have indicated that tally marks were counts of the number of days spent undertaking rituals, or the number of rituals performed. Some of the large tally mark series may well have been mnemonic devices for recalling the steps necessary to complete a religious ritual or ceremony. Informants also spoke of using tally marks to record the number of spirit helpers possessed by a vision seeker (Cline 1938) and

as a personal "signature" (Malouf and White 1953)—explanations that can be interpreted to mean that tally marks represent the personal medicine power of shamans and their successful journeys into the supernatural realm. Their great number and consistent execution indicate that tally marks were an important part of this area's rock art. Their significance is emphasized by their frequent placement at significant landscape features. At one site in the Bitterroot Mountains, the only motifs are tally marks painted along a horizontal vein of white quartzite that runs through a broad high cliff, while at a Cline River site, the tally marks line a prominent boulder.

Similarities in the form and execution of geometric designs across the Columbia Plateau suggest that many had conventionalized or standardized symbolic meaning for their creators. Rayed circles likely represent the sun, a powerful guardian spirit among Columbia Plateau groups, and other circles, dots, and crosses probably represent the moon, stars, and meteors, all of which were also important in Columbia Plateau cosmology. Likewise, many depictions of individual animals probably represent specific guardian spirits. In particular, images of some birds probably represent Thunderbird, one of the most powerful of the spirit beings.

The frequent juxtaposed association of a single human figure with an animal or abstract design apparently symbolizes the medicine power obtained during the vision

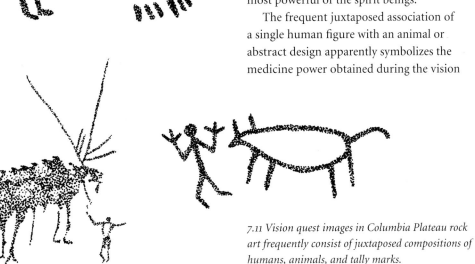

7.11 Vision quest images in Columbia Plateau rock art frequently consist of juxtaposed compositions of humans, animals, and tally marks.

quest. The human figure represents the shaman or supplicant, while the animal or geometric symbol represents the appearance to the vision seeker of a guardian spirit in the form of an animal or object. This association is most clearly demonstrated by a pictograph in southwestern Alberta depicting a human joined by a zigzag line to a Thunderbird, an image that suggests the transfer of power from a spirit being to a vision seeker (fig. 7.12).

Finally, strong evidence for the relationship of pictographs in this tradition to vision questing comes from the isolated location and inaccessible setting of many sites, as well as their association with landscape features that hold sacred connotations in oral traditions. Occasionally these pictograph sites even have associated vision quest structures—loosely piled rocks forming low walls —which served as fasting beds or sitting places for the vision seeker during his or her quest (Keyser 1981, 1993; Taylor 1973). Clearly, most Columbia Plateau rock art records the dreams of spirit seekers fasting among the sacred peaks and valleys of the Rocky Mountains.

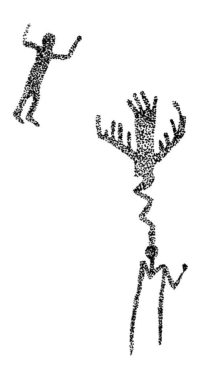

7.12 This Columbia Plateau tradition vision quest composition from southern Alberta shows the transfer of power from a Thunderbird to a human.

The Kokopelli of Grotto Canyon

One of the most intriguing Northwestern Plains rock art sites is Grotto Canyon, situated in the Rocky Mountains west of Calgary, Alberta. Although some pictographs here show similarities to other eastern Columbia Plateau sites, others bear an uncanny resemblance to rock art of the American Southwest, making them among the most mysterious and enigmatic of any in the region.

The Grotto Canyon pictographs are reached by a dramatic journey. Visitors must follow Grotto Creek from where it spills out of the mountains, into a small valley that quickly becomes a narrow, gloomy, twisting canyon formed by imposing cliffs topped by dark overhanging pines and spruce. Only a narrow strip of sky remains visible, and the rushing water drowns out all other sound. Around a bend, the pictographs suddenly appear on a smooth, luminous limestone wall at the canyon's narrowest point, where one's outstretched arms nearly span the chasm. Beyond the site, though the canyon appears to dead-end at a high cliff, it actually makes a sharp bend to the left and opens again into a broad, luxuriant alpine valley. This journey is a passage between two mountain realms. That the pictographs occur at its narrowest point hardly seems coincidence. The glowing, cryptic pictographs may mark a sacred place, while the magical passage through the canyon seems a metaphor for a shaman's spirit journey.

The pictographs at Grotto Canyon include several unusual human and animal figures that add to the mystery of the site. One human with wide "rabbit ears" and a tapered torso holds a spear and presides over two rows of elk, some with magnificent antlers or bodies filled with a lattice pattern (fig. 7.5). Another group of three humans is highly abstracted, with tapered lower torsos ending in strange shapes instead of legs and feet (fig. 7.7). Each wears a detailed headdress and holds rattles or similar objects. Their unusual forms and details lend these images an otherworldly air, suggesting a ritual significance.

Most intriguing, however, is a small, hunched human figure (fig. 7.13), with legs bent at the knees and thin "antennae" sprouting from its head. With both hands it holds a long, thin object to its mouth. Although this image is unique in both Northwestern Plains

7.13 The enigmatic Kokopelli figure of Grotto Canyon.

and Columbia Plateau rock art, anywhere in the Southwest it would be instantly recognized as Kokopelli, the flute player (Slifer and Duffield 1994). In Hopi traditions, this hunch-backed trickster has special powers and acts as both a fertility symbol and a rain priest. He can call the rain by playing his sacred flute, and he carries seeds, blankets and special gifts with which he seduces young women.

Images of flute-playing humans appear frequently in the rock art of Utah, Arizona, New Mexico, and Colorado; most are associated with the Anasazi (Basketmaker and Pueblo) cultures dating from about A.D. 500 until the 1500s (Slifer and Duffield 1994). Some figures are more obviously phallic and humpbacked than others, and many have insect attributes such as antennae. Often these images are associated with hunting scenes, while some of the older ones are simply single flute players drawn in an eternal dance on their canvas of stone. While they may not always represent Kokopelli, most undoubtedly personify a similar shaman or trickster character.

The resemblance of the Grotto Canyon figure to the Anasazi flute players seems too detailed to be coincidence. But how did he get here—so far from the land of the Anasazi and more than 600 miles north of his nearest

cousin? Interestingly, Hopi oral traditions tell how Kokopelli traveled far and wide, spreading both good and mischief. From a traditional perspective, the Kokopelli of Grotto Canyon is simply evidence of the wide travels of this powerful trickster, an image from the spirit world.

Kokopelli was also closely associated with shamanistic rituals and medicine powers. His fame and abilities may have spread widely, and his tradition may have been known to many different groups. We know that even before the horse, young men often traveled great distances in search of adventure, war honors, and medicine powers. Perhaps an Anasazi shaman who knew of Kokopelli traveled far to the north to leave a reminder of his culture in a canyon deep in an unfamiliar land. Or perhaps a young shaman's apprentice traveled south to the Anasazi, and upon returning home, commemorated his encounter with Kokopelli on the sacred cliffs of Grotto Canyon.

We will probably never know who painted Kokopelli and the other images at Grotto Canyon, yet the power of these images and their relationship to the landscape seem clear: they mark a sacred place where a shaman felt and experienced the energy of the spirit world.

8 / Dinwoody Tradition

Little Northwestern Plains rock art rivals the fantastic spirit figures of the Dinwoody tradition. Pecked and abraded into the red-brown sandstones of west-central Wyoming, these unearthly anthropomorphs owe their awe-inspiring qualities to their bizarre forms and shapes. Generally resembling humans, these large figures also have many attributes of spirit beings—internal designs, animal features, and distorted bodies (fig. 8.1). Many figures represent the powerful spirit beings encountered by Northern Shoshone shamans on their journeys through the spirit world.

Dinwoody rock art ranges from anthropomorphs as tall as 6 feet (2 m) to tiny figures under 6 inches (15 cm) high. Anthropomorphs often include highly abstract rectilinear and curvilinear patterns within their torsos. Some of the more fanciful composite designs show bizarre anthropomorphic beings with smaller figures carved inside the torso, or connected to the larger figure by a wavy line (fig. 8.2). They are frequently associated with wavy lines, series of dots or circles, and complex headdresses. The characteristic interior body designs have led some authors to group these petroglyphs into a more widespread Interior Line style that occurs across much of the southwestern United States. The Dinwoody tradition itself is restricted to a small area of Wyoming that includes the Wind River Valley and adjacent southern Bighorn Basin.

More than 75 percent of Dinwoody tradition petroglyphs are made by a combination of pecking, stippling, and abrading. Because these petroglyphs are usually pecked through the dark red to red-brown patina on the area's sandstone bedrock, many show up as a light figure on a darker background. The result is often a striking ghostlike imagery. A few petroglyphs show faded red paint on some parts, usually as bands or lines across the body, but no known examples in this area are exclusively pictographs. The use of paint may have once been more widespread, with the paint since faded, or the painted petroglyphs could be the product of later artists "refreshing" some glyphs as part of rituals or ceremonies.

Dinwoody tradition sites are found on large isolated boulders or on extensive open streamside or lakeside cliffs along the many drainages that cut this highly dissected landscape. In parts of this semiarid country, especially along the Wind River Mountain foothills, these sites bear such a notable association with lakes and streams that locals frequently refer to the petroglyphs as "looking out over the water." The best-known sites are Legend Rock and Dinwoody Lake, where broad cliff faces are covered with dozens of overlapping figures to create large, cluttered compositions. A few more sites of this size and complexity are scattered throughout the area, most notably along Muddy Creek, at Ring

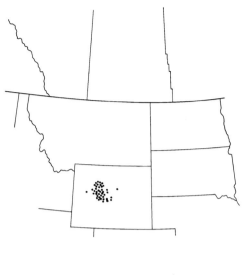

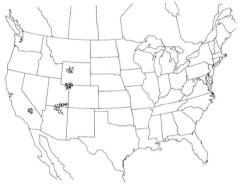

Map 8.1.

*above: Regional Distribution of Dinwoody
Tradition Rock Art*

*below: Continental Distribution of Related
"Interior Line" Style Petroglyphs*

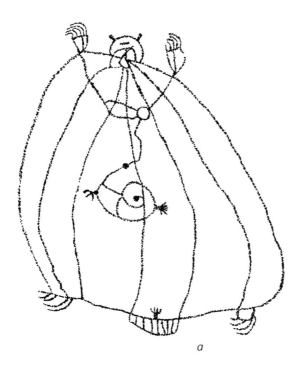

a

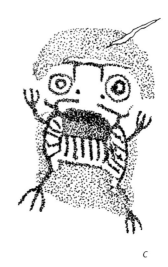

c

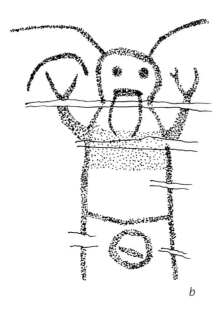

b

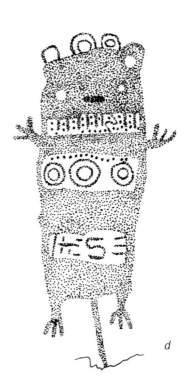

d

8.1 *Fantastic anthropomorphic beings in Dinwoody tradition art probably represent supernatural spirit beings. These interior line type figures show a variety of human and animal attributes. Note that a has four bear paws but smaller human hands within the body.*

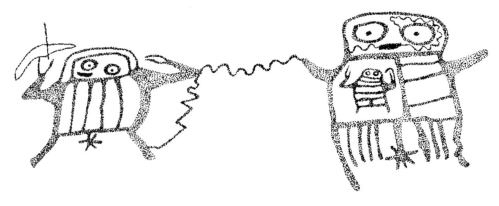

8.2 *This Dinwoody tradition composition shows an interior line anthropomorph with bow and arrow, connected by a wavy line to the arm and eye of a large composite figure, who has a smaller anthropomorph in his chest. Both large figures have a "starburst phallus," and the composite figure has a pubic fringe.*

Lake, and near Boysen Reservoir. Most sites, however, consist of one to six figures. Often several small sites will cluster in a drainage or around a lake shore.

History of Research

Probably because of their unique stylization and fantastic forms, Dinwoody tradition petroglyphs have long interested both professional archaeologists and amateurs. The earliest records are those of several soldiers who noted sites while posted to the Wind River Indian Reservation in the 1870s (Mallery 1893; Hendry 1983; Francis 1994). Other site reports continued to appear in the popular press since that time, but just before and after World War II, professional archaeologists began to conduct major recording projects at Dinwoody Lake, Boysen Reservoir, and a number of smaller sites (Renaud 1936; Sowers 1939, 1940; Gebhard 1951; Gebhard and Cahn 1950, 1954). These projects, mainly descriptive or involving relative dating schemes, attempted little analysis or interpretation.

Over the next forty years, a few archaeologists published additional sites in general articles (Gebhard 1969; Swaim 1975; Grant 1967, 1983; Wellmann 1979a; Frison 1978; Tipps and Schroedl 1985; Keyser 1990). Two interested amateurs have also recently made

This pecked anthropomorph from Dinwoody Lake, Wyoming, is perhaps the most famous petroglyph of this tradition. Note interior body decoration including smaller, horizontal anthropomorphs at bottom. Chalking not done by photographer. (Courtesy of Stu Conner)

numerous site records and published descriptions of some of their work (Hendry 1983; Stewart 1988).

Recent years have seen renewed focus on Dinwoody tradition rock art, primarily by Julie Francis and Larry Loendorf, both of whom have conducted major rock art research projects in the southern Bighorn Basin (Walker and Francis 1989; Francis 1991, 1994; Francis et al. 1993; Loendorf 1994). This work involves extensive site recording and description (fig. 8.3), relative and absolute dating efforts, and interpretation using ethnographic research. We have relied heavily on this recent work for this chapter, and continuation of their research promises to add greatly to our knowledge of this spectacular rock art.

The Rock Art

Dinwoody tradition rock art from the more than 100 sites we analyzed consists primarily of two representational classes of subject matter—highly abstracted anthropomorphs, and animal figures. A few material culture items are also depicted, as are a handful of nonrepresentational abstract designs.

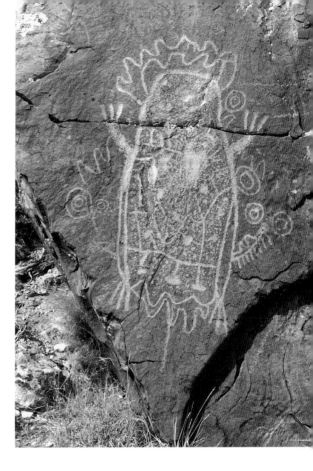

A bizarre abstracted Dinwoody tradition anthropomorph from Trail Lakes, Wyoming.

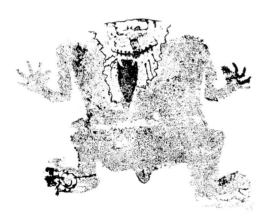

8.3 Careful recording shows that this fully pecked female figure wears a projectile point necklace and has a spiral design in the right foot. (Drawing courtesy of Linda Olson)

Anthropomorphs

Anthropomorphic figures are by far the most common elements in Dinwoody tradition rock art. More than 75 percent of the known Dinwoody glyphs are anthropomorphs or therianthropes (human/animal combinations), and only a Boysen Reservoir site has animal designs exclusively. In form, Dinwoody anthropomorphs are highly abstracted, elaborate, and so diverse as to nearly defy general description. Throughout this chapter, we refer to these figures as anthropomorphs precisely because their bizarre forms seem to represent spirit beings rather than humans.

Bodies range from long and linear to short and squat. Heads are round, square, or bucket-shaped, and sit directly on the shoulders. In some instances, a single body will exhibit two

or more heads side by side or stacked. Facial features are common. Eyes are pecked dots, circles, or concentric circles, and a few show tear streaks. Mouths are sometimes shown; noses are rare. Sometimes facial features are incorrectly oriented. One figure has a single Cyclops eye, and another has a mouth shifted to one side and eyes oriented diagonally down across the other side of the face.

Bodies can be fully pecked, stipple pecked, or covered with intricate pecked designs (fig. 8.4). Some anthropomorphs are composites showing secondary smaller anthropomorphs pecked inside the torso, or involve two figures sharing major body parts. Limbs can be long and linear or notably foreshortened, so that hands or feet appear as flippers. Arms and legs often have strange orientations, and some wind around a corner on the cliff or disappear into a crack in the rock. Multiple sets of legs or arms frequently appear on one body— often in strange places such as on the foot or head of a larger figure. A few figures lack arms, hands, legs, or feet. Frequently legs or feet extend outward on opposite sides of the torso (rather than downward) giving the figures the

appearance of a spread-legged sitting posture. Others appear to squat. Headdresses of horns, helmets, "crowns," drooping lines, or series of dots are often shown. Therianthrope figures frequently show bird or insect wings, claws in place of hands or feet, and bizarre horn or antler headdresses. Body patterns sometimes show curvilinear abstracts with attached claws, hands, or starbursts. One composite figure uses an animal as the midpoint of its torso.

Gender is infrequently shown, but some figures are phallic, and others have what probably are vulva representations. A few have paired circular torso designs that might represent breasts, and figures occasionally have a fringe of lines dangling from the lower torso between the legs. Such "pubic fringes" may be a female indicator since it is used on a few figures with the "breast" designs (Loendorf 1994; Gebhard 1969), but at least one example with this fringe also has a penis. The bizarre stylization of these figures frequently precludes secure identification of gender, even where presumed sexual features appear to be indicated.

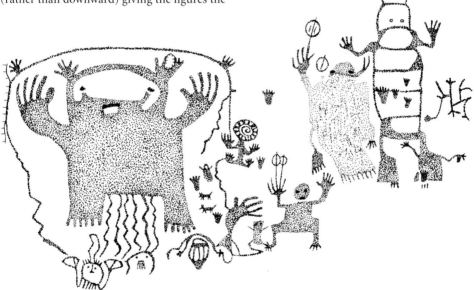

8.4 This large composition along Muddy Creek shows fully pecked, stipple pecked, interior line, and outline anthropomorphs, some connected by zigzag lines. Note "extra" hands and arms, pubic fringes, dogs, footprints (some inside body of figure), and hand-held wands.

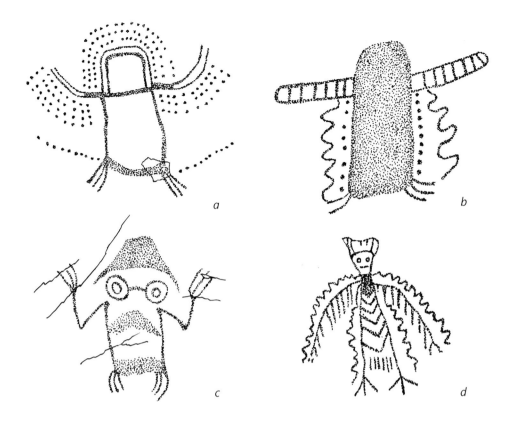

a

b

c

d

8.5 Birdlike beings are common in Dinwoody tradition rock art. These include interior line, fully pecked, and outline types. Note pubic fringe on d.

In her work at Legend Rock, Francis (1994) divided Dinwoody tradition anthropomorphs into five types: Interior Line, Fully Pecked, Linear, Wide Body, and Composite. Though quite useful in classifying these diverse representations, these types need some further refinement to be applied consistently across the entire tradition area (e.g., a pecked figure with horns showing a single band of interior lines seems to fit two types). Our impression from looking at all currently known sites is that the types as now defined are not mutually exclusive but rather show some intergradation. Likewise, different types appear to have been made by the same artists, since two or more are routinely used together in a small panel composition. Nonetheless, we have used Francis's types, along with an added category, "other," for examples that were too fragmentary or too different to fit a defined type.

Elongated Interior Line figures, undoubtedly a hallmark of the Dinwoody tradition, occur in large numbers throughout the area at nearly every site; there are almost three times as many of them as the next most common type. These anthropomorphs are generally distinguished by a body longer than it is wide which shows a pattern of pecked interior lines (figs. 8.1, 8.2). Interior designs range from simple geometric patterns to fantastic constellations of circles, dots, and wavy lines. Sometimes they occur in horizontal or vertical bands across the torso, suggesting clothing or tattooing. Many Interior Line figures are quite large. Arms and legs are shown in a variety of positions, but the most frequent posture is standing with extended arms or wings. In combination with the interior line torso

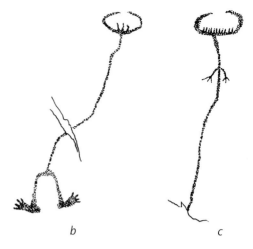

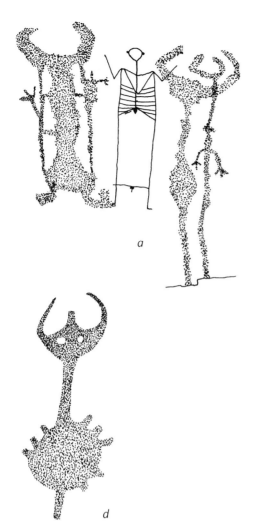

8.6 Linear anthropomorphs. Note superimposition of Ceremonial tradition V-neck human over Dinwoody figures in a; a-c, Legend Rock; d, Twin Creek.

Only three examples occur at sites south and west of Lander, and none are known from southern Bighorn Basin sites. The clustering of these figures at a few nearby sites suggests that they may represent their own type, but more complete data from other sites are needed to verify this.

Fully Pecked figures, the second most common type, have solidly pecked torsos and horns, headdresses, or other forms of head decoration (fig. 8.4). Bodies tend to be rectangular and squat, although some are more elongate. A spread-legged sitting posture is common. Except for the absence of Interior Line torso designs, general features reflect the variability in all types of anthropomorphs. Some figures that would otherwise be classified as Fully Pecked were put into the Interior Line type because of relatively small unpecked areas showing torso decoration. The simplest Fully Pecked anthropomorph is a rectangular body figure showing a hammer-head and claws extending horizontally outward from each of the four body corners.

Six sites show a total of eighteen tall Linear anthropomorphs whose bodies are nothing more than a long line (fig. 8.6). At Legend Rock, the body lines are wavy and often weave around other anthropomorphs or bend around a corner of the cliff. Heads are formed by a horned headdress, and arms, hands, legs,

decoration, wavy lines or series of dots often extend from or completely surround the figure.

Nearly fifty Interior Line figures are clearly depicted with wings in place of arms and hands (fig. 8.5). Both comblike bird wings (d) and stubby, rounded insect wings (b) are shown. Bird wings outnumber others by more than four to one. These winged figures occur most commonly at Dinwoody Lake and nearby sites in the upper Wind River drainage.

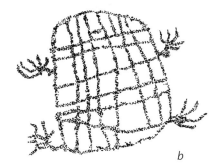
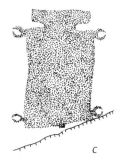

a b c

8.7 Wide body figures can have fully pecked or interior line style bodies.

and feet are usually shown. Other sites with similar figures are Twin Creek, Big Dry Creek, two sites in the Boysen Reservoir, and a composite figure at Coal Draw. On these figures the body line is straight rather than wavy, but headdresses and appendages are similar to those at Legend Rock. One figure at Boysen Reservoir has a well-drawn head with facial features.

As the name suggests, Wide Body figures show a distinctive body shape where width of the torso is usually equal to or greater than height. Generally these figures are shorter than most other anthropomorphs (fig. 8.7). The typical torso with a round top and flat bottom (a) led Francis (1994) to characterize them as bullet-shaped. Facial features and headdresses are rare, and hands and feet resemble stubby wings or claws. Legs are rarely shown. Viewed one way, one figure at Coal Draw resembles a turtle, but seen another way, it appears to be a Wide Body figure. This transformation of human and animal forms is often seen on other Dinwoody figures.

Three classes of figures are termed Composites (fig. 8.8). First recognized as a major component of this art tradition by Hendry (1983), Composites are not simply the superimposing of one figure over another, nor can they all be explained as additions to already existing figures. Many of the smaller figures or extra heads are clearly

important components of a single drawing and must have had clear meaning as part of the composition. The most common Composites show at least one small secondary figure pecked within the torso of the larger "host" anthropomorph. Others have two figures that share major body parts, and the third group shows multiple heads. Body styles of the host anthropomorph can be of any type except Linear. Examples at Legend Rock include Fully Pecked and Wide Body; those at Dinwoody and Willow Creek are Interior Line figures. Occasionally arms and legs of the secondary figure extend outside the body of the host, giving the impression of multiple sets of appendages. But not all figures with too many appendages are host Composites. Composites

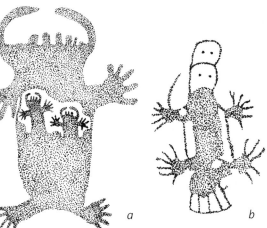

a b

8.8 Composite figures are common in the Dinwoody tradition (see also figs. 8.2 and 8.13); a, host composite; b, multiple head composite (note pubic fringe).

sharing body parts include "Siamese twins" at Coal Draw, and Interior Line figures joined by use of the same body lines at Dinwoody and Hall Creek. The multiple-head Composites occur primarily along Muddy Creek; Hendry (1983) calls these "Shadow" Composites.

Approximately one hundred other anthropomorphs could not be easily classified into the types developed by Francis. About half are small-pecked body figures that lack any of the other defining features of the Fully Pecked type and show little similarity to each another. Others are simple outline forms with undecorated bodies, and still others are partial glyphs so eroded that they cannot be confidently placed in any type. A few human footprints (not including those pecked as feet on some figures in the northern portion of the area) occur at a couple of sites. Single anthropomorphs at Legend Rock along Muddy Creek have footprints emblazoned on the body. The fact that footprints are so seldom found suggests that they were not particularly important in the tradition.

Animal Figures

Although some animals are an integral part of the Dinwoody tradition, they are far fewer than anthropomorphs and generally much less elaborate. Fewer than 150 animal figures occur

at the sites analyzed, and some of them may represent other traditions. By several criteria, some animals are unquestionably part of the Dinwoody tradition. These include lines connecting a few canids to classic Dinwoody anthropomorphs (fig. 8.9), similar production methods, patination equivalent to classic anthropomorphs, and arrangement of some into obvious Dinwoody tradition compositions (Walker and Francis 1989; Tipps and Schroedle 1985; Loendorf 1994). However, we concur with Gebhard (1969; Gebhard and Cahn 1950) that many of the small, completely pecked ungulates (bison, elk, deer, antelope) at Legend Rock, Twin Creek, Dinwoody, and Whiskey Basin sites are part of the older Early Hunting tradition extending from the Black Hills to the Rocky Mountains of Wyoming and Colorado. Clarification of which animals really belong to the Dinwoody tradition awaits further detailed site documentation and dating studies, such as those done by Francis (1994) and Gebhard (1969; Gebhard and Cahn 1950).

Despite the probable mixing of various animal forms from different traditions in the current literature, two types of animals do appear to be an integral part of the Dinwoody tradition: large Outline Pecked ungulates and smaller fully pecked canid and felid figures

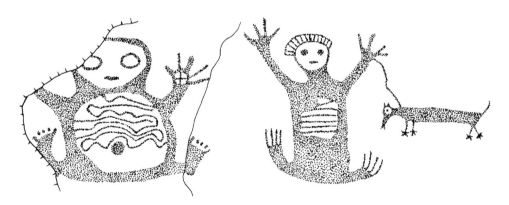

8.9 This Dinwoody composition shows a dog tethered to a sitting figure. Note cross design in left hand of larger figure.

(fig. 8.4). Both differ significantly from anthropomorphs. Generally they lack the diversity of form and extreme conventionalization and abstraction of the bizarre anthropomorphs. Instead, they are drawn far more realistically, with naturalistic anatomical details including horns, antlers, ears, tails, and feet or hooves.

Large ungulates have pecked outline bodies often decorated with fine vertical lines or light, diffuse stipple pecking (sometimes followed by abrading). Heads with antlers or horns are fully pecked, and the animals are shown in profile. Realistic detailed depictions of genitalia frequently occur, but hooves are shown as pecked outlines, solid circles, or inverted V shapes. Most known examples occur at Legend Rock, but others are found at Twin Creek, Tar Springs, and Boysen Reservoir.

Fully pecked canid and felid figures are smaller than the pecked outline animals. They are shown in profile, often with clearly depicted paws and long tails. Dog tails are raised, while those of cats extend straight out. At sixteen sites, at least twenty-two composite drawings show anthropomorphs in direct association with these animals. One animal is drawn as part of an anthropomorph's body and another "hovers" near a head, but most examples stand beside the feet of the anthropomorph. Frequently these animals are "tethered" to the anthropomorph (fig. 8.9).

At present, animals remain the most enigmatic component of Dinwoody rock art because it is not clear which ones are truly a part of the tradition or what relationship exists between Dinwoody tradition animals and those of the Early Hunting tradition. Clues from superimpositioning and panel composition occur at Dinwoody, Whiskey Basin, Twin Creek, Legend Rock, and probably other sites, but further studies focusing on stylistic criteria and relative and absolute dating evidence will be necessary to clarify these issues.

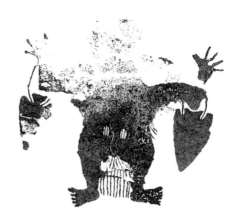

8.10 This large anthropomorph has a pubic fringe and projectile points hanging from both arms. (Drawing courtesy of Linda Olson)

Material Culture

Items of material culture are uncommon in the Dinwoody tradition, probably because the anthropomorphs represent spirit beings rather than real people participating in secular activities. While some simple abstract designs on these panels (such as the "wands" shown in the hands of anthropomorphs at two Muddy Creek sites) might represent tools or weapons, and some body decorations might represent clothing, neither can be confirmed. At present the only readily identifiable material culture items definitely associated with Dinwoody anthropomorphs are bows and/or arrows held by seven figures at seven sites, and about half a dozen projectile points incorporated into designs at Coal Draw and other Bighorn Basin sites (fig. 8.10). Three of the bows have arrows and one anthropomorph holds only an arrow (figs. 8.2, 8.3). Projectile points are corner-notched varieties common to the Late Prehistoric period about A.D. 1000.

Nonrepresentational Designs

Nine abstract designs are recorded at the sites we analyzed. These range from complex mazes to simple geometric shapes composed of pecked lines. Characteristically they tend to

be rectilinear in form, much like the torso of many anthropomorphs. They do not appear to be unfinished or eroded designs. Some may represent anthropomorphic figures, but simply lack sufficient detail to be so classified. The fact that some of the least detailed anthropomorphs would probably be classified as abstracts if they lacked one or two anatomical details supports this likelihood.

Compositional Arrangements

Dinwoody images are typically arranged in juxtaposed compositions showing relationships between figures but not implying activity. Compositions can include as many as two dozen figures, and several contain seven to fifteen. In these compositions, anthropomorphs are most frequently juxtaposed with other anthropomorphs; less common are animals juxtaposed with anthropomorphs. Most of these larger clusters probably represent the gradual accumulation of figures added by several artists over time.

Note that the "power" lines from the feet and elbow of this Dinwoody tradition anthropomorph at Trail Lakes, Wyoming, extend to the edge of the large boulder on which it is pecked.

Over-pecking to refresh some glyphs, added parts on others, and differential patination of figures on the same panel clearly show this accretion of images at some sites (Loendorf 1994; Tipps and Schroedle 1985). Other sites show compositions of only two or three figures, probably made by a single artist in one episode.

Far less common are sites where only a single anthropomorph is carved. At many, the figure is drawn in such a way that it interacts with the rock surface—either emerging from a crack or extending out to the very edges of a boulder. This interplay with natural features of the rock surfaces on which they are pecked is noted for all types of anthropomorphs at many sites. In contrast to the Ceremonial, Biographic, and Hoofprint traditions, where large open rock faces were sought and sometimes even prepared by smoothing their surfaces, Dinwoody anthropomorphs routinely cross or terminate at major cracks in the rock faces, and they occasionally extend around corners of cliffs or go right to the edge of a boulder.

One of the most common aspects of this interplay is seen in figures with a hand, foot, or body terminating at a major crack. This was first noted by Loendorf (1994) at Coal Draw,

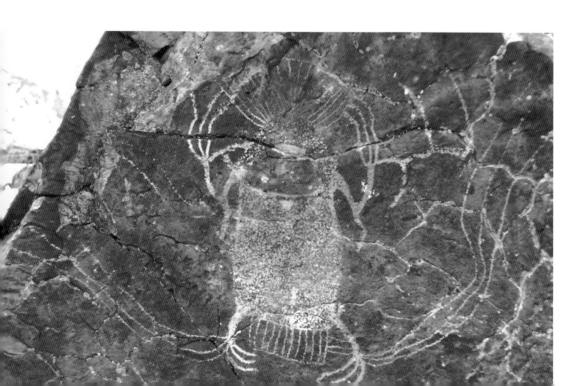

but similar figures at many other sites have since been observed. Sometimes more than one appendage on the same figure will end at a crack, and one anthropomorph at Torrey Lake is actually an upper body emerging from the large crack, so it appears to be entering or emerging from the rock. Appendages that cross major cracks or spalled areas, and appendages or attached lines that curve around a corner or go to the edge of a boulder, appear to be a similar interplay with the rock surface. Some figures whose hands, wings, or feet stretch to the edges of the boulder appear to be holding the edge or grasping the rock. The frequency of this interplay at so many sites lends credence to the idea that it was intentional, and indicates that the artists deliberately made the rock surface a functioning part of the composition.

Dating and Chronology

Dinwoody tradition petroglyphs include some of the best dated rock art on the Northwestern Plains, if not the whole of North America. Five major dating techniques, including superimpositioning, differential weathering, dated archaeological deposits, portrayal of datable objects, and rock varnish dating, have been used to date examples of Dinwoody petroglyphs and establish a general chronology for the tradition (fig. 8.11).

Superimpositioning was first used to arrange Dinwoody petroglyphs into a general chronology (Gebhard and Cahn 1950; Gebhard 1969); it showed that Dinwoody tradition anthropomorphs are younger than the animal and human figures arranged in hunting scene compositions from the Archaic period Early Hunting tradition. Examples at Dinwoody and the nearby Whiskey Basin site clearly demonstrate this superimpositioning. In addition, Dinwoody tradition anthropomorphs are superimposed on large pecked outline animals at Legend Rock and Twin Creek. Several sites also show Late Prehistoric Ceremonial

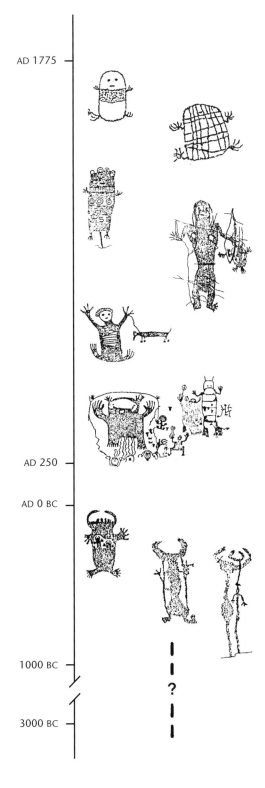

8.11 Dinwoody Tradition General Chronology

tradition motifs superimposed over Dinwoody tradition anthropomorphs, indicating that some Dinwoody petroglyphs are at least Late Prehistoric in age. One example at Legend Rock shows a V-neck human superimposed on Fully Pecked and Linear style figures (fig. 8.6), and another example shows a V-neck human and a bison superimposed on a fully pecked Dinwoody tradition figure. Superimposition of various incised figures (including shield-bearing warriors) over Dinwoody tradition anthropomorphs also occurs at an extensive site on the Little Popo Agie River south of Lander, Wyoming.

Differential weathering—appearing as darker rock varnish on older figures— supports the relative chronology of Early Hunting, followed by Dinwoody, followed by the incised Late Prehistoric Ceremonial tradition. At Legend Rock (Walker and Francis 1989) and the Twin Creek site, Early Hunting tradition animal herd compositions are more heavily patinated than some Dinwoody tradition figures, and at six Dinwoody Lake sites the same is true (Gebhard 1969). At a site on Beaver Creek, Dinwoody figures are significantly more patinated than a horse and bison from the Historic period.

In archaeological excavations at Legend Rock, a large classic Dinwoody tradition anthropomorph was found partially buried by archaeological sediments that dated to approximately A.D. 40 (Walker and Francis 1989). A level immediately below the petroglyph was dated to approximately 230 B.C. and unless the figure was carved unusually close to the ground, it too probably predates this earlier age. In either case, the figure dates to at least the Late Archaic period. Datable objects associated with Dinwoody tradition figures include bows held by six figures and corner-notched arrowheads attached to anthropomorphs at several Coal Draw sites (Loendorf 1994, 1995). The bows must postdate the introduction of this weapon onto

the Northwestern Plains at the beginning of the Late Prehistoric between A.D. 300 and 500, and the arrowheads are of types that date between A.D. 500 and 1000 in this area. This evidence indicates that these glyphs were carved during the Late Prehistoric period.

Direct scientific dating of Dinwoody tradition motifs has been attempted using both AMS radiocarbon and cation ratio (CR) rock varnish dating methods. Although the reliability of these dating methods has been recently questioned, six sites of this tradition have been dated: four sites have produced AMS radiocarbon dates and five sites have yielded CR dates (Francis et al. 1993; Francis 1994; Dorn 1995; Loendorf 1995). Twenty-two CR dates and five AMS dates from various Dinwoody anthropomorphs suggest that they were made and repecked between approximately 750 B.C. and A.D. 1700. Three CR dates and three AMS dates on Outline Pecked and Fully Pecked animals also suggest that four of these figures are older than 3000 B.C. One other Outline Pecked animal dates to approximately 500 B.C. and another Fully Pecked animal dates to A.D. 1650. Finally, "Fine Line" zoomorphs (which probably do not represent animals but rather abstract designs) date within the last 2000 years.

Although Francis argues that these dates demonstrate a nearly 6000-year span for Dinwoody tradition rock art, careful analysis suggests another possibility. The anthropomorphs and abstracts clearly cluster in the last 2700 years, but so far, only a single elaborate elk petroglyph and a small fully pecked rabbit are contemporary with them. Most of the simpler outline and fully pecked animal figures are more than 1500 years older than these unquestionable Dinwoody images, and no Dinwoody anthropomorphs have been dated older than 2700 years. It is clear from several sites that animal figures are occasionally associated with Dinwoody anthropomorphs, but it seems that these early dates

from Legend Rock may actually indicate Early Hunting tradition glyphs at that site separated from the Dinwoody figures. Thus, only two dated animal figures at Legend Rock are likely to be part of the Dinwoody tradition. This is consistent with the superimpositioning shown at this site and at Dinwoody and Twin Creek. More absolute dates will be needed to test this hypothesis.

Although controversy surrounds the validity of rock varnish dating for petroglyphs, the varnish dates from several Dinwoody tradition sites appear to be reasonably accurate. All of the AMS and CR dates on indisputable Dinwoody tradition images range from approximately 1000 B.C. to A.D. 1700. These dates correspond to the span of time indicated by other lines of evidence, including superimpositions, datable subject matter, and dated archaeological deposits. Finally, oral traditions of the Wind River Shoshone (who lived in this area in the Late Prehistoric and Historic periods) includes characters that are depicted in Dinwoody art.

Internal evidence from the varnish dates themselves also tends to support their validity. Multiple CR assessments on the same figures yield consistently similar dates except in one case where a repecked area yielded a considerably younger date, just as it should have. Additionally, dated superimpositions show the predicted consistency, where later glyphs superimposed on earlier ones always yield younger dates than the older images. Probably the best example of this is panel 48 at Legend Rock, where six varnish samples yielded two AMS radiocarbon dates and five CR dates. Superimposition and relative weathering provide a clear sequence of the petroglyphs on this panel, and the authors note, "All of the CR estimates from the panel are consistent with relative ages based upon superimpositions" (Francis et al. 1993:731).

In summary, the earliest unquestionable dates for Dinwoody tradition rock art occur in the Late Archaic period, and it appears that the characteristic motifs were carved continuously for over 2500 years until around the end of the Late Prehistoric, about 1700. CR dates at one site demonstrate repecking of an image almost 800 years after it was first carved. Superimposition, relative weathering, and an apparent gap in the radiocarbon/cation ratio chronology suggest that many animal figures at Dinwoody sites may represent the older Early Hunting tradition. (Early arguments in Gebhard 1969, Gebhard and Cahn 1950, and Hendry 1983 for considerably more recent origins do not hold up in the face of evidence. None of these bird images closely resembles any known Ghost Dance art, as Hendry unfortunately suggests, and there are no horses in Dinwoody art. In addition, she has not made use of available dating information for her Historic period dates.)

Distribution and Regional Relationships

One of the most important characteristics of Dinwoody tradition rock art is its restricted geographic range—a fact noted by every scholar who has studied it (Francis 1994; Wellmann 1979a; Gebhard 1969; Keyser 1990; Loendorf 1994). Most of the 150 sites of this tradition occur in the Wind River Basin, Popo Agie River drainage, and southern Bighorn Basin of west-central Wyoming (Map 8.1). Important sites in this area are found at Legend Rock near Thermopolis, at Dinwoody Lake, along Muddy Creek, and near Boysen Reservoir. A few glyphs at Castle Gardens also resemble Dinwoody tradition figures (Gebhard et al. 1987:56–60), as does one pecked in a Bighorn Mountain rockshelter (Hendry 1983:213).

Dinwoody tradition motifs are found almost exclusively in the Wind River and Bighorn Basins. So notable is their absence to

the east of the Bighorn River that Francis has proposed that the river was a prehistoric territorial boundary. At present, only the two Castle Gardens sites and one in the Bighorn Mountains challenge this hypothesis. Likewise, no similar rock art occurs in Montana or Idaho to the north or west. A few sites with similar, although somewhat simpler, motifs occur to the south of the Wind River Basin. One site on the Gros Ventre River is located just west of the Wind River Mountains, and several others occur in the Green River drainage of southwestern Wyoming and northeastern Utah (Gebhard 1969; Cole 1990:96–102).

Farther south and southwest, numerous examples of patterned body anthropomorphs that bear some resemblance to Dinwoody tradition figures are found throughout the Great Basin. These occur as far away as the Coso Range in southeastern California and the Colorado River drainage of southern Utah and northern Arizona, and include some Fremont and Barrier Canyon style figures from southern Utah (Wellmann 1979a). Just east of the Green River in northwestern Colorado are a few sites with painted anthropomorphs that also share the general aspects of form and patterned body (Cole 1990:100, 105). Across the Great Basin and Colorado Plateau these patterned body anthropomorphs have been lumped by some authors into a widespread Interior Line style whose distribution correlates well with the distribution of groups speaking Numic languages (Wellmann 1979a; Grant et al. 1968; Cole 1990; Walker and Francis 1989).

While much more research needs to be completed on the rock art of these areas, the general similarities among various patterned body anthropomorphs do seem to suggest that the Dinwoody tradition represents the northeasternmost extension of a widespread rock art tradition occurring across the southern Great Basin and the Colorado Plateau.

Cultural Affiliations

Because of its restricted area of occurrence on and adjacent to the Wind River Indian Reservation, several authors have attributed Dinwoody tradition rock art to the Numic-speaking Wind River Shoshone (Gebhard 1969; Hendry 1983; Loendorf 1994). The Shoshone do have traditional knowledge of some Dinwoody tradition rock art, although they attribute its manufacture to "water babies" or "mountain spirits." (These beings are shaman spirit helpers; such statements are metaphors for attributing the rock art to shamans.) In addition to this somewhat indirect admission of authorship, the Shoshone know many of these petroglyph sites (especially at Dinwoody Lake) as places where people seeking power go to obtain visions. Many Dinwoody tradition figures apparently represent mythological characters that populate the cosmology of the Wind River Shoshone (Loendorf 1994; Shimkin 1947a). Finally, this rock art bears strong stylistic resemblances to Interior Line rock art that occurs throughout the area occupied by other Numic-speaking groups.

This and other evidence led some researchers to assume that the rock art dated to relatively recent Late Prehistoric period times, since linguistic models originally proposed that the Wind River Shoshone immigrated into the area during the last 1000 years. Recent dating evidence, however, has shown that the rock art began in the Archaic period 2500 years ago, which suggests that the Numic migrations may have occurred earlier. Some archaeologists, however, have proposed a 3000- to 5000-year history for the Northern Shoshone in Wyoming, based on archaeological evidence showing continuous occupation sequences. Loendorf (1994) suggests that rock art dating provides strong support for this latter hypothesis.

While much more dating of these petroglyphs needs to be done before the

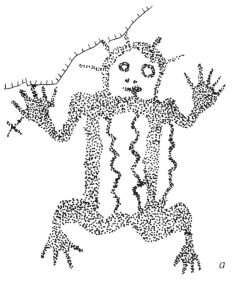

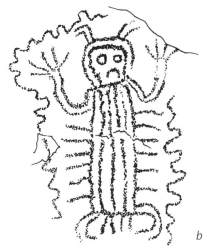

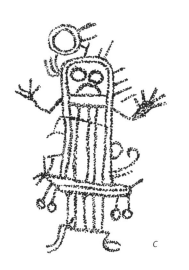

Numic migration problem can be solved, it seems certain that many of the Dinwoody tradition figures, especially those that date to the Late Prehistoric period, were made by Shoshonean artists. Determining whether a preexisting artistic tradition in this area was adopted and developed by the immigrant Shoshone, or whether they are long-term residents of this area who originated the Dinwoody tradition, awaits further research.

Interpretations

Dinwoody tradition rock art almost certainly functioned in the context of shamanism (Francis 1994; Loendorf 1994). Many images show interior designs (fig. 8.12), some of which appear to represent internal organs and skeletal elements. Such symbolism is common to shamanic rock art worldwide. Furthermore, the anthropomorphic figures often visually evoke the part human/part animal duality which frequently characterized a shaman's self-image.

Many of the figures also appear to represent supernatural or mythical figures such as Cannibal Owl, Water Ghost Woman, Split Boy, and other *ninimbi* (water spirit) figures. Such beings form the core of Shoshone mythology, and many were considered quite dangerous. Water Ghost Woman, for instance, was thought to have the ability to cause and cure epilepsy. With her sexual powers, she also lured men to their deaths by drowning. Some *ninimbi* also caused disease by shooting invisible arrows into a person, or stealing their *poha* or life force. Throughout Shoshone mythology, these figures routinely threaten humans (often cannibalizing them), and only

8.12 Interior line and composite figures are common in the Dinwoody tradition. Note zigzag power lines on a and b, pubic fringe on b, and animal in lower body of composite figure c.

can be vanquished by powerful male shamans (Shimkin 1947a; Loendorf 1994). Thus, these spirits were frequently sought by shamans as sources of power which could be used for controlling the weather, foretelling the future, or curing the sick.

Shoshone shamans used petroglyph sites as places to seek their visions, because the spirit world was thought to be linked to the rocks on which these figures were carved. Shamanistic trance imagery is full of descriptions of entering the cliffs to meet supernatural beings and learn their secrets. The numerous petroglyph figures that terminate at cracks in the cliff is compelling symbolism representing the spirits emerging from or entering the rocks.

Some archaeological evidence exists for shamans using some Dinwoody tradition petroglyph sites. Shamans often used a tubular stone pipe to suck out the foreign object that was thought to cause a person's disease (the *ninimbi* arrow) or to blow back into a person the life force that a supernatural being had

stolen. In front of a large petroglyph in Coal Draw, archaeologists found eight of these tubular stone pipes. This represents either a shaman's burial or his cache of ritualistic items. Finally, the petroglyphs themselves contain many examples of entoptic, or trance, imagery—primarily wavy lines and constellations of dots (fig. 8.13).

In summary, there is considerable evidence that much Dinwoody tradition rock art was created in the realm of shamanism, as shamans' records of their spirit journeys and encounters with spirit beings. Some may have been made, by shamans or others, during rituals leading up to trance states, or in ceremonies honoring the spirit beings who gave their powers to shamans. The stylistic unity of the great majority of figures and the great power ascribed to the designs suggest that most of the art was made by specialists who could brave the terrors of the spirit world and control these spirits for the benefit of the people.

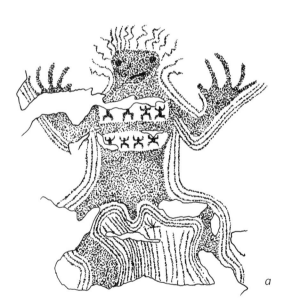
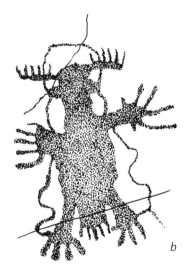

8.13 Dinwoody tradition figures are often enclosed in wavy lines: a, composite figure; b, fully pecked figure (note antlers and pubic fringe).

Poha Kahni: Where Spirits Live in the Rocks

The mythology of the Wind River Shoshone teems with evil spirit beings. Oka-moo-bitsch, the half-bird/half-human Cannibal Owl, captures and eats the souls of unwary hunters. Water Ghost Woman steals babies to torture and cannibalize them. Other monsters inhabiting this world include the Buttocks Bouncers, Cannibal Giant, and Water Buffalo—all of them magically endowed and invariably hostile to humans.

Called Pandzoavits, these beings practice all manner of evil and violence in a spirit world fraught with danger (Shimkin 1947a). Some Pandzoavits cause disease by shooting people with invisible "ghost arrows"; others lure the unsuspecting into lakes where, with large powerful hands, they pull their victims underwater to drown. The Cannibal Giant and Oka-moo-bitsch often disguise themselves as grandparents to capture and eat unwary humans. Often Pandzoavits could be heard crying like babies or fighting one another in the eruptions of hot springs and geysers.

Like all morality tales, these stories also had their heroes. Uncle Bat and Uncle Crane, Eagle, and Mourning Dove all help thwart the evil Pandzoavits and protect their human relatives. Other heroes had human form. In one tale (Shimkin 1947b), Split Boy asks his grandmother to cut him in half so that he might rescue his mother from Cannibal Giant. After succeeding, he grew partially back together as a Siamese twin. In another legend,

a group of young fishermen save a man from drowning in the sexual embrace of Water Ghost Woman. One story describes how Water Ghost Woman steals Mourning Dove's baby boy to be her husband but is finally overcome by the sexual prowess of the baby's Uncle Bat.

To gain power and knowledge, the Shoshone shaman journeyed into this dangerous supernatural world. First, he ritually bathed (sometimes in the Wind River hot springs near Thermopolis) and then traveled to a petroglyph site. Such a place was known as Poha Kahni (House of Power), for there, within the rocks, lived the spirit beings whose images were carved on the surface. Fasting and praying beneath the petroglyphs, the shaman eventually fell into a trance, during which he entered the supernatural world to battle the spirit beings and obtain their power. On these journeys, he had to be brave enough to confront the malevolent spirits and coerce them into giving him their powers or releasing a captured soul. From these powerful beings the shaman gained the knowledge that would cure disease, find lost souls, predict the future, control game animals, and bring rain.

Many Dinwoody tradition petroglyphs clearly fit into the cosmology of Shoshone legends and shamanic ritual. Many sites contain amazingly accurate images of the evil spirit beings of Shoshone mythology (fig. 8.14). One site shows Water Ghost Woman (a)

complete with crying eyes, breasts, long hair, and a bow to shoot her invisible, disease-causing arrows (Loendorf 1994). One foot seems to disappear into a crack in the cliff, giving the impression (like many of these figures) that she is moving between the supernatural and everyday worlds. Other spread-legged "sitting" figures (b) appear to be the Buttocks Bouncers, perpetrators of unspeakable evil, and short, squat figures with large hands are the underwater Pandzoavits. At Dinwoody, several large, winged creatures

with round staring eyes likely represent Oka-moo-bitsch, the Cannibal Owl; and two sites show a Siamese twin figure (c) that may represent the legendary hero Split Boy.

For more than 2,000 years, Dinwoody petroglyphs have stared out across the valleys of the Wind River and Bighorn basins—ghostly manifestations of the menacing spirits dwelling within the rocks. At these foreboding sites, countless generations of Shoshone shamans have confronted and overcome the awesome power of the supernatural world.

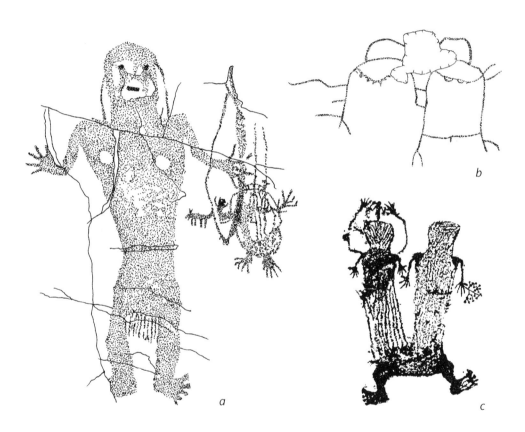

a

b

c

8.14 Some Dinwoody tradition figures represent named beings from Shoshone folklore: a, Water Ghost Woman, an evil cannibal who shoots her victims with spirit arrows (note bow and arrows, breasts, tear streaks, pubic fringe, and dog and turtle "familiars"). Her right foot disappears into a crack in the cliff; b and c represent Split Boy, powerful hero of many folktales. Drawing c courtesy of Linda Olson.

9 / En Toto Pecked Tradition

Centered in the Bighorn Basin of north-western Wyoming and extreme south-central Montana is a relatively little-known rock art tradition consisting of enigmatic groups of human figures executed in the En Toto Pecked tradition. They are distinguished by being completely *(en toto)* pecked out rather than just outlined. Another characteristic is its emphasis on humans arranged in small groups that suggest family portraits (fig. 9.1).

Only recently named and defined, the En Toto Pecked tradition consists almost entirely of humans, most with exaggerated sexual characteristics, and an occasional animal figure. This tradition has been fairly securely dated between approximately 500 B.C. and A.D. 1000. Only about two dozen sites have been recorded so far, more than half in the Bighorn Basin. A few outlying sites are found as far away as Lander, Wyoming, and Writing-on-Stone, Alberta. At some sites, such as Montana's Petroglyph Canyon and Weatherman Draw, and the Meeteetsee site in Wyoming, only En Toto Pecked motifs occur, but more frequently they are found at sites with other rock art traditions present.

En Toto Pecked rock art is composed exclusively of petroglyphs pecked into sandstone surfaces. The glyphs were produced either by indirect percussion, involving a small chisel stone struck by a hammerstone, or by carefully controlled direct percussion with a hammerstone. This method resulted in deep, broad depressions with rough, pitted surfaces. Pecking often follows a pattern or outline the artist had previously carefully incised into the rock surface. Most glyphs are heavily weathered and patinated, and many have incised glyphs from later traditions superimposed over the pecking. For the most part, sites are found on sandstone cliffs and bluffs situated in intermontane basin grasslands or along river valleys in rolling prairie.

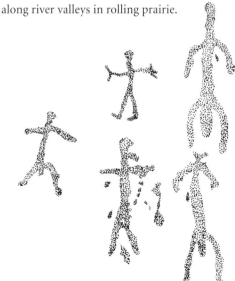

9.1 *This group of En Toto Pecked tradition humans at Weatherman Draw may represent a family or similar group.*

Map 9.1. En Toto Pecked Tradition Rock Art

above: Regional distribution

below: Continental distribution

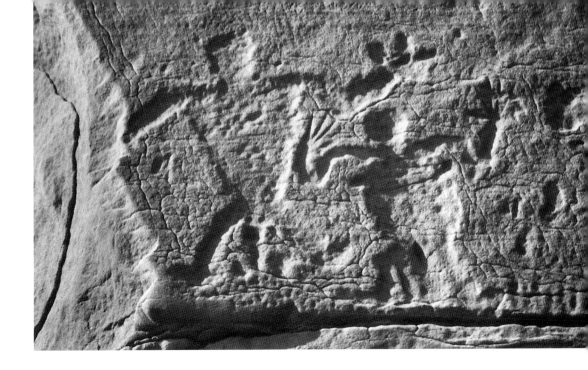

A pair of classic En Toto Pecked human figures at Writing-on-Stone. Note the genitals on the male (left), and the genitals, breasts, and incised fingers on the female (right).

Previous Research

Until quite recently, relatively little documentation or research has focused on the En Toto Pecked tradition. These petroglyphs were first noted by Stu Conner (Conner and Conner 1971:19), who provided a general description of the designs at Petroglyph Canyon and Joliet in south-central Montana. Later, Keyser (1977a) noted a similar group of figures at Writing-on-Stone and related them to Conner's description (fig. 9.2). Another site there has an animal figure and several associated pecked areas that also appear to be En Toto Pecked glyphs.

In the mid 1980s, the En Toto Pecked "style" was first named and described as a result of extensive survey work and site recording in Carbon County, Montana (Loendorf 1984; Loendorf and Porsche 1985; Francis 1991). Continued rock art research there and in the

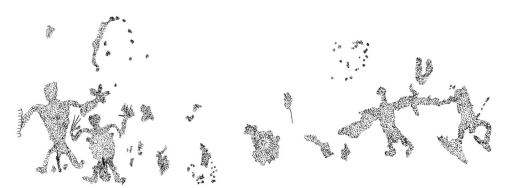

9.2 En Toto Pecked tradition petroglyphs at Writing-on-Stone. At left, note prominent genitals on man and breasts on woman. Fingers and vulva on the female figure are incised lines.

neighboring Bighorn and Wind River basins of Wyoming has resulted in the fuller definition of the tradition, and the dating of figures at three sites (Loendorf 1988, 1992; Walker and Francis 1989; Francis et al. 1993). Further work in the Bighorn Basin will likely locate more En Toto Pecked sites and provide an even better understanding of this rock art.

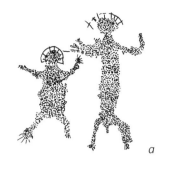

The Rock Art

En Toto Pecked petroglyphs are primarily representational designs in three broad categories: humans, animals, and material culture. Few nonrepresentational images appear; scenes and activities are absent; and compositions are simple and limited to small juxtaposed groups of humans and animals.

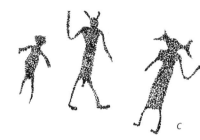

Human Figures

More than 125 human figures are found at En Toto Pecked tradition sites. These have solidly pecked rectangular or thickened linear bodies, often with pronounced sexual features (fig. 9.3). A few examples show the body as

The portrayal of "action", as suggested at Petroglyph Canyon, Montana by these bent legged "sitting" humans (center) and the bowman shooting a deer (far right), is rare in En Toto Pecked rock art.

9.3 *En Toto Pecked human figures frequently have pronounced sexual features. Note incised arc headdresses and fingers and toes on figures (a), and hair style on right figure (c).*

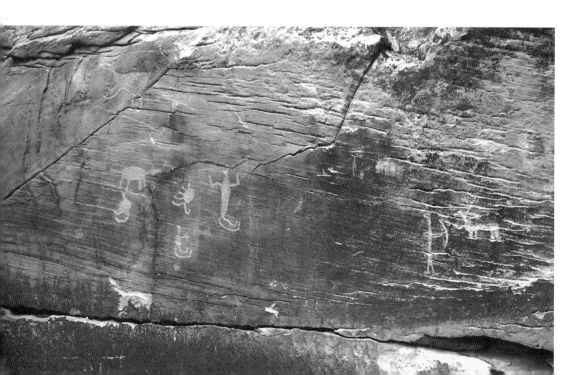

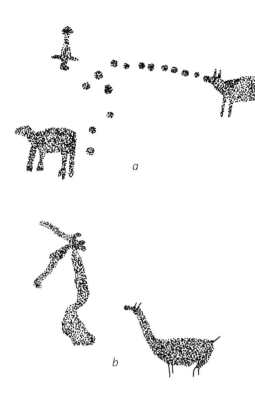

9.4 Animals are uncommon in En Toto Pecked rock art and usually unidentifiable as to species. a, Petroglyph Canyon; b, Writing-on-Stone (note incised legs, tail, and ears).

rounded or slightly triangular. The great majority of figures are front-view depictions, but at Petroglyph Canyon, three humans are shown in profile, two in sitting position. En Toto Pecked human figures nearly always have static poses; the only suggestions of activity are a bowman shooting an animal at Petroglyph Canyon and dogs tethered to two humans at another site.

Heads are round knobs atop short necks, occasionally with outward projections, and lacking facial features. Most arms are held out and upward, and frequently end in pecked hands and fingers. Legs are spread or straight down, and a few end in feet and toes. On some figures, scratched or lightly incised lines extend from the fingers or toes (fig. 9.2). Close examination shows that these lines are the

remnants of a pattern that the artist scratched into the surface before pecking the finished glyph. Such patterns have been noted on figures at Petroglyph Canyon, Weatherman Draw, Meeteetse, and Writing-on-Stone. Occasional figures show a series of short scratched lines radiating upward and outward from the head, sometimes enclosed at the top by an arc (fig. 9.3). Loendorf (1984) suggests it is some sort of headgear or power aura. Material culture items are rare, but two humans at Petroglyph Canyon hold bows, while others appear to be wearing headdresses.

The sex of nearly half the human figures is identifiable, with men shown five times more frequently than women. Eight clearly female figures have so far been recorded—almost as many as in all other Northwestern Plains rock art traditions. Sexual features are often very exaggerated. Male sex organs are elongated and thickened, female genitalia are deeply ground into the lower torso or represented by unpecked areas in the same position. The female figure at Writing-on-Stone also has pecked breasts on each side of her body just below the arms (fig. 9.2).

Animal Figures

En Toto Pecked animals are far less common than humans (fig. 9.4). Fewer than half as many animal figures occur, and several sites have none. Most animals are fully pecked profile quadrupeds in static poses. The bodies are relatively amorphous, with sticklike legs, and usually lack even the rudimentary details characteristic of human forms.

On the basis of body and head shapes, a few animals can be identified as bison, bears,

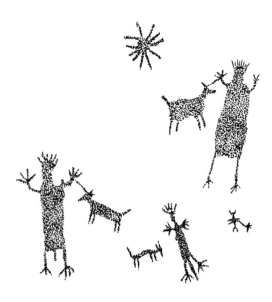

9.5 Animals (dogs?) are sometimes tethered to En Toto Pecked tradition humans. Note similarity to some Dinwoody figures (see fig. 8.9).

canids, mountain sheep, and deer. Birds, shown in frontal view, are found at three sites, and bear paws occur at four. At one site a possible scorpion is shown, and a probable snake is carved at Petroglyph Canyon. One bear at Petroglyph Canyon has an open, toothless mouth and upraised front legs, but this sort of detail is unusual. One bison at the same site was modified by a later Native artist to show blood running from the nose or mouth. An animal at Writing-on-Stone has incised legs, ears, and tail, suggesting use of a pattern like that used to make humans (fig. 9.4).

Nonrepresentational Designs

Several sites include a few nonrepresentational petroglyphs. Petroglyph Canyon includes a chain of interconnecting loops and two designs showing linear forms partially surrounded by dots. At Crooked Creek, Weatherman Draw, and Writing-on-Stone, short series of roughly pecked dots appear. Many sites also have numerous amorphous pecked "blobs," which appear to be entirely

non-representational, although some may be unfinished or eroded figures. At Writing-on-Stone, a small concretion near the center of the panel has been extensively pecked out.

Compositional Arrangements

Most En Toto Pecked tradition sites are characterized by compositions of small groups of static, juxtaposed human figures. Humans in frontal view are usually arrayed in groups of two to ten; these groups often include members of both sexes and some smaller individuals who may represent children (fig. 9.1). "Nearest neighbor" statistical analysis at Petroglyph Canyon showed that 80 percent of humans were most closely associated with other humans (Loendorf 1984). These groups clearly indicate a focus on depicting humans and their interrelationships in almost portraitlike style.

At several other sites, humans are associated with one or more animals in small juxtaposed groupings. At one Bighorn Basin site, dogs are tethered to two humans by lines leading from one hand to the animal's head (fig. 9.5). These human/animal pairs are also juxtaposed with another dog, a lizard, a scorpion, and a sunburst design. A line of pecked dots leads from one animal to another at a site in the Pryor Mountains. Other than the bowman, no obvious movement or interaction is shown, and activities are not recognizable.

Dating and Chronology

The En Toto Pecked tradition is reasonably well dated (fig. 9.6), particularly within the Bighorn Basin. In relative terms, bows held by two figures at Petroglyph Canyon and the absence of associated historic items at any site indicate that the tradition was carved in the Late Prehistoric period. Superimposition of En Toto Pecked humans at one site by a large, lightly incised bear and shield design (Loendorf 1992) suggest that it predates the

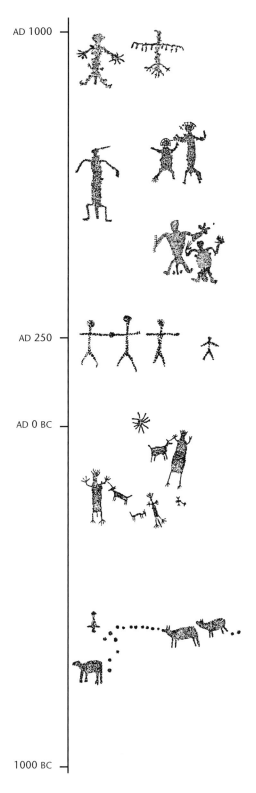

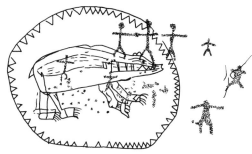

9.7 This large bear shield is incised over a group of eight En Toto Pecked stick figure humans. One human has been cation-ratio dated to between A.D. 340-415. The superimposed bear dates to less than 1000 years old.

AD 1000

AD 250

AD 0 BC

1000 BC

9.6 En Toto Pecked Tradition General Chronology

incised rock art traditions common to this area after A.D. 1000 (fig. 9.7). The relatively heavy repatination and weathered condition of the En Toto Pecked humans at Writing-on-Stone suggests that they also predate the incised shield-bearing figures, V-Neck humans, and Biographic scenes that date after A.D. 1000 in Alberta. Furthermore, when En Toto Pecked figures and Dinwoody tradition motifs occur on the same site panels, relative weathering and repatination suggest that the En Toto Pecked figures are younger (Francis 1991:423).

This relative chronology is supported by both AMS radiocarbon and cation ratio dating. Originally, Loendorf (1984) excavated below a panel of figures at Petroglyph Canyon and found occupation levels dating to approximately A.D. 750 and 1150. Although there was no direct correlation between these occupations and the rock art, it was reasonable to assume that the same people were responsible for both. Despite recent questions about rock varnish dating, subsequent AMS radiocarbon and cation ratio dates support this assumption. At present, varnish dates have been obtained from En Toto Pecked motifs at three sites. Although considered tentative, eight of the ten dates cluster between A.D. 350 and 950.

Several of these latter dates are consistent with independently obtained radiocarbon dates from archaeological levels at the Petroglyph Canyon site. Likewise, dating of superimposed traditions at the Bear Shield site and sequentially pecked parts of a bison image at Petroglyph Canyon yielded dates in correct sequence. The two oldest dates are also obtained from animal figures that show significantly greater varnish development than the more common human figures, but there is no independent confirmation of the actual ages indicated by these dates.

In summary, the correspondence of varnish dates with dated archaeological strata, the presence of bows and arrows in the rock art, and the internal consistency of dates with superimposed and sequential petroglyph manufacture, all suggest that the Late Prehistoric period age for this tradition is probably accurate. The two earliest dates, which place the beginning of the tradition in the Late Archaic period, cannot yet be independently confirmed.

Given this dating evidence, some tentative chronological developments within the tradition are noted. The oldest dates of 550 and 650 B.C. were obtained from two animal figures. This evidence, coupled with differences in repatination, which indicates that several animals at Petroglyph Canyon are

older than most of the human figures, suggests that the En Toto Pecked tradition began in the Archaic period with a focus on animal forms. Possibly the origin of this tradition has some relationship to the Early Hunting tradition. Using simple statistical analysis and relative degree of weathering, Loendorf (1984) also showed that En Toto Pecked humans with greater anatomical detail are older than simpler human forms. These older human figures are also more frequently associated with animals. Thus, it appears that the tradition originally began with animal forms (and probably some humans). Over the next 1500 years, however, it gradually developed an almost exclusive focus on human forms, before finally being replaced by incised rock art traditions shortly after A.D. 1000.

Distribution and Regional Relationships

The distribution of this tradition appears to be centered in the Bighorn Basin, a high, semidesert basin between the Rocky Mountains to the west and the Bighorn and Pryor Mountains on the east (Map 9.1). Immediately north and south, a few sites are found in the upper Yellowstone, Wind, and Popo Agie river drainages. The most distant example is a

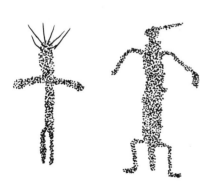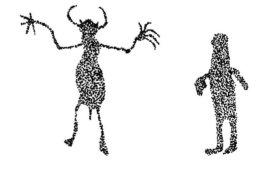

9.8 Simple figures characterize En Toto Pecked tradition rock art. Note incised line headdress on figure at left.

classic site at Writing-on-Stone, but a possible site occurs near Rapid City in the Northern Black Hills (Sundstrom 1993:184-88). The occurrence of isolated sites at Writing-on-Stone and possibly the Black Hills suggests that other examples of this tradition may be found between the Bighorn Basin and these areas, but as yet, none has been reported in the literature. More sites will likely be discovered in the Bighorn Basin and areas immediately south and east.

Relationships of this tradition to rock art found outside the Northwestern Plains are difficult to determine, because the definition of the tradition rests in large part on very basic pecked motifs in simple panel compositions (fig. 9.8), and the use of scratched patterns for the glyphs (Loendorf 1984). Neither panel composition nor scratched patterns are often the focus of site descriptions, especially those completed before the definition of the tradition. Loendorf's own thoughts about these relationships also seem to have changed since he first defined the tradition (Loendorf 1984, 1992; Loendorf and Porsche 1985). Initially, he believed the tradition was an in-place development by indigenous populations (Loendorf 1984). He discounted possible relationships with Great Basin petroglyphs, and felt that these sites showed Plateau tradition motifs most closely related to a series of sites at Birch Creek and the Blackfoot River in the upper Snake River drainage of southern Idaho. Some of these sites, such as Birch Creek, Stoddard Creek, and Antelope Creek, are pictographs that fit comfortably within the Columbia Plateau tradition (Keyser 1992), but they are not particularly similar to the En Toto Pecked tradition in technique, composition, or form. A few others, on the Blackfoot and Portneuf Rivers, do include pecked humans with hands and feet (Erwin 1930), but these figures are most similar to various Great Basin traditions, including their association with abstract dot and meandering line designs. In later work,

Loendorf (1992:81) indicates that the "style is found at dozens of sites in Wyoming, and it is well represented in the Great Basin."

Although stick-figure humans and simple animals occur as pecked petroglyphs in some areas of the Columbia Plateau, there are few other similarities between the rock art of the En Toto Pecked and Columbia Plateau traditions. Columbia Plateau rock art in western and central Montana and central Idaho is almost exclusively pictographs, and no Columbia Plateau petroglyphs were made using the scratched pattern for hands and feet. At no site do the typical red finger-painted pictographs of the Columbia Plateau tradition occur with En Toto Pecked tradition art. The rayed headdresses on a few En Toto Pecked figures do not closely resemble the rayed arcs common in the western Columbia Plateau style. More important, En Toto Pecked rock art lacks tally marks, large numbers of sun circles and other geometric designs, animal herds, and the vision quest settings typical of Columbia Plateau tradition rock art. Finally, the emphasis on hands and feet with fingers and toes and the relatively high frequency of women images does not occur in the Columbia Plateau tradition.

As part of a tradition of pecked rock art that is much more common in the Great Basin and on the Colorado Plateau to the south and west of the Northwestern Plains, it is likely that the En Toto Pecked tradition's closest relationships would also lie in that direction. To the east and north only the Black Hills area has extensive occurrences of pecked rock art, and much of this appears most closely related to Great Basin/Colorado Plateau traditions (Sundstrom 1990). Thus, in addition to Loendorf's (1992) assertion that En Toto Pecked rock art is represented in Great Basin traditions, there appears to be some possible relationships with the broadly defined Uncompahgre style of west-central Colorado (Cole 1990). Located only 400 miles (600 km) to the south, the Uncompahgre style includes

several varieties of pecked human and animal forms in various compositional arrangements. Archaeologically, this rock art fits within the Archaic Mountain tradition cultural complex (Black 1991) that may include other materials as far north as the Bighorn Basin. Further detailed comparisons are necessary to determine the extent and nature of the relationships between the En Toto Pecked, Uncompahgre, and various Great Basin traditions.

Similarities between the En Toto Pecked and Early Hunting traditions are limited to superficial correspondence between stick-figure humans and the pecked method of manufacture. No obvious women are drawn in Early Hunting tradition rock art, and none of the human figures is made on a scratched pattern like those in En Toto Pecked rock art. Fingers and toes are uncommon on Early Hunting tradition humans. Conversely, Early Hunting tradition animals are far more detailed and well made than those in En Toto Pecked rock art, and the complexity of its communal hunting scenes does not emerge in En Toto Pecked rock art.

It might be suggested that En Toto Pecked petroglyphs are merely the last pattern of Early Hunting tradition rock art, but the near absence of En Toto Pecked sites in the

Black Hills and southern Wind River Basin, where Early Hunting tradition sites are concentrated, lends no support to this idea. Likewise, the absence of any threads of artistic similarities between the latest patterns identified in the Early Hunting tradition and the earliest En Toto Pecked petroglyphs contrasts markedly with the similarities extending through six patterns and the many centuries of Early Hunting tradition rock art. The few similarities of these two traditions result more from commonalities derived from their ultimate origins in the same Western Archaic rock art macrotradition than from stylistic connections.

Cultural Affiliations

The identity of the people who made En Toto Pecked rock art is unknown. Authorship by southward-moving Athapaskan speakers, possibly represented by the Avonlea complex, has been considered but subsequently rejected, based on the absence of similar petroglyphs to the north in the Saskatchewan-Alberta-northern Montana homeland of the Avonlea bison hunters (Loendorf 1984). The few En Toto Pecked sites at Writing-on-Stone do not markedly alter the near-absence of these motifs in this homeland area, and the corre-

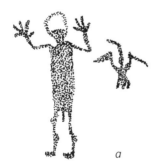
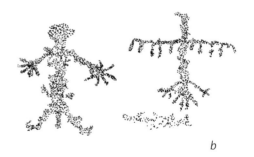

9.9 These compositions showing men juxtaposed with birds may be simple vision quest imagery. a, Joliet; b, Petroglyph Canyon.

sponding absence of En Toto Pecked motifs east of the Bighorn Mountains in association with the Beehive complex (thought to derive from Avonlea) supports Loendorf's conclusion.

Shoshonean speakers have also been proposed as the makers, based on general similarities between the En Toto Pecked tradition and those from the Great Basin (Loendorf et al. 1990). This hypothesis, however, highlights the two currently competing models for Shoshonean origins. One model argues that they were an indigenous Rocky Mountain population that spread southwestward throughout the Great Basin, while the other suggests they migrated northeast through the Great Basin to western Wyoming sometime between A.D. 1000 and 1500. If En Toto Pecked tradition rock art is Shoshonean, it would support the indigenous population hypothesis, given its early date. However, the fact that the tradition terminates about A.D. 1000 suggests otherwise, since the Wind River Shoshone used much of the Bighorn Basin until the treaty period. The possibility of multiple Shoshonean migrations even further confuses the issue, and Loendorf apparently does not feel strongly that Shoshonean authorship can be supported.

Interpretations

The function and meaning of En Toto Pecked petroglyphs is far from clear, although what the rock art does not symbolize is more obvious. Given the paucity of animal representations, and the near-absence of weapons and drive scenes characteristic of other hunting art, realistic and shamanistic representations of hunting do not appear to be an important aspect of these petroglyphs. This is further supported by the lack of association between animals and humans at most sites. Nor do most of the petroglyphs appear to be related to vision questing or other aspects of shamanism. Rock art associated with these rituals usually portrays power relationships between spirit beings (represented as animals) and humans, or visions encountered during spirit travels, and usually involves some combination of entoptic depictions (spirals, mazes, dot patterns), stylized power symbols (zigzags, rayed arcs, or concentric circles), or structured relationships between humans and supernatural beings.

Except for rays projecting from the heads of several figures and from the penis of one figure at Petroglyph Canyon, and half a dozen "dot series" at three sites, no entoptic or power symbols occur. Nor is there any obvious differentiation at any site between human figures and those intended to represent supernatural beings. The only possible structured relationships, other than the human groups, are man/bird compositions at Joliet and Petroglyph Canyon, and while these may be vision quest scenes, neither is an obvious representation of the acquisition of supernatural power or the possession of a guardian spirit (fig. 9.9). One other possible shamanistic use of this art is the pecking of "blood" flowing from the nose of a bison at Petroglyph Canyon (Loendorf 1992). Such symbolism sometimes metaphorically represents a shaman's trance in other rock art, but dating suggests that the blood pecking was added to the original bison more than 500 years after it was carved. Bleeding from the mouth might also indicate some sort of hunting ritual, since wounded animals frequently do this.

The depiction of human figures in mixed sex and age groups may be the best clue to eventually discerning the function of this rock art. Clearly, the relatively organized composition of these groups suggests they served some ritual purpose. Perhaps they were intended to represent family or other kinship units in a somewhat portraitlike pose. Such depictions are not common in other Northwestern Plains rock art traditions, and where they occur in rock art of the American Southwest, little functional information is available. The emphasis on sexual features perhaps also

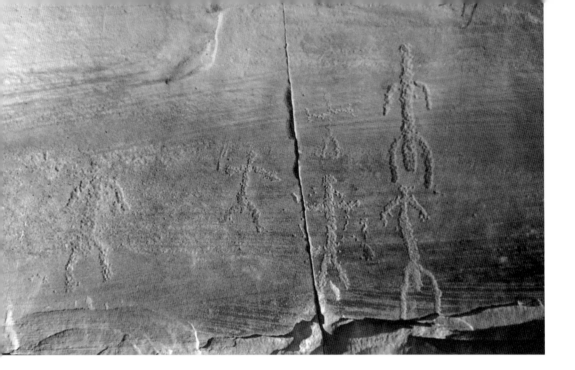

A "family group" of En Toto Pecked tradition humans at Weatherman Draw, Montana. (Courtesy of Tom Lewis)

relates to fertility rituals. Although exaggerated sexual features are found in some shamanistic and vision quest rock art, they rarely occur on female figures. The occurrence of amorphous pecked areas at most sites may also have some functional connotation, and their manufacture possibly had some ritual significance. Most of these do not appear to represent unfinished or eroded figures, and most are more than just random battering of the cliff.

In summary, there is too little information to make even a well-educated guess as to the function and meaning of this mysterious rock art tradition. The significance of these images could involve kinship group interactions, rituals associated with fertility—or something else so far entirely unsuspected.

10 / Pecked Abstract Tradition

The petroglyphs of the Pecked Abstract tradition are complex, asymmetrical, mazelike compositions that almost defy description (fig. 10.1). Pecked into the sandstones that underlie the Black Hills region, these glyphs are most often simple geometric forms, such as circles and starbursts, connected by undulating, curving, or gridlike lines. Despite their variability, these images are linked together into a broadly defined tradition by similarities of form, structure, apparent function, and location. Although the entirely nonrepresentational and abstract forms of this rock art might seem impossible to interpret, recent research suggests that these strange designs are the vision imagery of ancient shamans.

Dating from the Late Archaic and Late Prehistoric periods, sites of this tradition occur most frequently in the Hogback Ridge area of the Black Hills. However, nearly identical examples are found along the Musselshell River north of Billings, Montana, and in the Wind River drainage of western Wyoming (fig. 10.2). Although very limited in distribution on the Northwestern Plains, similar pecked abstract rock art is known from the Great Basin, Colorado Plateau, and Southwest regions.

Pecked Abstract designs were usually made by freehand percussion pecking, which created wide, shallow grooves that often still show individual peck marks. Some narrow, carefully pecked lines at sites in the northern Black Hills indicate that certain artists apparently used carefully controlled indirect percussion. Associated handprints and footprints at a few sites were produced by fully pecking out their

10.1 Pecked Abstract tradition designs often involve complex combinations of circles, starbursts, and curvilinear grids.

Map 10.1. Pecked Abstract Tradition Rock Art

above: Regional distribution
Large dot shows southern Black Hills.
Note single distant sites in western Wyoming and
south-central Montana.

below: Continental distribution

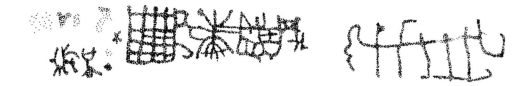

10.2 *This rectilinear grid is a Pecked Abstract tradition petroglyph from a site on the Musselshell River north of Billings, Montana. It is one of few Pecked Abstract sites so far recorded outside the Black Hills.*

forms. These petroglyphs are found on both vertical and horizontal surfaces of sandstone cliffs, outcrops, and boulders. The use of horizontal surfaces is more common in this tradition than in any other on the Northwestern Plains except the Hoofprint tradition.

History of Research

Pecked Abstract petroglyphs were first noted by anthropologists in the late 1930s (Renaud 1936; Buker 1937; Over 1941), but largely because of their abstract form, they were only vaguely described and discussed. Popular thought at the time had one such glyph representing "Coronado's Map," even though this Spanish explorer never came within 500 miles (800 km) of the site.

Pecked Abstract sites were first related to each another and recognized as a "style" in 1980, during a rock art survey of the southern Black Hills (Sundstrom 1981, 1984, 1990). At that time, Sundstrom recognized what she felt were two different styles—Pecked Geometric and Pecked Abstract—that fit chronologically between the Early Hunting tradition and the Late Prehistoric incised rock art common to the area. She speculated that the pecked styles dated to the early part of the Late Prehistoric period. Following additional fieldwork (Sundstrom 1993), information from new sites has shown that Pecked Geometric and Pecked Abstract are, in fact, two varieties of a single

tradition, which Sundstrom has named Pecked Abstract. Additional dating clues have also moved its time range back into the Archaic period, beginning around 500 B.C.

Other than Sundstrom's research, published descriptions and analyses of similar sites on the Northwestern Plains are virtually nonexistent. A few Pecked Abstract sites are discussed in the literature (Tratebas 1993), while others have been recorded by interested amateur researchers. Such sites are relatively unrecognized in the professional literature, probably because this tradition's formal simplicity and lack of representational motifs make it so difficult to interpret.

The Rock Art

The individual, disconnected nature of Pecked Abstract motifs at some sites, in contrast to the complex mazes found at others, originally led Sundstrom (1984, 1990) to define the rock art of this tradition as two completely separate styles. Additional analysis demonstrating the nearly identical form of individual images, and the discovery of sites transitional between those with individual motifs and those with mazes, have since led her to consider these differences as representing two varieties of a single style, or in our terms, two styles of a single tradition.

Geometric Abstracts

Pecked Abstract rock art most often takes the form of extremely complex curvilinear and rectilinear compositions in which individual elements are difficult to distinguish. Some sites show the basic geometric or abstract design elements—such as circles, squiggles, sunbursts, or stars—as independent figures or as

10.3 *A variety of small geometric designs are found as independent images in the Pecked Abstract tradition. Often these are similar to parts of larger compositions.*

part of small compositions with two or three connected designs (fig. 10.3). However, most sites are characterized by extensive mazes of interconnected design elements.

In the mazelike designs, various geometric design elements, including circles, ovals, spirals, squiggles, arches, crosses, dots, and rayed asterisk or sunburst figures, are interconnected by a seemingly random array of straight, curved, or wavy lines (fig. 10.4). Some "mazes" consist almost entirely of numerous wavy lines connecting only two or three other elements. Width and orientation can change rapidly along the same line, and often a line with smoothly carved, rhythmic undulations will suddenly change to an irregular zigzag or series of connected loops, or go almost completely straight.

Representational Motifs

Twenty-eight pecked human hand and foot prints are associated with geometric forms or mazes at seven Pecked Abstract tradition sites (fig. 10.5). One or two are somewhat realistic depictions of human extremities, but most are highly stylized, and some have extra digits or a finger ending in an abstract starburst design. Most appear to have been pecked as simulated prints rather than the outline of a real handprint or footprint. Usually multiple prints occur at a site: one has eight footprints and a handprint, while another has five footprints and four handprints. Although clearly representational, the execution and placement of

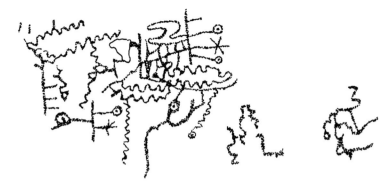

10.4 *Wavy line mazes often include other elements. This Black Hills example has six circles with central dots.*

these motifs, and the absence of related representational motifs, strongly associate them with the otherwise nonrepresentational, abstract rock art of this tradition. In addition, stick-figure humans are associated with mazes at two sites.

Compositional Arrangements

Rock art in this tradition is generally oriented in long horizontal compositions on vertical panels (fig. 10.6). Mazes routinely measure more than 5 feet (1.5 m) across, and some extend along cliff faces 12 to 14 feet (4 m). Pecked Abstract designs were also frequently made on horizontal rock surfaces and sometimes extend from horizontal faces to neighboring vertical faces.

The basic compositional arrangement involves various individual design elements connected by curvilinear and rectilinear lines to form grids or mazes. Frequently design elements are strung together to make chains of connected loops or circles, lines of dots, ladderlike designs, or amorphous clusters of circles or circles and dots. One frequent composition has circles, or circles with central dots, spaced along a single line like loosely strung beads on a string. The artists responsible for Pecked Abstract rock art exhibited a notable disregard, however, for careful spatial arrangement of their designs. Recognizable patterns of relationships are not present, and compositions are neither symmetrical nor balanced. Mazes often extend beyond the natural boundaries of the rock surface "panels" on these cliff faces, often spilling over onto neighboring surfaces. Designs extend up the back wall and onto the ceiling of a rock-shelter, around a projecting corner, or off a horizontal, tablelike surface and down a vertical one (fig. 10.7). Often small satellite compositions are scattered around a maze in a seemingly haphazard fashion.

The overall effect of these compositional characteristics creates a complex but very

10.5 *A few Pecked Abstract tradition sites have associated hand and foot prints.*

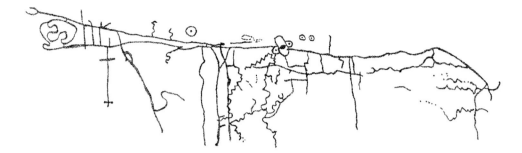

10.6 Some Pecked Abstract tradition compositions can be quite large. This one extends more than 12 feet (4 meters).

loosely structured, asymmetrical, and almost unbounded art. Viewing it from a modern Western perspective, this tradition appears to have few rules governing its production and composition—and those that exist appear to be highly flexible.

Dating and Chronology

Using a variety of dating clues, including relative weathering, patination, superimpositioning, and the relative age of rock surfaces, Sundstrom (1984, 1990) originally estimated that the Pecked Abstract tradition dated to the latter part of the Late Archaic period and to the early Late Prehistoric, roughly between A.D. 500 and 1200. Her evidence showed that Pecked Abstract designs were occasionally superimposed on Early Hunting tradition motifs, and that they sometimes appeared less patinated or were placed on more recent rock surfaces than motifs from the Early Hunting tradition. Using the same criteria, incised designs from several Late Prehistoric traditions always postdated the Pecked Abstract tradition.

Sundstrom's initial age estimates were in part predicated on a belief that rock art generally was not very old, and that the preceding Early Hunting tradition (which clearly predated Pecked Abstract at the sites she examined) dated to the Late Archaic

period and ended only approximately A.D. 500. More recent research (Sundstrom 1993; Tratebas 1993) indicates that the Early Hunting tradition ended almost 1000 years earlier (500 B.C.), and based on relative patination, the earliest Pecked Abstract sites are contemporary (or nearly so) with these last Early Hunting tradition sites. In addition, one Pecked Abstract tradition site has been tentatively dated by cation ratio to A.D. 650. Rock art dating elsewhere on the Northwestern Plains has also pushed the beginning of the later incised traditions back almost to A.D. 1000.

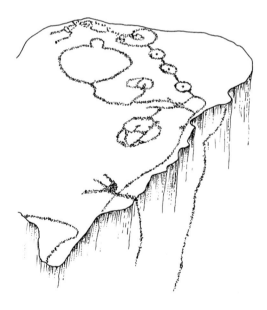

10.7 Pecked Abstract tradition designs often disregard natural "boundaries." In this example part of the design on a horizontal surface extends down a vertical face.

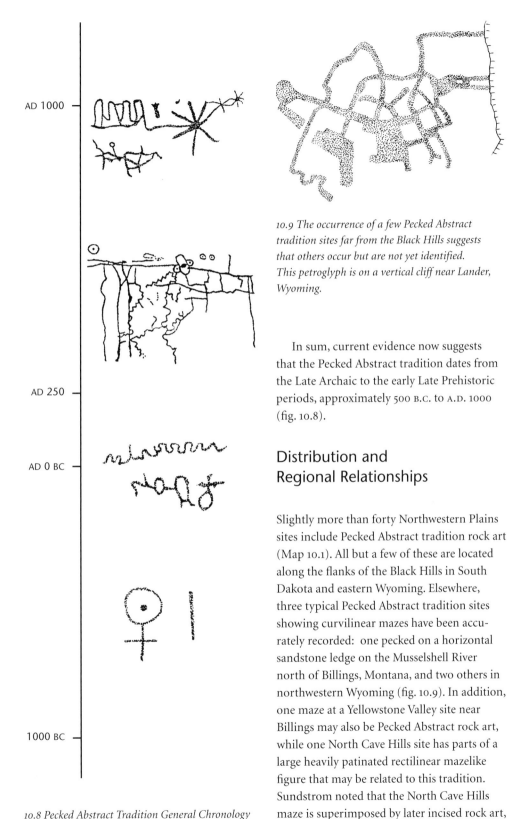

AD 1000

AD 250

AD 0 BC

1000 BC

10.8 Pecked Abstract Tradition General Chronology

10.9 The occurrence of a few Pecked Abstract tradition sites far from the Black Hills suggests that others occur but are not yet identified. This petroglyph is on a vertical cliff near Lander, Wyoming.

In sum, current evidence now suggests that the Pecked Abstract tradition dates from the Late Archaic to the early Late Prehistoric periods, approximately 500 B.C. to A.D. 1000 (fig. 10.8).

Distribution and Regional Relationships

Slightly more than forty Northwestern Plains sites include Pecked Abstract tradition rock art (Map 10.1). All but a few of these are located along the flanks of the Black Hills in South Dakota and eastern Wyoming. Elsewhere, three typical Pecked Abstract tradition sites showing curvilinear mazes have been accurately recorded: one pecked on a horizontal sandstone ledge on the Musselshell River north of Billings, Montana, and two others in northwestern Wyoming (fig. 10.9). In addition, one maze at a Yellowstone Valley site near Billings may also be Pecked Abstract rock art, while one North Cave Hills site has parts of a large heavily patinated rectilinear mazelike figure that may be related to this tradition. Sundstrom noted that the North Cave Hills maze is superimposed by later incised rock art,

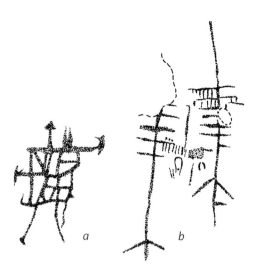

10.10 Two possible pecked Abstract tradition images from outside the Black Hills: a, near Billings, Montana; b, North Cave Hills.

and she thinks that the maze also represents incised tradition rock art. The lines appear to be pecked, however, and based on relative patination, they are significantly older than any other North Cave Hills petroglyphs, so they may in fact represent the Pecked Abstract tradition (fig. 10.10). A few other sites that may represent this tradition are reported but not yet accurately recorded.

Clearly, the Pecked Abstract tradition has its greatest concentration around the Black Hills. The near-absence of sites in the Yellowstone Valley and most of Wyoming, however, may not be an accurate representation of the actual distribution of this tradition. The absence of representational motifs, coupled with the difficulty of interpreting pecked squiggle designs, has probably contributed to a lack of professional and amateur interest in Pecked Abstract tradition sites. These sites often contain only well-patinated, curvilinear mazes, which may not be recorded, or in some cases even recognized. Additional fieldwork, especially in light of dating possibilities, may well result in record-

ing more Pecked Abstract sites.

Outside the Northwestern Plains, somewhat similar curvilinear pecked designs are found in regions to the south and west, including the Great Basin, the Colorado Plateau, the Southwest, and on the plains of southeastern Colorado (Map 10.1). Great Basin Curvilinear Abstract style rock art (Steward 1929; Heizer and Baumhoff 1962; Schaafsma 1971) occurs at numerous sites throughout Nevada and Utah and includes curvilinear mazes composed of circles, squiggles, dots, starbursts, and wavy lines. Many show the same disregard for natural surface boundaries as occurs at Black Hills sites, including the continuation of mazes from horizontal to vertical surfaces. In the Colorado Plateau, Cole (1987, 1990) defines an Archaic period Abstract Rock Art tradition that includes mazes formed from circles, circle chains, rayed circles, squiggles, and wavy lines that extend over and around rock surfaces, often following the edges of boulders. A few representational images also occasionally occur, including footprints, handprints, and bear paws.

To the south on the plains and canyon-lands of southeastern Colorado, Renaud (1936) recorded pecked curvilinear mazes very similar to those of the Black Hills. One is superimposed on a herd scene of small pecked quadrupeds. Both Buckles (1989) and Loendorf (1991) have recorded similar maze figures in this same area, dating them to the Late Archaic period. Further south, Schaafsma (1980) describes similar Archaic period abstract petroglyphs throughout Arizona and New Mexico. This evidence, coupled with the lack of similar sites to the north, east, and southeast of the Plains, strongly suggests that the Northwestern Plains Pecked Abstract tradition is part of widespread Archaic period petroglyph tradition that extends across western North America from northern Mexico to the Great Basin and Great Plains regions of the United States.

Cultural Affiliations

The cultural identity of the artists who made Pecked Abstract rock art is not known, largely owing to the age of the tradition and the lack of recognizable motifs. Throughout the range of this tradition, these petroglyphs were produced during the Archaic period when small, egalitarian bands of hunter-gatherers occupied western North America. For this reason, several authors (Cole 1990; Schaafsma 1980) have called this tradition "hunter-gatherer rock art," to distinguish it from rock art of later Great Basin and Southwestern farming cultures, such as the Fremont, Anasazi, and Hohokam.

On the Northwestern Plains, however, nearly all rock art is the product of hunter-gatherer groups. The Missouri River farming cultures made very little rock art, and much of what they probably created was made during bison-hunting expeditions out onto the true plains. Thus, no corresponding cultural shift from hunter-gatherers to horticulturalists exists to distinguish older from younger rock art on the Northwestern Plains.

The cultural origin of curvilinear Pecked Abstract designs, such as this at Trail Lakes, Wyoming, is unknown.

In the Black Hills area and throughout Wyoming and the upper Yellowstone valley, Late Archaic period archaeological sites are characterized by projectile points generally classified as Pelican Lake and Besant, plus a variety of other points that do not comfortably fit into either type. Much variation also exists between various Besant and Pelican Lake sites distributed from southern Saskatchewan and Alberta to central South Dakota and southwestern Wyoming. Furthermore, many sites in this region do not fit into either broadly defined cultural complex. Given this variation, it is probable that a variety of ethnic groups lived in the area between 500 B.C. and A.D. 1000. Any one of these Archaic period hunter-gatherer groups, or a combination of them, could have been responsible for the Pecked Abstract tradition.

Interpretations

At first glance, the absence of representational motifs in Pecked Abstract rock art implies that its function would be very difficult, if not impossible, to interpret. Nothing depicted in the rock art "makes sense" from a modern Western perspective (fig. 10.11). This led some early authors to suggest that these strange curvilinear and rectilinear patterns were maps,

or else merely meaningless doodles. Other scholars assumed they were more than doodles because they displayed broad geographic patterns, were well executed, and showed a nonrandom distribution across the landscape. They believed the maze designs must have some unknown ritual significance that likely could not be discerned because the artists were long gone.

Recent research, however, suggests that Northwestern Plains Pecked Abstract rock art functioned in a shamanistic context. This interpretive shift comes primarily from research concerning similarities and differences in the structure of art in different cultures, and the neuropsychological responses to trance experiences that are shared by all humans. Sundstrom (1990) notes that

this tradition does not conform to the typical structure for art produced by most egalitarian societies, such as the tribal- or band-level societies characteristic of Archaic period Northwestern Plains cultural groups. Around the world, egalitarian societies produce relatively simple, rhythmically repetitious art of generally symmetrical design. In such art, groups of similar sized elements tend to be centered within or framed by natural features of the rock surface, and much unused space occurs between and among figures. Pecked Abstract rock art, however, is characterized by complex, crowded, asymmetrical compositions with little rhythm, minimal repetition, little unused space, and almost complete disregard for the boundaries of the natural rock surfaces.

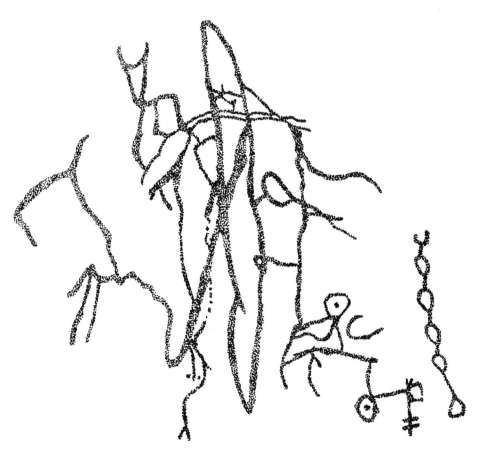

10.11 An enigmatic curvilinear maze with dotted circles and a circle chain.

10.12 Design elements such as spirals, grids, circle chains, and starbursts are common entoptic images.

Structurally, the rock art is so different from other Northwestern Plains traditions that one might assume it was carved by artists from a more highly structured social system. Yet neither does Pecked Abstract rock art conform to the structure of art typically made by hierarchical societies—such as farmers or animal herders organized into a chiefdom or state type of society. Furthermore, no such cultures occurred on the Northwestern Plains or in neighboring areas during the time that this art was carved. Therefore, Sundstrom (1990) suggests that this rock art tradition deviates from the expected pattern for egalitarian band-level hunter-gatherers because it was made in a context that does not accurately reflect social organization.

In this view, Sundstrom (1990) argues that Pecked Abstract rock art reflects shamanic trance experiences because it appears to almost exclusively represent entoptic imagery

(fig. 10.12). Ethnographic evidence documents that shamans experience these same entoptic forms during their trances—referring to them as flashing lights, dancing fire, sparks, or stars (Whitley 1994b). In the second phase of a trance, these forms are often perceived according to different principles, such as duplication, rotation, integration and super-imposition or juxtaposition. Somewhat similar Chumash rock art (in terms of form and structure) was apparently produced as a result of drug-induced hallucinations and displays many of these entoptic forms and perception principles.

In addition to the formal similarities between Pecked Abstract rock art and entoptic imagery, the absence of clearcut structure in this tradition supports its assignment to some sort of shamanic ritual (fig. 10.13). In general, structure in art reflects social boundaries or rules, and Sundstrom (1990) argues that this tradition's lack of structure may reflect the temporary loosening of social rules that resulted from an individualistic or mystical experience. Furthermore, this antistructured art fits well within the condition of "limi-nality" (a transitional or "in-between" state), which characterizes the suspension of normal everyday rules during a "life crisis" ritual. The shaman's vision quest is exactly this sort of ritual, a transformation from the everyday world to the incredibly perilous spirit world. In performances associated with such liminal states, new structures or antistructures are created and used.

On the Northwestern Plains, shamanism involved an ecstatic trance, produced more by sensory deprivation (including isolation, fasting, dancing to exhaustion, repetitious

drumming and singing, and self-inflicted pain)—which actually enhanced the perception of entoptic phenomena—than by hallucinogenic drugs. However, tobacco (an often powerful drug in its native form) was also used, and other drugs such as datura, peyote, and mescal may have been traded into the area and used during Archaic times.

In summary, it seems likely that the Northwestern Plains Pecked Abstract rock art was produced by shamans as part of rituals associated with trance experiences. Whether it was part of a shaman's initiation, commemoration of a successful vision, or part of a group ritual led by a shaman cannot be conclusively determined. However, the wide diversity of site locations suggests that it was made more as an individual ritual than through group participation. The concentration of Pecked Abstract sites around the Black Hills might seem to suggest that it was made by members of only one or two local groups, but ethnographically, many groups considered the Black Hills sacred, and in the hills there is evidence of Late Prehistoric period rock art that appears to have been made by people traveling long distances. A similar situation is noted in California, where shamans desiring special rainmaking power came from long distances across the Great Basin to have visions in the Coso Range. The Black Hills possibly served as a focal point for shamans from across a large area of the Northwestern Plains during the Archaic period.

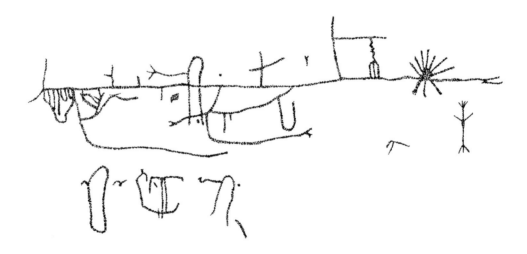

10.13 *This Pecked Abstract tradition site includes a human figure (far right) apparently associated with the maze, and perhaps representing a shaman.*

11 / Foothills Abstract Tradition

Hidden away in the Rocky Mountain foothills and outlying mountain ranges of central Montana and southwestern Alberta, the red pictographs of the Foothills Abstract tradition attest to a long tradition of shamanistic ceremonialism that flourished in this region for thousands of years. In caves, rockshelters, and canyons, highly stylized pictographs of humans, animals, masks, and mazes symbolize the transformations of shamans on spirit journeys. At other sites, large rock walls are entirely smeared with red paint or covered with clusters of human handprints—the product of ritual initiations.

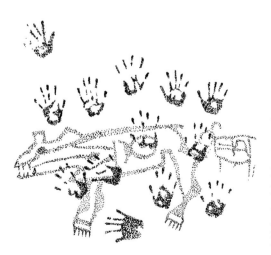

11.1 *This Grizzly bear superimposed by handprints suggests ritual reuse of a site, possibly for initiations or other rites of passage. Note internal organs shown inside bear and probable mountain sheep at right.*

The most notable of these sites graphically illustrate the power of the Bear Shaman. In one dark cave, a zigzag "power line" connects a shaman to a large grizzly bear. At another, a small cave forms the mouth of a large painted bear's face from which the shaman could speak to those gathered below for rituals. A painted image in another cave resembles a human when viewed one way, but is clearly a bear when viewed the other. Yet another site shows a large, open-mouthed grizzly bear on which more than a dozen handprints have been impressed—the marks of young participants in bear cult rituals (fig. 11.1). These sites are some of the most intriguing expressions of Northwestern Plains rock art, yet they remain poorly known, and there is still much to learn about their age, distribution, and function.

Foothills Abstract rock art incorporates many simple representational images, such as stick-figure humans, animals, and handprints, with highly abstracted images that appear to represent shamans, masks, and mazes. Humans are frequently connected to animals, handprints, or masks by way of long "power lines" (fig. 11.2). The rock art of this tradition consists almost entirely of red finger-painted pictographs. Sites frequently include groups of long finger lines, while broad surfaces liberally smeared with red pigment are common in the northern range of this tradition. Most handprints and smears were made by pressing pigment-covered palms against the rock surface.

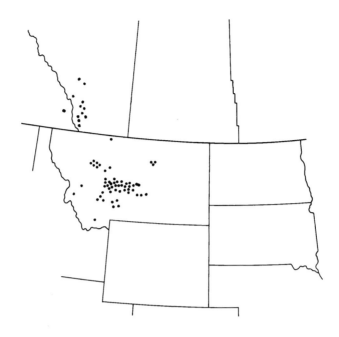

Map 11.1. Foothills Abstract Tradition Rock Art

Regional distribution

Dating from Late Archaic to Late Pre-historic times, Foothill Abstract sites occur along the flanks of the Rocky Mountains from southwestern Alberta to southwestern Montana. The tradition also extends eastward into several outlying mountain ranges of central Montana, including the Sweetgrass Hills, Little Rocky, and Little Belt Mountains. Sites are found in a wide variety of settings, including caves, rockshelters, exposed cliffs, large boulders, and large glacial erratics. They range from single figures or small groups to large, exceedingly complex collections of many different motifs painted at several different times. Smaller and simpler sites are by far the most common; the images are frequently painted in small caves or other cramped quarters.

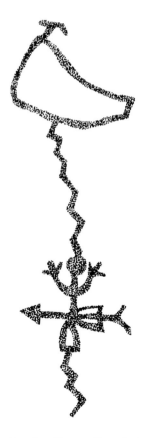

11.2 This abbreviated human figure is pierced by an arrow and run through by a zigzag power line.

History of Research

A few Foothills Abstract tradition sites were first reported in the 1950s and early 1960s (Leechman, Hess and Fowler 1955; Shumate 1960; Arthur 1960; Conner 1962b), with those in Montana loosely grouped into two styles by Malouf (1961). Almost twenty years later, Keyser (1977b, 1979a, 1990) defined the Central Montana Abstract style on the basis of formal similarities among motifs found at sites in six counties of central Montana. Using characteristic motifs (such as handprints and extremely stylized human figures), he argued that these wide-ranging sites shared many traits and formed a "style" that was significantly different from the Columbia Plateau and Ceremonial rock art, which also occurs in the same area. Based on the highly conventionalized figures, the prepon-derance of handprints, and the X-ray imagery common to many figures, he suggested that the art was the product of shamanistic rituals. Keyser also noted that it likely dated to the precontact era, given the absence of horses and guns.

In the 1990s, researchers working in Montana and Alberta began to discover many more sites with similar motifs, while new motifs and site types were also described (Greer and Greer 1994a, 1994b, 1995a, 1995b, 1996a; Klassen 1994a, 1998b). Recent surveys have extended the range of this rock art beyond central Montana and into south-western Alberta and southeastern British Columbia. On the basis of this work, it is now recognized that Central Montana Abstract pictographs are part of a larger tradition that includes several geographically restricted styles; as a result we refer to it as the Foothills Abstract tradition. The work of Mavis Greer (1995) has also developed the role shamanism played in the creation of this rock art, and its relationship to ritual and landscape also has been explored (Klassen 1998b).

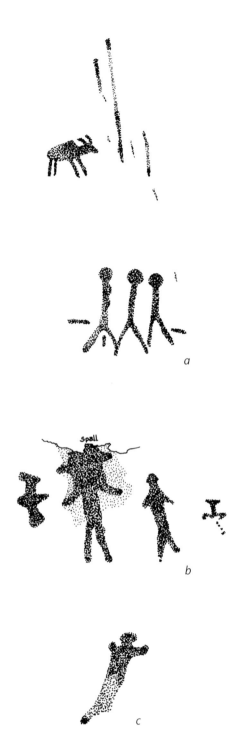

11.3 Foothills Abstract tradition humans frequently lack appendages or have significantly foreshortened arms or legs. Note that the row of armless humans (a) are juxtaposed with an animal and finger lines on a single panel. Upside down figures (b) and leaning figure (c) may be "flying."

The Rock Art

Foothills Abstract rock art includes a wider diversity of images than any other North-western Plains tradition, and incorporates significant amounts of both representational and nonrepresentational images. Motifs can be grouped into eight major categories: human figures and anthropomorphs, animals and zoomorphs, masks, mazes, handprints, finger lines, smears and wall paintings, and geometric abstracts.

Human Figures and Anthropomorphs

Humans and anthropomorphs are a common component of the Foothills Abstract tradition, and they show amazing variety of form (fig. 11.3). In her study of Smith River rock art, Greer (1995) identified eight varieties of human figures and a ninth anthropomorphic variety. All but one include a wide range of body types and associated details of anatomy and costume, including rectilinear forms with various combinations of arms, legs, heads, and headdresses. By far the most common human is the simple stick figure with a bulbous head, legs, arms, and sometimes a phallus; they rarely have hands, feet, or headdresses. In the Smith River area, a third of the humans are stick figures, and other sites show similar or even higher proportions of these simple figures. Almost no humans are shown with facial features or internal body parts.

An absence or severe foreshortening of arms or (less commonly) legs characterizes many of these figures. Some stand erect, while others appear to be flying or levitating based on their odd positioning relative to other figures. Still others are shown emerging from cracks in the wall. Frequently, these "flying" figures are oriented significantly away from vertical, or are upside down, and in some instances they appear on ceilings or positioned on walls above other figures. Sometimes flying figures will have especially unrealistically extended body parts. One tipped, legless stick

figure has a flattened head and splayed fingers half as long as his body. Several have greatly extended legs—the most impressive of these holds objects in both hands and has legs that extend horizontally across the cliff face for a distance more than ten times the length of the body (fig. 11.4).

Human figures also are frequently drawn with upraised arms. Usually these extend outward and bend up at the elbow, although some simply angle upward away from the body. Occasionally these "hands-up" figures hold objects or are drawn with spread fingers. This arms-up posture is typically associated with religious rituals including dancing, praying, and trance behavior for shamans and vision supplicants, and appears in the art of many cultures. Headdresses are also common, usually drawn as simple curved horns at either side of the head, but more elaborate versions include multiple-line "crowns." Some heads are oddly triangular- or diamond-shaped, suggesting that they wear some sort of hatlike

headdress or a mask. The idea of masked humans is supported by the presence of mask images at several sites.

In contrast to human figures, anthropomorphs are sufficiently abstracted so that they appear to represent supernatural beings rather than real humans. Although not particularly common, they comprise some of the most striking images in Foothills Abstract rock art and are often so bizarre as to defy description. No two figures are alike, even at the same site, and a wide variety of conventions are used to create or accentuate their bizarre forms. Sometimes the artist drew internal body designs—in some cases these apparently represent internal organs, but in others they appear as wavy lines running vertically down the body. Occasionally appendages are foreshortened or absent, and sometimes body parts are extremely surrealistically drawn, such as the rectangular head on one figure or the flattened ovals representing legs on another. Sometimes

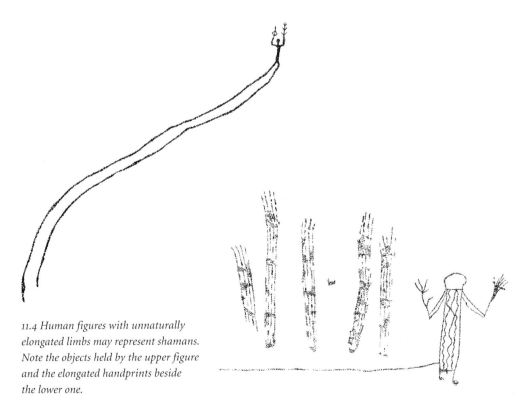

11.4 Human figures with unnaturally elongated limbs may represent shamans. Note the objects held by the upper figure and the elongated handprints beside the lower one.

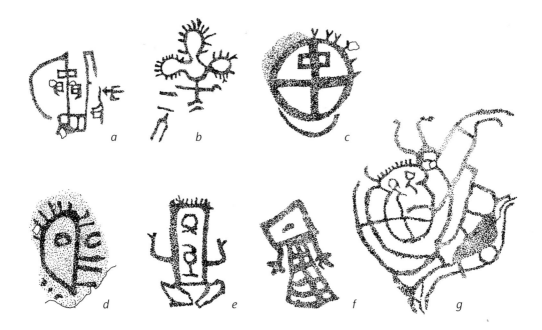

11.5 Foothills Abstract art shows a spectrum from complex maze designs (a, b), through probable masks (c, d), to very abstract anthropomorphs or zoomorphs (e–g) where only one or two features distinguish them. Note arms and "crown" or "hair" (e), arms (f), and eyes and "crown" or "hair" (g).

lines extend outward from bodies, or figures are pierced by arrows. A few figures are obvious therianthropes incorporating human and animal parts.

The most highly abstracted anthropomorphs have only a single human characteristic as part of a painted maze design (fig. 11.5). In one example, two eyes peer out from a "nest" of wavy lines (g), and two other figures are recognizable only by attached arms (e, f). Only the single indisputably human feature allows us to separate the anthropomorphic figure from the complex abstract maze—for example, an upper rectangle is recognized as a head, or flattened ovals are recognized as legs. These figures bridge a gap between the elaborated humans (like those with long legs or levitating out of cracks) and the mask and maze figures found at the opposite end of

the spectrum of "humanness" (Keyser 1990). This spectrum ranges from stick figures to anthropomorphs to masks, and finally to geometric maze figures—all without any obvious break in the sequence. The similarities among anthropomorphs, masks, and mazes implies a unity of meaning and function for all these categories of images.

Animal Figures and Zoomorphs

Animals are significantly less common in this rock art tradition than human and human-related motifs (Greer 1995; Keyser 1979a). As many Foothills Abstract sites are only partially recorded, and more than half the known examples remain unpublished, and because bizarrely drawn anthropomorphs and clusters of handprints often draw the most attention, we anticipate that more animal figures will be identified in this tradition. Nonetheless, based on well-documented and reported sites, it seems apparent that animals were not a significant focus, except for certain species at specific sites.

Animals in this tradition are found as four basic forms: side-view, solid color, block-body quadruped forms; spread-eagled birds; plan-

view turtles, lizards, and snakes; and a few animal tracks. Quadrupeds, the most common, include depictions of bear, bison, canids, elk, mountain sheep, and other unidentified animals (figs. 11.3, 11.6).

Bears, known from ten sites, are the most common of the large quadruped animals. Most appear, from their pronounced humps, to be grizzlies. Long, exaggerated claws are frequently drawn, and one large bear has a dotted face pattern indicating "tear streaks," typical of grizzly bears drawn in several areas of western North America. Of the other large animals, only mountain sheep—identified by

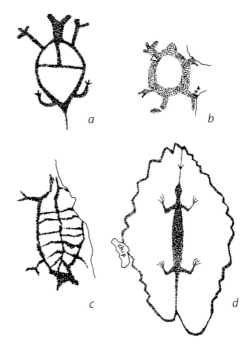

11.7 Turtles and lizards are common in Foothills Abstract art. Note power line surrounding lizard; c is black painting from an Alberta site; others are red pictographs from central Montana sites.

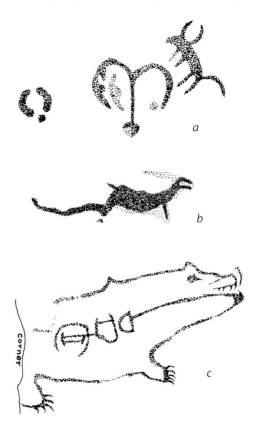

11.6 Foothills Abstract animal figures also show foreshortened body parts, trailing lines, and interior lines probably representing internal organs. Like the bear in fig. 11.1, this bear (c) also has an associated group of more than a dozen handprints. The composition of animal, masklike abstract, and possible hoofprint (a) is from an Alberta foothills site; others are from central Montana.

the characteristic swept-back horns—occur frequently. Three bison are represented by front-view skull or head images. One large unidentified quadruped has abstracted hooves and a cross and circle attached to its snout. Of the other painted animals, turtles are the most common (fig. 11.7), although twelve of the seventeen examples occur at a single site. Birds occur at more sites than turtles, usually as the spread-eagled "thunderbird" motif.

Animal tracks are not a major motif in this tradition. The most common animal tracks are bear paws, some of which can be confused with simulated handprints, but bird tracks and a few cloven hoofprints also occur. Some of the hoofprints and bird tracks identified at Smith River sites may fit in the geometric category, but a few of the bison tracks are clearly painted hoofprints with dewclaws indicated.

Analogous to the difference between humans and anthropomorphs, a few zoomorphic figures with basic animal shapes show such abstraction that they clearly do not represent living creatures. Zoomorphs, like anthropomorphs, may represent spirit beings. The best examples include a bisonlike zoomorph with highly abstracted details including a sawtooth backbone and odd horns and eye, and bearlike figures at Audrey's Overhang and Bear Mask Cave. The Audrey's Overhang bear shows extensive internal detail and an odd, almost unrecognizable head. Keyser (1977b) originally illustrated this figure in a vertical position and identified it as a highly abstract anthropomorph (see fig. 1.2). Short claws on its two feet were later identified, and when the image is rotated 90 degrees, it appears to be a very abstract bear. Like the blurred distinctions between some stylized handprints and bear paws, this shows the transformation imagery inherent in some bear depictions. Finally, Bear Mask Cave has a very special zoomorphic painting—a large bear's face is painted to include a small cave that serves as the bear's mouth.

Masks

It has been suggested that some of the figures initially identified as anthropomorphs (Keyser 1979a, 1990) represent masks, based on the identification of mask images at new sites (Greer and Greer 1994a; Greer 1995). Like anthropomorphs, each mask has its individual appearance; the only two that are even vaguely similar are painted at the same site (fig. 11.5). These masks include fairly obvious representations showing eyes, a mouth, and upright hair or feathers, and considerably more abstracted examples that are no more than mazes with two dots for eyes. One mask clearly represents a bear's head. At some sites, masks appear to take the place of humans or anthropomorphs, but at others, they are painted on panels that also include humans, anthropomorphs, or both.

Mazes

Mazes range from simple designs lacking only the eyes that would identify them as masks to elaborate, convoluted compositions of circles, rectangles, lines, and dots. A few are linear arrangements of dots, circles, rectangles, loops, or other shapes connected by a line. Often arrows or crossbars extend from a linear maze. One maze has a number of facelike images stacked above and beside one another with an arrow extending upward. One linear maze, formed of lines and dots, incorporates small dancing human figures into the dot pattern. When viewed as a whole composition, however, this maze appears to form the head and

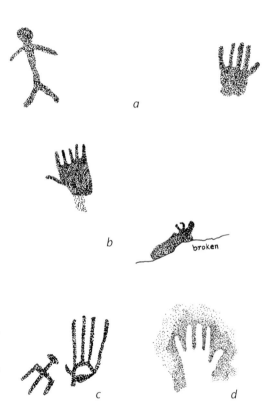

11.8 The hallmark handprints of the Foothills Abstract tradition are often juxtaposed with other figures. The handprint in b may be a bear paw with added "thumb." The "skeletal" style handprint in c is juxtaposed with an attenuated human or bird figure; and d shows one of the few known hand stencils.

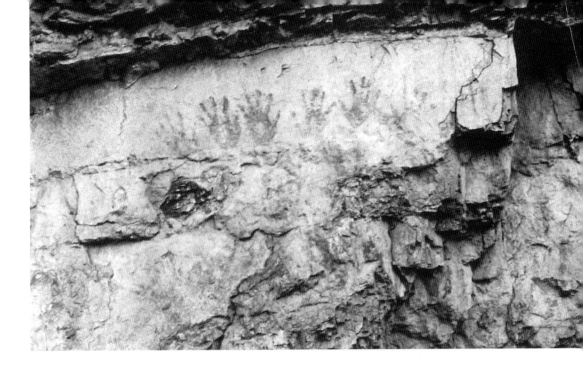

Panels of handprints like this one in Montana's Smith River drainage characterize many Foothills Abstract tradition sites.

neck of a bear in profile. Like masks and anthropomorphs, no two mazes are the same or even especially similar, except in the sense that they all represent approximately the same degree of formal abstraction.

Handprints

Handprints are common, and they occur alone or in groups ranging from two to more than twenty-five (fig. 11.8). At some sites handprints are the only image; at others, they are associated with other motifs. At several sites, handprints are superimposed on other paintings—sometimes over the red wall-paintings that characterize many of the northern sites—but in the most dramatic example, thirteen hands are painted over and around a large red grizzly bear (fig. 11.1). Groups of impressed handprints occur on the cliff face below at least three buffalo jumps—two in Alberta and one near Great Falls, Montana.

Handprints include actual prints, made by pressing the paint-covered palm and fingers directly on the rock surface; simulated prints, which do not conform to the size or proportion of real hands; and a few hand stencils, made by holding the hand against the cliff and blowing, spitting, or smearing pigment around it so that a negative, unpainted image remains when the hand is removed. Real handprints far outnumber simulated prints and stencils. Handprints also grade into finger lines and smears. Some finger lines appear to be made by impressing the palm and fingers against the surface and then dragging the pigment-covered fingertips downward (fig. 11.4). Others reverse that process so that the palm impression is at or near the bottom of long finger lines. Some smears retain individual finger impressions but look as though the paint-covered palm was rotated to create a smear.

Some simulated prints have six fingers, or the thumb shown in an unnatural position, and a few are outsized. The largest simulated handprint is more than 16 inches (40 cm) tall and surrounded by fifteen actual handprints. Although most of the simulated hands are

realistic (some may even be actual handprints overpainted to fill in areas such as the central palm and knuckles, which frequently lack pigment in hand impressions), a few are clearly stylized handprints not intended to look realistic. Both left and right actual and simulated handprints are known, but because of erosion and the unevenness of some painted surfaces, it is not possible to tell which hand is represented in more than half of the handprints. Where handedness can be determined, there is a decided preference for right hand impressions. It is difficult to distinguish between some simulated hand-prints and some bear paws—in several cases, different observers have classified the same image differently. Given the distinctive transformation relationships between bears and humans in this art, this is not surprising.

Confirmed hand stencils have only recently been discovered at two Foothills Abstract sites in central Montana (Greer and Greer 1999). About twenty stenciled handprints made by daubing white clay around hands and fore-

At the Split Rock site in southern Alberta, smears of red ochre cover both inside walls of the passage formed by this large broken glacial erratic.

arms are located at two related sites in central Wyoming (Loendorf and Francis 1987). The affiliation of these sites with the Foothills Abstract tradition has not been firmly established.

Finger Lines

Although they are one of the most common components of this tradition, finger lines have only been recently recognized as important. These lines are not the short, evenly spaced, evenly pigmented tally marks so characteristic of Columbia Plateau tradition rock art. Rather, they are relatively long streaks, often with uneven pigment application, painted vertically or horizontally on the rock surface. Finger lines occur singly or in groups of two to four, although groups of three seem most common, and they sometimes occur in clustered arrangements. They are usually relatively straight or gently curved, rather than sinuous. Some groups of three lines appear to have been made by drawing the index, middle, and ring fingers across the rock surface. In some cases, long finger lines connect to other figures. Finger lines are frequently quite long—at one site, a single horizontal line stretches nearly 25 feet (8 m). In the Smith and Judith River drainages these lines are

either the only or the dominant paintings at several sites, and frequently a small site composed primarily of finger lines will be located near a larger, more complex site with multiple designs.

Smears and Painted Walls

Relatively large pigment smears are an important characteristic of Foothills Abstract rock art. These smears are not merely areas where paint-covered hands or brushes were cleaned, but instead represent deliberate application of pigment for the purpose of coloring a large area of a panel or a wall. In the Smith River area, these smears range from small areas less than 4 inches (10 cm) across to much larger ones that sometimes cover most of a panel with red pigment (Greer 1995). At one site, the smears are painted in a roughly circular arrangement. Interestingly, these painted surfaces at the Smith River sites were rarely overpainted by other figures.

Painted walls, on the other hand, are common in the northern area of this art tradition, and at many of these sites, hand-prints, stick-figure humans, masks, anthropo-morphs, or finger lines are overpainted on the pigment-smeared walls. Almost all Foothills Abstract sites in Alberta and the single site in British Columbia have extensive smeared areas or entire walls painted red; the paint at one site south of Canmore extends for nearly 30 feet (9 m). At the Split Rock site south of Calgary, both interior walls of a narrow passageway, formed when a large glacial erratic split in two, are painted red. The entire interior of a small cave in the Sweetgrass Hills is painted red, and Look-out Cave has an extensive red-painted wall extending below cultural deposits. Most of the sites on the upper Sun River in west-central Montana include extensive painted walls—a characteristic that draws attention to the sites from a considerable distance away (Greer and Greer 1994a).

Possibly related to the painted walls are the spattered areas found at some sites. These are "clouds" of small paint droplets spattered over painted surfaces, as if the artist had flicked his paint-covered fingers or a small brush at the cliff. Spattered areas are associated with a few painted wall sites, but also occur at sites without smears or painted walls. Sometimes the spatters extend a significant distance above other painted figures.

Geometric Figures

Geometric figures occur in limited numbers in Foothills Abstract rock art. They include short lines, zigzags, V shapes, circles, crosses, triangles, rectangles, and groups of dots. In many instances, two or more of these basic shapes are grouped as elements of small, compact, geometric designs. The most complex of these geometric designs are similar to the simplest geometric maze figures, and therefore may be related (fig. 11.9).

One interesting pattern is the preponder-ance of geometric figures and simple geomet-

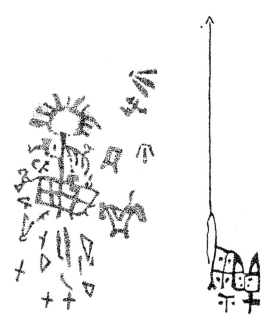

11.9 Complex geometric designs from sites in Montana's Smith River drainage form simple maze figures.

These Foothills Abstract figures are randomly distributed across the domed ceiling of a small sandstone cave near Pekisko, Alberta.

ric designs painted in caves rather than in rockshelters or at open bluff sites. On the Judith River, several small caves have interior domed chambers, large enough for only a single person, where the ceiling is painted with geometric designs including crosses, circles, lines, and dots. Similar geometrics are painted in similar ceiling locations at two Alberta sites.

Compositional Arrangements

Most Foothills Abstract sites consist of single images or small groups of juxtaposed pictographs. Associations and interaction between most figures in juxtaposed groups are not readily apparent, although in some cases the figures appear to be arranged in a row. Sometimes geometric designs or elements are associated with humans or animal figures, or humans and animals are clustered together (fig. 11.10). At one site, several turtles are clustered around a very abstract design which may be an anthropomorph. At a number of

sites, humans, animals, and geometric designs are directly connected by zigzag lines (fig. 11.2). Two turtles are connected to power lines, and one lizard with an extended forked tongue is an elaborate, carefully drawn figure surrounded by a diamond-shaped pattern of zigzag lines (fig. 11.7).

Sites with more than 50 images are uncommon, but a very few have as many as 100 to 150 figures. The placement of figures generally appears to be quite random, and in many cases different motifs and designs are intentionally superimposed over others. This is particularly apparent at sites where handprints are superimposed over bears or other designs, or at wall-painted sites where numerous handprints, finger lines, and geometric elements are superimposed on smears.

Another attribute noted occasionally at Foothills Abstract sites involves scratches into the pigment of some painted designs, apparently done with a sharp stone flake (fig. 11.11). In some cases, these scratches all but obliterate small figures, while at other sites they simply crisscross pigmented areas. A stone flake apparently used to scratch pigment from

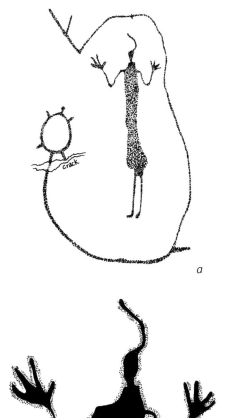

Dating and Chronology

Although the Foothills Abstract tradition has only been dated roughly by relative means, a few lines of evidence suggest that it spans the Late Archaic and Late Prehistoric periods (fig. 11.12). Early investigators, noting the absence of horses and guns, inferred that the rock art predated the Historic period. Historic items still have not been identified at any Foothills Abstract site. Given the supernatural qualities attributed to both horses and guns by all documented Northwestern Plains groups, and the early incorporation of these motifs into the Columbia Plateau, Ceremonial, and Hoofprint traditions, their complete absence remains strong evidence that Foothills Abstract art was discontinued before approximately A.D. 1700.

Other evidence suggests that the tradition is much older, predating the last half of the Late Prehistoric period. The classic motifs of Late Prehistoric Ceremonial tradition rock art—V-neck humans, shield-bearing warriors, and boat-form animals—are missing from Foothills Abstract pictographs. Only a single V-neck figure is clearly associated with this tradition, and it does not closely resemble those typical of the Ceremonial tradition (Greer 1995:264). Furthermore, at several central Montana and southwest Alberta sites, Ceremonial tradition paintings appear

11.10 This Foothills Abstract composition shows a tall human figure (a) with a turtle on a tether. Note that the human is completely outlined in white pigment (shown by stippling in b, the enlarged detail).

images was recently found stuck into a crack in a cliff at a site near Helena, Montana. At one site on the lower Musselshell River, painted handprints have the palms pecked out instead of scratched. Neither the scratches nor pecked areas form recognizable figures or patterns of any sort, but clearly they were done as an intentional modification of the painted images.

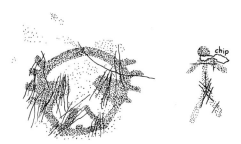

11.11 Badly scratched areas on Foothills Abstract tradition pictographs indicate that the images were revisited and modified by later users. This mask and stick figure are from the upper Judith River, where such scratched modification is common.

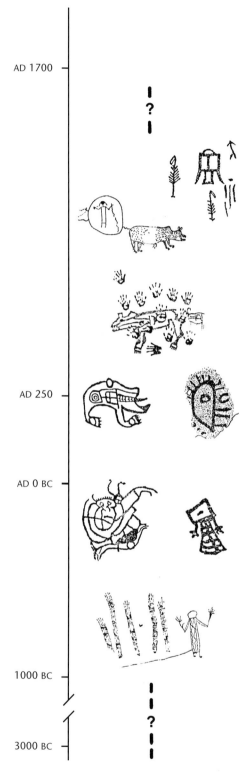

AD 1700

AD 250

AD 0 BC

1000 BC

3000 BC

11.12 Foothills Abstract Tradition General Chronology

to have been added to preexisting panels of Foothills Abstract designs. At several Montana sites, black charcoal Ceremonial motifs are superimposed on Foothills Abstract images, and at other sites these motifs are painted on separate panels adjacent to the Foothills tradition rock art.

Likewise, a few examples of typical Columbia Plateau tradition vision quest scenes—simple stick figures, tally marks, and sun symbols—appear to be later additions to some Foothills Abstract sites. One of these is a direct superimposition, painted on a heavy wash of calcium carbonate that covers and partly obscures an abstract maze design, and others are added peripherally to Foothills tradition rock art panels (Keyser 1979a; Greer 1995:253-54). The Ceremonial and Columbia Plateau traditions both show a strong inclination for using preexisting rock art sites as a "canvas" for making new images (usually during the conduct of vision quest or similar rituals), which implies that these Foothills tradition sites already existed as an attraction for later Late Prehistoric period artists. If, as seems reasonable, the Columbia Plateau vision quest paintings are associated with the Flathead and Pend d'Oreille groups who entered this area during the Late Prehistoric period, it implies that the Foothills Abstract rock art predates at least A.D. 1500. Oral tradition among the Blackfeet lends some support to the conclusion that Foothills Abstract art predates the most recent inhabitants of the area. A Blackfeet elder indicated that a well-known Foothills Abstract tradition site on the upper Sun River was not their doing, but instead had always been known by them to predate their arrival in the area.

Using a series of superimposed images, Greer (1995) undertook an extensive seriation analysis at more than sixty Foothills Abstract sites in the Smith River drainage of central Montana. She discovered that over time there was a shift in pigment preference and a trend from more highly abstract to somewhat more

representational images. Thus, the earliest pictographs in this area tend to be finger lines, simple abstracts, and handprints painted with orange and reddish-orange liquid pigment. Later additions to Foothills Abstract rock art are more complex abstract anthropomorphs, zoomorphs, and bears, which seem to correspond to the adoption of dark red, purple-red, and yellow liquid pigment. The latest paintings are a few Ceremonial tradition images and possibly a Biographic scene drawn with black, red, and yellow crayon pigments, some of which are superimposed directly on the Foothills Abstract rock art. Limited and admittedly speculative cross-dating of a few Foothills Abstract images at these sites with somewhat similar images in other western North American rock art leads her to suggest that the earliest Foothills Abstract images may predate 1000 B.C. and thus are of Middle Archaic age, while the latest were painted in the Late Prehistoric period shortly after A.D. 1000.

Although her scheme is restricted to the Smith River study area, Greer has made similar preliminary observations for sites in the Judith River drainage and Little Belt Mountains. Additionally, Greer has observed a Foothills Abstract tradition red wall-painting in Lookout Cave, in the Little Rocky Mountains of north-central Montana, that is partially buried by cave sediments containing Late Prehistoric period artifacts. Although the Lookout Cave deposits have not been securely dated, the wall had to have been painted before they accumulated, and thus must date to the Late Archaic period or early in the Late Prehistoric period. At present, no Foothills Abstract pictograph has been dated by any direct method. With all of this in mind, Greer's (1995) chronological model provides a starting point for comparing dating evidence from Foothills Abstract sites in other areas of the Northwestern Plains.

In summary, the Foothills Abstract tradition likely began in the Archaic period and continued into the Late Prehistoric period. Exactly when it started is still conjectural, but limited evidence suggests that this tradition was being painted by at least the Late Archaic period. Sometime shortly after A.D. 1000, the tradition was discontinued, as shown by the absence of classic Ceremonial tradition images in the rock art and the reuse of some of these sites by the latest precontact occupants.

Distribution and Regional Relationships

Foothills Abstract tradition pictographs are characteristic of the transition zone between the Rocky Mountains and the far Northwestern Plains. Scattered from Calgary, Alberta, on the north to Dillon, Montana, on the south, these painted sites are most frequently found in the deeply dissected foothill and canyon country along the east flank of the Rocky Mountains and along the margins of outlying ranges such as the Little Belt Mountains, Little Rocky Mountains, and the Sweetgrass Hills. A few sites from Calgary to central Montana are found in rolling prairie settings—most frequently at major buffalo jumps or large glacial erratics within view of the Rockies—and along the upper Musselshell River, which skirts the south flanks of the Little Belt and Big Snowy mountain ranges (Map 11.1). Currently only two sites with handprints, in the upper Bitterroot Valley and near Phillipsburg, Montana, and a site with extensive smearing near Columbia Lake in British Columbia, extend the range of this tradition west of the Continental Divide; a single site south of Billings, Montana, and two adjacent sites in the Bighorn Mountain foothills are the only ones that clearly imply that the tradition extends southward into Wyoming. This distribution, however, has been significantly expanded in just the last decade, and extensive foothill areas from the Bearpaw and Highwood Mountains of north-

central Montana to the Bighorn Range of central Wyoming remain poorly known. Additional research may reveal more sites in these areas and extend the range of this tradition into Wyoming.

The Foothills Abstract tradition has few relationships with other known rock art traditions, either on the Plains or in adjacent regions. To the west, Columbia Plateau rock art also includes primarily red pictographs, but the characteristic motifs—simple vision quest images and hunting scenes composed of animal figures, simple stick-figure humans, and tally marks—differ significantly (Keyser 1979a; Greer 1995). While the differences in some of these motifs are proportional (e.g., many more simple stick-figure humans occur in Columbia Plateau sites than in Foothills tradition sites) others are nearly absolute. For instance, on the entire Columbia Plateau, handprints are exceedingly scarce—fewer than a dozen of the nearly one thousand known sites have this motif, and in no instance are more than two or three handprints found at any site (Keyser 1992). This is in marked contrast to the Foothills Abstract tradition where handprints are frequently painted in groups of 15 or more and even an incomplete overview of site data shows more than 50 sites containing a total of more than 300 such images. In fact, investigators have commented on the prominence of handprints in this rock art since its initial description (Shumate 1960; Conner and Conner 1971; Keyser 1979a; Greer 1995). Likewise, mazes, abstract anthropomorphs, and wall paintings are almost exclusively found at Foothills Abstract sites, while tally marks are essentially restricted to Columbia Plateau tradition sites.

Differences between the Foothills Abstract tradition and other Northwestern Plains rock art traditions are even more marked. Of the shield-bearing warrior, V-neck human, and boat-form animal motifs characteristic of Ceremonial tradition rock art, only a single V-neck human appears in Foothills Abstract

rock art, and its extreme simplicity suggests that its V-shaped shoulders are more likely an accidental similarity than a stylistic relationship. Likewise, the horses, weapons, and combat scenes characteristic of Biographic tradition art are entirely lacking. Although a few painted hoofprints appear at Foothills Abstract tradition sites, nothing like the extensive hoofprint panels of the Hoofprint tradition occur. Moreover, the only panel of vertically arranged figures identified by Greer (1995:203–4) is not similar to any Vertical Series tradition site. Finally, although Malouf (1961:6) related some of the Foothills Abstract anthropomorphs to rock art of the Dinwoody tradition, this was based only on the extreme stylization of the human figure rather than any perceived formal similarity. Close study shows clear distinctions between the anthropomorphic images of the Dinwoody tradition and those in Foothills Abstract sites.

Elsewhere outside the Northern Plains, no currently identified rock art bears close stylistic similarity to the Foothills Abstract pictographs. In sum, it appears that the Foothills Abstract tradition is not closely related to any other rock art tradition on the Northwestern Plains or surrounding regions, and represents an in situ development unique to this region.

Cultural Affiliation

The probable age of Foothills Abstract tradition rock art precludes its affiliation with any of the ethnographically known groups occupying this area of the Northwestern Plains. The Blackfeet, Shoshone, and Crow were relatively recent immigrants into the area, arriving after approximately A.D. 1200. The Flathead, Pend d'Oreille, and Kutenai are not likely the artists, given the significantly different motifs characterizing the Columbia Plateau tradition common throughout their territory in western Montana, northern Idaho, and southeastern British Columbia.

This area was densely occupied during the transition from the Late Archaic period to the Late Prehistoric period by people whose material culture fits within the Pelican Lake complex. Pelican Lake, most frequently characterized by corner-notched projectile points, had a generalized economy focused at least seasonally on communal bison killing. Lithic raw material quarries in the same area as the Foothills Abstract tradition are known to have been extensively exploited by Pelican Lake complex people, and several large Pelican Lake bison kills are also scattered throughout the general area. Some authors have proposed that the Pelican Lake complex included ancestors of the modern Kiowa, as well as the Kutenai, Nez Perce, and even other groups, so it is possible that some or all of these peoples' ancestors made Foothills Abstract tradition rock art.

However, Foothills Abstract pictographs are located in territory that various authors think was the original homeland of the Kiowa and a migration corridor for the Plains Apache and other Athapaskan groups (Schlesier 1994). The Kiowa even have oral traditions of living in central Montana. Although none of these peoples' descendants has a surviving artistic

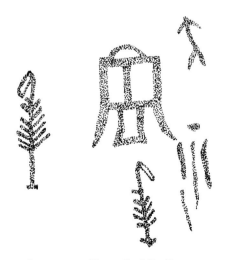

11.13 Images at an Alberta Foothills Abstract tradition site.

tradition similar to Foothills Abstract rock art, very limited evidence supports authorship of this tradition by these groups. Southeast of the primary range of the Foothills Abstract tradition, a number of somewhat similar bear images (mostly petroglyphs) are found at sites in Carbon County, Montana, and a few sites in this same area have groups of handprints. This may have been the route taken by the Kiowa and various Apachean groups as they moved from the Northwestern Plains to the Southern Plains in the centuries after approximately A.D. 1000. A date of less than 1000 years ago for the bear image at the Bear Shield site in Carbon county (Loendorf 1992) fits the proposed movement of these groups. With the limited evidence available, the Kiowa seem to be the best candidate for making this rock art, but the evidence is far from strong.

Interpretations

Based on form, typical motifs and their associations with one another, and to a lesser extent on characteristic site locations, Foothills Abstract rock art appears to have functioned primarily in a ceremonial context involving rituals conducted by shamans. Some sites may also have served a "marker" or public display function, although this role may also have been associated with certain types of ceremonialism.

Formally, this art has been called abstract (Shumate 1960; Keyser 1979a, 1990) or conventionalized (Malouf 1961) because so many of the forms are not simply representational. As considerable effort has been spent discussing this designation (Greer and Greer 1995b; Greer 1995), some rationale for the name seems appropriate here. More than thirty years ago, after initial examination of a handful of sites widely scattered across four Montana counties, it became clear that this art was stylistically distinct from other more familiar traditions, including the Columbia Plateau, Ceremonial, and Biographic tradi-

tions. Keyser (1979a) observed that the rock art lacked clear naturalistic conventions to indicate anthropomorphs, zoomorphs, or almost anything else (fig. 11.13). However, there never seemed to be a conventionalized way of rendering any of these forms, and no two examples share any constellation of similar details or features

As a whole, then, the art appears highly individualistic with no strong structural guidelines controlling how the artists depict even obviously related images. Given the highly idiosyncratic appearance of many of these images, it seems misleading to argue that a particular design is representational simply because one person identifies it as a mask when others equally knowledgeable just as readily see it as a curvilinear maze (fig. 11.14). This art is replete with images for which multiple identifications have been proposed: one person's anthropomorph is another's bear, a bear paw appears to someone else to be a handprint, and an anthropomorph is identified elsewhere as a shield. Contributing to this potential confusion is the fact that when

various easily identified images are arranged side by side on a spectrum, it becomes obvious that a series of small gradations easily relates an image that is clearly a human to a complex geometric maze that lacks any obvious anthropomorphic feature.

It thus seems inappropriate to call this art conventionalized when the only convention might best be summarized as "every artist for himself." Hence we retain the name "Abstract" for this rock art tradition while recognizing that many figures tend to be abstracted from real models and so loosely representational as to be subject to varying interpretations. Finally, the many geometric abstracts in this art further complicate matters, especially if circular or rectilinear mazes are not automatically identified as shields or masks.

But what does the abstracted form of this art suggest about its function and purpose? Many of the pictographs seem to be visual metaphors for many aspects of shamanism. Worldwide, shamans describe their initial trance experience as involving flight, levitation, or stretching or foreshortening limbs

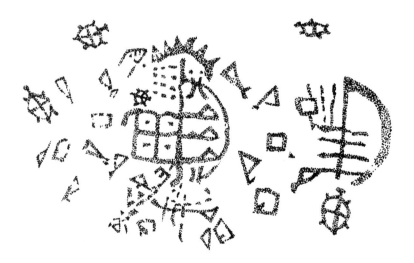

11.14 Some observers see the central part of this complex maze as a human figure because of the "crown" or "hair" at the top. Five small turtles are painted around this figure; the one at upper right is distorted by an irregularity in the rock surface.

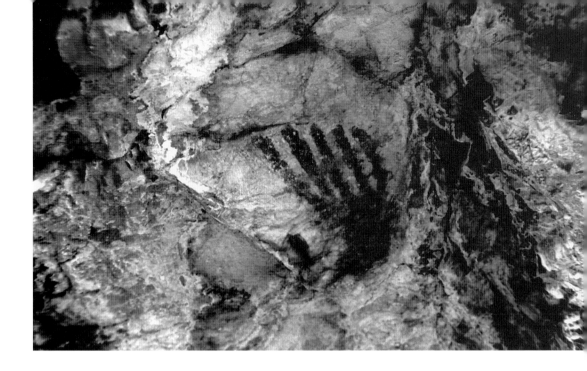

This Foothills Abstract tradition painting from the Missouri River drainage near Helena, Montana, can be interpreted either as a simulated handprint or a bear track.

and bodies to enter the spirit world through cracks or holes (often in cliffs or rocks). Often accompanying this is a feeling of light-headedness expressed metaphorically as lightning, whirlwinds, or arrows emanating from the head or limbs. Ultimately these shamans magically transform themselves into the beings who are their spirit helpers— bears, mountain lions, trolls, mountain sheep, or cannibal monsters.

Pictographs of humans with elongated legs, arms, or fingers, arms drawn as lightning bolts, zigzag lines emanating from the head or coursing through the body (fig. 11.2), or bodies lacking arms, legs, or both, are quite common in Foothills Abstract rock art. Humans are also frequently painted in positions where they appear to float or fly above a scene, or to emerge from a crack or hole in the wall. The unrealistic stretching of body parts appears to be a visual metaphor for the transformation or levitation that accompanies out-of-body experiences common in shaman's trances (fig. 11.15). Similar depictions are used in shamanic rock art in other parts of North America, as well as around the world. Other figures seem to be metaphoric "shape-shifters," representing the shaman's transformation. Viewed one way, they appear to be anthropomorphic, but viewed another way, they seem to be masks, or zoomorphs, or entirely nonrepresentational

11.15 This human figure with elongated legs has small birdlike figures near its head. Similar imagery in rock art elsewhere in North America denotes shamans.

(figs. 11.5, 11.9). In other instances, small stick-figure humans or arrows are juxtaposed with or incorporated into maze designs and may represent the contact between a shaman and the supernatural.

Handprints sometimes appear as similarly metaphorical images (fig. 11.8). Some simulated prints are significantly larger than life and others show a "skeletal" imagery similar to some anthropomorphs and zoomorphs. In a few cases, simulated handprints occur with clusters of real handprints or in association with smaller stick-figure humans or animals. At one site, a simulated handprint is attached to a large concentric circle maze by a zigzag line, and a bear paw is painted below. Other handprints at this site have unnaturally extended digits and are connected to the elongated legs of a human who holds objects in both upraised hands. Even handprints can sometimes be "shape-shifters," as in the case of simulated prints that are just as readily identified as bear tracks.

Masks also suggest shamanism, especially when they occur as frequently as they do in this tradition, and in forms that readily grade into mazes and anthropomorphs (fig. 11.5). Masks are commonly used in shamanic rituals, often representing spirit beings or heightening the transformation of the shaman into the spirit. Well-known examples of their use occur in African witch doctor rituals, Zuni Kachina dances, the Iroquois "False Face" society, and the "masks within masks" shamanic performances characteristic of Northwest Coast and Inuit groups. While there is no clear Foothills Abstract representation of a shaman wearing such a mask, the fact that masks and masklike images are so popular in the rock art implies that they were important ritual items. In the Foothills Abstract tradition the mazes and masks, and many of the anthropomorphs and zoomorphs, use skeletal imagery somewhat similar to other examples of shamanic art.

Finally, of the animals shown in this tradition, only mountain sheep, elk, and bison were typically game animals. These and other animals, however, were the focus of ceremonial activities in ethnographic cultures. Other animals painted in this tradition, such as birds, turtles, lizards, and snakes, were not economically important but also functioned in cere-monial contexts. In the cosmology of several Plains groups, bird and turtle are opposed as representative of earth/sky dualism. Three snake images have "head-dresses" of sorts and may represent the horned or feathered serpent, a common mythological animal in other areas. It seems clear that all these animals were painted for ceremonial reasons, rather than as some sort of hunting imagery.

In addition to shamanism-related subject matter, Foothills Abstract tradition rock art seems to fall into three distinct, broadly defined site types characteristic of ritualism (Greer 1995): private ceremonial sites, public ceremonial sites, and marker sites. The private ceremonial sites are found in small caves or rockshelters or on small isolated panels far from major occupation areas. The smallest of these caves are niches no bigger than a crawl space for a single individual. These private sites are most often painted with only a few motifs or geometric images, and are frequently difficult to access. Their often secluded location implies that they were painted during private rituals. Some were likely used for obtaining personal power through the vision quest trance experience, while others were used for conducting private rituals intended to ensure harmony between humans and the spirit world, maintain the natural order of things, create cosmic equilibrium, or provide world renewal. In Greer's (1995) model, the personal power sites were visited only by shamans or ritual initiates, whereas those focused on maintaining the public good were painted by shamans but were likely visited by most members of the society, either singly or in small groups, as part of their religious rituals.

Public ceremonial sites, in contrast, are found in locations large enough for people to congregate, and the art is relatively accessible and easily observed. Frequently these sites show much larger concentrations of many different images. Although the rock art here is usually out in the open, it is frequently not visible from long distances. At such public ceremonial sites, shamans would have led public rituals designed to maintain social order and reinforce sacred concepts. A group composed of many or most of a society's members participated; the Plains Indian Sun Dance was one such ritual in Historic period cultures. Public ritual sites were probably used year after year, with paintings added at many different times.

Finally, Greer (1995) has suggested that some Foothills Abstract tradition sites in the Smith River drainage served a marker function because they are public displays where limited types of images are often repeated many times. She argues that these public rock art displays "act as a sign or billboard announcing a message." They are located on exposed bluffs along natural travel routes, and occasionally at stream confluences or the junction of two trails. Frequently, these are so brightly painted that the sites are noticeable from a considerable distance, long before individual figures can be recognized; while in other instances, the bluff, rock, or cave in which the pictographs are painted is itself the eye-catching attraction. Greer suggests that marker sites designate territory or possibly show use of an area by a particular individual, and that handprint clusters, finger lines, and smears located at the mouths or heads of canyons, or where high walls create a narrow restriction in a canyon bottom, are the most common combination of images and settings characterizing marker sites. In the Sun River drainage extensive smears or complete wall paintings announce the sites from a considerable distance, but seen up close they are often covered with handprints and clusters of finger lines (Greer and Greer 1994a).

While some sites may be territorial markers, no compelling evidence suggests that the shamanic ritual model does not apply to them. Handprint clusters and extensive smears seem to be more than that necessary to simply designate "ownership," and both can also be explained in terms of ritual performance. The repeated pressing of hands covered in red ochre against rock, and the rhythmic movement of the hand across the rock face, suggest a ritualistic production—as if the ochre acted as the flux to transfer energy between human and sacred rock (Klassen 1998b). The association of handprints and finger lines with shamanic imagery at private ceremonial sites also suggests that handprints were more like a "signature" signifying participation or attesting to an accomplishment. The frequency of handprints in all three site types suggests that they were a special and important element of this art. These marker sites may have represented some sort of oath taken by initiates who used nearby ritual sites to obtain power or to become members of a special group. In this manner, they may well have marked sacred areas used by particular shamans or sacred societies and thus served to delineate areas of special ritual power that may have been off limits to the uninitiated. The close association of many marker sites with nearby ritual sites provides support for their functional interrelationship. Paint spatters, often associated with wall-painted sites, and the presence of scratching at numerous sites, also implies that some ritual behavior was involved with the rock art.

Overall, the imagery suggests that much of this art was based on shamanic acquisition of power, initiation of members into sacred societies, and the use of that power to promote public good and maintain group cohesion. Yet it is also clearly apparent that bears played a crucial role in some of these rituals (fig.

11.16). Bear imagery in the Foothills Abstract tradition is relatively frequent, and more than 15 percent of sites include bears or obvious bear paw pictographs. Not only do their numbers reflect their importance, but other characteristics of the rock art do as well. The Greers note that many small private ceremonial sites are caves or rockshelters that serve as bear dens for winter hibernation. Others have large bears painted inside, and one has a "handprint" that may be a bear paw. Finally, the long vertical finger lines, so common at many of these sites, may also represent bear symbolism, since they mimic the scratches that bears make in their dens and on logs and trees when they search for grubs. Images at almost a dozen sites can be identified either as bear paws or simulated handprints (depending on how broad the defining criteria), implying a bear/human transformation metaphor which indicates the importance of bears in this rock art.

Bear ceremonialism is found in the northern hemisphere around the world, and in central Europe it dates back to Neanderthal times, more than 50,000 years ago. In the ethnographic period, bear shamans were common in both Eurasian and North American cultures. But why was the bear so important to the people who made this rock art? Obviously, bears are dangerous, and it was not uncommon that someone in a group would have been mauled or killed by one. Among many Plains Indian groups, killing a bear was a deed as brave as killing an enemy, and it counted as a war honor. Equally important, bears are the most human in appearance and action of any common northern hemisphere animal, and they lend themselves readily to anthropomorphization. Among many groups, bear shamans (some of whom had bear power as their war medicine) were thought to transform themselves into bears to cure illness or conduct raids on enemies.

11.16 Bear imagery is common in Foothills Abstract rock art. Here the bear is associated with birds, a power line, a mask, and a probable shaman figure. In the enlarged details, note the dotted tear streaks on the bear's face.

Several important sites suggest how some bear rituals may have incorporated rock art. At the Whitetail Bear site, more than a dozen real handprints are superimposed on a large, red-painted grizzly bear (fig. 11.1). Obviously the bear was painted first, but a mineral wash suggests that the handprints were made long after. Based on the size and the relative length of the fingers, all but one of the handprints appear to be adolescent males. They were painted at different times as single impressions, rather than left-right pairs, and all but one are deliberately superimposed on or placed immediately adjacent to the large bear. These hand impressions are probably the signatures of individuals or several small groups of initiates who obtained bear power or were instructed in bear cult rituals at this site. The Reighard Shelters show significant similarities to Whitetail Bear. Located on the lower Musselshell River, these sites include a large, painted humpbacked grizzly bear with internal organs (fig. 11.6), and more than sixty handprints painted in two small nearby rockshelters. On one panel the handprints are superimposed on and surround two probable shaman figures.

Bear Mask Cave also provides clues as to what the rituals might have included (fig. 11.17). The bear's face, with the cave as its mouth, is located in a small natural amphitheater in a narrow, steep-walled limestone canyon. From the narrow canyon bottom, several dozen people can view the cave opening, which is located just slightly higher than the audience and across the entrenched stream channel. The cave itself is only a few feet high, but it can be entered through a small side passage from a larger adjacent cave (not visible from outside either cave). Immediately in front of the caves is a narrow shelf of limestone, which forms a terrace large enough for one or two performers to conduct a ritual.

The acoustics and setting of the small canyon-bottom amphitheater suggest that a shaman might have used this site for transformation performances in which the "bear" would have spoken in the voice of the hidden shaman. A person speaking inside Bear Mask Cave can remain completely unseen but can be heard throughout much of the small amphitheater. After one sees the site, it takes very little imagination to reconstruct a fire-lit ceremony in which the bear shaman disappeared in a flash of flame or a puff of smoke, entered Bear Mask cave by way of the secret passage, and then was heard speaking from the mouth of the bear. Ethnographic accounts document this type of performance by shamans in many different societies worldwide.

Bear Mask Cave clearly illustrates the strong evidence linking this tradition with ritual, shamanism, and the power of the bear. Overall, it seems likely that ritual performances were held in association with many Foothills Abstract sites as part of initiations and ceremonies intended to maintain the sacred order and sense of equilibrium with the spirit world. As such, Foothills Abstract rock art provides tangible evidence of the mysterious religious world of an ancient people.

Bear Power, Bear Dreamers

No stronger magic could be found across the Northwestern Plains than that of Grizzly Bear, whose supernatural powers embodied both the warrior's ideal and the healer's arts. Many tribes had a Bear Dreamer society, a fraternity for those warriors brave enough to have obtained bear power in their visions. Other men were bear shamans, known for their abilities to cure disease with bear medicine.

Through visions, Bear Dreamers became the bear's human persona. Among many groups, they were the mightiest warriors and much feared by all enemies; they took a vow to charge straight toward the enemy and never retreat. Grizzly bear warriors painted tear streaks extending down from their eyes to mimic the glandular secretions that often mark a grizzly's face. Dressed and painted as bears, these warriors rushed directly into battle brandishing only their shield and a bear knife—the handle made from a grizzly bear's jawbone—and snorting or growling like their supernatural helper. For the Blackfeet, transfer of the bear knife bundle to an aspiring warrior was a two-week ritual marked by strenuous ordeals.

Bears were considered so powerful in many Plains societies that only shamans could use a bear's skin or even call it by name. Others used a variety of avoidance names, including "Bear Old Man" and "Elder Brother." Bear shamans wore bearskin costumes in their curing rituals. They shuffled about on all fours, growling and snuffling at their patient, and then stood erect to "dance" and paw at the sickness. Among many groups, these shamans were thought to transform themselves into bears to cure illness or conduct raids on enemies, and when a bear attacked or killed a person, the obvious conclusion was that the bear was, in fact, a transformed shaman from an enemy group.

Bear medicine was considered so strong because bears seem human in so many ways. They frequently stand and walk upright, and use their forepaws to manipulate objects. A sitting bear's front legs hang like arms, and bear tracks look much like hand and foot prints. Like humans, bears are omnivorous, and people would have frequently encountered them in berry fields, big game calving grounds, and root-digging areas. Hallowell (1926) wrote: "The human qualities of bear ... aroused awe, wonder, [and] fear ... which, in turn gave rise to an attitude of veneration." And yet, in some ways, bears seem far "wiser" than humans, for they can live all winter without eating and emerge from their winter-long hibernation with no ill effects— a magical feat that mimics shamanic trance behavior.

Across the Northwestern Plains, bear pictographs and petroglyphs symbolize

the powers that made warriors strong and shamans wise. Sites of many different rock art traditions include the characteristic bear track motif, while others show snarling, full-profile bears with teeth, clawed feet, and the distinctive hump that denotes the grizzly—most powerful of the bear clan. Still other sites show bears pierced with arrows or being attacked by well-armed hunters—demonstrating the courage of the bear warrior.

Bear symbolism is strongest in the Foothills Abstract tradition. Grizzly bear shamanism seems to be the focus of many

11.17 Bear Mask Cave may have been used in shaman rituals to conjure up the power of the bear. Its small opening forms the mouth of a painted bear face.

Foothills Abstract pictographs. Realistic bears are painted at several sites, while another bear forms part of one of the mazelike images so characteristic of this tradition. Several pictographs are located within or just outside caves that even today bears use as dens. In one cave, a large spotted bear with dotted tear streaks is connected to a shaman figure and other ghostlike images by a long painted line.

Perhaps the most fascinating site is Bear Mask Cave, which I visited in 1994 with colleagues who had rediscovered it two years earlier (fig. 11.17). Following the tracks of a large black bear for more than a mile down the soft bottom of a stream valley, we eventually entered a natural amphitheater framed on three sides by massive limestone cliffs towering more than 100 feet (30 m) above us. At the foot of the cliff, just above the stream, a bear's head is painted so that the opening of a small bear's den cave appears to be the bear's mouth. As an experiment, one of my colleagues crawled into the tiny cave to demonstrate the acoustical magic of the site. His disembodied words emerged from the cave in muffled tones and reverberated across the amphitheater. Awed by the experience, I recalled the words of an old shaman: "Bear, we are the same person, you and I"—and I better understood the power of the bear.
—J.D.K.

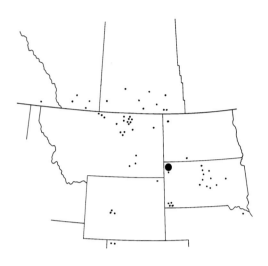

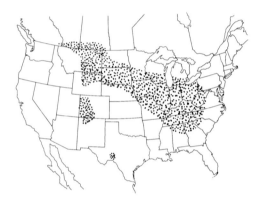

Map 12.1. Hoofprint Tradition Rock Art

above: Regional distribution
Large dot shows North Cave Hills.

below: Continental distribution

12 / Hoofprint Tradition

At more than sixty sites scattered from the Missouri River in South Dakota to the Rocky Mountain foothills, the primary motifs are remarkable pecked images of animal hoofprints. Executed with careful attention to realistic details, these petroglyphs are instantly recognizable as the tracks of bison, deer, elk, and even horses and mules. Although Hoofprint tradition petroglyphs are predominantly cloven-hoofed ungulate tracks, a few horse hoofprints, bird tracks, large animals, and human designs are also carved at some sites. Varying in size from single tracks to concentrations of more than two hundred individual designs, sites sometimes include groups of hoofprints associated with carvings of bison, elk, humans, faces, and female genitalia (fig. 12.1). Representing the westernmost extension of a widespread rock art tradition common throughout the Eastern Woodlands, ethnographic evidence shows that these Northwestern Plains petroglyphs are related to themes of fertility, fecundity, and the sacred relationship between women and bison.

Glyphstones or petroglyph boulders are also part of the Hoofprint tradition. A variety of pecked petroglyphs, including hoofprints, bison heads, and human faces—some with weeping eyes—are found on glyphstones. Glyphstones consisting of roughly parallel straight lines pecked across basketball- to refrigerator-sized boulders are often known as ribstones. The largest and most intricate of

these ribstones is the Sleeping Buffalo, originally located on a hill overlooking the Milk River (fig. 12.2). This large granite boulder resembles a reclining bison and was extensively modified with pecked lines representing ribs, backbone, horns, eyes, nose, and mouth.

Although Hoofprint sites are found as far north as southern Saskatchewan and Alberta, most occur south of the Missouri River,

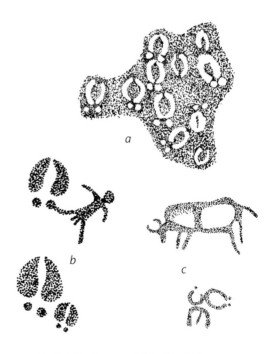

12.1 Typical Northwestern Plains Hoofprint art. Note superimposition of woman's leg over dewclaw on bison track (b).

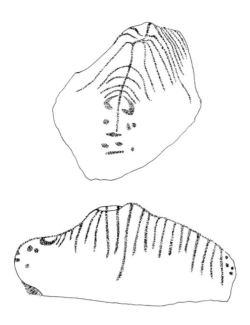

12.2 Two views of the "Sleeping Buffalo" petroglyph boulder near Malta, Montana. The association of this boulder with other hoofprint boulders supports the inclusion of ribstones in the Hoofprint rock art tradition.

ranging from the Black Hills to the Rocky Mountains. They are primarily Late Prehistoric in age, although some date to the early Historic period. Hoofprint petroglyphs were manufactured by pecking, incising, and abrading—often two or three of these techniques were used to make a single design. At one North Cave Hills site in South Dakota, a series of hoofprints indicate a sequence of manufacture beginning with pecking the rough shape, refining it by incising, and then finishing the interior of the glyph by abrading. Many of the bison heads at Roche Percée were made by pecking or drilling out separate dots that form the figure outline. No pictographs are clearly associated with Hoofprint art.

Hoofprint petroglyphs are usually carved into the vertical sandstone cliffs of the buttes and canyons that characterize this region. At a few sites, most notably St. Victor, Medicine Rocks, and Snake Butte, designs are carved

into horizontal sandstone bedrock outcrops. Many hoofprint sites, including ribstones, are also carved on glacial erratics—large boulders deposited by the retreating continental ice sheets at the end of the last Ice Age. These carved boulders are found primarily north and northeast of the Missouri River.

History of Research

Perhaps the earliest documented reference to a Hoofprint tradition site was made in 1857 by James Hector, who visited the Roche Percée site while exploring southern Saskatchewan on the Palliser expedition. Twenty-two years later, George Dawson of the Geological Survey of Canada returned to Roche Percée and sketched a number of the petroglyphs at the site (Wintemberg 1939).

Hoofprint tradition rock art was first professionally described by anthropologists before World War II. Will (1909) and Over (1936, 1941) recorded some of the petroglyphs in the North Cave Hills of western South Dakota, and Wintemberg recorded and described the Roche Percée and Pinto sites in southeastern Saskatchewan. In the 1960s, several extensive hoofprint sites were reported in Montana and Wyoming, often by amateur archaeologists writing in amateur-sponsored publications (Eichhorn 1958; Conner 1962a; Hoy 1969).

In his thesis on Medicine Creek Cave, Buckles (1964) was the first professional archaeologist to recognize the regional distribution of this tradition. By the early 1980s, several archaeologists had reported sites and begun to recognize hoofprint motifs as part of a distinct regional tradition (Johnson 1975; Darroch 1976; Sundstrom 1981). To date, studies in the North Cave Hills of South Dakota (Keyser 1984, 1990), at the St. Victor site in southern Saskatchewan (Jones and Jones 1982), and in the Black Hills (Sundstrom 1993, 1995) are among the most complete descriptions of this tradition.

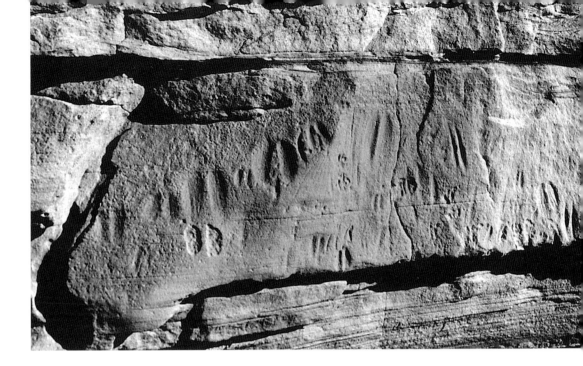

Sites like this one in South Dakota's North Cave Hills, which contain hoofprints but few other images, were the first to be recognized as Hoofprint tradition rock art.

The Rock Art

For the most part, the subject matter of Hoofprint tradition rock art consists of animal and human designs. Unlike other representational traditions, however, Hoofprint rock art does not primarily depict animal and human figures; instead, it mostly shows animal tracks. Other images include occasional human faces, bison heads, a few animal figures, and projectile point designs. Only a very few nonrepresentational geometric designs are part of this tradition.

Animal Figures

Animal-based motifs are the hallmark of this tradition; more than nine hundred ungulate tracks are carved at more than fifty sites (fig. 12.3). These hoofprints occur at almost every site, ranging from single images at several sites to more than a hundred tracks carved at

St. Victor, Simanton, and Little Popo Agie. Hoofprints range in size from about 1 inch (3 cm) to more than 10 inches (25 cm) long, but many are approximately life size.

More than 85 percent of the animal tracks are those of cloven-hoofed ungulates: bison, deer, elk, pronghorn antelope, mountain sheep. Approximately 40 percent of the hoofprints show dewclaws, and a few can be fairly reliably identified as to species.

12.3 Miscellaneous hoofprint images from the North Cave Hills, South Dakota include deer (a-c), bison (d), and horse (f-h). Note that horse hoofprints show the triangular "frog" at the base of the track. The exaggerated wings on g make it a mule track.

The larger, nearly semicircular hoofprints represent bison, while smaller, slightly more teardrop-shaped tracks probably represent deer, mountain sheep, or even antelope. Some intermediate-sized tracks with dewclaws probably represent elk. Most hoofprints, however, are sufficiently generalized so that they might represent any of these species (although those with dewclaws cannot belong to antelope, which lack them).

Several other types of animal tracks occur at some twenty-five sites. Bird tracks, bear tracks, horse and mule hoofprints, and even two examples of canine or feline paw prints are recorded. Bird tracks are the most numerous, but they tend to be found most often at sites in the eastern portion of the region. Ethnographic accounts occasionally identify these as "Thunderbird" tracks.

Approximately thirty bear tracks are associated with Hoofprint petroglyphs. Some, such as those at St. Victor, are quite realistic, while others are more stylized, with rectangu-

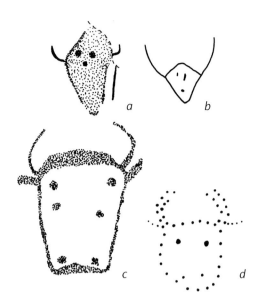

12.5 Bison heads are drawn at several Hoofprint sites; d is a pattern of drilled holes at the Roche Percée site in Saskatchewan.

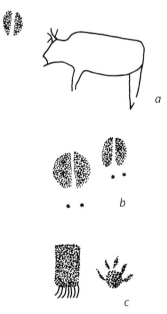

12.4 Hoofprint tradition images from a South Dakota site show a bison associated with hoofprints on one panel (a, b) and a bear track and paw print on another panel (c).

lar paws and long, incised claws. Because bear tracks are found in nearly all Plains rock art traditions, it is possible that some were added to Hoofprint sites by other Native artists, but others are undoubtedly part of this tradition. Two cat or canine tracks occur at the McKenzie Butte and Little Popo Agie sites.

Horse and mule hoofprints are depicted at a few sites in the eastern portion of the region (fig. 12.3). These are realistic hoofprints, different from the C-shaped tracks common in Biographic tradition scenes. Some of the naturalistic C-shaped hoofprints may indicate shod horses or tracks on hard ground. Others are nearly round and exhibit the frog, the small V-shaped wedge protruding into the rear of the track, indicating unshod horses. One such track at a North Cave Hills site has interior lines and "wings" that extend outward from the frog, creating a long, narrow track that contrasts to a horse's nearly round hoofprint. This is a very realistic image of a burro or mule track.

Animal figures also occur regularly in this tradition, with more than thirty-five examples

recorded (fig. 12.4). Big game animals are usually incised, although a large bison cow and calf near Ludlow Cave in the North Cave Hills are deeply abraded (see fig. 2.4). These bison, and an elk at Medicine Creek Cave, have abraded hoofprints in place of hooves. They are some of the largest individual figures in Northwestern Plains rock art. The bison cow is nearly 7 feet (2 m) long from tongue to tail and more than 3 feet (1 m) tall. The elk, shown only with its front quarters, head, and antlers, is nearly 5 feet (1.5 m) tall.

Other bison are associated with hoofprints at four sites, and front-view bison heads are found at four more sites (fig. 12.5). Front-view mountain sheep heads occur at Medicine Creek Cave, and an elk is shown on one Missouri River petroglyph boulder. A bison at the Red Canyon site near Lander, Wyoming, has one hoof indicated with a small, finely carved hoofprint. A few front-view birds are pecked at the Pinto and Roche Percée sites. Smaller animals associated with hoofprints include turtles at six sites, a lizard, snakes, and three unidentifiable zoomorphs.

Human Figures

Like animal designs, Hoofprint tradition humans are shown in two ways. Most common are handprints and footprints, but faces and full-body human figures also occur. Handprints or footprints occur at twenty-four sites, but they are most frequently found along the Missouri River in South Dakota and at St. Victor where thirty-five footprints were recorded. Handprints occur in pairs at Snake Butte and at four boulders originally located along the Missouri River near Mobridge, South Dakota.

Fourteen human faces occur at nine sites (fig. 12.6). Some are quite elaborate, with eyes, mouth, neck, and even a headdress shown, while others are simple circles or ovals with dots for eyes and a line or dot for the mouth. There are striking formal and compositional similarities between faces directly associated

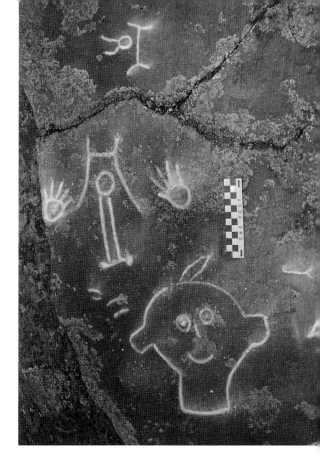

Some Hoofprint tradition sites like Snake Butte, Montana, include faces, hands, and penisforms in addition to hoofprints. Chalking not done by photographer. (Courtesy of Stu Conner)

with hoofprints at sites in the North Cave Hills and Red Canyon south of Lander, Wyoming. In addition to faces, humans are shown as simple stick figures at four sites, and as square-body figures at St. Victor. The stick figure at Saddle Butte, identified as a female by the genitalia, is very slightly superimposed on a buffalo hoofprint. Near Lander, a deeply abraded human face is associated with two bison hoofprints. In southern Saskatchewan, faces pecked at St. Victor and the Weyburn glyphstone are quite sophisticated images.

Nearly forty-five representations of genitalia, including both vulvaforms and penisforms, occur at twenty sites (fig. 12.7). Most are rectangular, oval, or V-shaped

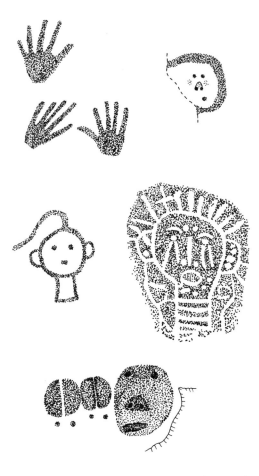

12.6 Humans are shown in Hoofprint tradition rock art as faces and occasional handprints.

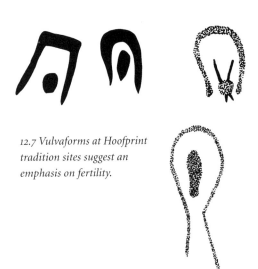

12.7 Vulvaforms at Hoofprint tradition sites suggest an emphasis on fertility.

vulvaforms with an interior line or small cupule. Penisforms are engaged in sexual intercourse with vulvaforms at St. Victor and Snake Butte, and another occurs at the Cranbrook site. Two North Cave Hills sites have rows of vulvaforms. Previous authors have assumed that these represent human genitalia because of their similarity to motifs used to identify female humans (like the one at Saddle Butte), but it is possible that they represent animal genitalia.

Geometric Designs

A few abstract geometric or nonrepresentational designs are clearly associated with Hoofprint rock art. Foremost among them, occurring at eight sites, are circles or ovals, sometimes bisected by lines or with interior crosses. Several petroglyph boulder sites also include abstract compositions of dots and lines, sometimes called pit and groove petroglyphs (Grant 1967). On some glyphstones, the grooves wind sinuously among the pits or cupules, while on other boulders the cupules are separated by straight lines. Cupules are only occasionally found at nonboulder sites. At a few boulder sites, H shapes are also pecked into the rock.

Compositional Arrangements

Compositions at hoofprint sites are relatively simple (fig. 12.8). Although hoofprints sometimes occur singly, they usually are found in juxtaposed clusters ranging from three to as many as twenty-five. Some sites, such as St. Victor and a few in the North Cave Hills and southern Black Hills, have several discrete hoofprint clusters, suggesting that groups of glyphs were sometimes intended as a single composition. Many other sites, however, show only loosely aggregated clusters of tracks lacking any apparent patterned structure. A few sites have clearly associated motifs: two show a human face with two adjacent hoofprints, two others have coupling genital forms, and a row of hoofprints is abraded on

12.8 Petroglyphs at the St. Victor site, Saskatchewan. Note face and human footprint.

the large bison cow and calf near Ludlow Cave. Linear series of hoofprints occur at St. Victor, Snake Butte, and Little Popo Agie; at the first two, the tracks lead toward the edge of the horizontal outcrop. On some petroglyph boulders and at Roche Percée, representations of bison heads and other figures are surrounded by dots or by dots and lines.

Dating and Chronology

The few dating clues available for Hoofprint tradition sites suggest a Late Prehistoric to Protohistoric period age for this rock art (fig. 12.9). Datable subject matter includes the

corner-notched projectile point forms carved at Snake Butte, which could represent point styles dating anywhere from approximately 1000 B.C. to A.D. 1700. However, the human faces with barred neck at St. Victor and on the Weyburn glyphstone (fig. 12.4) have been stylistically related to the Late Prehistoric period Devils Lake–Sourisford burial complex, which dates between A.D. 900 and 1400 (Jones and Jones 1982). At the St. Victor and Simanton sites, catlinite pipes and a small ceramic vessel of this same burial complex were recovered from excavations adjacent to the petroglyphs.

Other associated archaeological deposits also point to a Late Prehistoric age. A hoofprint boulder at the Wahkpa Chu'gn bison killsite at Havre, Montana, seems to be associated with the operation of this buffalo pound, which has levels dating from approximately A.D. 200 to 1500. A hoofprint petroglyph boulder at another site west of Glasgow, Montana, appears to date to the Old Women's phase (A.D. 800–1800), based on artifacts found associated with it and a nearby tipi ring site (Darroch 1976). At other boulder sites in southwestern Saskatchewan, Late Prehistoric period artifact-bearing deposits were found to cover cupule petroglyphs (Steinbring and Buchner 1993). Finally, superimpositioning of three separate rock art traditions at a complex petroglyph site near Ludlow Cave in the North Cave Hills indicates that Hoofprint art postdates Ceremonial rock art but predates probable Historic period Biographic rock art at that site (Keyser 1987b). As such, the Ludlow Cave Hoofprint petroglyphs probably date to A.D. 1300-1700 (see fig. 2.4).

Nonetheless, the Hoofprint tradition survived into the Protohistoric period, based on the occurrence of horse track petroglyphs at twelve sites scattered from the Missouri River and Black Hills to the Milk River above Havre, Montana. Some of these might be stylized bison tracks, since somewhat similar hoofprints at St. Victor and one or two other

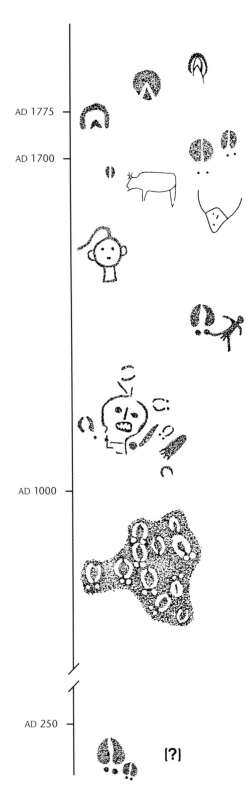

AD 1775

AD 1700

AD 1000

AD 250

[?]

12.9 Hoofprint Tradition General Chronology

sites have dewclaws and therefore represent cloven-hoofed ungulates. Horse hoofprints at four North Cave Hills sites clearly show the frog, a characteristic indicator of the equine single-toe track and must therefore represent horses and thus postdate A.D. 1700 (fig. 12.3).

In summary, Northwestern Plains Hoofprint tradition rock art appears to fit comfortably within the Late Prehistoric and Protohistoric periods between approximately A.D. 500 and 1800. A reliable beginning date for the rock art has not been determined, but horse and mule tracks at twelve sites show that the tradition was still being used in the early postcontact era.

Distribution and Regional Relationships

On the Northwestern Plains, the Hoofprint tradition extends north and west from the Missouri River of central South Dakota through the Black Hills and Cave Hills to the Yellowstone River in south-central Montana, and northward to the Missouri Coteau region of southern Saskatchewan and Alberta (Map 12.1). Major concentrations of sites occur in central South Dakota, the Black Hills, and north-central Montana. Glyphstones and ribstones, including pit and groove petroglyph boulders, are found primarily north of the Missouri River across northern Montana, southern Alberta, and southern Saskatchewan. Outlying sites occur at Cranbrook, British Columbia and in the Little Popo Agie River drainage south of Lander, Wyoming.

Northwestern Plains Hoofprint rock art is part of a much broader rock art macro-tradition found throughout the eastern and central United States. At sites scattered from the upper Ohio Valley in Pennsylvania and West Virginia, through the central southeast in Kentucky, Tennessee, and Georgia, and into the midwestern states of Missouri, Iowa, Wisconsin, and Minnesota, related rock art

motifs include cloven hoofprints, trident bird tracks, and human handprints and footprints. Thunderbirds, occasional vulvaforms, bear tracks, and human faces also occur. In his survey of North American rock art, Grant (1967:137) wrote: "Over the entire Eastern Woodland . . . the most abundant motifs are the Thunderbird, hands, footprints, animal and turkey tracks."

Wellmann (1979a) listed fourteen states with sites where these motifs are found together, and Swauger (1974) describes a group of upper Ohio Valley sites where these motifs are the primary designs. In fact, nearly every motif in Northwestern Plains Hoofprint rock art is duplicated at Eastern or Midwestern Woodlands sites—including crosses in circles, bisected circles, and penis and vulva motifs. Even the carved projectile point images at Snake Butte are duplicated at the Jeffers site in Minnesota and others farther east.

Much smaller groups of sites with hoofprints occur on the Colorado Plateau (Cole 1990; Renaud 1936; Schaafsma 1980) and on the Edwards Plateau in west Texas (Turpin 1992). In the Colorado Plateau, about ten sites have ungulate hoofprints, bear tracks, and human handprints and footprints. Frequently these cluster together on a panel, and sometimes tracks are found in long lines, as at Little Popo Agie in Wyoming. This Hoofprint rock art may, in fact, be closely related to that in western Wyoming, given the extent of Late Prehistoric Period contact among tribes in these areas. In Texas, seven sites on horizontal exposures of limestone bedrock show hoofprints, atlatls, bear tracks, projectile points, and occasional stick-figure humans (Turpin 1992). These sites seem to span the Late Archaic to Late Prehistoric and are interpreted as having functioned in hunting magic rituals.

In the Columbia Plateau and Great Basin regions, hoofprints are extremely rare. Single sites near The Dalles on the Lower Columbia River and near Lake Tahoe have a few ungulate hoofprints. Because The Dalles was a trade

12.10 *Miscellaneous designs from the Cranbrook Petroglyphs, British Columbia. Note penisform at left, and the similarity of all designs to Northwestern Plains motifs.*

center attracting people from as far away as the Northwestern Plains during the Late Prehistoric period, it is certainly possible that the artist who carved the two hoofprints there was a visiting trader from the Plains.

Another exception is the site west of the Continental Divide near Cranbrook, British Columbia (fig. 12.10). The Cranbrook site is clearly out of place in Columbia Plateau rock art (Cassidy 1992; Keyser 1992), and several archaeologists have remarked on its similarities to Northwestern Plains Hoofprint sites (Cornford and Cassidy 1980; Keyser 1984). Bear tracks, cloven hoofprints, bird tracks, and tracks of rabbit, cougar, and wolf are pecked into a horizontal bedrock outcrop. Associated with these tracks are several bisected circles and a single large penisform. The petroglyphs show clear similarities with Northwestern Plains sites such as Snake Butte and St. Victor, and many of the images duplicate those at Northwestern Plains Hoofprint sites. Even the Cranbrook bear tracks closely resemble Hoofprint tradition bear tracks.

Considering everything known about the Cranbrook petroglyphs, they appear to be more closely related to the Northwestern Plains Hoofprint tradition than to any other rock art. Their location along a trail near the Crowsnest Pass—a major travel route across the Continental Divide from the Northwestern Plains to the Columbia Plateau—suggests that

the site may have been made by people who regularly traveled between the two areas while hunting and trading.

Cultural Affiliations

Determining the cultural affiliation of most Hoofprint rock art appears relatively straightforward, based on the distribution of Hoofprint sites across eastern North America and the Northwestern Plains. The distribution of the Siouan language family from the Mississippi River to the Rocky Mountains shows a very close correspondence to the site distribution of Hoofprint tradition rock art. In addition, ethnohistoric references to Siouan-speaking groups using a Hoofprint site for religious purposes, and extensive Siouan mythology centered on the theme of fertility, womanhood, and bison appear to be reflected in the rock art. Finally, the proposed range of dates for Northwestern Plains Hoofprint tradition petroglyphs accords with the general dating of the expansion of Siouan speakers onto the Plains during the last half of the Late Prehistoric period.

The possibility also exists that some Algonkian-speaking groups (notably the Plains Cree and possibly the Cheyenne) used and even made some Hoofprint petroglyphs, particularly glyphstones. Some Eastern Woodlands Hoofprint sites are in the range of Algonkian speakers, and some Northwestern Plains Hoofprint sites and glyphstones were and still are used as offering sites by the Plains Cree. The Cree had close ties to various Assiniboin groups in the Historic period, which may well have been a continuation of prehistoric patterns. It seems unlikely, however, that the Hoofprint tradition is widely associated with Algonkian speakers, since it is absent over much of their range in northern North America and occurs very infrequently in the Northwestern Plains territory occupied by the Algonkian-speaking Blackfeet, Plains Cree, and Plains Ojibwa.

Although some authors have tried to ascribe Hoofprint motifs at various sites to specific groups, such as the Mandan, this approach seems to have little application regionwide, as so many Siouan-speaking groups occupied this area. Rather, it seems most probable that these Northwestern Plains sites were made and used by members of most Siouan-speaking groups, including the Mandan, Hidatsa, Crow, Assiniboin, the Dakota and Lakota Sioux, and perhaps even the Ponca.

Interpretations

Most Hoofprint rock art apparently functioned in a symbolic context related to a set of cosmological beliefs that viewed women and bison as the producers and sustainers of life. In her study of South Dakota rock art, Sundstrom (1993:295) describes this relationship among the Lakota Sioux as "an overreaching mental association between women and bison as reproductive and life-sustaining forces." She notes that this association was fundamental to the belief systems of several Siouan-speaking Plains groups and was thus reflected in their art, religion, status system, color symbolism, names, and other aspects of their bison-hunting societies. Themes of fertility, fecundity, and the sacred relationship between womanhood and the bison recur throughout these Siouan belief systems. One Lakota Sioux culture hero was a woman who transformed herself into a bison after giving the Sioux their sacred red pipe and the basic constructs of their culture.

Considerable rock art evidence shows that this relationship between fertility, femaleness, and bison (and even other game animals) occurs throughout the Hoofprint tradition. At both Snake Butte and St. Victor, there are two instances of symbolic copulation of penisforms and vulvaforms, and vulvaforms are clearly associated with hoofprints at as many as twenty sites across the Northwestern

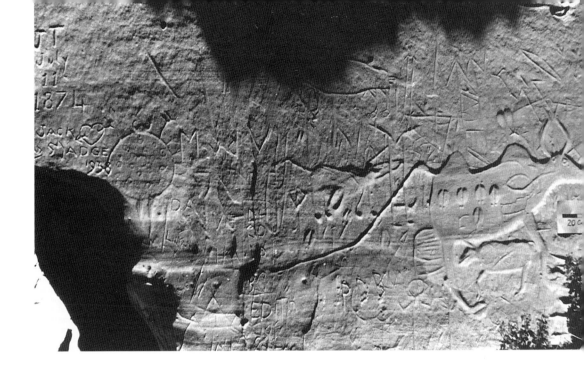

This North Cave Hills site includes a large intaglio bison cow and calf composition and numerous hoofprints. These are superimposed on earlier Ceremonial tradition images like the shield-bearing warrior at left.

Plains (fig. 12.11). At Saddle Butte on the middle Milk River, a pecked female figure was placed just touching a bison hoofprint (fig. 12.1). It is also possible that some of the bisected circles or ovals so common at Hoofprint sites in northern Montana represent vulvaforms or sexual symbolism. The number, configuration, and associations of vulvaforms within the Hoofprint tradition implies a strong concern with fertility.

Furthermore, the bison cow and calf composition at the site near Ludlow Cave appears to be a birth scene (see fig. 2.4). Emblazoned on the engraved body of the larger animal is a group of five hoofprints and another smaller bison.

Thunderbird and turtle—both important motifs in this tradition—were also major deities in the Siouan belief system, ruling the separate realms of earth and sky. The turtle is symbolic of protection, longevity, and the forces of the subterranean realm, in direct opposition to the Thunderbird, who rules the sky. In this system, Thunderbird is an extremely powerful figure whose destructive nature is readily associated with the lightning storms and tornadoes that characterize the region's spring and summer seasons. The

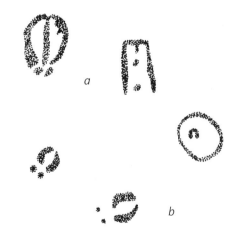

12.11 Sometimes hoofprints are juxtaposed with vulvaforms (a) or circles (b), which may represent the same thing.

turtles found at five sites and the trident bird tracks at ten sites may well symbolize the mythical turtle and Thunderbird figures. Carved Thunderbird tracks may be supplications to this powerful deity, who required appeasement to prevent harm to humans (fig. 12.12).

Contextual evidence also suggests that some Hoofprint petroglyphs were associated with ritual activities relating to communal bison hunting. At Saddle Butte, two small petroglyph boulders are located in an extensive tipi ring campsite just across the Milk River from a cluster of more than ten Late Prehistoric period bison kills; and in the North Cave Hills, many of the hoofprint petroglyphs are adjacent to large Late Prehistoric period bison-processing sites. Park (1990) also makes a connection between the numerous hoofprint petroglyph boulders and several major bison kills nearby in the Big Bend region of the Milk River.

These associations between petroglyphs and bison kill or processing sites imply that some of the rock art was the subject of rituals conducted by a hunt shaman. For example, a buffalo-jump killsite is apparently associated with the St. Victor petroglyphs, and lines of hoofprints oriented toward the cliff edge may have been produced during shamanic rites that attempted to control the bison and induce them to jump over the cliff (Jones and Jones 1982). Similar lines of tracks oriented toward

edges of low cliffs also occur at Snake Butte. The single hoofprint petroglyph on the boulder sitting on the bluff above the bison pound at Wahkpa Chu'gn also suggests it was placed there to lure bison into the corral.

The interpretation of Hoofprint rock art as supplicative hunting magic is supported by archaeological and ethnographic evidence that shows these sites were thought of as places of supernatural power (Keyser 1984). At the Simanton petroglyph boulder, offerings of red ochre and a catlinite pipe were uncovered. The Sleeping Buffalo boulder also has pecked into its hump a receptacle or altar that was apparently used to leave offerings. Explicit references to a religious function for several Hoofprint tradition sites are also documented. Accounts by Lewis and Clark, Prince Maximilian, and other early explorers indicate that in the early 1800s, the Medicine Rock site, located in North Dakota's Cedar River drainage, was used by the Mandan and Hidatsa to predict the future and petition the spirits for success in hunting and warfare (Porsche and Loendorf 1987). The sandstone formation at Roche Percée was also considered sacred; according to James Hector, who visited the site in 1857, "[the] Indians never pass this stone without making some offering to the Manitou which to their mind it represents, such as rubbing vermilion on it, or depositing beads, tobacco, or the like in the crevices" (Wintemberg 1939:175).

The two functional explanations for Hoofprint tradition rock art—symbols of fertility and hunting magic—are actually quite complementary. Clearly, female fertility and game animals (especially bison) are linked at many sites, often by symbolic association between hoofprints and representations of human genitalia. The importance of bison to Late Prehistoric period Northwestern Plains cultures is clear from the archaeological record, which includes thousands of buffalo killsites and processing sites. Both archaeological and ethnohistoric evidence indicates that

12.12 *Bird tracks in Hoofprint tradition rock art probably represent Thunderbird.*

other big game animals were equally important at some times of the year, especially in the rough breaks country around the outlying buttes and mountain ranges.

Given the importance of big game hunting to these cultures, it seems very likely that ritual behaviors would develop as an attempt to guarantee both the productivity of the game animals and their availability to the hunters. This would be especially true for horticulturalist groups adopting an economy oriented toward bison hunting as they moved onto the plains from the Eastern Woodlands. Thus, the religious rituals designed to increase bison fertility formed the core of much Northwestern Plains cosmology—even as recently as the Ghost Dance religion of the late 1880s, which was intended to bring back the bison that had been overhunted to the edge of extinction.

Along with this emphasis on bison productivity, Northwestern Plains Indian religion was concerned with controlling bison and other game animals so they could be successfully hunted. Evidence of shamanic activity associated with communal bison kills and the hunting of other large animals occurs throughout 10,000 years of the archaeological record, and the ethnographic record is full of references to shamanic activities, ranging from the Blackfeet "Iniskim" (Buffalo Stones) and the Plains Cree offerings to the Sleeping Buffalo petroglyph boulder (fig. 12.2), to the role of "buffalo runner" in the successful operation of a communal kill. It seems likely that many hoofprint petroglyphs associated with bison kill or processing sites and those with associated ritual paraphernalia represent efforts by prehistoric shamans to control the success of the hunt.

In the end, it is not surprising that bison motifs figure so prominently in Hoofprint tradition rock art. The importance of bison hunting to Plains Siouan cultures is difficult to overstate, and life without bison was inconceivable to these peoples. Much of Siouan religion focused on ensuring the fecundity of this animal, symbolized by the sacred relationship between women and bison. Hoofprint rock art, portraying themes of fertility and hunting magic, vividly illustrates the sacred role of bison.

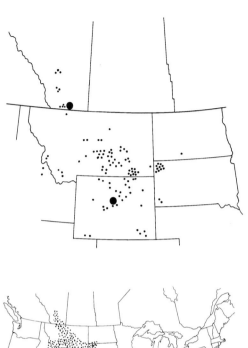

Map 13.1. Ceremonial Tradition Rock Art

above: Regional distribution
Large dots indicate Writing-on-Stone (Alberta) and
Castle Gardens (Wyoming).

below: Continental distribution

13 / Ceremonial Tradition

Perhaps no Northwestern Plains rock art illustrates the role of medicine power in Plains cultures as clearly as the petroglyphs and pictographs of the Ceremonial tradition. Portraying sacred visions, guardian spirits, and ritual paraphernalia, the images of this tradition are pictorial manifestations of the medicine powers that protected warriors in battle, gave them strength against enemies and status among peers. Like the medicine paintings on shields and tipis, this rock art represents the personal relationship of warriors to the mysterious forces of the spirit world.

Ceremonial tradition rock art is among the most common and widespread on the Northwestern Plains, with sites scattered from southern Alberta to southern Wyoming, and from the Rocky Mountains to the Black Hills. Spanning more than a thousand years, this tradition originated long before Europeans arrived on the Plains and continued well into the 1800s. The most prevalent designs are shield-bearing warriors, elaborate humans, conventionalized animals, ritual objects, and weapons (fig. 13.1). The detailed, static, and carefully executed designs of this tradition, generally found as isolated single images or in small juxtaposed groups, are presented in a manner suggestive of ceremonial or ritualistic purposes. With shared formal characteristics and underlying continuities in meaning, the motifs of the Ceremonial tradition can be interpreted as religious iconography.

Ceremonial tradition rock art occurs as petroglyphs and pictographs, and all major designs were produced using both techniques. Petroglyphs are more common, but some sites are exclusively painted, while others include examples of both painted and carved images.

13.1 This incised panel at Verdigris Coulee near Writing-on-Stone shows classic Ceremonial tradition rock art superimposed (at right) by Biographic scenes showing weapon capture and a horse raid. Kidneys and heartlines appear on two humans and an antelope, and two V-neck humans hold ceremonial feather fans. Skunks are known at only one other Plains site.

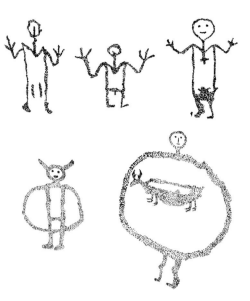

Isolated, incised figures, such as this bison at Writing-on-Stone, are typical Ceremonial tradition images.

13.2 The few pecked shield-bearing warriors and V-neck humans are nearly all found in the region between Billings, Montana and Cody, Wyoming.

Most petroglyphs are deeply incised with even, precise strokes, often augmented with fine, lightly incised details. Incised petroglyphs were made with bone or antler tools, which work well on the region's soft sandstones, but some Historic period examples were undoubtedly done with the point of a metal knife or other tool. Although most petroglyphs probably were drawn freehand, some circular shields are nearly perfect circles, suggesting that a thong-and-pin compass was used to make them. Sometimes a rough

sketch is found nearby on the same panel, further indicating careful preparation before undertaking the finished carving. Few scratched Ceremonial petroglyphs are known, but many older, lightly scratched designs may have worn away faster than more deeply incised images. Occasionally, pecked or abraded details have been added to incised Ceremonial images. Petroglyphs produced entirely by pecking or abrading are found only at a few sites in a limited area of south-central Montana and northern Wyoming (fig. 13.2).

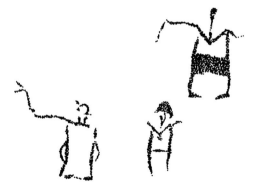

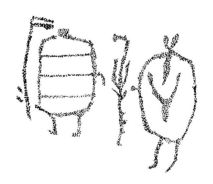

13.3 Black-painted V-neck and rectangular humans and red-painted, shield-bearing warriors on a single panel at a site just south of Calgary, Alberta.

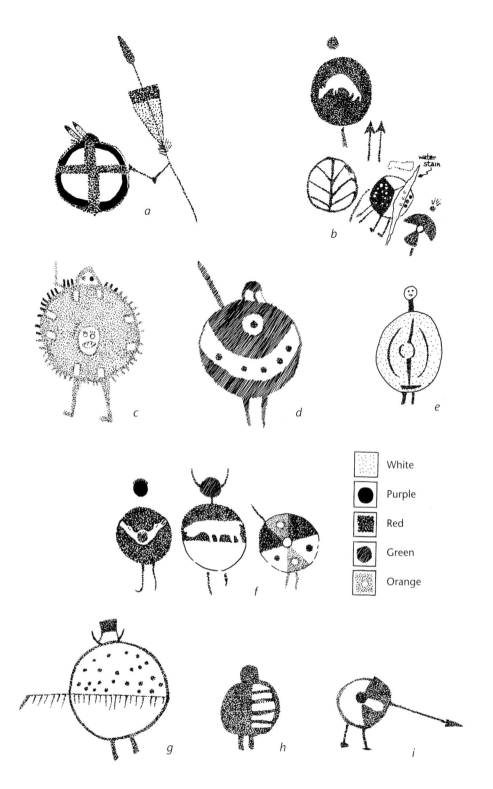

13.4 Shield-bearing warrior pictographs include both polychrome (a–f) and monochrome (g–i) images. Very lightly colored parts of some figures suggest that the blank areas on several figures (for instance b, f) were probably originally painted but the pigment has faded away.

Ceremonial tradition pictographs are most often red monochrome paintings, but orange, yellow, white, and black monochrome pictographs are also known (fig. 13.3). Several pictographs of different monochrome colors are occasionally found together on the same panel. Polychrome paintings are infrequent, but such designs occur at several Montana sites. The most spectacular Ceremonial polychromes are found at the Valley of the Shields in south-central Montana, where five different colors were used to paint shield-bearing warriors—as many as three colors for a single figure (fig. 13.4). Liquid pigments were applied with fingers, brushes, and porous bits of bone, or pictographs were drawn with lumps of greasy ochre used like crayons or chalked directly onto the stone with a piece of raw pigment or charcoal. Sometimes two or more different applicators were used on the same figure.

Some images were both incised and painted. Incisions of some petroglyphs are filled with red ochre, and pigment also was smeared across figures or entire panels. The most dramatic of these combination glyphs occur at Castle Gardens, where incised petroglyphs are painted with pastel hues of white, green, red, and yellow (fig. 13.5). The most complex is the Great Turtle shield, composed of sixty separate incised sections, alternately painted green, orange-yellow, or purplish red, creating a remarkable polychrome mosaic.

Most Ceremonial tradition sites are situated in the prairie grassland or foothill regions of the Northwestern Plains. Ceremonial rock art was usually carved or painted on vertical sandstone cliffs, which often form valley walls along major rivers or coulees. At Writing-on-Stone, for example, nearly 100 sites are scattered along the cliffs lining the Milk River and smaller tributary coulees. Other images are carved on cliffs at the bases of buttes, mesas, and buffalo jumps, or sometimes on the walls, floors, or ceilings of small caves or rockshelters (fig. 13.6). Sites often are located on or near unusual geological features that stand out from the surrounding landscape—canyons, mesas, sandstone outcrops, and isolated peaks—and many are on high points of land with sweeping vistas of the surrounding prairie.

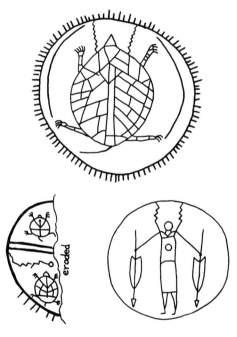

13.5 *Incised and painted shields from Castle Gardens, Wyoming. The Great Turtle shield (top) has segments of carapace, legs, and head painted in various pastel shades of orange-yellow, reddish purple, and green. These colors are very faded but still visible, possibly because the figure was stolen from the site before 1940 and kept in a museum since its recovery shortly thereafter. The other figures also show faint traces of pigment.*

Previous Research

Rock art of the Ceremonial tradition is some of the best known from the Northwestern Plains, since most designs are quite distinctive, and they occur in large numbers at many of the most spectacular sites in the region. The earliest published illustrations of this rock art are several panels from Writing-on-Stone (Smith 1923). Even at this early point, Smith

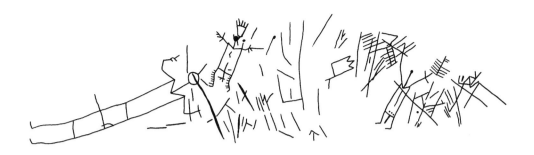

13.6 A group of Ceremonial figures incised across the sloping floor of a small sandstone cave at Writing-on-Stone.

recognized that similar designs occurred as far south as Wyoming. During the 1930s, Renaud (1936) undertook the first academic investigations of rock art, describing Ceremonial tradition designs at Castle Gardens and several other Wyoming and South Dakota sites.

Other early descriptions of Ceremonial rock art occurred in South Dakota (Over 1941) and again at Castle Gardens (Sowers 1941; Gebhard 1951). Gebhard's comparison of the rock art at Castle Gardens and Dinwoody led him to propose a classification of Wyoming rock art into six "types," but after recording many other Wyoming sites during the late 1950s, he revised his classification scheme into three chronological styles (Gebhard 1969). The latest, which he called the "Plains or Late Hunting Style," corresponds fairly well to our Ceremonial tradition. At about this same time, he suggested that the shield design diffused or spread onto the Plains from the Great Basin around A.D. 1000 (Gebhard 1966).

Interest in rock art throughout the region began to grow in the late 1950s and 1960s, and numerous Ceremonial tradition sites were recorded during this period. The paintings at Pictograph Cave, although recorded in the late 1930s, were published at this time (Mulloy 1958). Site descriptions appeared regularly in Wyoming and Montana archaeological journals (Secrist 1960; Grey and Sweem 1961), and the earliest systematic attempt to record

rock art at Writing-on-Stone took place (Dewdney 1964). Dewdney also devised a classification scheme for the rock art, and made the first attempt at a chronological sequence. His remarkable drawings formed the basis of subsequent discussions of Writing-on-Stone rock art for the next decade (King 1965; Wormington and Forbis 1965; Habgood 1967; Dempsey 1973). From the early 1960s onward, Stuart Conner recorded Montana sites and published numerous reports on rock art of the Ceremonial tradition (Conner 1962a, 1962b, 1980, 1984, 1989a, 1989b; Conner and Conner 1971). Conner's work formed the original core of much Ceremonial rock art research in the region.

In the mid-1970s, Keyser (1975) proposed that the shield-bearing warrior was related to the Late Prehistoric period expansion of the Plains Shoshone. A year later he undertook a comprehensive investigation of Writing-on-Stone, recording many new Ceremonial panels and describing the designs at more than fifty sites (Keyser 1977a). His primary contribution was the classification of Writing-on-Stone rock art into two major categories, which he called "Ceremonial" and "Biographic." Building on Renaud, Gebhard, Dewdney, and his own previous work, Keyser (1977a) linked Ceremonial rock art to the Shoshonean culture and postulated that the tradition was essentially restricted to the Late Prehistoric period. A few years later, he also conducted a major rock art survey in the North Cave Hills of western South Dakota, which identified more Ceremonial tradition sites (Keyser 1984).

Despite its obvious importance, the first complete survey and description of Castle Gardens rock art was not undertaken until 1980 (Gebhard et al. 1987). More recently, additional research on the Ceremonial tradition in the southern portion of the region has occurred, including dating of shield-bearing warriors (Loendorf 1990), and overviews of Wyoming (Francis 1991) and Colorado (Cole 1990) rock art. Recent survey work in Montana by Mavis and John Greer (Greer 1995) and in Alberta (Klassen 1994a, 1995) has added many new Ceremonial sites to the record.

Although Keyser's (1977a) original description for Ceremonial rock art forms the basis for our definition of this tradition, recent work has challenged some aspects of his description and interpretation, revising and expanding our understanding of Ceremonial rock art (Schuster 1987; Magne and Klassen 1991, 1992; Loendorf 1990; Klassen 1995). Significant revisions include a broader ethnic

origin for the tradition, earlier dates for its inception, and documentation of its continuity into the Historic period. Recently the role of shamanism in Ceremonial rock art (Barry 1991) and the relationship of iconic imagery to sacred landscapes (Klassen 1998a) has been explored. These new ideas have been incorporated into our discussion of this tradition.

The Rock Art

Ceremonial tradition rock art is almost exclusively representational, with very few geometric and abstract images. The representational figures primarily fall into the human, animal, and material culture categories.

Human Figures

Ceremonial tradition humans are simple, schematic figures, with little emphasis on naturalism. They are generally depicted with outlined rectilinear body forms, often elaborated with decorative or anatomical

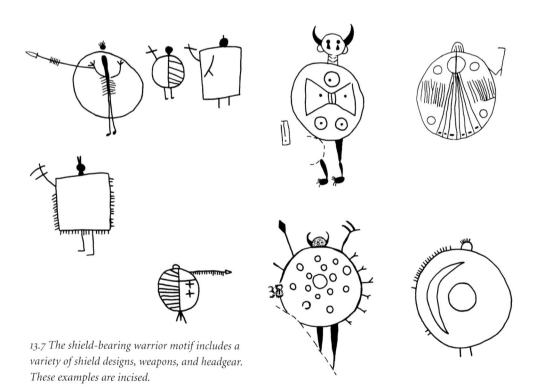

13.7 The shield-bearing warrior motif includes a variety of shield designs, weapons, and headgear. These examples are incised.

196

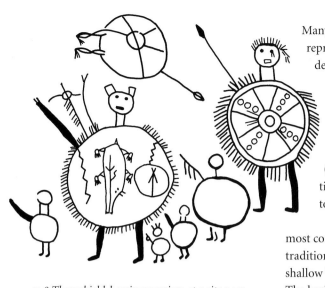

13.8 *These shield-bearing warriors at a site near Sheridan, Wyoming, show facial features (note tear streak) and elaborate shield designs (note bear at left).*

Many of the shields are also decorated with representational and nonrepresentational designs. These include geometric decorations ranging from simple rectilinear or curvilinear designs to complex patterns and combinations of shapes, and figures of animals, humans, and material culture items (fig. 13.8). Occasionally representational and geometric designs are found together on a single shield.

The V-neck human is probably the most common and distinctive Ceremonial tradition figure—easily identified by the shallow V forming the shoulder area (fig. 13.9). The basic body form is two vertical lines for the torso and legs, V-shaped shoulders, a stick neck, and a dot or circular head. Most have a horizontal waist, feet, arms, and hands, and some have facial features. Their typical stance is frontal, with arms held out to each side and bent upwards at the elbow. Most V-neck humans are oriented upright, but some are shown on their sides or even upside down. In some cases, torsos are greatly elongated relative to legs and arms, and occasionally the waist is shown as a shallow, inverted V reminiscent of the shoulder shape.

Like shield-bearers, V-necks show much variation of form and detail. Some are little more than two parallel lines joined by a V, while "classic" examples are highly detailed and elaborated. Many classic V-neck figures are shown with genitalia, internal organs such as kidneys, or lifelines which represent the throat and heart. In several cases, one human figure is joined to another by an extension of the male genitals (fig. 13.10). Some V-neck humans also have a series of upside-down chevrons incised in their torsos. These have been variously identified as ribs, tattoos, clothing, or bone breastplates, but the occurrence of similar designs on associated boat-form animals lends credence to their identification as ribs. V-neck humans are also frequently associated with material culture

details such as headdresses, clothing, fingers, and genitalia. Internal organs are sometimes depicted, and those few with sexual features are nearly all male. Almost all these humans are drawn as static frontal figures with upraised arms bent at the elbow. Humans are the most common and distinctive designs of this tradition, and most forms are easily distinguished from those in other traditions. The majority are of three conventionalized types: shield-bearing warriors, V-neck humans, and rectangular-body humans.

The shield-bearing warrior is the best known Ceremonial tradition human figure (fig. 13.7). These examples show a standing human holding a large circular (occasionally rectangular) shield in front of the torso. At its simplest, this design is nothing more than a circle for the shield, two vertical lines for legs, and for the head a small circle or dot. In most cases, however, this basic form has added anatomical features such as arms, hands, feet, genitalia, and faces, and includes elaborations such as detailed headdresses, staffs, spears, or other weapons, and shield fringing.

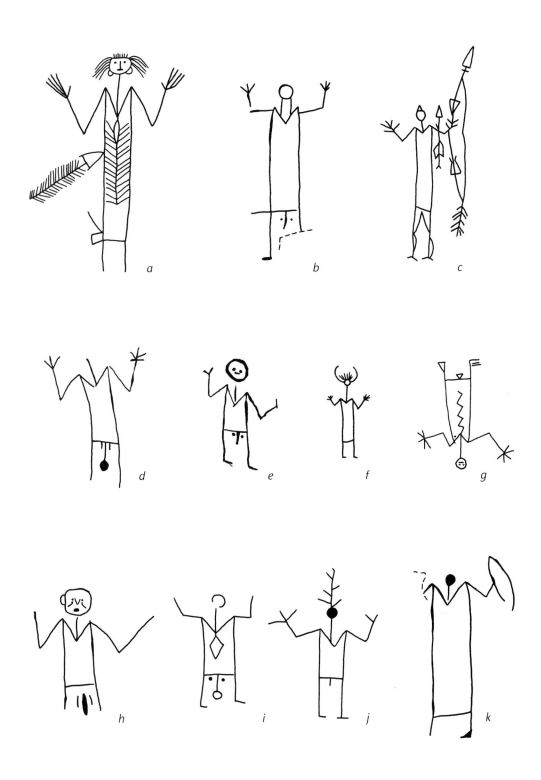

a *b* *c*

d *e* *f* *g*

h *i* *j* *k*

13.9 *The distinctive V-neck human figures incised at sites throughout the Northwestern Plains frequently show genitals (a, b, d, e, g–j), weapons (k), lifelines(a, g, i), and headdresses (f, j). Note female figure with tear streaks (h) and image carved upside down (g).*

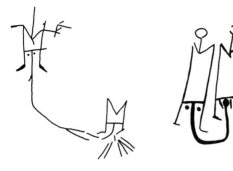

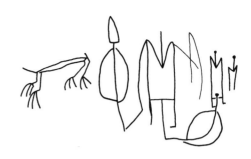

13.10 *V-neck humans joined by an extension of the male genitals likely represent sexual union.*

items. Headdresses are a common accouterment, and some figures appear to wear fringed or feathered clothing. They also commonly hold weapons or ceremonial objects.

The unusual V-shaped shoulder form distinguishes this design from other anthropomorphs found elsewhere in North American rock art, but on the Northwestern Plains, it appears to be closely linked to the shield-bearing warrior design. Several shield-bearing warriors clearly show the body of a V-neck human behind a "transparent" shield, or have a V-neck human as a shield design (fig. 13.11).

Rectangular-body figures are also frontal outline forms. Some rectangular body figures are almost identical to V-neck humans except for the shoulder shape, and are depicted in similar poses and with the same anatomical details and elaborations (fig. 13.1). Although the rectangular torso outline is common to rock-art humans in many other regions of North America, the remarkable similarity between some Northwestern Plains rectangular-body and V-neck humans indicates that they are closely related in Ceremonial rock art (Magne and Klassen 1991).

In Historic period Ceremonial rock art, some humans are also drawn on horseback (fig. 13.12). In these cases, the mounted humans retain the basic formal characteristics of either V-neck or rectangular-body figures, but the pictorial emphasis has turned to the relationship of the human with the horse. Mounted humans are generally less detailed and more sketchy, and in many cases the human figure is indeed secondary to the more detailed horse. Finally, a few human figures are unique or unusual in shape and detail,

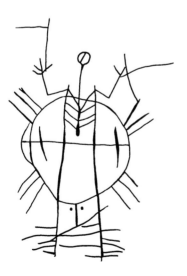

13.11 *A V-neck human behind a "transparent" body shield.*

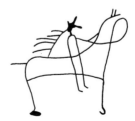

13.12 *A rectangular-body human mounted on a horse.*

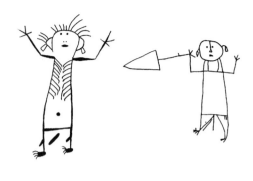
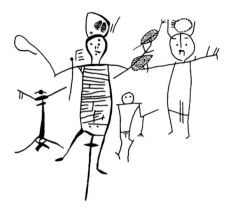

13.13 Rectangular-body human figures show
many of the same features as V-neck humans
(note hoofprint with dewclaws in headdress of
the largest of the grouped figures).

but they are linked to Ceremonial rock art
by their spatial or compositional association
with other distinctive designs of this tradition
(fig. 13.13).

Animal Figures

Like humans, most Ceremonial tradition
animals are schematic and highly convention-
alized. They are generally carved or painted
with a simple, outlined, curvilinear body
form and include some anatomical details.
They are usually shown as static images and
almost always in profile. Animals represented
include bears, bison, elk, deer, mountain
sheep, pronghorn antelope, skunks, dogs,
birds, insects, turtles, and snakes. During
the Historic period, horses were also carved
and painted. A few mythical creatures are
also represented. Based on body form, most
animal figures can also be classified into three
different types or styles: boat-form, mature-
style, and naturalistic animals.

Boat-form animals are characterized by
a distinctive body shape, which varies from a
boat or crescent shape, to a more elongated or
ovate form (fig. 13.14). Mountain sheep, deer,
and pronghorn antelope are the most com-

*A simple, incised bear near Ashland, Montana,
includes details such as teeth, tear streaks, a lifeline,
and an arrow in its back.*

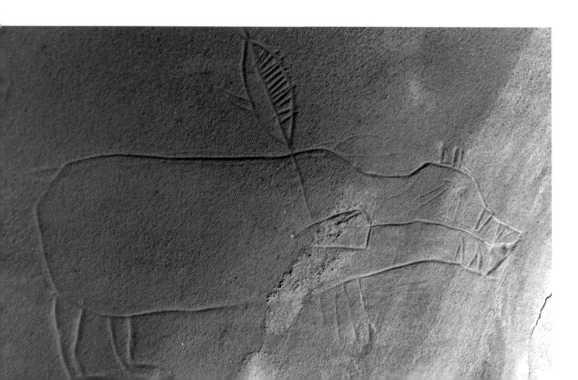

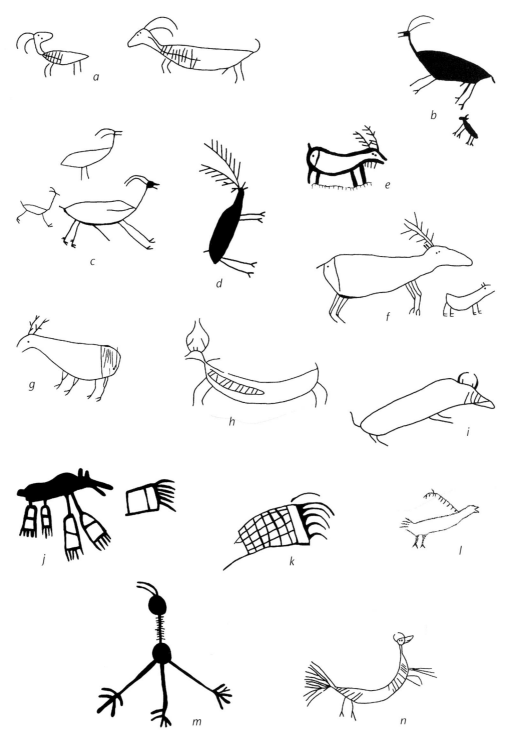

13.14 Ceremonial art includes a variety of animal species, most of them in boat-form style (a-h, l, n): a-c, mountain sheep; d-g, elk/deer; h, pronghorn antelope; i, bison; j, k, bear and bear paws; l-n, birds (n is probably a sage grouse in its mating ritual "dance" posture). Note that adult/juvenile compositions in a-c, f all have male adult animals.

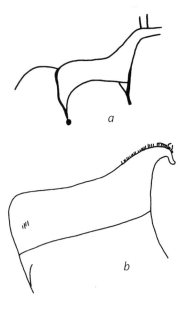

13.15 *Mature-style animals include horses (a-b) and a few other species like this very detailed elk (c).*

mon boat-form animals, but skunks, birds, and bison are also occasionally depicted in this style. In these conventionalized forms, anatomical details are rendered somewhat schematically, and realism is not emphasized, but enough detail is often included to identify their species. For example, the horn shape readily distinguishes mountain sheep from pronghorns or deer. Bison have a hump and shorter horns, and bears have a hump, long claws, and often teeth. The raised, bushy tail easily distinguishes the skunk. The bipedal stance, clawed feet, spread tail, beaked head, and outstretched wings identify a bird, possibly a dancing grouse. Other anatomical details shown on various boat-form animals include ears, tails, and even the pronghorn's distinctive rump patch. Many boat-form animals also show internal organs, such as ribs, kidneys, "kidney belts," and lifelines. Although most boat-form quadrupeds are shown in a naturalistic horizontal stance, they are occasionally oriented vertically or diagonally, sometimes head down. Boat-form animals are rarely associated with historic items, but a few boat-form horses (with riders) indicate that this style continued into the postcontact period.

The mature-style animal figure is a more recent development than the boat-form type.

The most common mature-style animal is the horse, but drawings of a few other animals also resemble this style (fig. 13.15). Mature-style animals are highly schematic and characterized by a flowing, streamlined body shape in which a few simple strokes elegantly capture the form of the animal with little recourse to naturalism or details. In classic examples, a single sinuous line forms the upper head, neck, back, and rear leg; a second line forms the lower head, throat, and front leg; and a third gently arcing line forms the belly. Snouts are often left open, and legs are generally a single straight line. Usually only two legs are shown, with little or no modeling of limbs. Other anatomical features are restricted to schematic ears, hooves, and tails rendered with simple lines. As this form is used primarily for horses, it is largely believed to be a postcontact development for animal depictions.

A few Ceremonial tradition animals display a greater emphasis on naturalism or realism than boat-form or mature-style types. Their body shapes and anatomical details more closely resemble the real animal's appearance. Specific details include hooves, fetlocks, ears, tails, and realistically drawn legs. This realism makes naturalistic animals easy to identify; naturalistic bison, elk, and other animals are known.

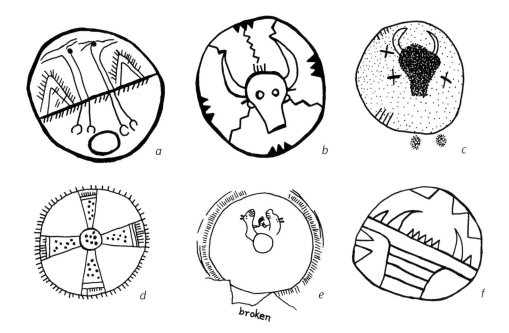

broken

13.16 *A variety of incised, decorated shields were made in both Ceremonial and Biographic art. Shield b is part of a warrior's record of his coups.*

Mythical animals are recognizable animal figures with unnatural or imaginary details. The most common is Thunderbird, which can be recognized by comparison to ethnographic records. Most likely some of the other animals also represent mythical beings.

Material Culture

Images of material culture items, also an important component of the Ceremonial tradition, include clothing, weapons, and ceremonial objects. While many are intimately associated with humans or horses, they are sometimes also drawn as individual independent designs. Like humans and animals, material culture designs vary from schematic and conventionalized to quite realistic.

Decorated and undecorated shields are obviously associated with shield-bearing warriors, but independent decorated shields are also known from a number of sites, including Castle Gardens and the North Cave

Hills (fig. 13.16). Some are as elaborate and detailed as those carried by shield-bearing warriors, and include images of animals or humans.

Many humans, including shield-bearing warriors, wear headdresses. Some are quite complex, while others show only buffalo horns or a few feathers. One shield-bearer's large, elaborate headdress may represent a "stand-up" headdress like those once common among the Blackfeet. Some branching designs may represent feathers or antlers. Some horsemen wear long, flowing feather headdresses. Other clothing is rarely shown in Ceremonial rock art, except for feathers or leather fringes hanging from arms or legs.

Occasionally weapons occur as independent designs (fig. 13.17). More commonly, however, weapons are held by or are associated with humans (fig. 13.18). Most are spears with large triangular heads and shafts often decorated with dangling feathers, but bows and arrows, clubs, and axes are also occasionally pictured. One shield-bearing warrior wields an atlatl and two darts. Some V-neck humans and a single shield-bearer hold or stand beside flintlock guns, identified by the

trigger guard, hammer, and frizzen. Shield-bearing warriors and V-neck humans sometimes hold ceremonial weapons known as bow-spears. These are long single-curve bows with a large spear point at one end and feathers at the other, and the best examples show the spearhead hafting, feathers, and other decorations hanging from the bow. Other ceremonial items include feather-decorated staffs and rakelike objects that represent a row or fan of feathers attached to the end of a pole (fig. 13.19).

Few animals other than horses are shown in direct association with material culture items. A few bison and elk have arrows or spears passing across or piercing their bodies (fig. 13.20). Horses, on the other hand, are shown with reins or other riding tack, or feathers tied in the tail. Some horses are shown with scalp-decorated halters and feathered amulets.

Compositional Arrangements

Most Ceremonial designs are carefully executed and symmetrical, showing little evidence of movement or action. Direct

13.17 Isolated weapons at Writing-on-Stone include guns and war axes. Many examples are likely iconic images, although some may also tally captured war trophies. Gun in b is a red pictograph; others are incised petroglyphs.

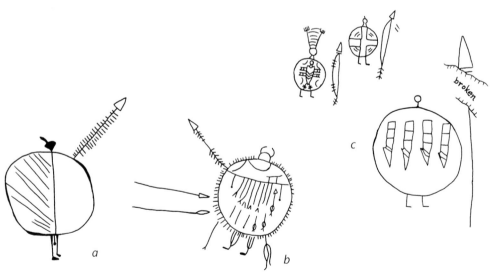

13.18 Incised shield-bearing warriors are associated with spears and bow-spears. Note the dragonfly shield design on the small warrior at left in c.

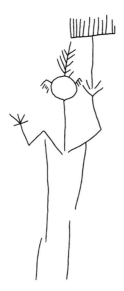

13.19 *A V-neck human holding a feathered ceremonial staff.*

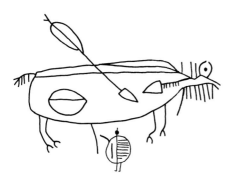

13.20 *A large arrow pierces this bison.*

interaction between figures is also absent, and they rarely compose integrated scenes. Instead, Ceremonial designs appear generally as single, isolated images, or as small groups of juxtaposed, loosely associated figures. Thus each design stands alone as a separate image, or the relationship between designs is implied but not explicitly pictured.

Juxtaposed compositions are recognized by the similar age, subject matter, form, or technique of the images, coupled with their close spatial relationship. Juxtaposed groups can be composed of several similar designs, such as a group of painted shield-bearing figures (fig. 13.21). Although they have no direct physical connection, their proximity and formal similarity implies a meaningful or symbolic relationship. Two or more different types of images may also be shown as a juxtaposed group. For example, a shield-bearing warrior may be closely associated with a ceremonial object or weapon. Three incised shield-bearing warriors with bow-spears at Writing-on-Stone provide a good example of a juxtaposed panel: each occurs as a separate image juxtaposed with a weapon, and no explicit interaction is shown among them (fig. 13.18). Their formal similarity and positioning, however, strongly suggest their symbolic relationship.

13.21 *A juxtaposed group of red pictograph shield-bearing warriors at Writing-on-Stone.*

13.22 *A loosely juxtaposed group of Ceremonial figures.*

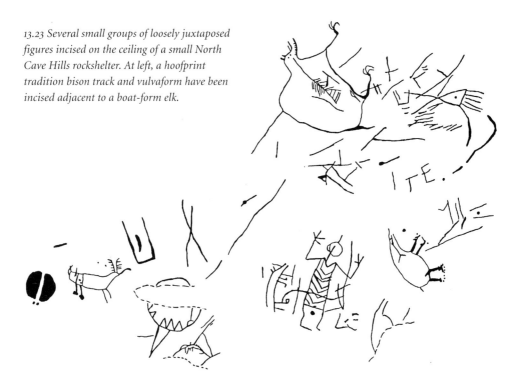

13.23 Several small groups of loosely juxtaposed figures incised on the ceiling of a small North Cave Hills rockshelter. At left, a hoofprint tradition bison track and vulvaform have been incised adjacent to a boat-form elk.

The simple juxtaposed compositions in Ceremonial rock art do not exhibit perspective or use ground lines, although occasionally a group of designs are aligned to a crack or other natural feature. While many Ceremonial tradition panels consist of a single image or a single juxtaposed group, more typically a panel will have several individual images or separate, loosely juxtaposed groups distributed across the surface (figs. 13.22, 13.23).

Dating and Chronology

The Ceremonial tradition is relatively long lived. The earliest sites may date to the Late Archaic period before A.D. 250, while the latest were made during the 1800s. The tradition flourished, however, during the latter part of the Late Prehistoric period and was the dominant Northwestern Plains rock art tradition from approximately A.D. 1000 until the early contact period (fig. 13.24). Although absolute dates have recently been obtained at a few sites, determining the age of this tradition

still relies primarily on analyzing subject matter. Guns and horses date some Ceremonial rock art to the Historic period, but it is the shield-bearing warrior that links this tradition to the pre-contact era (fig. 13.7).

Shield-bearing warrior designs show the large body shields widely used by pedestrian Plains warriors before the arrival of the horse. The only known archaeological specimens of these body shields were found in south-central Utah and have been radiocarbon dated to approximately A.D. 1500 (Loendorf and Conner 1993). They are approximately 3 feet (1 m) in diameter, with painted geometric designs similar to some rock art shield-bearing warriors. Body shields were used throughout much of the Late Prehistoric period by many different Northwestern Plains groups. The best ethnographic description comes from a story told by Saahkómaapi, an aged Plains Cree warrior, to the fur trader David Thompson in southern Alberta in 1787 (Thompson 1962). He described a battle before the advent of horses, in which enemies crouched behind

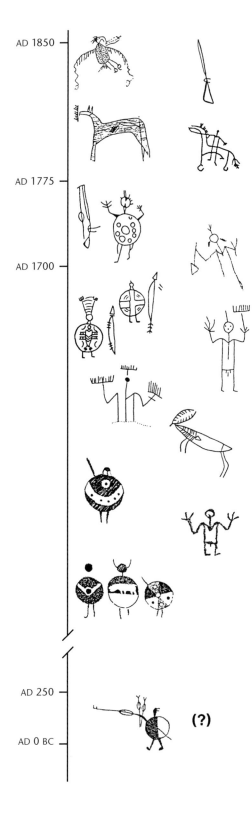

AD 1850 —

AD 1775 —

AD 1700 —

AD 250 —

AD 0 BC —

(?)

13.24 *Ceremonial Tradition General Chronology*

shields big enough to hide two warriors (fig. 13.36). After the arrival of the horse around 1730, these large body shields were quickly abandoned for much smaller equestrian shields easier to use on horseback. These small shields are routinely pictured in Historic period Biographic art, and numerous examples survive in museum collections.

Since body shields were primarily Late Prehistoric period artifacts, it seems reasonable to suggest that most shield-bearing warrior images also date to the same period. Many shield-bearing warriors are shown with bows, which on the Plains also date to the Late Prehistoric. In one case, however, a shield-bearing warrior at a site near Great Falls, Montana, holds an atlatl and darts (fig. 13.25). Archaeologically, the atlatl predates the bow and arrow, so its depiction implies that this image may be of Late Archaic age, or more than 1700 years old.

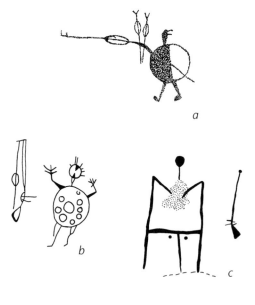

a

b

c

13.25 *Weapons associated with some shield-bearing warriors and V-neck humans provide dating clues. a, shield-bearing warrior with atlatl and darts; b, shield-bearing warrior with gun; c, V-neck figure with gun.*

The Late Prehistoric age for most shield figures is supported by a number of absolute dates from Bighorn Basin sites. At the Valley of the Shields, two pigment-stained abraders (used to smooth the cliff surface and possibly apply paint) were found beneath a panel of painted shield-bearing warriors in an occupation level radiocarbon dated to A.D. 1100 (Loendorf 1990). Several tentative AMS radiocarbon and cation ratio dates for Ceremonial tradition petroglyphs in northern Wyoming and southern Montana, including a shield figure, an incised bear, a bear paw, and a large shield with a bear decoration, have indicated these are less than 1000 years old (Francis et al. 1993; Dorn 1995). Although these techniques for dating rock art are still experimental, the results corroborate other dating evidence that indicates a Late Prehistoric period age for Ceremonial tradition rock art.

Other evidence generally supports the Late Prehistoric age for many Ceremonial designs. For example, a group of V-neck figures in the North Cave Hills is superimposed by images of the Hoofprint tradition (see fig. 2.4). Based on these superimpositions

the Ceremonial rock art on this panel was estimated to date between A.D. 1400 and 1625 (Keyser 1987b). Many other Ceremonial tradition images also are probably of the Late Prehistoric period, since they are associated with shield-bearing warriors. In particular, classic V-neck humans and boat-form zoomorphs are often closely associated with shield-bearing warriors and rarely appear in association with guns or horses.

Nonetheless, much Ceremonial rock art dates to the Historic period, and even shield-bearing warriors continued to be carved into the early contact era. At Writing-on-Stone, one shield-bearer is clearly associated with a flintlock gun (fig. 13.25). Other shield-bearers at Writing-on-Stone and in the North Cave Hills are shown on horseback, and stylistic evidence suggests that these are very early horse images, perhaps drawn when the artists were still unfamiliar with these animals. At Writing-on-Stone a few V-neck warriors also ride horses shown in a similar early equestrian style (fig. 13.26). Ceremonial scenes incorporating horses and trade items are obviously postcontact in origin.

In summary, the Ceremonial tradition may have originated as early as the Late Archaic period, but it flourished during the latter part of the Late Prehistoric. The shield-bearing warrior continued for only a short time into the early postcontact era, but other Ceremonial designs, including those associated with horses and guns, were drawn well into the 1800s.

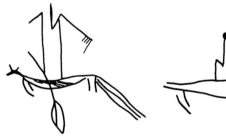

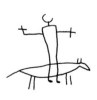

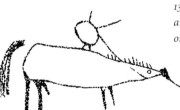

13.26 The earliest horses and riders are stiffly drawn figures mounted on boat-form horses.

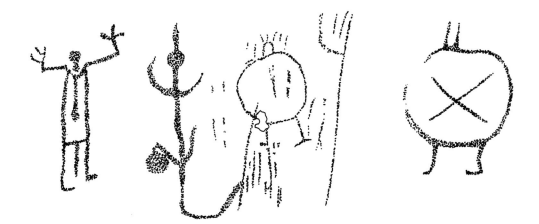

13.27 *This panel northwest of Calgary, Alberta is one of the most northerly panels of Ceremonial rock art.*

Distribution and Regional Relationships

Ceremonial rock art is the second most widespread of Northwestern Plains traditions (Map 13.1). The major designs, such as shield-bearing warriors and V-neck humans, are easily recognizable, and their distribution is relatively well documented. Ceremonial tradition sites are known from just north of Calgary, Alberta (fig. 13.27), to northern Colorado in the south. They occur from the Rocky Mountains right across Montana and Wyoming and extend as far east as Medicine Rock in North Dakota and the Black Hills and Cave Hills of South Dakota. A shield-bearing warrior and some V-neck humans are located as far southeast as central Kansas (Wedel 1959, 1969) and southeastern Colorado.

Major concentrations of Ceremonial sites occur in southwestern Alberta, in the middle Yellowstone Valley of Montana, and in south-central Wyoming. Important Montana sites include Bear Gulch, Pictograph Cave, Valley of the Shields, and Weatherman Draw. Probably the two most significant sites of this tradition are Castle Gardens, in central Wyoming, and Writing-on-Stone in southern Alberta, found

more than 450 miles (750 km) apart at opposite ends of the Northwestern Plains. The largest and perhaps finest collections of Ceremonial designs on the Plains are located at these sites, and in many ways these localities best represent this most characteristic of Northwestern Plains rock art traditions. Remarkable similarities in the rock art, including examples of shield-bearing warriors, V-neck humans, and animals, which are virtually indistinguishable at the two sites (fig. 13.28), illustrate the extraordinary internal consistency of this rock art tradition across a vast region.

The major Ceremonial designs—shield-bearing warriors, V-neck humans, boat-form zoomorphs, and mature-style horses—form a distinctive Northwestern Plains rock art tradition, even though some of the designs are also found outside the region. Shield-bearing warriors are relatively common in the northern Rio Grande region of New Mexico and the eastern Great Basin and Colorado Plateau (Schaafsma 1980; Cole 1990). A few shield-bearers also occur in western Montana and southeastern Idaho. While they display formal similarities to Plains shield-bearers, those from the Great Basin are generally pecked or painted, and their shield designs are more rectilinear, with fewer representational images. Shapes of heads and appendages also differ. Nonetheless, the formal similarities of these images have led some researchers to

suggest connections between the rock art of these areas (Gebhard 1966; Keyser 1975).

Some Ceremonial tradition boat-form animals are also superficially similar in form to mountain sheep and elk in Great Basin and Columbia Plateau rock art. However, unlike the incised examples from the Plains, the Great Basin and Columbia Plateau animals are generally pecked (and sometimes painted), and their bodies are filled in so that internal organs are not shown. Overall, the classic incised, outline Ceremonial tradition boat-form animal style is restricted to the Plains.

The V-neck human is also restricted to the Plains (fig. 13.9). The characteristic and distinctive V shoulder is unique to human figures found east of the Rockies, and the only examples outside the Northwestern Plains are in central Kansas and southeastern Colorado. Likewise, the classic mature-style horse is restricted to the Plains (fig. 13.15). This distribution suggests that these designs developed independently on the Plains and are not closely related to rock art in any other region.

As the foregoing illustrates, Great Basin rock art has the strongest formal relationships to the Ceremonial tradition, yet these are mostly superficial similarities of subject and form. The characteristic association of the uniquely Plains V-neck humans with boat-form zoomorphs and shield-bearing warriors identifies a complex of designs that clearly developed as a separate tradition on the Plains.

Cultural Affiliations

The wide distribution, considerable formal variation, and complex regional relationships of this tradition make it difficult to determine the cultural affiliations of Ceremonial rock art. Based on formal similarities of some Ceremonial designs to those in Great Basin rock art, some researchers have suggested that the origins of this tradition are in this area. The Great Basin sites with similar designs are generally associated with the Fremont culture, dated from A.D. 400 to 1300. Some archaeologists think that the Fremont culture may be ancestral to the historic Shoshone, who

13.28 This panel from Castle Gardens, Wyoming shows V-neck figures almost identical to those from Writing-on-Stone, nearly 500 miles (800 km) distant. These early style figures are grouped in what may be early narrative scenes.

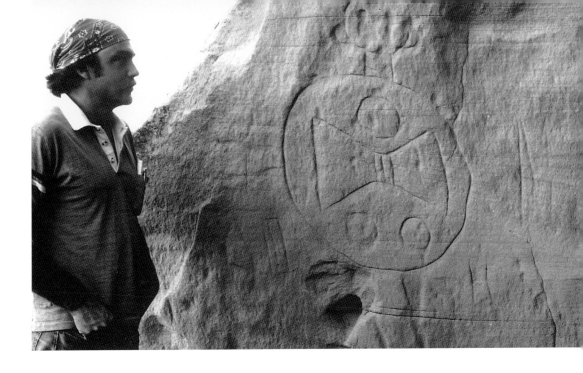

This unusual, large incised shield-bearing warrior is found in the North Cave Hills of South Dakota, near the eastern edge of the Northwestern Plains.

probably migrated onto the Northwestern Plains of Wyoming around 1300. Keyser (1975, 1977a) used this reasoning to suggest that the Shoshone brought the shield-bearing warrior and boat-form animal images onto the Plains, and that the rock art traditions of the Shoshone eventually developed into the Ceremonial tradition.

More recent research suggests that this Shoshonean origin hypothesis is too simple (Magne and Klassen 1991, 1992; Loendorf 1990; Schuster 1987). First, some Northwestern Plains shield-bearing warriors have been dated to before A.D. 1300, i.e., earlier than the proposed Shoshonean expansion onto the Plains. Second, the wide distribution of this design goes well beyond archaeologically and historically substantiated Shoshone territory. Third, in addition to differences between Great Basin and Plains shield-bearers, considerable formal variation appears in Plains shield-bearing warriors, suggesting that

several ethnic styles for this design may be present. Finally, all Plains groups apparently used large body shields, and recent research into Plains shield heraldry has identified shield-bearing warrior shield designs as Crow, Cheyenne, Sioux, and probably Blackfeet (Cowdrey 1995; Keyser and Cowdrey 2000; Nagy 1994; Sundstrom and Keyser 1998). Clearly, there are several reasons to believe that the shield-bearing warrior design was present on the Plains before the Shoshone, and that it was an important design in the rock art of several Plains groups. In all likelihood the Shoshone were just one of several groups who made Ceremonial tradition rock art.

Like the shield-bearing warrior design, boat-form animals are widely distributed and show differences in style within and between regions. They are associated with shield-bearing warriors and V-neck humans across the Northwestern Plains and probably were carved and painted by members of many ethnic groups. The cultural origins of V-neck humans and mature-style zoomorphs (particularly horses), on the other hand, are clearly on the Northwestern Plains, and they are not found outside the region.

As a complex of related designs, it appears the Ceremonial tradition has its origin on the Northwestern Plains. Possibly its deepest roots are in the middle Yellowstone Valley where the greatest concentration of sites occurs and images date back to A.D. 1000 and even earlier. Since this is the historic home of the Plains Shoshone, they may have played a pivotal role in the initial development of this rock art, but the wide distribution and variation of designs across the region demonstrates that other groups originally or eventually participated in its production. Thus we suggest that Ceremonial rock art was a Plains-wide phenomenon shared by many different ethnic groups. Formal variation among different examples of the same design suggests that many distinct styles, perhaps representing ethnic or temporal differences, may eventually be identified within the Ceremonial tradition. For example, different shield-bearing warrior styles, specific types of headdresses, ritual objects, and shield designs may someday be linked to particular

cultures. Additional research with shield heraldry, hide paintings, and ledger drawings of known cultural affiliation will undoubtedly clarify the ethnic affiliations of additional Ceremonial rock art images.

In the end, it seems reasonable to suggest that Ceremonial tradition rock art was made by most Late Prehistoric and Historic period Northwestern Plains cultural groups. Ceremonial tradition sites in southern Alberta are well within the historic range of the Blackfeet, while sites in western South Dakota are in territory occupied by Mandan, Hidatsa, Sioux, and Cheyenne groups between A.D. 1300 and 1800 (fig. 13.29). Montana and Wyoming sites are in the homeland of the Crow, Shoshone, Kiowa, and Arapaho. The likelihood that this rock art cuts across ethnic and language boundaries is one of the most fascinating aspects of the Ceremonial tradition, attesting to the widespread, cohesive nature of the Plains way of life, which arose many centuries before the arrival of the horse.

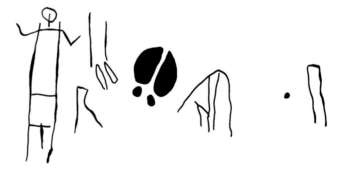

13.29 This North Cave Hills panel shows both Ceremonial and Hoofprint art. The tipi and two snakes at bottom may be part of Hidatsa eagle-trapping rituals, which took place in the North Cave Hills area and involved pole wickiups and snake rituals.

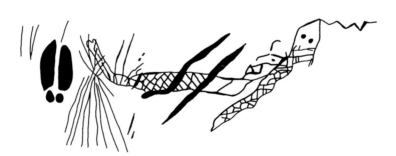

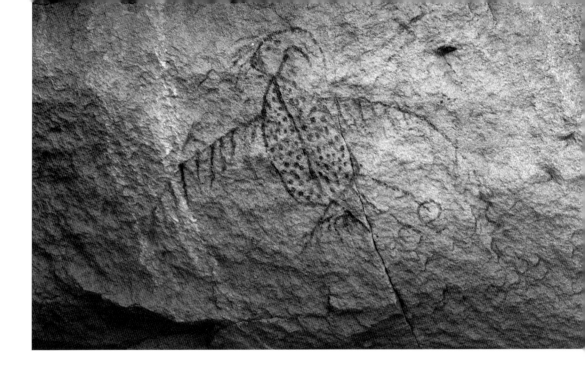

Interpretations

Anthropological interpretations of Ceremonial tradition rock art have generally proposed that the designs have a ceremonial or religious function relating to vision quests, ritual activities, and shamanism. In the first substantial attempt at interpreting function and meaning of Ceremonial rock art, Keyser (1977a) cited the absence of "secular activities" and "utilitarian objects," and the association of humans with ceremonial objects and religious imagery, to argue that the tradition represents "supernatural" vision quest experiences, as opposed to actual events. More recently, Barry (1991) has suggested that Writing-on-Stone rock art is related to shamanism and spirit-traveling, while Klassen (1995, 1998a) has further explored the relationship of Ceremonial images to religious iconography and sacred landscapes.

The preceding interpretations have in common the suggestion that these images are related to medicine powers derived from the spirit world. In this sense, Ceremonial tradition rock art fits the definition of iconic imagery in that each image is an icon or

This magnificent red Thunderbird, with lightning zigzags trailing from wings and "hailstone" dots on breast, is painted at Writing-on-Stone.

symbol relating to a sacred or ceremonial theme. Iconic imagery from many different cultures around the world depicts detailed, static, frontal, and symmetrical images of religious subject matter. Found alone or in small groups, iconic images portray no obvious movement or interaction, and although they generally depict specific objects or beings, they do not depict events or activities taking place at a specific time or location. Rather, they symbolize manifestations of spiritual power relating to the timeless, eternal present of the spirit world.

Although iconic art forms are often simple, their meaning and significance are not. Iconic imagery can be understood through the process of iconographical analysis, which explores artistic expressions from the perspective of form and subject matter as well as the ethnographic and historical context of the images. Thunderbird, for example, is an iconic motif frequently pictured in Plains Indian art.

In Plains oral traditions, Thunderbird is a powerful spirit being who dwells in a cave deep in the mountains. Every spring he emerges to fly across the prairies amid great storm clouds, bringing rain to the land. His flapping wings create thunder, and lightning shoots from his eyes. Thunderbird has some of the strongest medicine of all spirit beings, and his image was often painted on the shields, tipis and clothing of warriors who had obtained Thunderbird power through dreams and visions.

One of the most magnificent examples of an iconic motif in Ceremonial tradition rock art is a red pictograph at Writing-on-Stone showing a large speckled bird with zigzags trailing from its wing tips (see fig. 3.2). On a superficial level, we can simply "read" this image as the depiction of a large bird, but iconographical analysis helps us to probe much deeper into its meaning and significance. Given our knowledge of Plains culture, this image is readily identifiable as Thunderbird, a motif that represents the traditions and powers of a spirit being. On an even deeper level, this awareness provides a starting point to better understand the underlying sacred themes and beliefs of Plains spirituality— the dualism of earth and sky, and the relationship of humans to the spirit world.

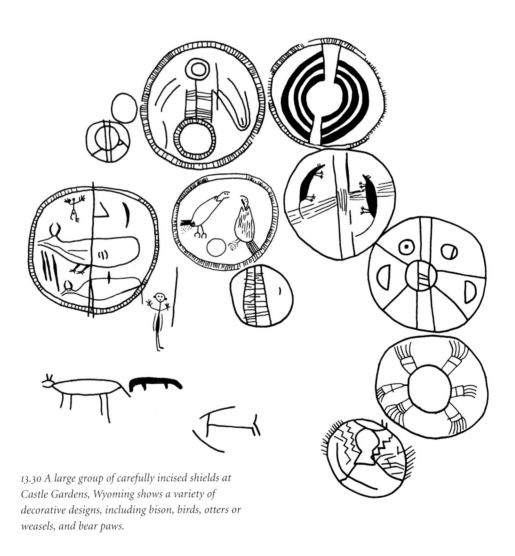

13.30 *A large group of carefully incised shields at Castle Gardens, Wyoming shows a variety of decorative designs, including bison, birds, otters or weasels, and bear paws.*

We are able to recognize many other Ceremonial tradition rock art designs as iconic symbols relating to visions, guardian spirits, and medicine powers. For example, decorated rock art shields probably held much the same significance as the real thing. In Plains cultures, a shield was more than simply defensive equipment—it was invested with powers bestowed upon the warrior-owner by the spirit world. Its medicine design, received in a vision, was what protected the owner in battle, rather than the physical shield. Decorated shields were held in high regard and displayed in a place of honor outside the owner's tipi. Many shield designs were passed from generation to generation, or exchanged in elaborate ceremonies, and an enemy's shield captured in combat was a worthy war trophy.

Many shields represented in Ceremonial rock art, whether carried by warriors or shown as independent objects, show medicine designs similar to those found on painted historic examples (fig. 13.30). The shields were carved and painted onto rock surfaces in sacred areas where the spirit world was nearby, perhaps as a warrior's way of commemorating and thanking the guardian spirit for its gift of medicine. Rock art shield designs undoubtedly represent specific guardian spirits of individual warriors; as the medicine design of each warrior was unique, these rock art images can be likened to sacred signatures. Images of warriors bearing shields also represent the direct relationship of medicine power to a specific human (figs. 13.3, 13.4, 13.7). In these designs, the shield and warrior are essentially inseparable. They are drawn as a single iconographic entity: whereas the shield is the earthly embodiment of a spirit protector, its possession by the warrior represents his bond with the supernatural and confirms this sacred relationship.

Other Ceremonial human figures are similarly iconic. Humans in static frontal poses, arms bent at the elbow and hands held aloft, either drawn as isolated figures

13.31 A loosely juxtaposed group of iconic Ceremonial figures shows a mountain sheep and V-neck humans with raised arms holding feather fans. Note that figure on right is a female.

or loosely associated in juxtaposed groups, are similar to religious imagery around the world (fig. 13.31). Here the human figure is "presented" to a cosmic audience, arms raised as if in supplication or prayer, appealing to the spirits for strength or honoring their benevolence. These humans often include many anatomical details linked to sacred attributes, such as hearts, kidneys, genitals, and ribs—all parts of the human body where medicine powers concentrate. In traditional Plains Indian iconography, lifelines showing the throat and heart also represent the primary location where medicine powers reside in both humans and animals. Illustration of these sacred organs clearly indicates that these are not humans as they appear in the real world, but rather are representations of spiritual manifestations.

Clothing and objects associated with many humans also imply a relationship to ceremonial activities and medicine power. Elaborate headdresses and fringing evoke a sense of

ritual and ceremony, as these accouterments were associated with status and authority. Often these figures hold objects of known ceremonial regalia, such as feathered wands, bow-spears, or decorated staffs (figs. 13.1, 13.19, 13.31). Such objects indicated membership in medicine societies, and were carried during rituals and ceremonies to honor the spirits and invoke medicine powers. Other human figures are shown with spears, bows, or guns, but they are not brandished as weapons. Instead they are held upright in a nonthreatening display, and in many cases they simply float beside their owners, as if they have a life of their own (figs. 13.18, 13.21, 13.25). These images symbolize the power inherent in

weapons and ceremonial objects (Warburton and Duke 1995) and are representations of the medicine power these items confer upon their owners.

In some cases, weapons and ceremonial objects are depicted as isolated designs, or in small juxtaposed groups (fig. 13.17). They may represent war trophies, each symbolizing a war honor or coup, or items given away to enhance the giver's status; both types of depictions are known from hide paintings (Brownstone 1993). Some images of isolated weapons, however, may have a deeper iconic meaning arising from the spiritual connotations of each coup. A coup represents a physical act of bravery or daring, but on a deeper level,

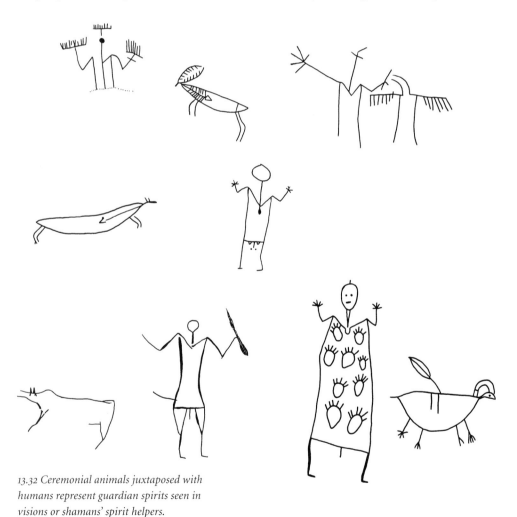

13.32 Ceremonial animals juxtaposed with humans represent guardian spirits seen in visions or shamans' spirit helpers.

The left animal in this pair of juxtaposed mountain sheep looks back towards the second animal, implying a connection between the two. Note the lifelines and ribs shown in both animals.

a successful coup symbolizes individuals' medicine power, which gave them courage and protected them from harm. Each coup not only heightened an individual's status and respect, but also served to confirm and strengthen his supernatural powers. A single isolated flintlock gun painted at Writing-on-Stone, depicted without reference to any other image, is a good example of a weapon displaying iconic characteristics that likely symbolize its medicine power. The gun may represent a record of a specific event. On another level, however, it is an icon of everything that it represents—the bravery of the warrior who captured it, the strength of the medicine power that protected and inspired him, and the respect, status, and rights arising from its capture as a war trophy.

Like humans, most Ceremonial animal figures are detailed static images, frequently drawn with lifelines, internal organs, genitals, and ribs. Some are isolated images, while many others are juxtaposed with humans or other animals (fig. 13.32). They show no evidence of movement or activity, although in some cases they are oriented vertically or in other unusual positions. All these character-

istics are typical of iconic images that represent religious themes. These animals probably represent guardian spirits, since they are similar to dream animals painted on Historic period shields and tipis. Animals juxtaposed with humans probably represent the spirits seen in vision quests and symbolize the transferal of their power to the dreamer. In a classic example of iconic vision quest imagery, one panel at Writing-on-Stone displays a variety of animals juxtaposed with humans and ceremonial objects (fig. 13.1).

Although animals are not shown in typical hunting contexts, arrows and spears sometimes pass across or pierce their bodies. These scenes may show a dream, or they may represent the ability of a hunter to obtain the medicine power of an animal. Some of the animals shown are clearly those with powerful medicine, and they also appear as medicine designs on shields. For example, one warrior

has a shield emblazoned with his grizzly bear spirit helper and its tracks, while two more grizzlies are carved nearby, one pierced by an arrow (fig. 13.33). Like the historically known Bear Dreamers, this rock art warrior seems to flaunt his bear medicine. Given the prohibition against killing a bear (unless one possessed bear power or wished to acquire it), this killed-bear scene probably represents a vision quest experience by a warrior seeking power.

While Ceremonial rock art flourished in the Late Prehistoric period, the use of iconic imagery continued into the contact era, as demonstrated by some horse images. Plains Indians viewed the arrival of the horse as miraculous—its sudden appearance, mysterious origins, remarkable abilities, and advantages to humans were all seen as evidence that the horse originated in the spirit world. In

other words, the origin of horses was "mythologized"—the historical event was incorporated into Plains cosmology, and the horse became a sacred icon, a metaphor of power (Penney 1992). The Blackfeet, for instance, credited the origin of horses to both the sky and underwater spirits, from which horses obtained their supernatural powers (Ewers 1955). The horse was quickly assigned strong medicine power, and horse medicine could be obtained through visions. In several Plains groups, this gave rise to the Horse Medicine society, and this horse cult quickly became one of the most important medicine-bundle societies. Among the Blackfeet, for example, owners of horse bundles gained access to wide-ranging medicine powers, including the ability to heal horses, help warriors capture them on raids, hinder enemies' mounts, and keep herds from straying (Ewers 1955).

As the significance of the horse in Plains cultures increased, it also appeared more frequently in rock art. Some of these horse images display the characteristics of iconic representation: they are not associated with an activity, and their isolated, static depiction suggests a deeper symbolic significance (fig. 13.34). Like isolated weapons, they may represent stolen animals—a major coup—but some are more likely iconic images emphasizing the horse's spiritual associations; the many images of horses in Plains art symbolize their sacred value and its potent medicine, perhaps created as part of a prayer for power (Penney 1992; Maurer 1992). This interpretation is strengthened by the presence of red ochre pigment within the incisions of several horse petroglyphs at Writing-on-Stone (fig. 13.34). Ochre held many sacred connotations and was often used in association with rituals. Its presence here suggests that these horse images held iconic significance.

Examples of static isolated images of mounted warriors are common at postcontact period sites, and some mounted riders can also be interpreted as iconic imagery (fig.

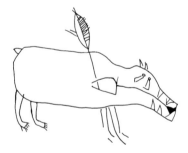

13.33 This shield-bearing warrior and wounded grizzly bear are carved in a small rockshelter. Note the bear's teeth and tear streaks and the bear and bearpaw shield design.

13.13). Although some may represent horse capture or ownership, others may symbolize the relationship of humans to the medicine power inherent in the horse. Many of these mounted warriors clearly exhibit the formal characteristics of iconic images—they do not inherently depict any more movement or interaction than a warrior holding a shield. Before the horse, a warrior's medicine powers primarily resided in his painted shield, but in the equestrian period, much of these powers also came to reside in the horse. Horses brought honor, status, and wealth to their owners, but most important, they directly conferred their medicine powers to their owners. Like the iconic shield-bearing warrior, some mounted warrior images likely represent the possession of horse medicine power rather than document a specific coup. In terms of iconographical significance, these designs may have directly replaced the shield-bearing warrior motif during the postcontact era.

The preceding interpretations for Ceremonial designs share a common underlying iconographic theme: they explain the rock art as pictorial manifestations of the medicine powers derived from the vision quest. This interpretation is frequently reinforced and supported by the location of much Ceremonial rock art. These images, intended solely for a supernatural audience, were placed in isolated private locations. Most sites are located on or near unusual landforms, often

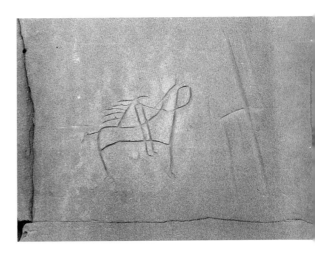

This incised horse and rider at Writing-on-Stone may be an iconic image, since no obvious action is illustrated.

in caves or rockshelters, or set in high places with sweeping vistas of the surrounding landscape. The close association of Ceremonial rock art with these medicine rocks and sacred landscapes strongly supports the idea that this rock art resulted from the vision quest and the acquisition of medicine power.

Some Ceremonial images may also be of shamanistic origin. In many parts of the world, shamans are believed to hold special powers that allow them to transform into spirit beings and travel to the spirit world. Most Plains cultures recognized shamans or medicine men as individuals having particu-

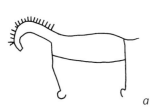

13.34 Some horses likely represent iconic medicine imagery. Both figures in b have red paint rubbed in the incisions.

larly powerful medicine, and hence greater access to the powers and guidance of the spirit world. Images frequently associated with shamanic art include humans and animals with skeletal or "X-ray" bodies and internal organs, elongated or oddly shaped bodies, human-animal composites (therianthropes), and juxtaposed human and animal designs. Humans and animals oriented in unusual positions, as if flying or falling, are also typical of shamanic art (fig. 13.35). All of these characteristics represent the transformations of shamans and their spirit-world experiences. Some Ceremonial tradition rock art clearly fits this general pattern of shamanist imagery, and it seems possible that some of it was made by shamans.

In Plains cultures, however, access to the spirit world was not restricted to shamans; all individuals had equal opportunity to seek visions. Although shamans often helped interpret a vision, they were not a necessary go-between for people and spirits. All

individuals could also depict those dreams as paintings on shields, tipis, and clothing. The egalitarian structure of recent Plains societies, the emphasis on the vision quest ritual, and the manufacture of vision images by laymen in Historic times, all serve to indicate that Ceremonial tradition rock art, unlike such art in other areas of western North America, was not restricted to shamans. This tradition is dominated by the vision quest images of generations of Plains warrior artists.

In the end, it is not surprising that Plains oral traditions often refer to Ceremonial rock art as having been created by spirit beings. A warrior creating a pictograph or a petroglyph did so under the power of his guardian spirit, and so he might disclaim personal responsibility for making the image. Therefore, such traditional accounts can be viewed as metaphorical explanations of the roles these images play in a cosmological world view, as messages from the spirit world communicated through the hands of the artist.

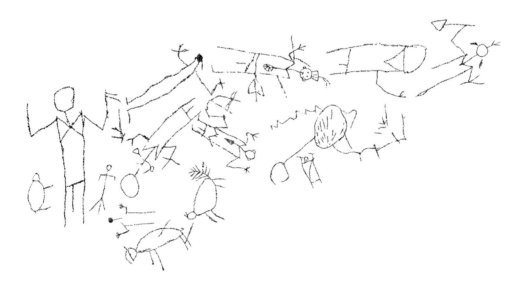

13.35 *This panel of juxtaposed Ceremonial tradition figures may represent shamanic trance imagery, drawn with charcoal on the ceiling of a small sandstone rockshelter. Note lifelines, facial features, headgear, and earrings.*

A remarkable aspect of Ceremonial rock art is its continuity as a tradition from prehistoric times to the postcontact period. Similar types of images with similar iconographical meanings span the transition from the dog days to the equestrian period. For example, the distinctive V-neck human originated in precontact times but continued to be depicted well afterward, and animals are shown as characteristic iconic images in both periods. These designs likely had the same iconographic significance in both periods, attesting to the longevity of the vision quest and importance of medicine power in Plains cultures. Likewise, the iconic meaning of weapons and ceremonial objects, whether bow-spears or guns, was more or less the same before and after the horse arrived. A few iconic shield-bearing warriors were made in the Historic period; the best example is a shield figure with a flintlock at Writing-on-Stone (fig. 13.25). In this classic iconic image, the isolated shield figure stands with arms raised aloft, presenting himself to the spirit world, while the flintlock floats beside him, a symbol of his great medicine power. Nonetheless, the iconic shield-bearing warrior design largely disappears after contact, when the body shield was abandoned after the arrival of the horse. Iconic images of horses and even mounted riders largely assumed the place of shield-bearers in the Historic period, ensuring temporal continuity in meaning for Ceremonial tradition rock art despite great cultural changes.

As we shall see in chapter 14, "Biographic Traditon," however, rock art depicting shield-bearing warriors and mounted warriors was not utilized in iconic contexts alone. Beginning in the Late Prehistoric period, both shield-bearing figures and pedestrian warriors appeared in rock art portraying events and action. In the end, the arrival of the horse and the significant changes it brought to Plains cultures led to the major shift in the emphasis of Northwestern Plains rock art from the sacred icons of the Ceremonial tradition to the action-packed stories of Biographic art.

Saahkómaapi and the Big Dogs

The introduction of the horse caused far-reaching changes in Plains Indian warfare. Mounted warriors had enormous advantage over pedestrian opponents, and the balance of power quickly shifted in favor of groups with horses. This change had profound influence on pictorial traditions and eventually led to the eclipse of the Ceremonial tradition by Biographic rock art.

Nowhere in Northwestern Plains rock art is the influence of the horse on warfare more dramatically illustrated than at Verdigris Coulee, along the Milk River of southern Alberta. On a high cliff face, deeply incised and carefully executed petroglyphs show several combat scenes between mounted and pedestrian warriors (fig. 13.36). Several characteristics indicate that these carvings represent one of the earliest such conflicts. The boat-form horses are reminiscent of many Ceremonial animal figures, and quite different from later Historic period horse images. Several also wear leather armor, indicated by a cross-hatched pattern obscuring the body. Historical records indicate that equestrian armor was used only briefly. Finally, both the pedestrians and their mounted enemies carry large body shields. Because these shields were unwieldy and impractical on horseback, they, too, were abandoned shortly after the arrival of horses.

The significance of the Verdigris petroglyphs is evident from a story told to the explorer David Thompson in 1787 by an elderly Plains Cree man named Saahkómaapi, who described a pre-horse battle he participated in as a young man around 1725. With several Cree companions, he joined a Piegan war party against their "Snake" (possibly Shoshone) enemies. The Crees' weapons included metal-tipped spears and longbows and arrows, and both sides used large body shields.

> After some singing and dancing, they sat down on the ground, and placed their large shields before them, which covered them: We did the same, but our shields were not so many, and some of our shields had to shelter two men. . . . Our iron-headed arrows did not go through their shields, but stuck in them; on both sides several were wounded, but none lay on the ground; and night put an end to the battle, without a scalp being taken on either side. (Thompson 1962:241)

A few years after this battle, the Snake obtained horses. Emboldened by their advantage, they began to raid deep into Piegan territory, and soon the Piegans put out another call for assistance. Saahkómaapi had heard rumor of horses and was uneasy.

> By this time the affairs of both parties had much changed; we had more guns and

222

iron-headed arrows than before; but our enemies the Snake Indians and their allies had Misstutim (Big Dogs, that is Horses) on which they rode, swift as the Deer, on which they dashed at the Peeagans, and with their stone Pukamoggan knocked them on the head, and they had thus lost several of their best men. This news we did not well comprehend and it alarmed us, for we had [then] no idea of Horses and could not make out what they were. (Thompson 1962:241–42)

Nonetheless, Saahkómaapi and two companions joined the Piegans in a second battle, and the Snakes were easily defeated when the Plains Cree and their allies used their guns to great effect. As the Snake party had not used horses in this skirmish, only later did Saahkómaapi actually see his first Big Dog:

We were anxious to see a horse of which we had heard so much. At last, as the leaves were falling we heard that one was killed by an arrow shot into his belly, but the Snake Indian that rode him, got away; numbers of us went to see him, and we all admired him, he put us in mind of a Stag that had lost his horns; and we did not know what name to give him. But as he was a slave to Man, like the dog, which carried our

things; he was named the Big Dog. (Thompson 1962:244)

Saahkómaapi's first-person account of pre-horse battles and one of the earliest encounters with the horse on the Northwestern Plains sheds new light on Verdigris Coulee. Because the petroglyphs depict both pedestrian and mounted warriors holding large body shields, this scene must record a battle very soon after the arrival of horses but before body shields were abandoned. This panel could well represent a battle occurring in the same era as Saahkómaapi's account, perhaps involving mounted Shoshone and pedestrian Blackfeet warriors. The battle also appears to be told from the perspective of the Blackfeet, for not only are the pedestrian warriors shown in greater detail, but the horses and riders are depicted more ambiguously, as if the artists were unfamiliar with drawing mounted warriors.

The Verdigris Coulee petroglyphs record one of the first Blackfeet experiences with horses, and one can imagine the effect of this encounter: the horse seemed like a magical animal sent from the spirit world, invested with the strongest of medicine powers. This extraordinary experience was undoubtedly an event of great significance, and it is not surprising to find it recorded in such detail.

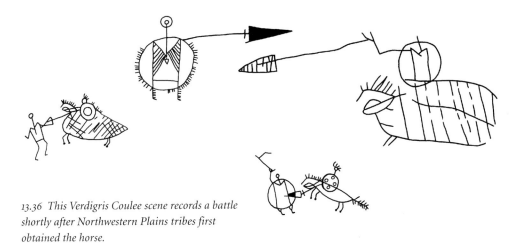

13.36 This Verdigris Coulee scene records a battle shortly after Northwestern Plains tribes first obtained the horse.

14 / Biographic Tradition

One of the most fascinating aspects of Northwestern Plains rock art is the rapid rise and development of the Biographic tradition from the early 1700s to the late 1800s. Although Biographic art originated in the Late Prehistoric period, it expanded and flourished during the early postcontact era. The Biographic tradition is closely related chronologically and geographically to the Ceremonial tradition, and both were produced by the same people. Biographic rock art, however, was created for very different reasons and under very different cultural circumstances.

The Biographic and Ceremonial traditions consist of similar types of representational subject matter, and they share many rock art designs. Unlike the Ceremonial tradition, whose imagery represents visions of the spirit world, images of the Biographic tradition are largely "narrative," depicting everyday occurrences and recording historical events. The degree of narrative storytelling in this tradition is unparalleled in rock art elsewhere in North America; many of the stories it relates can still be understood more than a century later.

In Biographic rock art, we see multiple interacting figures composed into scenes depicting events and activities. Ranging from relatively simple compositions, such as a combat between two warriors (fig. 14.1), to complex panels showing large-scale battles, these scenes incorporate numerous pictorial devices to indicate action, movement,

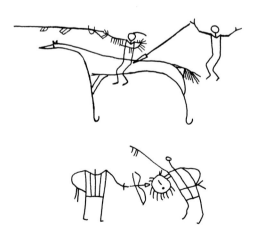

14.1 Simple combat and coup-counting scenes.

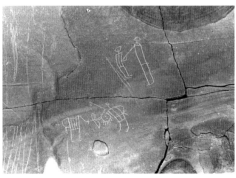

These combat scenes at Writing-on-Stone, showing coup counting and weapon capture, are lightly scratched through a dark patina.

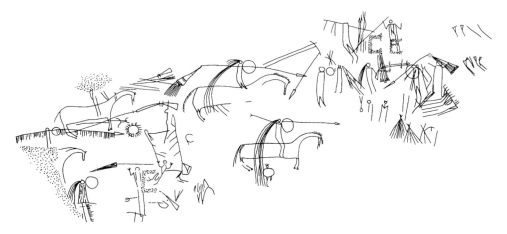

14.2 This battle scene near Lander, Wyoming, is one of the region's most complex Biographic compositions. Note the carefully drawn weapons, warriors, and horse accoutrements. Stippling indicates erosion and graffiti.

direction, and the passage of time (fig. 14.2). Such compositional and formal characteristics make some Biographic rock art a simple form of true pictography or "picture-writing."

In technique, Biographic rock art is also very similar to that of the Ceremonial tradition. Designs occur as petroglyphs and pictographs, but petroglyphs are far more common. Most are lightly scratched into the rock surface; others are incised, although usually with finer, shallower grooves than those characteristic of Ceremonial rock art. The preponderance of scratched images may partly reflect the younger age of most Biographic art—fewer of its scratched images have been lost to erosion—but it also likely reflects the use of metal tools that would have easily etched a quick petroglyph into sandstone. The narrower, finer lines characteristic of incised Biographic petroglyphs probably also result from metal carving tools. In some cases, the interior of an incised or scratched outline figure is rubbed or abraded (fig. 14.3).

Pictographs are uncommon in the Biographic tradition. Occasional red, orange, or black images have been recorded, but polychrome paintings are unknown. Some red pictographs were painted with fingers or a thin brush, but commonly red and black figures were drawn by directly marking the cliff with a raw lump of ochre, ironstone, or a piece of charcoal. This technique produces a "crayoned" effect if the raw pigment has a "greasy" consistency, or a powdery "chalked" appearance if it is drier.

Like the Ceremonial tradition, Biographic sites are closely associated with striking geologic formations, such as steep cliffs, caves, and hoodoos, often set in spectacular

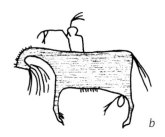

14.3 Scratched and abraded horses and riders. Shading on the horse (b) indicates abrading.

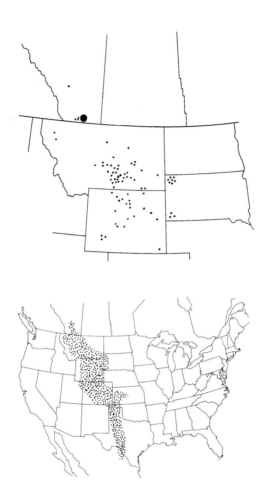

Map 14.1. Biographic Tradition Rock Art

above: Regional distribution
Large dot shows Writing-on-Stone.

below: Continental distribution

landscapes. Most sites are found on similar surfaces and landforms as Ceremonial tradition rock art—and often on the same panels. Generally these sites are carved or painted on the smooth, vertical, sandstone cliffs lining river valleys or along mesas and buttes, but images are also carved on isolated sandstone outcrops and on the walls inside rock shelters and caves. Most Biographic rock art occurs in prairie settings or in basin and range terrain; foothills or mountain valley sites are rare. Originally Biographic rock art was also routinely drawn or carved on dead trees that lined many river bottoms near villages (fig. 14.4). Early European explorers noted such painted trees, particularly along the middle Missouri and lower Yellowstone Rivers, where sandstone cliffs are less common. Only place names, such as "Painted Woods," remain today to document these long-gone Biographic tradition sites.

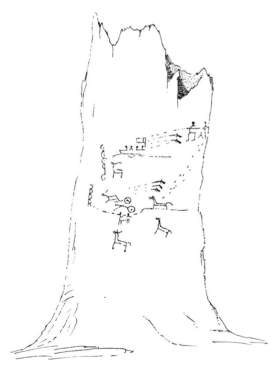

14.4 This tree stump painted with a Biographic scene was recorded by an early traveler in 1866.

Previous Research

Many early explorers, including Lewis and Clark and Ambrose Bierce (1866), noted Biographic rock art on the Northwestern Plains. James Doty, who first explicitly described the narrative function of the rock art, probably made the most significant of these early references. In 1855, he stopped at "the Writings" on the Milk River (Writing-on-Stone), where he observed, carved onto the sandstone cliffs,

> representations of men, horses, guns, bows, shields, etc. in the usual Indian fashion. . . . No doubt this has been done by wandering war parties, who have here recounted their "coups" in feats of war, and horse stealing, and inscribed them upon these rocks, in the same manner as they are often seen painted on their "Medicine Robes," and the lining of lodges. (Doty 1966:19)

His description acknowledges and documents the biographic nature of this rock art more than a century before archaeologists turned their attention to this aspect of the petroglyphs.

Few Biographic sites were studied until the 1960s, when Stuart Conner (1962a; Conner and Conner 1971) began recording sites in central Montana, and Selwyn Dewdney (1964) made the first systematic survey of Writing-on-Stone. In his brief description, Dewdney (1964:28) noted that Historic rock art at the site shows more "action" than older rock art, and he suggests that these petroglyphs represent the beginnings of the "widespread Plains Indian practice . . . of painting elaborate, detailed and highly naturalistic picture stories on hides."

Until recently, few researchers recognized Biographic rock art as a distinct tradition or explored the functional aspects of the images in detail. The first comprehensive study was Keyser's report on Writing-on-Stone (1977a), which recorded a large number of new panels

that to this day make up more than half of known Biographic rock art sites. On the basis of this study, Keyser defined the rock art of this tradition, which he termed "Biographic art," proposing its functional difference from Ceremonial rock art, in that it showed action and recorded events. According to Keyser's original definition, Biographic rock art was culturally and temporally distinct from Ceremonial rock art. It was thought to have originated in the early Historic period primarily as the result of the migration of the Blackfeet, Gros Ventre, and Plains Cree into the area from the northeast.

Keyser's original definition of Biographic rock art was widely accepted. Since then other Biographic sites have been identified and described from other areas in Montana (Conner 1980; Lewis 1986a, 1986b), Colorado (Buckles 1989; Cole 1990), and South Dakota (Keyser 1984; Sundstrom 1984). Biographic rock art sites have even been documented as far south as Texas, New Mexico, and Mexico (Parsons 1987; Turpin 1989; Schaafsma 1975).

In later papers, Keyser (1979b, 1984, 1987a, 1989, 1991) has continued to explore the function and meaning of Biographic rock art at Writing-on-Stone and other Northwestern Plains sites. An important part of this work has involved identifying the pictorial elements used to interpret the meaning of scenes, which he calls the Biographic art lexicon (Keyser 1987a). Another aspect of this work involves comparing Biographic rock art to other forms of Plains Biographic imagery on robes, clothing, and in ledger books (Keyser and Cowdrey 2000; Keyser and Brady 1993).

More recently, the question of the ethnic and temporal origins of Biographic rock art has been reexamined. Several papers have demonstrated the close formal relationship between Ceremonial and Biographic rock art forms and designs, as well as the coexistence of both traditions during the end of the Late Prehistoric period and throughout the early Historic period (Magne and Klassen 1991;

Klassen 1995, 1998a). This has led to the recognition that both traditions were created by the same people, but for different reasons. Finally, the role of some aspects of Biographic rock art as a territorial boundary marker has been considered (Bouchet-Bert 1999), and the continuity of the Biographic rock art tradition into the twentieth century has been explored (Klassen et al. 2000).

The Rock Art

Like Ceremonial rock art, the subject matter of Biographic rock art consists almost entirely of representational images of humans and animals, with a notable emphasis on material culture items. Many of the basic formal types in each category are shared by the two traditions, but important differences in details and frequencies exist. Human and animal figures of the Biographic tradition are often shown in more active poses and integrated into more complex compositions. Overall, the emphasis in Biographic rock art is on simple, conventionalized images that are easily recognized and repeated.

Human Figures

Humans are generally similar in form to those of the Ceremonial tradition, although they more frequently interact with others. Although sometimes elaborated with decorative or anatomical details, these Biographic tradition humans are generally less detailed than their Ceremonial tradition counterparts. Most are simple and schematized, with outlined rectilinear body forms, including shield-bearing warriors, V-neck and rectangular-body humans, and triangular-body humans.

A few shield-bearing warriors are found on some of the earliest Biographic panels (fig. 14.5). Although some lack detail, several examples include elaborate headdresses, shield designs, and weapons. Biographic tradition shield figures often brandish weapons directly

14.5 An early Biographic panel with shield-bearing warriors in several simple combat scenes.

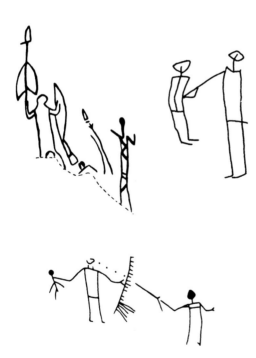

14.6 Rectangular-body humans often show minimal anatomical detail.

toward other humans, unlike the static weapons displayed with Ceremonial shield-bearing warriors. Several Biographic tradition shield figures are also shown on horseback.

V-neck humans occur less frequently in the Biographic tradition than in Ceremonial rock art. Rectangular-body humans, on the other hand, are by far the most common Biographic figure, and proportionately much more frequent than their counterparts in the Ceremonial tradition. The schematic or stylized form of some Biographic V-neck and rectangular-body humans closely resembles the Ceremonial versions. Some are quite detailed and include hands, feet, lifelines, and genitals, as well as elaborate headdresses and even clothing. More often, however, Biographic V-neck and rectangular-body humans are very simple, with only minimal detail (fig. 14.6). Many lack heads and arms, and the legs are simple continuations of the torso, without even a waistline to mark the lower extent of the body.

Triangular-body humans are more closely associated with Biographic rock art than any other tradition. These figures have a torso formed by an inverted triangle whose sides continue downward to form two stick legs.

Arms are usually a horizontal continuation of the top of the torso, although they may also be bent at the elbows. Heads are either a dot at the end of a stick neck, or formed by a t shape, which may represent a brimmed hat. Anatomical details, such as feet, internal organs, and genitalia, are usually absent, while clothing and headdresses are rare. Triangular-body humans often hold guns and occasionally ride horses.

Some of the most recent Biographic human figures are drawn in a style similar to late nineteenth-century ledger drawings (fig. 14.7).

These figures are rendered more realistically or naturalistically than humans in any other Northwestern Plains rock art tradition. A few examples depict profiles of detailed, realistic human heads. These realistic figures and faces show the influence of European artistic traditions; nonetheless, they retain many details of form, posture, and composition characteristic of traditional Biographic rock art.

Biographic figures differ most from those of other traditions in their portrayal of action. Whereas humans in Ceremonial rock art are strictly frontal, static depictions, many

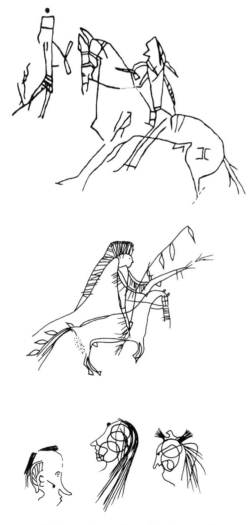

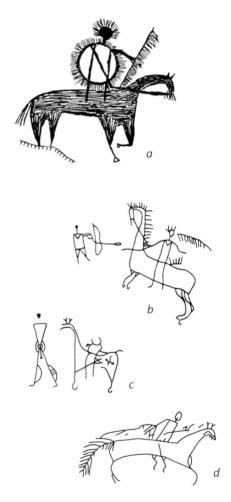

14.7 The latest Biographic rock art images often show detail comparable to ledger drawings.

14.8 Biographic figures are often shown interacting in dynamic poses. Note comb-shaped scalp symbol under rider's outstretched arm (b), and brand on horse's hindquarters (c).

Animal Figures

Biographic rock art animals are also schematic and highly conventionalized. They are profile figures with simple, outlined, curvilinear body forms and limited anatomical detail. Horses are by far the most common animal, but a few other species also appear. The styles used to depict them are very similar to those of the Ceremonial tradition.

Early horses have simple, stylized boat-form bodies, while some of the latest drawings are remarkably realistic and lifelike, as with the most recent humans. However, the great majority of horses are in mature-style, which makes use of elongated bodies and necks to create a fluid image well suited for representing horses (fig. 14.9). The head is often just the upper end of two curving parallel lines that form the neck, and the legs are simply extensions of the lines delineating the body. The nose is often left open. Ribs, kidneys, and lifelines are never shown, but manes, tails, ears, and hooves appear frequently. Bridles, halters, saddles, and other horse tack may be added, and many horses have riders (see figs. 3.1, 14.10). Occasionally brands or other markings are shown on the horses' flanks.

Despite their overall simplicity, mature-style horses retain a graceful, flowing shape that creates a perfect visual metaphor for the speed and grace of the real animal. Some are so simple and highly conventionalized that, reduced to only two lines representing the head and neck, they are hardly recognizable as horses without reference to more complete examples of mature-style horses.

Other than horses, few animals are clearly associated with Biographic rock art. A few bison are depicted in hunting scenes, while bears, dogs, and several other species occasionally occur (fig. 14.11). Most of these animals are rendered in a fashion similar to mature-style horses. The lack of diversity in animals represented in Biographic rock art is likely due to the dominant place of the horse

14.9 A variety of mature-style horses. Note split ears on bottom figure.

Biographic tradition figures are shown in active semiprofile poses; most are shown interacting with others, and many are shown riding horses (fig. 14.8). These figures brandish weapons, quirts, and other objects. The dynamic stance of both pedestrian and mounted figures results in semiprofile poses, even when the torsos continue to be shown front view. On many pedestrian figures, for example, legs are bent at the knee, both arms are held to one side, and the body is bent over (fig. 14.1). Although riders have both legs visible on one side of the horse, they often lean over with arms held forward.

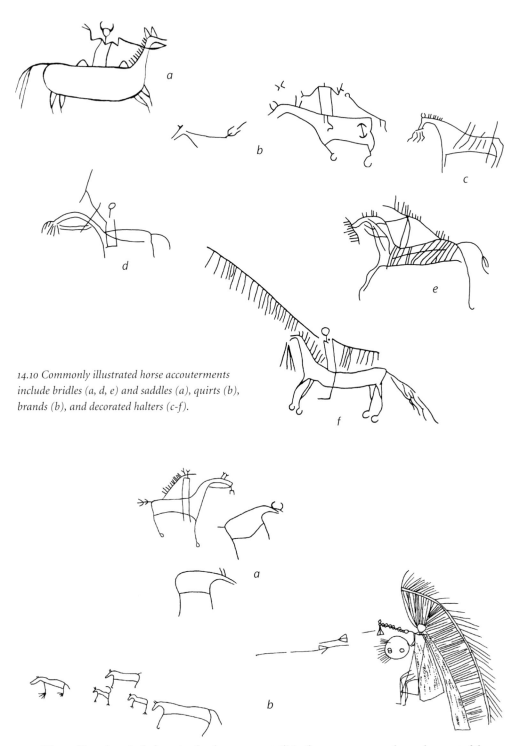

14.10 Commonly illustrated horse accouterments include bridles (a, d, e) and saddles (a), quirts (b), brands (b), and decorated halters (c–f).

14.11 Biographic rock art includes animals other than horses in hunting scene compositions (a) and sometimes in coup-counting scenes. The bear at left (b) may represent a counted coup, as do encounters with bears on painted robes. The dog (with upraised tail) in the same scene may be used as part of the narrative, as they do in some robe paintings. Note that the detailed warrior in b carries a tomahawk whose handle is wrapped with ermine pelts (see also fig. 14.16).

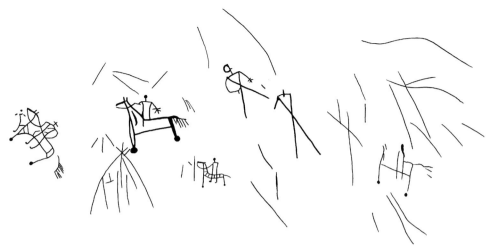

14.12 A variety of horsemen, some in combat scenes, and a tipi are carved at this site near Writing-on-Stone.

in the activities that Plains cultures portrayed in their rock art (fig. 14.12).

Material Culture

Material culture items in Biographic art include many of the same types of objects noted for the Ceremonial tradition, including shields, weapons, ceremonial objects, and clothing. Historic items, however, such as guns, swords, trade axes, and horse tack, are far more common in Biographic rock art. This tradition also includes objects rarely or never associated with Ceremonial rock art, such as tipis, travois, wagons, boats, and buildings. Other drawings represent scalps, fortification breastworks, and captured war trophies.

A few Biographic figures carry large body shields, but mounted horsemen or pedestrian warriors carrying the smaller equestrian shields are much more common. Weapons include spears, bows and arrows, clubs, hatchets, swords, and guns. These drawings tend to be simpler than those of the Ceremonial tradition, but some feathered spears and flintlock guns are quite detailed. Ceremonial objects are relatively rare, except for war medicine bridles, shields, and war bundles associated with

mounted riders in several combat scenes, and scalps suspended from carrying poles. Headdresses and fringed leggings and jackets are present, and a few humans have t-shaped heads, which may represent brimmed hats. The latest Biographic rock art shows more detailed, realistic costume. One detailed panel at the Joliet site, drawn about 1880, shows a woman wearing an elk-tooth-decorated dress and dancers sporting elaborate Hot Dance regalia (see fig. 2.3). Other hide dresses are shown, and one man in a Cave Hills scene wears leggings made from the pants of a cavalry uniform. These scenes are most similar to the detail shown in contemporaneous ledger drawings.

Horse tack includes halters, reins, and saddles (figs. 14.7, 14.8, 14.10). Riders also wield quirts, and the manes and tails of horses are sometimes decorated with feathers. Decorated

14.13 Both horse and rider in this combat scene are covered with hide armor.

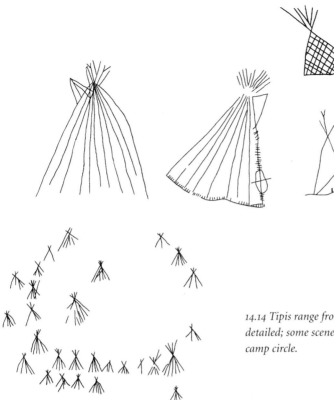

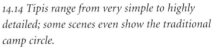

14.14 Tipis range from very simple to highly detailed; some scenes even show the traditional camp circle.

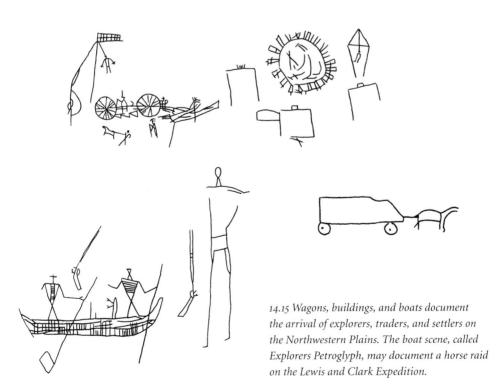

14.15 Wagons, buildings, and boats document the arrival of explorers, traders, and settlers on the Northwestern Plains. The boat scene, called Explorers Petroglyph, may document a horse raid on the Lewis and Clark Expedition.

halters include representations of suspended scalps and feathers, war-medicine halters, and Spanish chain-mail bits (fig. 14.10). One horse at Joliet has silver Spanish conchos decorating his headstall. Several unmounted horses drag travois. One of the more unusual horse accouterments is hide armor (fig. 14.13). For a short period after the introduction of the horse to the Plains, certain Native groups covered their mounts in armor made from several overlapping layers of heavy hide. This armor, thick enough to stop most arrows, was based on similar pedestrian body armor used prehistorically. Horse armor was used only briefly. It was ineffective against the gun and too heavy and cumbersome to use when opposing swift cavalry.

Tipis are quite common in the Biographic tradition (fig. 14.14). Some are only simple X shapes showing two crossed poles, but others have many poles, and the most elaborate even include the smoke flap, pegs, and tipi door. At several sites, tipis are drawn in small groups or even camp circles. At one site, a camp circle surrounds a central tipi with several humans inside. This same site also shows fortifications or pits with people inside.

Some objects in Biographic rock art are clearly associated with the arrival of Euro-Americans (fig. 14.15). At several sites, wagons and buildings are drawn. At Writing-on-Stone, one scene shows a man hanging from a flag-pole next to a wagon and several buildings. The panel at Explorer's Petroglyph shows several humans in a boat.

Pictograms and Ideograms

Some elements of Biographic rock art do not readily fit into the preceding categories. For example, panels frequently include a series of short dashes that represent human footprints, or one or more series of C shapes, which represent horse tracks. A series of dots or a line with terminal dot extending from a gun barrel represents the path of bullets. These pictorial elements demonstrate certain characteristics of pictographic and ideographic images—nonrepresentational or abstract designs that symbolize real objects or actions. Nonetheless, these nonrepresentational elements are generally associated with other clearly representational designs.

A Biographic tradition tally of items at Nordstrom-Bowen, Montana, includes (from left to right) gun, spears (2), tomahawks (2), coupsticks/lances (2), sword, bow, quirts (2), and scalp pole (several additional scalp poles farther to right are not shown).

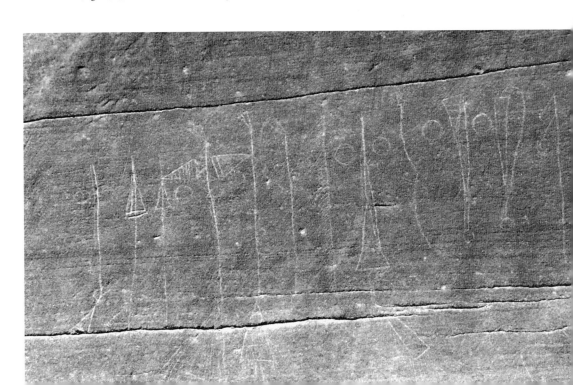

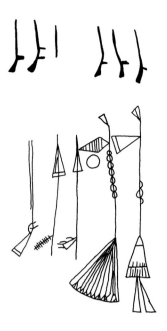

Composition

The Biographic tradition is most readily distinguished from Ceremonial rock art—and from rock art of all other traditions—on the basis of composition. Biographic rock art includes two main types of composition: static groupings (or tallies) of objects, animals, and humans; and animated scenes depicting humans, animals, and objects involved in activities. While tally compositions are simple and straightforward, the animated scenes include some of the most complex illustrations found in Northwestern Plains rock art.

Tally compositions generally consist of repeated images, numbering from a few to several dozen, arranged in a row. The most common tallied items are humans, horses, and weapons or similar objects. A grouping can show repeated images of a single item,

14.16 *Tallies of weapons denote a man's captured war trophies.*

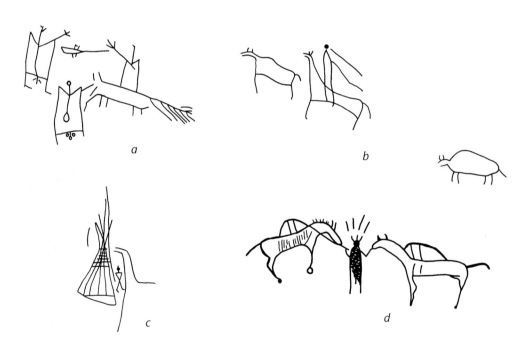

14.17 *Biographic scenes portray various actions: a, combat; b, bison hunting; c, d, horse stealing. Note in c how the theft is shown by interposing the human between horse and tipi.*

236

or a combination of several (fig. 14.16). Tallied human figures and horses are static, with no apparent evidence of interaction or movement. Objects and weapons are usually depicted in an upright position. All of the repeated images are usually similar in form and size, highly conventionalized, and usually lack detail and elaboration. Human figures often lack arms and heads, and occasionally a row of them is joined by a horizontal line. In some cases, the form of the subject has been reduced to its bare essentials and abbreviated to such a degree that the identity of the images are all but unrecognizable except in reference to their context or to other images.

Biographic tally groupings can be distinguished from the static Ceremonial compositions, with their generally random groupings, often elaborate and detailed images, and variation in the images' size and appearance.

Animated compositions involve multiple images integrated into scenes portraying activities and events (fig. 14.17). Ranging from simple scenes with two or three figures to complex scenes involving hundreds of figures, the key characteristic of all animated scenes is that they portray action and interaction. Animated compositions most commonly include horse raids, battles, and individual combat (coup-counting), which together account for more than 90 percent of Biographic scenes. Other activities include hunting, sex acts, a hanging scene, dances, and other group gatherings.

Humans are the main subject of these scenes, but they are usually associated with various combinations of horses, weapons, and objects. Humans are shown in active poses, often leaning forward with bent arms and legs, doubled over as if struck by a weapon, or falling backward (figs. 14.1, 14.6, 14.8). They wield weapons, hold objects, and ride horses. To indicate direct interaction, humans face each other, sometimes in semiprofile, with arms and feet pointing in the direction of the other figure. Weapons are also often directed at an opponent or raised as if in attack or defense. All these postures and arrangements give the clear impression of movement and action. The sense of movement and action is heightened by the graceful, flowing forms of horses, many of which have bent legs, appear to rear up, or toss their heads.

Many pictorial devices are also incorporated into animated scenes to represent

Lightly incised horses and riders at Joliet, Montana, show stylistic developments that date them to after A.D. 1870.

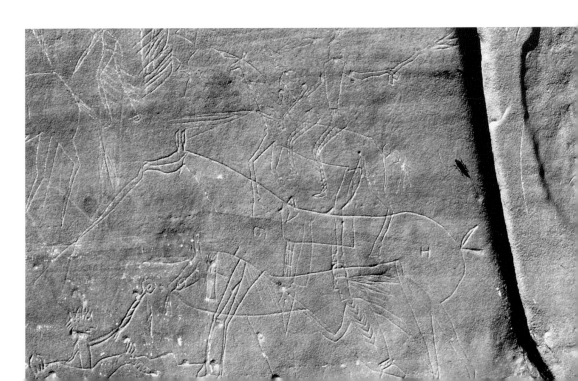

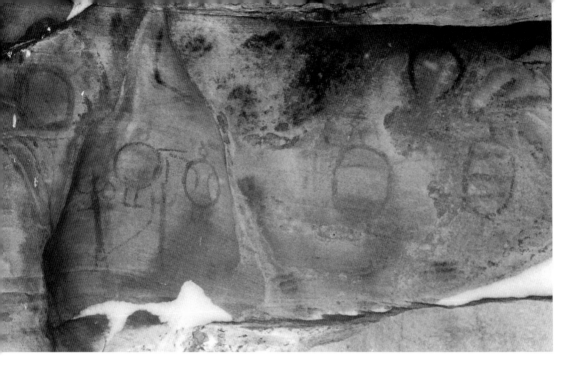

This painted panel southwest of Calgary, Alberta is one of the most northern Biographic rock art sites. Shield-bearing warriors and the absence of horses and guns date it to the Late Prehistoric period.

movement and action. A line of short dashes, representing footprints, or a series of C shapes, representing hoofprints, indicate the movement of humans and horses within a scene. Likewise, a line of dots from a gun's muzzle represents the path of bullets (fig. 14.6). Tracks and bullets are also used to link a series of sequential events, each represented as a separate group of images, in order to tell a story that takes place over time and space. Sometimes a sophisticated pictographic shorthand is used to avoid crowding a scene. Thus, some opponents are represented only by their weapons, or a horse is represented only by its tracks. In other cases, a weapon may be shown twice in the same scene to represent two uses of it in subsequent events.

Other pictorial details create the sense that the action is taking place in a real time and place. For instance, the figures are often placed along one or more ground lines representing

the ground surface, or multiple perspectives may be employed to create the illusion of depth or action across space. In some cases, the setting of an action or event is indicated by adding certain details to a composition, such as showing a tipi as part of a horse-raiding scene (fig. 14.17).

Dating and Chronology

The Biographic tradition originated in the Late Prehistoric period but reached its greatest development and expression in the Proto-historic and Historic periods (fig. 14.18). While the age of the earliest examples is not secure, several Biographic rock art panels certainly date from before the introduction of the horse. Most Biographic rock art, however, was produced during the eighteenth and nineteenth centuries, while related imagery on robes and ledgers continued well into the first decades of the twentieth century. A few Biographic rock art panels dated to after 1870 are some of the latest examples of rock art in North America. One such Biographic petro-glyph shows two automobiles with passengers; carved in 1924 by the Piegan elder Bird Rattle,

AD 1900

AD 1775

AD 1700

14.18 Biographic Tradition General Chronology

it commemorates a trip to Writing-on-Stone (Klassen et al. 2000).

Although Biographic rock art has not been directly dated, the age of many sites can be established to within a few decades solely on the basis of subject matter. Sites lacking depictions of guns and horses likely date to the Late Prehistoric period. These scenes show pedestrian shield-bearing warriors and V-neck humans fighting with clubs, bows, and spears (figs. 14.5, 14.19). Only a few Late Prehistoric sites have been identified, suggesting that Biographic rock art had its origins toward the end of this period.

Other sites appear to date to the Proto-historic or contact transition era. The Verdigris battle scene, near Writing-on-Stone, includes several pedestrian shield-bearing warriors in battle with mounted riders (see fig. 13.36). Some riders carry large shields, and two horses are wearing body armor. Other sites without guns in the North Cave Hills and along the middle Yellowstone River also show armored horses, riders with large shields, and pedestrian opponents (fig. 14.20). Since horse armor was used only briefly, after the intro-duction of the horse and before the gun, these scenes date to the early Protohistoric era. Some horses in the Verdigris battle scene have a boat-form body shape like the typical animals associated with precontact rock art. This lends added support to the early Proto-historic age for this panel. Several other Biographic sites also have boat-form horses, indicating they also likely date to the Late Prehistoric/Protohistoric transition (fig. 14.17). One such site has a distinct boat-form horse involved in a relatively complex narrative scene, suggesting that Biographic rock art was already well developed in the early postcontact period.

The vast majority of Biographic rock art can be dated to the Protohistoric and early Historic periods. These sites include guns and horses, and other datable European trade objects, but lack drawings of Euro-Americans

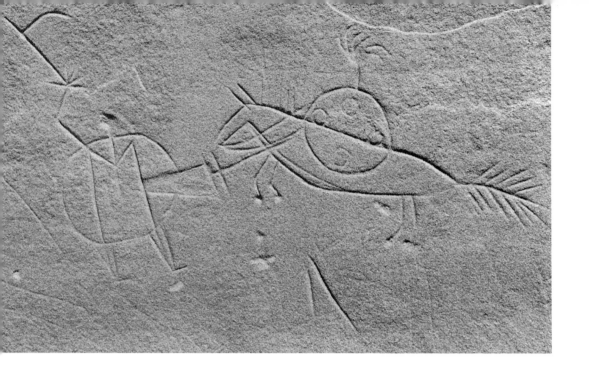

In this combat scene from Verdigris Coulee, Alberta, a rider on a boat-form horse attacks a pedestrian shield-bearing warrior. This combination indicates an early Protohistoric age.

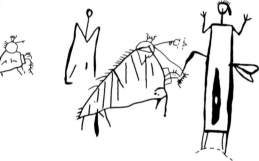

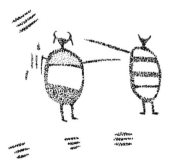

14.20 An early Historic period combat scene showing shield-bearing warriors riding horses covered with hide armor.

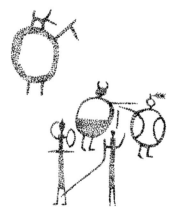

14.19 This painted Late Prehistoric period panel southwest of Calgary, Alberta, shows several combat scenes.

or their settlements. This indicates the sites were probably made from approximately 1750 to 1830, during the period when trade items were commonplace, but before large numbers of Euro-Americans entered the area. Horses in these scenes are predominantly mature-style animals.

Finally, some sites can be dated to the late Historic period, after the arrival and permanent settlement of Euro-Americans (fig. 14.15). Some show wagons, buildings, military insignia and uniforms, men wearing brimmed hats, and other trappings of Euro-American settlement. These details indicate that the sites date from the mid to late 1800s, and a few continued to be made right into the present century. At Writing-on-Stone, the two automobiles carved in 1924 by Bird Rattle are drawn in very similar fashion to early representations of wagons, and the passengers are similar to simple Biographic rock art human figures.

In addition to being dated by subject matter, the approximate age of many Biographic rock art drawings can be determined by comparing them to images drawn on robes, clothing, shields, tipis, and ledgers collected during the Historic period. The strong formal similarities between these drawings and many rock art images indicate their general contemporaneity, but even more detailed comparisons have been used to date some rock art scenes to specific decades (fig. 14.21). Such analysis shows that one dance scene at the Joliet site (see fig. 2.3) was carved between 1879 and 1889 (Keyser and Cowdrey 2000), and coup-counting scenes at Joliet, in the North Cave Hills, and in the Black Hills were made when warfare between Plains tribes and the U.S. Cavalry was at its height.

The production of Biographic rock art waned with the forced settlement of Plains Indians onto American reservations and Canadian reserves. The sacred sites and sandstone cliffs suitable for rock art were no longer easily accessible, and with the passing of the buffalo days, many of the old traditions were lost or abandoned. Nonetheless, the Biographic tradition lived on into the twentieth century in the form of painting on hides, tipis, clothing, and in ledgers. In some communities this tradition has been recently revitalized and incorporated into modern artistic expressions.

This automobile petroglyph, carved in 1924 at Writing-on-Stone by the Blackfeet chief Bird Rattle, displays similarities to earlier examples of Biographic rock art.

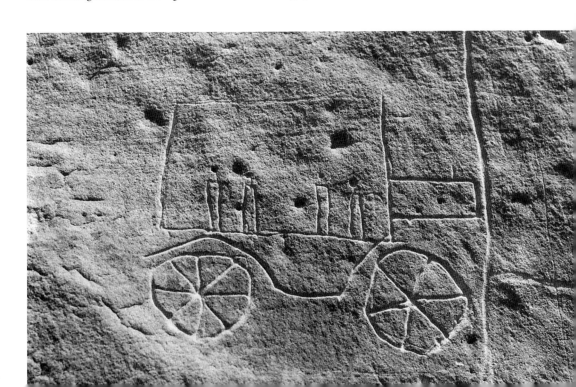

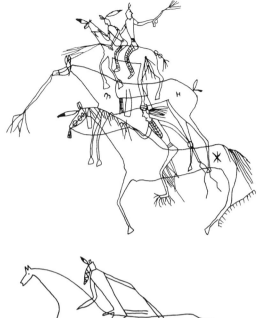

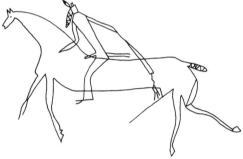

14.21 *The latest drawings in Biographic rock art show realistic horses and humans. These, from the Joliet site, are very similar to ledger drawings done after 1870.*

Distribution and Regional Relationships

Biographic rock art is the most widely distributed of all Plains traditions (Map 14.1). Sites have been recorded as far north as Calgary, Alberta, and as far south as Texas and northern Mexico, and from the Columbia Plateau and Colorado Plateau to central Kansas. Although notably widespread, this tradition reached its greatest expression and development on the Northwestern Plains. The majority of sites are concentrated in

southern Alberta, south-central Montana, northern Wyoming, and northeastern South Dakota. Biographic sites are particularly numerous along the Musselshell and Yellowstone Rivers in south-central Montana, and this area includes the Castle Butte, Joliet, Nordstrom-Bowen, and Pictograph Cave sites. Wyoming sites are widely distributed from the Green River Basin to the Little Popo Agie River and Bighorn Mountain foothills in central Wyoming. In South Dakota, sites are located in the North Cave Hills and Black Hills. In Colorado they are found in the northwestern part of the state and along the Purgatoire River in the southeastern corner. The single greatest concentration of Northwestern Plains Biographic rock art, however, occurs at Writing-on-Stone in southern Alberta. Along a 10-mile (16 km) stretch of the Milk River and its tributary coulees, this tradition is represented by nearly thirty sites, including five major battle scenes and hundreds of horses, humans, and weapons.

While many aspects of Biographic rock art are quite distinct, it shows strong relationships to the Ceremonial tradition, sharing much subject matter and many designs. The incorporation of the distinctive V-neck human figure into both traditions is unlikely to be merely coincidence or imitation, since it is so widespread and occurs in so many contexts, often independent of Ceremonial rock art. The shared subject matter and formal conventions make it seem clear that the roots of the Biographic tradition lie in the Ceremonial tradition, a relationship reinforced by their geographical, chronological, and ethnic overlaps.

Many distinctive Biographic forms and designs appear to have originated on the Plains. For example, V-neck humans and mature-style horses are restricted to the Plains, suggesting that these forms developed independently in this region. On the other hand, some designs, such as triangular-body

humans, probably were borrowed or diffused from other areas. On the Northwestern Plains, triangular-body humans are exclusively associated with the Biographic tradition, indicating that this design is a late addition to Plains rock art. This same human design is also common in Algonkian rock art from the Canadian Shield and Northeastern Woodlands, suggesting it may have originated there.

The Biographic tradition may in fact have been strongly influenced by late forms of Algonkian imagery. Some examples of Algonkian Canadian Shield pictographs, which resemble Biographic rock art, are interpreted to represent "narratives" of the spirit travels of shamans (Rajnovich 1994). The most obvious narrative Algonkian imagery, however, is the "song scroll" drawings of the Ojibwa. Consisting of rows of representational pictures and symbols on sheets of birch bark, song scrolls record the ritual songs of the Ojibwa Midewiwin ceremonies. The scrolls could be "read" by Mide practitioners, as each drawing represented a segment of a sacred song. Of all aboriginal pictorial traditions in North America, Midewiwin song scrolls most closely resemble Biographic rock art in both form and function.

Biographic rock art also paralleled the development of Biographic imagery in other media, specifically Robe and Ledger art. Similar forms and designs appear in both traditions, and they depict similar scenes and subject matter with the same compositional conventions. Moreover, both traditions share the same geographical distribution and overlap in time. On the other hand, the coup-count and tallying aspects of the Biographic tradition also may be the precursor of the Vertical Series tradition. Although current evidence is sketchy, similarities of imagery and arrangement suggest that the pictographic and narrative conventions of the Biographic tradition were transformed into the ideographic system of Vertical Series rock art.

Cultural Affiliations

The wide distribution of Biographic rock art clearly indicates its pan-Plains cultural affiliations, with most basic forms, designs, and compositional expressions being shared among all Plains groups. This is supported by the similarly diverse cultural affiliations of the closely related Robe and Ledger art tradition. Nonetheless, regional and ethnic variants or styles of Biographic rock art may be present. For example, the specific form of both humans and horses varies within and among sites, and these varieties may represent different styles of different ethnic groups. Likewise, the analysis of the material culture depicted in rock art may point to ethnic styles, since certain objects may be restricted to specific cultural groups. For example, horse armor is commonly thought to be of Shoshonean origin, while certain types of feathered warbonnets are often linked to Siouan groups. Similarly, shield designs and certain types of decorated halters may identify other groups (Cowdrey 1995; Keyser 1991; Keyser and Cowdrey 2000; Nagy 1994; Sundstrom and Keyser 1998). Careful study of these variations may reveal rock art styles that can be linked to specific tribes.

At this point, however, we know that the Blackfeet, Cheyenne, Crow, and Sioux are responsible for much of Northwestern Plains Biographic rock art. Many rock art designs can be clearly linked to similar images painted by these groups on robes, clothing, and ledgers. Other groups, such as the Flathead, Arapaho, Hidatsa, Mandan, Plains Cree, Gros Ventre, and Shoshone, are undoubtedly also responsible for some of the rock art. No matter which of these groups originated this rock art tradition, the others rapidly began to follow suit, and by the early 1800s, virtually all ethnic groups on the Northwestern Plains participated in the Biographic tradition.

Interpretations

Biographic tradition rock art was primarily used to record a warrior's personal accomplishments and important life events—accomplishments that heightened the warrior's status and honor. Thus rock art was used to advertise the individual's standing in society and the world (Keyser 1977a, 1987a; Klassen 1998a). By recording specific events and activities, Biographic rock art forms a pictorial history of the people and cultures of the Plains, drawn by their own hands. Although it depicts historical events, Biographic rock art also celebrates medicine power, since coups also demonstrate the power of a successful warrior's spirit helper, and so even these images ultimately originated in the relationship of humans to the spirit world.

These pictorial records were drawn in two distinct forms: multiple images, representing tallies of things such as war trophies; and integrated, animated scenes, representing biographical events or activities such as counting coups on enemies. Both forms of Biographic rock art are similar to the "war records" that warriors drew on robes, clothing, tipis, and ledgers throughout the Historic era. Many war-record paintings now held in museums around the world are well documented in the ethnographic literature, since their creators often explained their significance in great detail to those who collected them. By way of analogy, we can use this ethnographic record to interpret the meaning and significance of many Biographic rock art scenes.

In Robe art war records, multiple repeated images represent a tally of objects captured in battle, items given away to enhance prestige or status, or the number of successful coups counted on enemy warriors. Many similar tallies are found in Biographic rock art. For example, a row of guns probably represents the number of weapons captured by a warrior or war party during one or more raids. Another panel depicts a row of spears, a gun, hatchets, coup-sticks, a sword, and

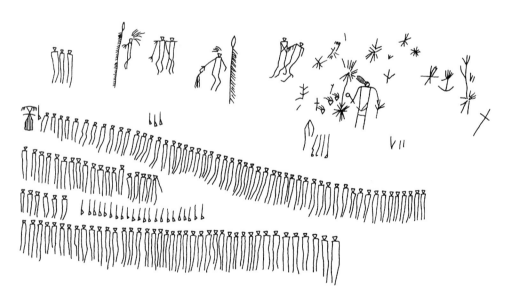

14.22 This Black Hills Biographic composition almost certainly documents Sioux or Cheyenne coups from their wars with the U.S. Cavalry in the 1860s and 1870s.

14.23 In this horse-raiding scene at Writing-on-Stone, many horses are indicated only by their necks and heads.

quirts (fig. 14.16). A quirt was often drawn to document a horse given as a gift, but the other objects are war booty, the capture of which represented a coup. Each coup heightened a warrior's status by demonstrating his bravery and the strength of his medicine power.

Other Biographic rock art panels show rows or groups of simple human figures, all generally the same size and form. The static images are generally scratched, lack details or elaborations, and show little concern for precision and form of the lines, suggesting hasty execution. One such site is a row of finger-painted triangular-body humans, arranged much like similar images on Historic period Blackfeet robes. Another site in the southern Black Hills has 119 armless humans lined up in four rows associated with 22 guns and a military insignia and saber (fig. 14.22). This form of simple, noninteracting representation gives the distinct impression that the humans are part of a tally, in which their number rather than their specific attributes are significant. These tallied humans record a warrior's coups and the number of soldiers killed by a group.

Multiple static images of horses arranged in rows or groups also represent the number of horses captured on a raid. The horse raid tally is developed to its farthest extent on one panel at Writing-on-Stone, where as many as eighty horses are represented by simple pairs of curving, roughly parallel lines (fig. 14.23). This pictorial shorthand, derived from the characteristic head and neck shape of the

mature-style horse, is a simple and effective way for quickly showing large numbers of horses in herds—a characteristic development of a pictographic system. Set among these horses are a row of headless, armless human figures, and several horsemen. The row of humans may represent coups counted on enemy warriors, and the riders appear to be involved in capturing the horses. While the mounted warriors suggest that this panel represents a specific event accomplished by several individuals, its composition also suggests it may be a lifetime tally of horses captured by one individual. Other groups

This juxtaposed composition of a human figure, tipi, and horses is similar to hide painting scenes representing the results of a horse raid.

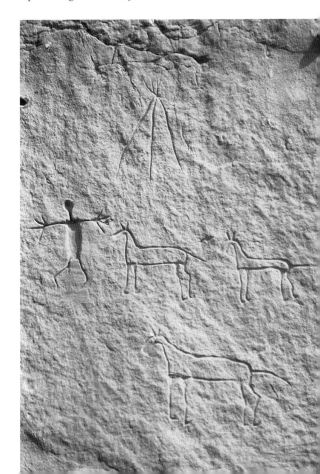

of horses at different sites represent animals stolen in a specific raid. At Writing-on-Stone, three horses juxtaposed with a human figure and a tipi form an image almost identical to those common on Plains hide paintings. Ethnographic documentation for these hide paintings reveals that similar scenes are a biographic record of horses captured on a specific raid.

Although tallies are important in Biographic rock art, this tradition is better characterized by animated scenes depicting real events, ranging from individuals in hand-to-hand combat to complex compositions of major battles involving hundreds of warriors, and from a single hunter pursuing a bison to large-scale horse raids. Biographic rock art thus becomes a form of pictorial storytelling. These scenes often use explicitly narrative imagery to show a sequence of actions occurring over time and across space. The Biographic tradition is notable for the complexity of its narrative imagery—easily the most well-developed narrative rock art in North America. By 1800, aspects of this rock

art had developed into true picture-writing.

Although many types of events are portrayed in Biographic rock art, the development of this narrative imagery is best illustrated by examining the progression of combat and battle scenes from the precontact era until the late 1800s. The earliest examples of narrative rock art are several combat scenes with shield-bearing warriors (figs. 14.5, 14.19, 14.24). The large body shields and the absence of guns and horses indicate a Late Prehistoric date. In each case, the shield figures directly interact with each other, and they exhibit a rudimentary pictorial narrative. For example, on one panel a large shield figure points a feathered spear at the head of a smaller enemy, who raises a weapon in defense. This creates a simple progression for the narrative, since the asymmetrical composition leads our eye from the larger figure on the left, down the outsized spear, to the smaller figure on the right. The exaggerated size of the spear also suggests that the weapon touching the victim is the central action of this scene, thus emphasizing the act of counting coup.

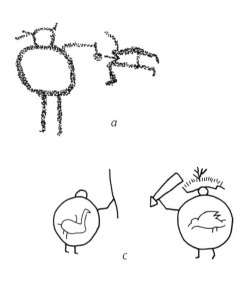

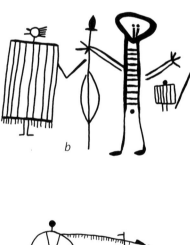

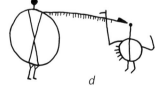

14.24 Late Prehistoric period Biographic combat scenes often involve shield-bearing warriors: a, pecked petroglyph from southern Black Hills; b, incised petroglyph from Wyoming; c, d, incised petroglyphs from Writing-on-Stone.

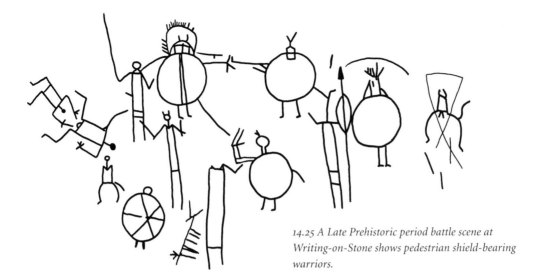

14.25 A Late Prehistoric period battle scene at Writing-on-Stone shows pedestrian shield-bearing warriors.

On another panel, two precisely executed shield-bearing warriors face each other, brandishing their weapons (fig. 14.24). Again, this composition implies movement between the two participants, and their elaborate shield designs clearly proclaim the warriors' medicine powers. On this panel, the sacred and personal significance of the medicine shield is integrated with the historical narrative of a coup, mutually reinforcing these concepts.

Large, complex narratives involving precontact shield-bearers are rare, but one Writing-on-Stone panel shows five shield figures fighting six other humans (fig. 14.25). Most of these figures are relatively static, but as a whole this panel suggests a narrative scene. Two shield-bearers point weapons at each other, and a third brandishes a weapon above a human's head. Another pair of humans also appears to interact. Each pair may represent a separate action within a larger event. Although not fully developed, the compositional arrangement gives a general impression of activity, movement, and a sequence of events.

The earliest well-established Protohistoric narrative panels are those at Writing-on-Stone and in the North Cave Hills, where mounted shield figures attack pedestrian warriors (see fig. 13.36). The large body shields, boat-form

horses, absence of guns, and combat between pedestrians and horsemen date these scenes to the Protohistoric period, probably about 1730. The figures on these panels are detailed and precisely drawn, and the groupings also show narrative conventions. The scenes involve direct interaction, with riders attacking pedestrian warriors with raised weapons. The pedestrians are shown in active poses, the victim often falling backward in defeat. At the North Cave Hills site, a characteristic Crow pompadour hairstyle identifies the pedestrian woman victim. Overall, the detailed narration indicates that these drawings represent real historical events that occurred at specific places and times.

Simple narrative scenes involving two warriors in combat are also relatively common (figs. 14.1, 14.6, 14.8). Although the age of some showing only pedestrian warriors is unknown, the presence of guns or mounted warriors in many simple combat scenes date them to the Historic period (fig. 14.26). Although these combat scenes are functionally equivalent to those involving prehistoric pedestrian shield figures, the action is often far more developed, with a greater use of narrative conventions. Several devices create a greater sense of place, movement, and action. Horses are often found on slightly oblique ground lines, with bent legs

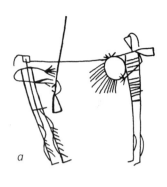

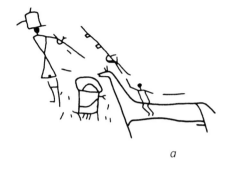

a

a

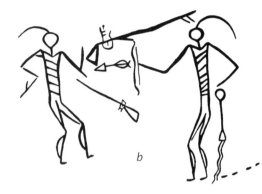

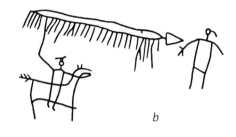

b

b

14.27 Horsemen frequently count coup on enemies. The rectilinear object (a) is a skin bag parfleche captured as a war trophy; the fringed spear (b) is exaggerated to emphasize the weapon's power.

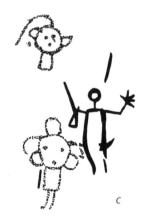

c

14.26 Pedestrian combat scenes document weapon capture and striking an enemy. a, Wyoming, showing capture of gun. b, Castle Butte, Montana: Tracks, quirt, and multiple weapons provide a detailed narrative for the composition. c, South Dakota Black Hills: This scene was drawn by modifying an earlier pecked circular face (like the upper one) into a woman with breasts and a dress by the addition of arms, legs, and a head. The warrior counting coup with his gun stock was then incised.

to make them seem as if they are rearing (fig. 14.8). Riders lean forward with raised weapons, and pedestrian figures fall backward (fig. 14.27). Horsemen often quirt their mounts, emphasizing the rush into battle. In some cases, a pedestrian reaches forward in a very realistic pose to seize an enemy's weapon. Such captured weapons often "float" off the fingertips of the vanquished foe. Tracks, wounds, and bullets indicate even more specific action sequences. In one scene at Castle Butte, the fight between two pedestrians can be understood by recognizing the quirt the winner carries, coupled with his track sequence to indicate that he dismounted to engage his foe (fig. 14.26). A single gun, shown twice in the scene, documents the winner's capture of this weapon and the subsequent dispatch of his enemy.

These combat scenes undoubtedly represent specific coup-counting events, and in

each case the narrative emphasizes the physical act itself. However, these images also have ceremonial aspects. Weapons are sometimes greatly exaggerated in proportion to the combatants, implying emphasis on the power of the specific weapon used to count coup (fig. 14.27). Other examples show war medicine bridles, decorated shields, or weasel- or otter-skin medicine bundles carried by a mounted warrior. Carried for the spiritual protection they offered, these items further document the warrior's medicine powers, which made his coup possible (fig. 14.28). One North Cave Hills composition documents a warrior's accomplishments in hunting and warfare, while a large decorated shield juxtaposed with the coup scenes represents the powers of the guardian spirit (fig. 14.29). Like the scenes known from robe art, this panel records coups in the context of a warrior's medicine power.

A more developed form of visual narrative is represented at one southern Alberta site where a hatchet, a spear, and three guns are clearly interacting with a human figure (fig.

This Biographic tradition combat scene at Castle Butte, Montana, illustrates a Crow warrior's coup. (Courtesy of Stu Connor)

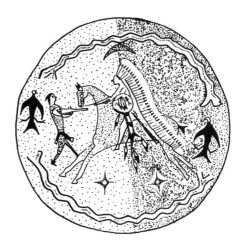

14.28 This Sioux shield demonstrates very well how a Biographic combat scene can also serve a Ceremonial function (as the power symbol on this shield).

14.30). Precedents in hide paintings reveal that this composition represents several coups being counted on an enemy. The narrative emphasis in this scene is focused not on the actors, however, but on the action relating to the coup. The individual or individuals counting coup (who authored this narrative) are outside the picture, only implied by the "floating" weapons. These weapons are not a static tally of objects, but instead have become pictograms representing an action performed

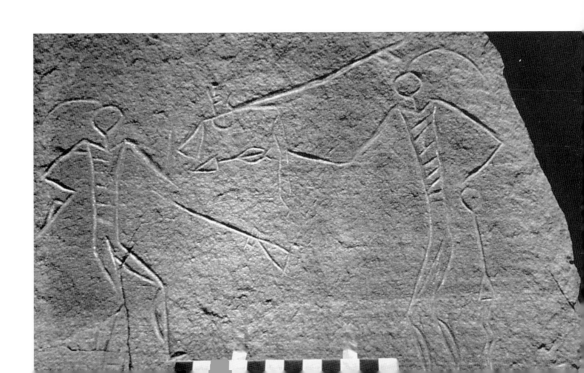

by the subject upon the object. This is most evident for the gun, upper right, showing a series of dots leading from the muzzle to the victim's head. This device indicates how the victim was killed and how one coup was counted, and also serves to depict the event in time and space as a sequence of events moving from right to left, from (implied) subject to object.

This high degree of visual narration or story-telling, developed to the level of pictography, distinguishes most Historic period Biographic rock art from its prehistoric precursors. Indeed, several large postcontact compositions exhibit a degree of narrative complexity unlike anything known from the precontact era. For example, one panel shows a mounted horse, three pedestrian humans, and several free-floating spears and guns, all involved in a battle (fig. 14.31). The single boat-form horse and few guns suggest a

14.30 This petroglyph is a detailed pictographic narrative of coup counts in the killing of an enemy.

relatively early postcontact age, but the composition is more complex than those described previously. At least three pairs of actual or implied combatants are shown in direct conflict. While three humans are depicted with some detail, most actors in this battle are represented only by their weapons.

The narration in this scene is heightened by several pictorial conventions. For example, the actors and objects are rendered in multiple perspective, including various combinations of frontal, profile, and bird's-eye views, all of which help to create the illusion of activity occurring in a three-dimensional space. This is most evident in the depiction of the pedestrian fighting the horseman. Moreover, interactions between the combatants are structured among objects not directly involved with the action—two groups of tipis—which creates a physical setting. Finally, the narrative

14.29 This North Cave Hills composition documents a man's accomplishments in warfare, hunting, and sex. Note that the large shield is a detailed rendering of the one carried by the mounted warrior.

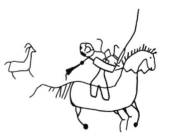

action is made even more apparent by the use of series of dashes and C shapes to depict sequential movement and direction of humans and horses. In one case, a bullet's path is indicated by a line leading to it from the gun barrel.

The pictorial conventions and forms employed here stem from an attempt to represent an event involving several actors in a specific physical setting, and from multiple points of view— in other words, the reproduction of a sequence of events based on experienced reality. This panel exhibits many of the characteristics associated with pictorial narratives. The overall effect causes the viewer to glance from action to action, producing a sense of movement and a sequence of events which recreates the chaotic activity of a battle, while at the same time placing the battle in the context of real space.

All these narrative devices have been termed a lexicon of pictorial conventions characteristic of Biographic picture-writing (Keyser 1987a). These include pictographic symbols and conventions used to convey the passage of time and movement across space, the identity of particular participants in a scene, and the timing and consequences of specific actions and events. Research has demonstrated that by using this lexicon, one can read many of these narrative Biographic scenes and thus identify specific details unavailable from most other Northwestern Plains rock art. Although examples have been identified from all across the Northwestern Plains (Keyser 1987a; Keyser and Cowdrey 2000), one particular scene at Writing-on-Stone stands out as an example. The Rocky Coulee battle scene consists of four horsemen in direct conflict with five pedestrian warriors (fig. 14.32). Other details include tipis, weapons, a shield, and a row of four standing noncombatants. The pedestrian force represents a group of horse raiders engaged in battle by the occupants of the tipi camp.

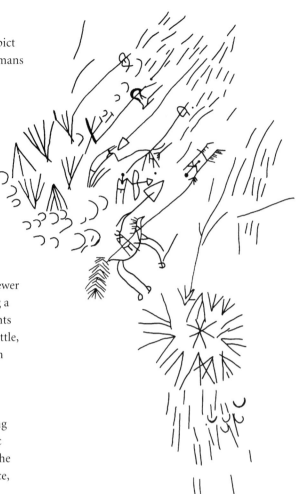

14.31 *This complex narrative petroglyph of a battle scene at Writing-on-Stone shows action from several vantage points.*

Tracks show a long journey from the raiders' camp to the scene of the fight, and horse tracks show the path of the camp's mounted defenders. Although the uppermost rider uses his spear to kill one pedestrian (as indicated by blood flowing from a stomach wound, the dead man's posture, and the unfired gun), all the horsemen were subsequently killed by the raiders. Bullets from two guns kill three horsemen, and the central sword-wielding warrior dispatches a fourth. This swordsman's tracks also indicate that he ran up and seized his opponent's gun. The four noncombatants

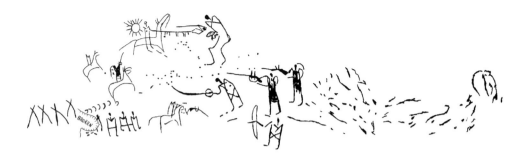

14.32 *Understanding the Biographic art lexicon helps us to read the story of this painted battle scene at Writing-on-Stone.*

either represent captives or coups counted on the dead riders.

The pictographic conventions on this panel depict a specific sequence of events occurring over time and space, and create an incredibly complex battle narrative involving at least nine people. A single perspective and a suggestion of visual depth, created by the orientation of all figures in relation to the same implied ground line, organize the composition and create the impression of an actual spatial environment. Furthermore, these images are drawn on a small, smooth rock face surrounded by large deteriorated surface areas that serve to frame and contain the action, thereby helping to separate pictorial space from "real" space. All these characteristics emphasize the narrative intentions of this panel—the recreation of a real event as a visual story.

The intensified narration of Biographic imagery culminates in the famous Writing-on-Stone Battle Scene (fig. 14.33). This panel includes more images and exhibits a more complex composition than any other narrative rock art panel. Many of the same lexicon conventions are employed here, but on a greater scale than seen anywhere else in Plains rock art. The detail and complexity of this composition documents that it is a visual narrative recounting a specific historical event. It seems to be linked to the oral history

of a major Blackfoot battle fought in 1866 (Dempsey 1973). Thus, the Battle Scene illustrates the overlap between visual and oral history.

The development of Biographic narrative imagery in the Historic period is related to the significant changes in Plains Indian culture that arose from the effects of contact with Euro-Americans. Far-reaching cultural changes resulted from the introduction of new diseases, the fur trade, and the arrival of guns and horses. The horse, however, had the greatest material and social impact on Plains tribes (Ewers 1955; Mishkin 1940; Penney 1992; Secoy 1953).

The sudden appearance of the horse, and its strength and ability, were seen as indications of the great medicine power of this animal. In addition to its spiritual importance, the horse also completely reorganized Native economies. It made hunting easier, especially for small groups, and bison hunting largely changed from a communal to an individual activity. The horse also increased the speed and ease of travel, which led to greater contact, and conflict, between groups. As the horse became more common, warfare patterns changed from infrequent large-scale battles to frequent small-scale raids and horseback skirmishes. In battle, horsemen had considerable tactical advantage over pedestrians, and thus the balance of power shifted dramatically during the Protohistoric period.

Because of the horses' medicine power and immense practical value, their ownership became one of the greatest indicators of status and wealth in Plains cultures, thus leading to

the development of the horse raid as a central focus of warrior society. The capture of horses improved a young warrior's economic outlook and provided a primary opportunity for a warrior to prove his bravery. Horse raids created numerous chances for counting coup, both by stealing the horses and by fighting the enemy, their owners. A complex system of graded war honors quickly developed in all Plains groups, and stealing horses, especially a picketed horse from in front of its owner's tipi, was one of the most notable. Warriors with the greatest war honors gained respect and status, and became important leaders with great influence.

The heightened significance of war honors and counting coup was reflected in the increasing emphasis on painting individual war records on robes and clothing. War records illustrated a man's status and documented his medicine power, and each scene was referred to while recounting the deeds of warriors and chiefs in ceremonies. The expansion of Biographic art reflected the changing status system, and rock art was used to record coups and war honors at sacred places on the landscape. In this way, the purpose of rock art shifted from presenting the visions and symbols of medicine power to recording biographic or historic events. This heightened concern with historical events required a greater emphasis on the forms of narrative imagery used to tell these stories, and fostered the development of pictorial conventions to show action over time and space—active poses, interacting figures, complex compositions, multiple perspectives, ground lines, pictographic symbols.

Despite the historical nature of Biographic rock art, this tradition was never entirely divorced from the spirit world. Narrative renderings of "historic" deeds are intimately associated with the "cosmic" powers which made those deeds possible: "Because the warrior depended on spiritual power and protection, any account of military exploits was by extension also a celebration of the validity and efficacy of those powers" (Maurer 1992). All in all, even the most narrative of scenes resonates with the medicine powers which gave a warrior his strength and courage.

The complex narrative imagery of the Biographic tradition grew out of the need for documenting war honors and chronicling biographical events, using simple, easily recognized and repeated pictographic symbols. This need likely also spawned the development of an even more complex type of narrative rock art known as the Vertical Series tradition, which used both pictograms and ideograms. However, some of the most recent manifestations of Biographic rock art shifted away from pictographic forms, and they show an increasing emphasis on naturalism and realism. The initial rise of narrative imagery in Biographic rock art, and the subsequent shift to realistic depictions, was paralleled by similar developments in Robe and Ledger art—a trend to be explored more fully in the next chapter.

The Battle Scene at Writing-on-Stone

B iographic rock art reached its zenith with the Battle Scene panel at Writing-on-Stone. It includes the greatest number of figures in the most complex composition of any Northwestern Plains rock art scene. Its detail and complexity clearly suggest that it depicts an actual historical event, possibly linked to a famous battle fought along the Milk River in 1866.

The Battle Scene shows a large group of pedestrian warriors attacking a large camp circle of tipis (fig. 14.33). In the camp are several groups of humans, including three figures inside the largest, central tipi. At the camp perimeter, a row of fourteen guns, two held by humans, represents warriors defending the camp. The attacking party consists of an advance guard of more than a dozen armed warriors, followed by more than three dozen pedestrian figures. Several rearguard figures carry bows or guns, and at least eight lead horses, six of which pull travois. A stream of bullets issues from the muzzle of nearly every gun in the scene.

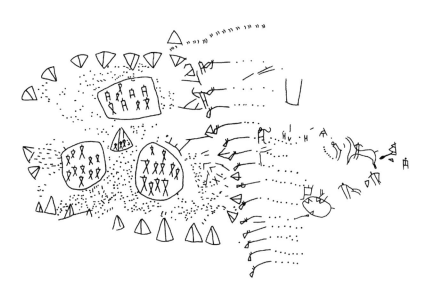

14.33 The Battle Scene at Writing-on-Stone.
A central combat scene shows a fight between a gunman and a person with an axe. Note the tipi camp circle (left) with interior fortifications and central tipi with people inside, and the attackers' horses pulling travois (far right).

Several figures interact between the tipi camp and the attacking party, and in the panel center, two humans engage in hand-to-hand combat. One figure leans forward and fires a gun, while the second brandishes a battle axe. Bullets pass across the body of the axe-wielding figure, and a dot on the breast indicates that this individual was wounded or killed. The central position, intricate detail, and direct interaction of these two figures suggest that they illustrate the panel's primary event.

This scene may relate to a battle described in 1924 by a Piegan elder named Bird Rattle. In his story, he directly linked the rock art of Writing-on-Stone to the "Retreat up the Hill" battle, fought somewhere along the Milk River in 1866. In the fall of that year, the Piegan winter camps filled all of the coulees between the Milk River and the Sweetgrass Hills. Every day the elders would go down to the cliffs to interpret the "writings" on the rock.

[One day] several old men went down to Writing-on-Stone. When they reached the place they were amazed to find no writings, no signs. . . . A few days before, they had

seen and read many writings where now there was nothing. This was unheard of. . . . As far as they knew there had never been known a time when there were no writings on the stone. They thought about this for a long time, but they could make nothing of it. (Dempsey 1973:35)

The next morning, a war party of Gros Ventres, Plains Cree, and Crow warriors surprised the Piegan chief Many Horses and his wife, Lone Coup, in a small coulee some distance from the main camp. While defending her husband, Lone Coup attacked the Gros Ventres leader with an axe, but in the ensuing struggle both she and Many Horses were shot and killed. The war party then advanced on the Piegan camps.

According to Bird Rattle, however, certain petroglyphs had warned the Piegan of the impending attack:

That morning quite a party of men went down to the river to see what writings might have been made during the night. . . . There were more writings than they had ever seen before and the old men, wiser

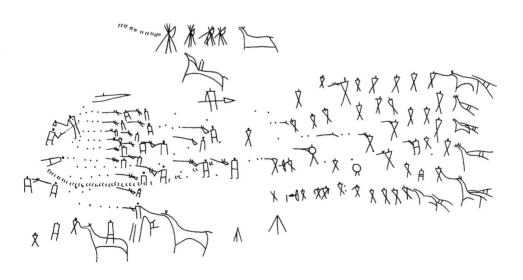

than the others in these matters, began to read the signs. . . . They saw a small party of Gros Ventres and before them Many Horses and his wife, dead. They looked further. Here was a battle and the Gros Ventres running away. . . . It was easy to identify the Crees and Crows, some dead and some running away. The writings covered all the cliff. (Dempsey 1973:38–39)

This warning allowed the Piegan to prepare for the battle, and in the end, soundly defeat the attacking party. The battle fought that day was one of the most decisive of Blackfeet victories, and a disastrous defeat for the Gros Ventres, Crow, and Plains Cree, who lost more than 300 warriors.

Dempsey speculates that the Battle Scene may be the very same panel alluded to in Bird Rattle's account of the battle. In this case, the camp on the left would represent the Piegan, while the attacking party on the right would represent the Gros Ventres, Plains Cree, and

Crow. Perhaps the central combat scene represents the courageous act of Lone Coup, dying in defense of her husband.

Whatever the case, it seems clear that this complex panel originally recorded an actual historical event, although the circumstances surrounding it and its depiction may have quickly become mythologized. As Dempsey puts it:

> It is possible that the pictographs were placed there *after* the event, and over the years, in telling and re-telling the tale, they became a part of the story itself. . . . By the time Bird Rattle told his story in 1924, the whole supernatural aura of the pictographs and their predictive powers had blended into the factual tale. (Dempsey 1973:42)

In other words, an historic event was transformed into a sacred legend—and both fact and legend are now preserved in the rock art.

15 / Robe and Ledger Art Tradition

Northwestern Plains rock art is part of a much larger pictorial tradition that also includes paintings and drawings made on a variety of perishable materials. From earliest Historic times, and probably long before, Indian artists painted images on tanned hides fashioned into robes, clothing, tipi covers, tipi liners, and shields. Later in the Historic period, drawings were also made in ledger books, on scraps of paper, and on sheets of muslin and canvas obtained from explorers, traders, and missionaries. Paintings and drawings made on these perishable materials are collectively known as Robe and Ledger art—a tradition that continued well into the early twentieth century.

A few Robe and Ledger drawings illustrate sacred themes similar to those of Ceremonial rock art, but most relate to Biographic rock art. Robe and Ledger art primarily recorded the exploits and accomplishments of warriors. Its earliest examples show simple, conventionalized figures in compositions ranging from relatively static images of warriors in combat to large, complex, animated battle scenes with many participants (fig. 15.1). Later, the

This painted bison robe in the Danish National Museum, Copenhagen, shows combat scenes and captured war trophies. Note the row of crescent-shaped scout service symbols along the bottom edge.

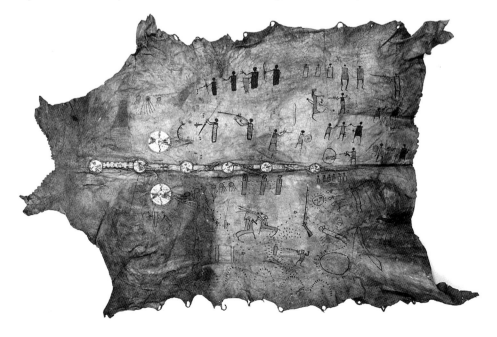

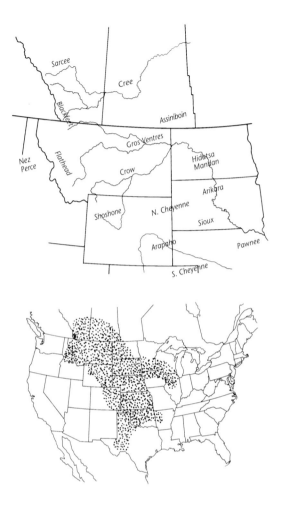

Map 15.1. Robe and Ledger Art Tradition

above: Regional distribution showing Northwestern Plains tribes who drew this art

below: Continental distribution

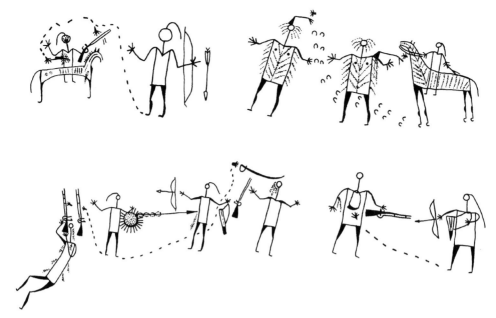

15.1 These images from an early Blackfeet painted robe collected before 1790 show V-neck and rectangular-body warriors in a variety of combat scenes. Note the capture hand in each scene, track sequences, and wounds. (Original in Musée de l'Homme, Paris.)

introduction of new techniques and materials led to the development of realistic, detailed ledger drawings, similar to the rock art dancers carved at the Joliet site.

Because Robe and Ledger art is well documented, it is an important key to understanding much Biographic rock art. Many surviving items were actively collected and obtained directly from the artists who made them (or from their families); thus, they can be well dated and associated with particular groups and known historic events. Frequently the artists explained the meanings of their drawings directly to the collectors, providing their own account of the symbols and conventions they used to tell their stories. Thus these hide and ledger drawings provide a wealth of information for dating rock art, assigning specific styles to particular cultural groups, and understanding the stories of many biographic scenes.

In this book, the term "robe art" refers to representational images painted on objects and clothing made of hide or cloth. Some robes also feature geometric and abstract images, but these types of designs have little in common with most rock art and are not discussed in this chapter. "Ledger art," on the other hand, refers to representational images painted or drawn on paper.

The earliest examples of representational robe art were produced on tanned bison hides, and occasionally on the hides of elk or other animals. These hides were cut and sewn into clothing and tipis, made into shields, or used uncut, as robes. By the late 1800s, canvas, muslin, and cowhides had largely replaced bison hides. Early robe art was painted with red, orange, and yellow ochre-based pigments, and natural black and white pigments, applied using thin bone or wood brushes. In later years, commercial trade paints replaced the natural pigments, providing a more colorful palette for the artists. The paper used for ledger art often came in the form of ledger books provided to Native artists by explorers, soldiers, missionaries, and traders; other notebooks and loose sheets were also used. Ledger art images were made with watercolor paints, ink, colored and lead pencils, and crayons.

History of Collection and Research

Robe art has attracted the attention of Europeans from the very earliest days of exploration on the Plains. While traveling in the American Southwest in 1540, both Pedro de Castañeda and Francisco Vasquez de Coronado collected hides painted with representations of animals (Castañeda et al. 1990). Coronado described the source of these painted robes as being eight days' journey to the north, suggesting they originated on the Plains. La Verendrye also observed painted bison robes while exploring the upper

Like bison robes, painted war shirts were used to record the coups of the shirt owner. On this Sioux warshirt in the Bernisches Historisches Museum, Bern, Switzerland, coups are indicated by the various weapons and capture hands touching each enemy.

Missouri in 1738 (Ewers 1939), but did not record the kinds of images portrayed.

The oldest existing painted robes are in the Musée de l'Homme in Paris. These were collected from "the plains of Canada" sometime before 1789, and they may be significantly older than this date (Barbeau 1960; Horse Capture et al. 1993). Several of these robes are painted with representational figures reminiscent of early Biographic rock art. One of the oldest and most famous painted robes, collected from the Mandan by Lewis and Clark in the winter of 1804–5, depicts a battle between the Mandan and several other groups around 1796. Another early robe was presented by the Pawnee to the Yellowstone Expedition of 1819–20.

Between 1820 and 1852, a number of important painted robes were collected by various explorers, naturalists, and artists traveling in the Northwestern Plains (Ewers 1968; Keyser 1996; Keyser and Brady 1993; Klassen 1994b; Maurer 1992). Perhaps the

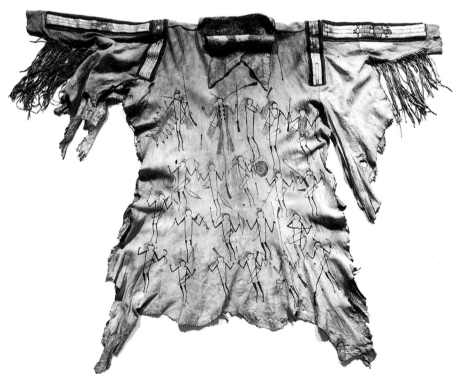

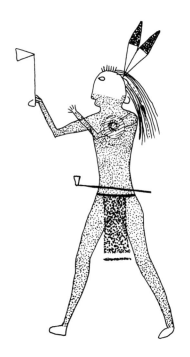

15.2 *Self-portrait drawn by Mandan Chief Mato-Topé (Four Bears) on a bison robe in 1834. (Original in Bernisches Historisches Museum, Bern.)*

most famous collector was the German aristocrat Prince Maximilian von Wied-Neuwied, who went up the Missouri River in 1832-34. He collected several painted shirts and hide paintings with representational images and took important notes on many of these objects.

Likewise, European artists George Catlin, Paul Kane, Rudolph Kurz, and Karl Bodmer made sketches of painted robes in the early to mid 1800s. Bodmer, who accompanied Prince Maximilian, drew several important specimens, including the famous Mandan robe by the chief Mato-Topé (fig. 15.2), and a painted robe worn by a Piegan chief. Known for the accuracy of his paintings, Bodmer also took notes on many of the items he saw. The first photograph of a hide painting, apparently a Blackfeet specimen, was taken in 1858 during the Hind expedition across the Canadian prairies. The Lone Dog winter count, the first brought to wide attention outside Native communities, was described by Garrick Mallery (1877).

By the mid 1800s, paintings on bison robes and hide clothing were going out of fashion because of increased use of wool blankets and capotes, and also owing to the dwindling numbers of bison and the increased European trade in bison hides. Even so, the collecting of hide paintings peaked during the latter half of the nineteenth century, when numerous government officials, travelers, and ethnologists acquired them as gifts or purchased them as curios and museum specimens. The tradition continued into the 1920s with drawings and paintings on deer- and cow-hides, canvas, and muslin (Brownstone 1993; Ewers 1983). Today nearly two hundred specimens of robe art are held in museum collections worldwide (Klassen 1994b).

The earliest known ledger drawings were collected from the Northwestern Plains in the 1830s. Karl Bodmer collected drawings by the Mandan warriors Four Bears and Yellow Feather in 1834. Four Bears' drawing is the same scene that he also painted on two robes now in European museums (Holm 1984; Keyser 1996). In the 1840s, the Jesuit priests DeSmet and Point collected ledger drawings from one Blackfeet and three Flathead warriors (Keyser 2000; Point 1967). Occasional ledger drawings were made throughout the rest of the pretreaty period, primarily by the Cheyenne, though single drawings by both Ute and Comanche artists are known from the southern Plains. The heyday of ledger art, however, came after 1875. Several Southern Cheyenne artists interned as prisoners of war at Ft. Marion, Florida, were probably the most prolific ledger artists (Petersen 1968, 1971; Szabo 1994). Of these, Howling Wolf is probably the best known. Across the North-western Plains, artists from many groups produced hundreds of these drawings during the late 1800s and early 1900s. Like robe art, many ledger drawings were acquired throughout this period by travelers, soldiers, officials,

and missionaries, and many now reside in museum collections.

Robe and Ledger art has attracted scholarly interest from its earliest collection. Exhibitions of Native artifacts including painted robes were organized in France before 1790. Lewis and Clark, Prince Maximilian, Catlin, and DeSmet were all naturalists collecting data and specimens for scientific purposes. Catlin arranged exhibits of his paintings and artifact collections in both the United States and European capitals; he also published a two-volume study of North American Indians that contains numerous drawings of and references to painted robes (Catlin 1844). Formal

The ledger drawings made in 1842 by Flathead chief Five Crows (Ambrose) are among the earliest collected. French script at lower right and numbers in drawing are annotations by Jesuit Fr. Pierre-Jean De Smet, who collected the drawing. (Courtesy of Jesuit Missouri Province Archives, St. Louis)

anthropological interest in this art began in 1893 when Mallery published "Picture-Writing of the American Indian," which deals extensively with winter-count hide paintings and a few ledger drawings. Around this time, other scholars, such as Rev. John Maclean (1896), also began to describe hide paintings.

Shortly after Robe and Ledger art was no longer regularly made and collected, anthropologists began studying museum collections (Vatter 1927; McClintock 1936; Ewers 1939). Some of this work also involved obtaining insights about the items from knowledgeable Indian elders, including some who were the artists (Brownstone 1993). It was not until twenty-five years later, however, that archaeologists began to relate these drawings to rock art (Rodee 1965; Conner and Conner 1971). Since that time, numerous authors have explored the relationships among rock art, robe art, and ledger drawings (Conner 1980; Keyser 1987a, 1989, 1991, 1996, 2000; Keyser and Brady 1993; Keyser and Cowdrey 2000; Klassen

15.3 These Blackfeet robe drawings in a and b are nearly identical to rock art drawings c and d found at Writing-on-Stone.

1994b, 1995; Maurer 1992; Schuster 1987). This approach has provided new interpretations and increased our understanding of all these art forms. Overall, Plains Robe and Ledger art is relatively well published: more than ninety robe art pieces and forty ledgers (ranging from single drawings to collections of more than a hundred separate illustrations) are pictured in various articles and books.

Description

As discussed in this chapter, Robe and Ledger art includes only objects with representational images, focusing primarily on paintings on hide robes and drawings in ledger books, although it refers to other items such as tipi covers and clothing.

Subject Matter and Form

The subject matter portrayed in Robe and Ledger art is remarkably consistent with that of Biographic tradition rock art. Humans, animals, and material culture items predominate in most paintings and drawings. In most robe art, particularly earlier examples, the form of images is also very similar to Biographic rock art (fig. 15.3). Most figures tend to be simple, conventionalized outline drawings of humans and animals. In later robe art and most ledger art drawings, humans and animals are depicted with more naturalism and realism, and exhibit increased detail and color. Accompanying this stylistic development, undoubtedly influenced by the artists' contact with Euro-American artistic concepts, later ledger drawings also incorporate landscape features as well as buildings, trains, and boats. Some pictograms and ideograms also appear.

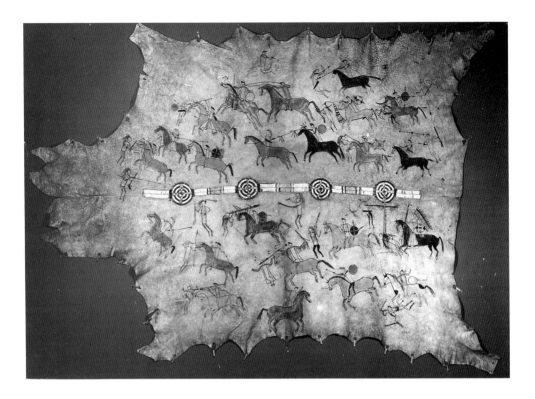

A Cheyenne bison robe in the Deutsches Ledermuseum, Offenbach am Mein, Germany, is painted with 25 coup count scenes. Note weapons, shields, and clothing of the participants.

Human figures are the most common image on both robes and ledgers. In early Robe art, humans are found in typical Biographic rock art forms, including V-neck, rectangular-body, and triangular-body humans, generally seen in frontal poses with minimal details. Most are monochrome, but the bodies of some humans are infilled with color. Although many humans take part in action scenes, they generally appear in relatively static poses. In later robe art and most ledger art, humans are drawn with greater detail and identifying characteristics, including elaborate clothing, accouterments, headdresses, and facial expressions. There is a much greater use of color, and many figures are polychrome. These humans also tend to be shown in more active poses. In some cases,

three-dimensional techniques, such as foreshortening and modeling, were used to create the illusion of depth and perspective.

Like humans, most early examples of animals are depicted as simple, relatively conventionalized, outline figures. Most are shown in profile, with minimal details and color. By far the most common animals are horses, with and without riders (figs. 15.1, 15.3). In early examples of Robe and Ledger art, horses are drawn as mature-style animals like those found in Biographic rock art. In later robe art and most ledger drawings, horses are drawn in a more naturalistic, modeled form and with realistic detail.

Very few animals besides horses appear. A number of bears are shown fighting with humans, and some big game animals appear in hunting scenes. In addition, a few robes and ledgers portray large groups of various birds and animals. Most are common Northwestern Plains animals such as deer, elk, bear, antelope, moose, bison, skunks, wolves/coyotes, cattle, turtles, and a variety of birds. However, the

Crow chief Medicine Crow drew a set of zoo and circus animals after his trip to Washington, D.C. A few depict mythological creatures.

Weapons, shields, clothing, ceremonial objects, and horse tack are frequently included in these drawings. Most of these items are being used by humans, but others appear singly or in groups. Tipis, blankets, and various introduced items, including buildings and wagons, are also depicted. In later ledger art, artists drew trains, boats, and buildings that they saw on trips to the east. Material culture items are drawn like their counterparts in Biographic rock art (fig. 15.4).

A variety of pictographic symbols were also used, including C shapes and dashes to represent horse and human tracks, dots to represent the path of bullets, and various symbols to represent wounds and coups. A disembodied hand (the "capture hand") frequently indicates a weapon taken from an enemy or the most daring coup of all, touching an enemy with the bare hand (fig.

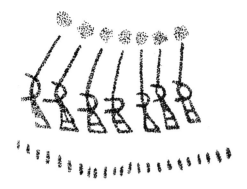

15.4 This red painting from Montana's Pictograph Cave shows a composition nearly identical to ones in ledger drawings by the Flathead chief Five Crows. The muzzle blasts and marks behind the gun stocks suggest that it represents an attacking force.

This ledger drawing by Flathead Chief Five Crows shows opposing forces represented by ranks of guns and tick marks. (Courtesy of Jesuit Missouri Province Archives, St. Louis)

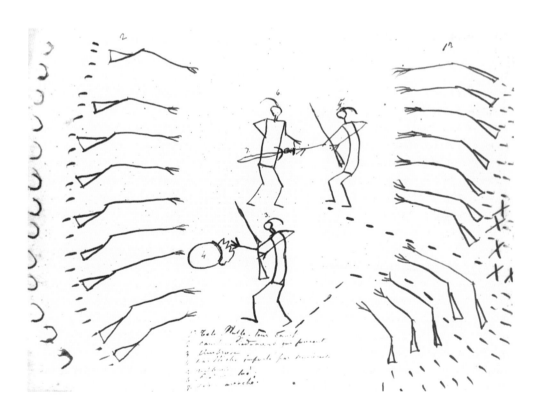

15.5 *The capture hand conveys the idea of counting coup by touching an enemy or taking his weapon. This Crow drawing with the highly stylized hand is from a robe in the Danish National Museum, Copenhagen.*

Ledger drawing by the Sioux warrior Red Dog (now in Indianer Museum der Stadt Zurich, Zurich, Switzerland) has a name glyph "tethered" to warrior's head. Many other components of the Biographic art lexicon occur in this drawing. Annotation at lower right (by unknown collector) reads "Dismounts kills a Pawnee."

15.5). So-called name glyphs were drawn to represent specific individuals. They would show an animal or object corresponding to the person's name (e.g., Red Dog) or depict an identifying object or characteristic connected by a line to the human's head.

The activities or events depicted in Northwestern Plains Robe and Ledger art consist primarily of warfare and horse-raiding scenes, with fewer hunting, dancing, and courtship drawings. A variety of miscellaneous events, primarily drawn in ledgers, are also portrayed, including camp scenes, interactions with traders and Indian agents, and councils with military officers. After groups were confined to reservations, some scenes of buildings, towns, and Indian school activities also appear.

Compositional Arrangements

Robe art images are primarily found in three basic compositions. On some robes, each image is isolated and does not interact or

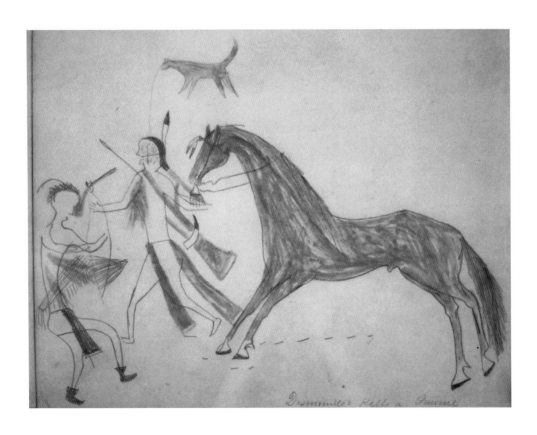

	Blackfeet	Sioux	Hidatsa/Mandan	Crow
"Capture Hand"				
Coup counted				
Horse captured				
Captured picketed horse				
Scalp taken				
War party leader				
Scout service				
Fortified war party				
Fought behind breastworks				
Arrow/bullet wound				
Knife wound				
Wounded horse				
Blanket captured or given away				
Horse given away				

15.6 Common Signs and Symbols of Northwestern Plains Robe and Ledger Art

connect with others. Such images are usually scattered randomly across the hide, or sometimes they are arranged symmetrically. Images are often oriented in different directions and on different ground lines. Calendrical records, or winter counts, have a linear arrangement of separate images. Often they spiral outward from a central figure, but others are arranged in rows. The individual images are not connected and do not interact.

More commonly, however, the composition of robe art involves multiple interacting images integrated into scenes. Some robe paintings are a single large, integrated scene, but more frequently hides are painted with several separate scenes (fig. 15.1). Isolated images are occasionally scattered among the different scenes, but more commonly, rows or groups of humans, horses, and various weapons and objects (tallies) are found among the scenes. Scenes are generally not associated with each other, but on some robes, a series of scenes was connected by a line of horse tracks. Some scenes are all oriented in the same direction; others are oriented randomly. In most cases, scenes are separated only by empty space. Lines drawn to frame separate scenes were only done on items made for commercial sale in the 1900s. In ledger art, a single image or scene was generally drawn on each page, but a few ledger drawings show multiple images per page.

As in Biographic rock art, a variety of conventions is used to create a story line. These are most common in combat scenes, and they include horse tracks, human footprints, flying bullets, breastworks, muzzle blasts, wounds, scalps, details of costume and equipment, tipis and camp circles, name glyphs, posture, and symbols for scout service, weapon capture, horse stealing, wounds, and war party leadership (fig. 15.6). Often a drawing of two men, which appears very simple at first glance, will contain as many as eight to ten of these conventions and, in fact,

tell a whole story detailing not only the outcome of the conflict, but who the participants were, why they were there, what they did, and the order of action. Some conventions used in Robe and Ledger art have yet to be found in rock art, but as more research occurs others are likely to be discovered.

Dating and Chronology

The origin of robe art is unknown, as no prehistoric archaeological examples of painted hides have been found. The oldest existing painted hides were collected during the latter half of the 1700s, but this medium was likely used long before the earliest surviving examples were created. Certainly robes were tanned far back into prehistory. We also know that rock art drawings of shield-bearing warriors, V-neck humans, and combat scenes were made in the Late Prehistoric period. Many of these images are similar to those on the earliest known painted robes, suggesting long artistic antecedents. This well developed Late Prehistoric rock art strongly suggests that painted robes also originated before contact. Moreover, the observations of painted hides by Castañeda and Coronado in 1540 and La Verendrye in 1738 clearly suggest that this practice predates the arrival of Europeans on the Plains.

Whatever its earliest origins, robe art was commonly produced in the late 1700s and throughout the 1800s, as evidenced by the many examples collected from this time period (fig. 15.7). Although the use of bison robes began to decline by the 1860s, robe art continued to be made on other types of hides, and later on canvas and muslin. The earliest known ledger drawings, on the other hand, were collected between 1834 and 1845, but some examples of this form may have been drawn earlier. Numerous exploration parties traveled through this region prior to 1834, and it is quite likely that some Indian artists

AD 1900 —

obtained paper from these expeditions and made ledger drawings, but these have not survived. Ledger drawings were first produced in number in the late 1860s and saw their greatest popularity between 1875 and 1890. By the late 1800s, Robe and Ledger art was often produced for commercial sale, and both types survived into the twentieth century.

The technique and style of robe and ledger drawings changed during the Historic period (fig. 15.7). As a general trend, earlier pieces show simpler, more conventionalized drawings of both humans and horses and a higher percentage of combat drawings. These two-dimensional representations are characteristic of pictographic drawings, with knob-headed, front-view humans and stylized, mature-style horses. A few artists, most notably among the Blackfeet, maintained this style into the twentieth century. In later years, the emphasis in many robe paintings and most ledger drawings turned to increased naturalism and realism. These use color, texture, name glyphs, perspective, and detail to create realistic portraiture.

The most detailed drawings tend to be found in ledgers and on muslin from the

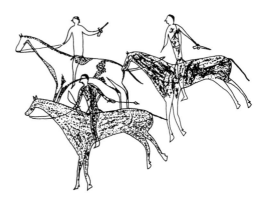

15.8 This drawing from the Summit Springs Ledger (Colorado Historical Society Archives, Denver) dates to 1869. Note how similar these figures are to the latest Biographic rock art drawings, such as the petroglyphs from the Joliet site (see fig. 14.21).

AD 1775 —

15.7 Robe and Ledger Tradition General Chronology

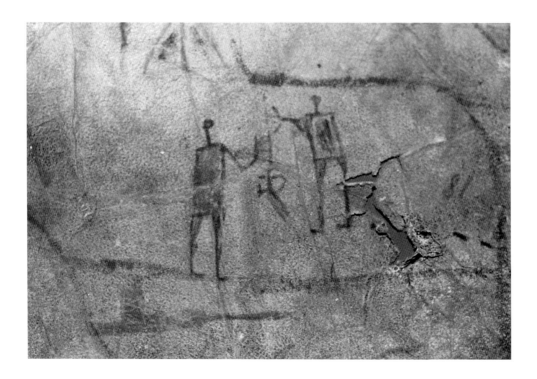

This late period combat or coup scene, painted on a robe by Blackfeet elder Wolf Carrier in 1909 or 1910 (now in Royal Ontario Museum, Toronto), shows the capture of a gun from an opponent. This scene is remarkably similar to earlier Biographic rock art.

treaty period. Four Bears and Yellow Feather were drawing relatively detailed horses and men with clothing and facial features in 1834, but not until after the 1860s did such realism become commonplace (fig. 15.8). During its heyday, ledger art was characterized by highly realistic portraits showing facial features, clothing, personalized shields, naturalistic horses and weapons, and even background scenery in some illustrations. Overall, the notable shift toward realism in Robe and Ledger art style occurred in the late 1800s. Some very early hide paintings, however, show complex use of color, costume, and details, while a few reservation-period drawings are done in the two-dimensional, monochrome style that is more like earlier Biographic drawings.

Distribution, Cultural Affiliations, and Regional Relationships

The distribution of Robe and Ledger art spans the entire Great Plains, from Canada to Mexico, and from the Rocky Mountains to the Mississippi River (Map 15.1). Examples of its paintings and drawings have been collected from virtually every part of the Northwestern Plains, and nearly every Historic period group from this area produced it. The Mandan, Lakota Sioux, Crow, Northern Cheyenne, and Blackfeet produced the majority of known works. Examples are also known from the Arapaho, Hidatsa, Arikara, Plains Cree, Assiniboin, Sarcee, Nez Perce, Shoshone, Flathead, and Gros Ventre. For many of these latter groups, however, only a few pieces survive. For example, documented Flathead specimens include only fourteen ledger drawings by three artists, and two painted robes (Keyser 2000). A variety of factors may cause this unequal representation among groups, but it is most likely that many more items were produced than are now preserved

in collections. This is clearly illustrated by several early historic photographs and the paintings of Kurz, Catlin, and Bodmer, which portray numerous warriors wearing decorated robes that no longer survive.

Robe and Ledger art was culturally and geographically widespread across the Northwestern Plains, but this tradition also extended across the Southern Plains. Painted robes and ledger drawings similar to those of the Northwestern Plains are known from the Southern Cheyenne, Kiowa, Comanche, Ute, Apache, Quapaw, Ponca, Illinois, and Iowa. As with Biographic rock art as a whole, remarkable similarities exist between ledger drawings and painted robes throughout the Plains. Even cursory study shows that Flathead, Blackfeet, and Crow artists used many of the same conventions as the Kiowa, Southern Cheyenne, and Comanche warriors living more than a thousand miles (1600 km) to the south.

There are differences, however, in the frequency of various actions portrayed in the north and south, and a much greater use of landscape features to set the scene appeared in Southern Plains ledger art (Greene 1994; Petersen 1971). Southern Plains ledger artists drew many more courting scenes and fewer combat and horse raiding scenes than did their northern counterparts. In later Southern Plains drawings, landscape features such as trees, rivers, and hills sometimes overshadow the actions. Many of these differences can likely be traced to the influences exerted on a number of very prolific ledger artists who were incarcerated in Florida as prisoners of war between 1875 and 1878. During their imprisonment these artists were encouraged to draw—initially for their own amusement, but later because a demand for these drawings grew among art patrons. Changes in the individual styles of specific artists such as Howling Wolf can be traced through time and reasonably attributed to their interaction with new people, new situations, new places, and their exposure to western European artistic styles and traditions (Szabo 1994).

With examples of robe and ledger drawings from all tribes throughout the region, it is possible to begin defining particular styles used by some groups (fig. 15.9). Although not without some uncertainty, researchers speak of styles specific to the Crow, Blackfeet, Sioux, Cheyenne, and Pawnee (Ewers 1983; Taylor 1994). Other authors study the "style" or "signature" of specific individuals known to have drawn or painted certain items (Keyser 1996, 2000; Keyser and Brady 1993; Robertson 1993). Research currently under way promises to significantly expand our definition and understanding of these group and individual styles. As Robe and Ledger art is clearly related to Biographic tradition rock art, both in form and content, continued research into style will likely enable us to begin applying even more of this knowledge to rock art.

Interpretations

Robe and Ledger art can be classified into four basic functional categories: vision imagery, winter counts, war records, and images of daily life. Vision imagery displayed medicine powers, while winter counts were used as calendars. Most Robe and Ledger art, however, consisted of war records to

15.9 *This row of warriors on Running Rabbit's robe, painted in 1909, represents a Blackfeet war party in a fight with the Cree. (Original in Royal Ontario Museum, Toronto.) The slashes across the first and third figures are painted red and likely indicate warriors killed by the Cree.*

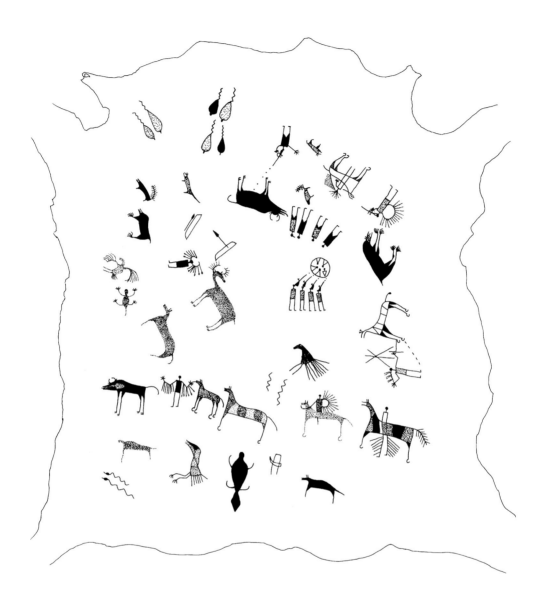

15.10 This Blackfeet painted robe shows a combination of iconic and biographic drawings. The birds and several other animals are probably iconic imagery relating to visions (note the human wearing antlers juxtaposed with the elk). Other images show captured war trophies and biographic scenes including combat, hunting, and horse-stealing. The bear with the combat scenes probably also represents a coup. (Original in Canadian Museum of Civilization, Hull, Québec.)

document war honors and personal accomplishments. In later years, much ledger art was used to record everyday events. Many of the latter were produced for commercial sale during the early reservation period.

Paintings on shields, tipis, and "medicine robes," with imagery relating to spirit powers, dreams, visions, and rituals, are most similar to the iconic rock art of the Ceremonial tradition. These images generally show humans (often with zoomorphic attributes), animals, mythological creatures, ceremonial objects, and even astronomical phenomena. They are shown as static, isolated images, and do not exhibit compositional associations that suggest a historical narrative. Instead, they express the sacred relationship of an individual, the spirit world, and the beings and objects associated with medicine power. By representing sacred subject matter, medicine robes confirm and consolidate the spiritual power and status of the owner.

A few robes clearly depict vision and medicine imagery, that is, supernatural guardian spirit beings (often in animal or part-animal/part-human form), or the ceremonial paraphernalia associated with medicine power (fig. 15.10). One example has various human and animal figures, including turtles and lizards, scattered across the hide. Each of these animals held important spiritual powers, and they probably represent guardian

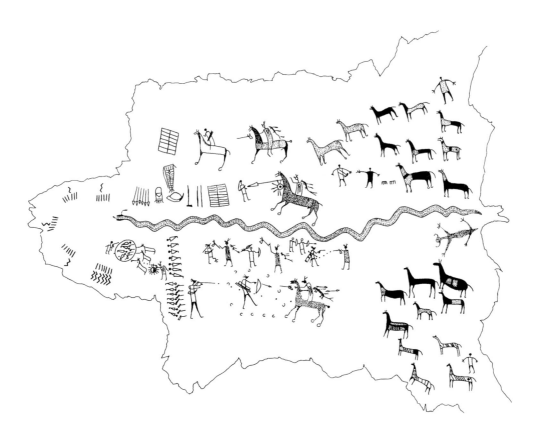

15.11 Classic Blackfeet Robe Art. Images document stolen horses, weapons and blankets captured, scout service, and coups counted. Robe owner shown in most scenes with animal-skin medicine bundle on his back. Central snake and horned lizard probably represent guardian spirit images. (Original in Royal Ontario Museum, Toronto.)

spirits. A plumed snake and horned lizard on a Blackfeet war record robe may also represent the guardian spirits of the robe's owner (fig. 15.11). Another robe drawing of a man holding a snake may represent a vision experience. A few ledger drawings show scenes of young men receiving a spirit helper's power during a vision experience. For example, a Northern Cheyenne ledger drawing shows a young man receiving a sacred pipe from a half-buffalo/half-woman spirit being, and two Sioux drawings show Thunder beings that appeared in the visions of the noted warrior Black Hawk. A Blackfeet "Holy Robe" shows medicine pipes, a sweat lodge, a bison skull, a sun and moon, and a camp circle with Sun Dance lodge (Klassen 1994b). These paintings symbolize the ceremonial aspects associated with various sacred objects. Vision imagery is more common on other types of objects, including painted tipis, shields, and drums, which often show the guardian spirit that protects the item's owner. The study of medicine robes and related imagery is relevant to much Ceremonial rock art, since it is similar in form, which in turn suggests it may have served a related sacred function.

Winter counts are pictorial memory aids used to keep track of history. On these records, a series of simple images (year glyphs) represent the most significant events or individuals that distinguish each year from the next (years being marked by the passage of winters). Although most year glyphs were unique, certain conventions were followed to represent similar types of events and identities. For example, individuals are often represented by name glyphs. The keeper of the count used each year glyph as a mnemonic device to help remember the events of a particular year. The responsibility for the counts and their histories was passed from generation to generation.

At least thirty-five different pictorial winter counts from a wide variety of cultural groups

Coup count scene drawn on a Crow bison robe (now in the Bernisches Historisches Museum, Bern, Switzerland) documents a warrior's war honors.

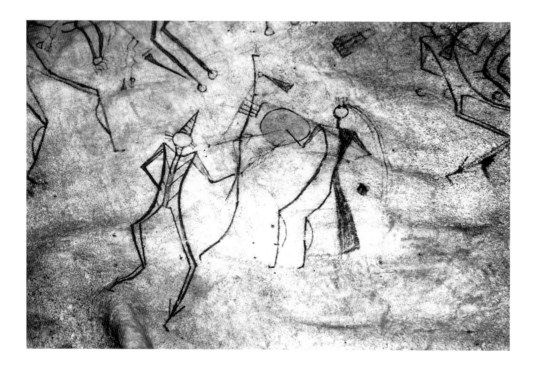

are still in existence; some record events occurring as early as the 1700s (Howard 1960, 1976). It seems likely that all winter counts were originally kept on animal hides, where the year glyphs were usually arranged in a counterclockwise spiral starting from a single image in the center of the hide. Only a few of the original hide winter counts survive, and most existing counts are drawn on canvas and muslin or ledger books. When kept in a book, one or more year glyphs were placed on each page. Although many individual images in winter counts bear a superficial resemblance to Northwestern Plains rock art, the actual compositional relationship—a spiraling, linear series—is not known. In some cases, a similar mnemonic historical function may have been intended in the rock art, but nothing resembling the form of this long-term pictorial history has been noted. Nonetheless, a number of winter count designs are similar to the images found in Vertical Series rock art, and the structured arrangement of Vertical Series designs suggest that this tradition may be related to winter counts—a topic more fully explored in the next chapter.

Most Robe and Ledger art functioned primarily to document a man's war record and personal accomplishments. Taking an enemy's weapon, stealing horses, touching an enemy, and leading a war party were the primary coups. A warrior could not become a respected member of society without accomplishing these feats and then advertising them. Among the Crow, for instance, any man who wished to be a chief had to perform at least one of each of these brave deeds, and in 1907 fewer than a dozen warriors claimed this status. Giving away property (usually captured weapons, ceremonial objects, and stolen horses), being a successful hunter or war party scout, being a member or lead dancer of a military or religious society, and having sexual conquests further augmented a man's status.

Advertisement of coups and secondary deeds initially took place immediately

15.12 *Above the row of vanquished enemies and horse tracks on this Sioux warshirt is a row of pipes indicating war parties led. (Original in Hamburgisches Museum für Völkerkunde, Hamburg, Germany.)*

following their accomplishment, when the war party returned to camp or after a give-away ceremony or dance. They were also regularly recounted at fraternal gatherings (men's societies) and ceremonial events, such as the Sun Dance or Grass Dance. Another way of advertising them was to decorate one's personal possessions with drawings of these deeds. The most important article to be thus embellished was a warrior's bison robe (fig. 15.11). These were worn about camp on special occasions, so that all could see the events that proved the wearer's bravery and power. Other clothing and tipi covers and liners were also extensively used for such purpose (fig. 15.12). When ledger pages and muslin sheets (both of which took up less space than a robe or tipi cover) became available, they quickly became a means to document and display such successes.

Most robe and ledger drawings show combat scenes or enemies on which the artist has counted coup (figs. 15.1, 15.5, 15.9, 15.11). Combat scenes include all possible combinations of mounted and pedestrian warriors, battle pit or breastwork fortifications, and

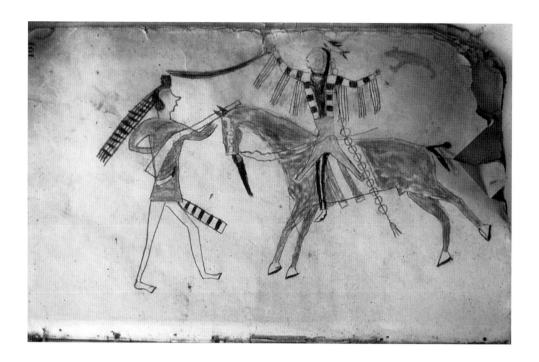

A detailed drawing from the Tie Creek Ledger (now in Bear Butte Museum, Ft. Meade, South Dakota) shows a Cheyenne warrior counting coup with a sword on a Crow enemy. A name glyph indicates that the victorious warrior had a name based on "Bear."

weapons including guns, knives, shields, spears, bows, arrows, clubs, coup sticks, and tomahawks. Often opposing forces of combatants are shown. Details of dress may include carefully rendered clothing, face and body paint, and medicine amulets. Horses, often decorated or dressed for war, are involved in more than half the scenes. Horse decorations and equipment include bridles, halters, saddles, bobbed tails, brands, painted decorations, and feathers, scalps, or medicine amulets hung from bridles, tails, and equipment. Wounds are shown on both horses and humans in a variety of ways. Some combat scenes actually show a man fighting a bear, but such actions were counted as coups and ranked as a war deed. Some pieces show

groups or tallies of enemies killed, or those on which coups were counted rather than complete combat scenes (fig. 15.11). The enemy warriors in these scenes often wear elaborate costumes and hairdos and carry weapons, but in other cases they are shown as conventionalized symbols. Frequently the weapon used to kill or touch these enemies is also shown.

Stealing horses was also a major coup in the graded war honor system, and not surprisingly it is the second most commonly drawn subject in Northwestern Plains robe and ledger art (fig. 15.3). These scenes range from simple drawings of a warrior cutting the horse's picket rope in front of its owner's tipi, to groups of men driving away entire herds of horses (fig. 15.11). Some horse-stealing scenes are very complex, showing a raider sneaking into a camp circle, cutting loose an enemy's favorite horse, and overcoming obstacles to finally escape. These scenes use many of the conventions of combat scenes to provide a story line. The simplest merely show a man driving away a single horse he has taken from an enemy.

Scenes recording personal accomplishments, such as significant feats of daring while hunting, occur in both robe and ledger drawings. These show hunters, mounted or on foot, killing a variety of big game animals. Weapons are frequently, though not always, shown. Wounds, flying bullets and arrows, and track sequences similar to those shown in combat and horse raids provide a similar narrative content to some of these hunting scenes.

Scenes showing everyday events and activities are rare in robe art but relatively prevalent in later ledger drawings; for example, drawings of dancers are common in ledger art. Some show groups of dancers in social dances, or single dancers in Sun Dance ceremonies. The majority of these drawings show individuals or small groups performing the Grass (or Hot) Dance—the precursor to the modern War Dance. Grass Dance scenes often include weapons, costumes and headdresses, and various body-painting marks. In these performances, Grass Dancers recounted their coups in detail and participated in sham fights with members of other tribal societies. All of these dance scenes were drawn after tribes were confined to reservations, suggesting that recounting coups by participating in dances, and then portraying these events, became a substitute for maintaining status after the cessation of intertribal warfare in the 1880s.

A few Northwestern Plains ledger drawings also show courtship scenes. Most often this takes the form of the young man and woman standing together, wrapped in the man's blanket or robe—a common courtship ritual in these societies. Courting scenes are significantly more common in Southern Cheyenne ledger art from the Southern Plains. This may in part be the result of the dislocation of many Southern Plains artists who drew in ledgers while interned far from home as prisoners of war in Florida. Southern Plains courtship scenes use many of the same conventions as warfare and horse raiding scenes, but those from the Northwestern Plains are generally simpler.

In the last quarter of the nineteenth century, after the end of intertribal warfare, ledger art became an outlet for Indians living on reservations, or held as prisoners of war, to relive their war exploits and remember the buffalo days. In this period, warriors made drawings of many traditional activities, such as hunting and ceremonies, which had rarely been depicted previously. The incredible impact of new cultural experiences on these artists also led many to illustrate new objects and events, including those they encountered on trips to the east. The Cheyenne chief Howling Wolf drew trains, steamships, and classroom scenes, and the Crow chief Medicine Crow drew trains, boats, the U.S. Capitol Building, and twenty different zoo and circus animals (Szabo 1994; Heidenreich 1985). The animal drawings by Medicine Crow after his 1880 visit to Washington, D.C., may also have been intended to enhance the artist's status, since the subjects would have been unfamiliar to anyone else in his tribe. Medicine Crow named each of the animals in terms with which he was familiar: alligator was called "Big Snake with Legs," camel was "Elk with Big Back on Him," and elephant was "Long Nose Bull." These one-of-a-kind ledger drawings offer unique insight into the radical changes occurring in all parts of Indian life in the late 1800s.

Although skilled artists had always made painted robes and war shirts for trade, by the end of the nineteenth century, Robe and Ledger art was increasingly produced as a commercial venture. During the reservation period, some artists produced hide and ledger drawings for the sole purpose of selling them, and many did so to support themselves and their families. These drawings were made at the bequest of government officials or tourists who collected this type of art, or for anthropologists who acquired examples for museum collections (Brownstone 1993). Even big

business got involved. Before 1920, the Great Northern Railway commissioned some two dozen Blackfeet warriors to paint their war deeds on canvas and muslin sheets, which were then hung as mural decorations in the lobbies of hotels in Waterton Lakes and Glacier National Park, on the Alberta-Montana border just west of the Blackfeet reservation. The changing function of Robe and Ledger art—from war records serving to establish status, to a means of acquiring money and goods—coupled with the willingness of non-Indians to pay for pictures other than war scenes, is largely responsible for the significantly wider variety of reservation-period drawings made in ledgers and on muslin.

The value of robe paintings and ledger drawings, beyond their value as art objects, is twofold. For anthropologists, historians, and contemporary Native communities, they provide first-person accounts of past cultural forms, events, and objects, many of which no longer exist. These pictures also illustrate many traditional events and activities that took place before written historical documentation. Thus they form an invaluable pictorial history of Native groups recorded by their own members.

For archaeologists studying rock art, these drawings are also extraordinarily valuable. They often can be assigned to a particular group, and sometimes the artist himself explained how he used the symbols and conventions to record the story of the illustrated action. Knowing how these conventions were used in ledgers or on robes, and seeing the same images drawn in rock art scenes (whose exact age is rarely known and whose authorship is anonymous), we can project the known meanings backward in time and thereby gain significant new understanding of rock art (Keyser 1987a; Keyser and Cowdrey 2000). For example, ledger drawings from the Flathead chiefs Ambrose and Adolphe are a direct transcription of early Biographic drawings onto paper (Keyser 2000), thereby providing a common link among rock art, robe art, and ledger art. Continued research on their connections will help to take us back into the minds and cultures of artists who lived long before contact with Europeans on the Northwestern Plains.

Counting Coup at Crossfield Coulee

The pictographs of Crossfield Coulee, north of Calgary, Alberta, illustrate the direct connection between Northwestern Plains rock art and painted bison robes. Many paintings at this site are nearly identical to those painted on several Blackfeet robes, and they provide an excellent example of how comparisons with hide paintings can help us interpret rock art.

Found in a small cave in an isolated sandstone outcrop perched on the edge of a shallow prairie coulee, the pictographs represent several painting traditions. The older paintings show a series of faint handprints and several shield-bearing warriors— one of the most northerly occurrences of this common Northwestern Plains motif. The most interesting images at the site, however, consist of a row of ten humans associated with at least six flintlock guns (fig. 15.13). Each human

figure has a solid, circular, knoblike head atop a triangular body, and a lower torso that ends in a single bent leg. The three best-preserved figures each have a single left-pointing foot. The flintlocks, oriented stock downward, show a cock and hammerplate facing to the right.

A robe painted in 1909, by the Blackfoot chief Running Rabbit, depicts several rows and groups of similar guns and humans, the latter with the same characteristic triangular body shape and single bent leg. This robe is accompanied by brief written descriptions of each painted scene provided by the artist (Brownstone 1993). According to Running Rabbit, one row of humans represents warriors involved in a battle between the Blackfoot and the Plains Cree (fig. 15.8). These figures are clearly engaged in combat, and each holds a gun pointed at the enemy. Although remarkably similar in form to those at Crossfield Coulee, the compositional arrangement of these human figures and their "active" appearance differ somewhat.

The humans in a second scene on Running Rabbit's robe more closely resemble

15.13 These coup-count pictographs at Crossfield Coulee north of Calgary, Alberta, show rows of enemies and captured guns.

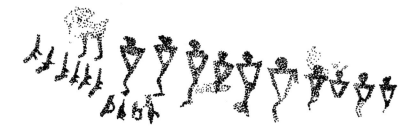

those found at Crossfield Coulee (fig. 15.14). According to Running Rabbit, each represents a Cree he killed in battle. Beside the row of humans are a number of objects, including a spear, war pipe, war club, and powder flask, that Running Rabbit captured from the Crow. In the Blackfeet coup-counting system, each enemy killed or wounded and every object captured in battle conferred status upon the warrior and confirmed his medicine powers. Therefore, these paintings record the coups that Running Rabbit counted against Plains Cree and Crow enemies.

Running Rabbit's bison robe provides an excellent opportunity for understanding the origin and meaning of some of the Crossfield Coulee pictographs. Given the strong similarity in subject matter and composition, we can assume that the humans and objects painted in the cave served the same purpose and had the same meaning as those on the robe. Thus, the row of flintlocks represents guns captured in battle, while each human figure represents an enemy killed in combat. By way of analogy with the hide painting images, the pictographs almost certainly record the coups and war honors of a warrior. In addition, the formal similarities between the rock art and the

robe images strongly suggest that these images belong to a single style originating in the same culture, at about the same point in time. The site is well within the historically documented territory of the Blackfoot— one tribe of the larger Blackfeet confederacy. With these clues, we can confidently identify the latest Crossfield Coulee pictographs as Blackfoot, painted here in the latter part of the nineteenth century.

While painted robes like Running Rabbit's are invaluable interpretive clues to certain aspects of Crossfield Coulee, they alone cannot answer all our questions about the rock art. For example, why did a warrior paint his war record in this isolated cave, among the handprints and shield figures of an earlier artistic tradition? Perhaps an answer lies in the context of the site itself. Unlike robe art, the location of these pictographs suggests they were intended for a nonhuman audience. Isolated caves were important vision quest places, and we know that rock art was a way of communicating with the spirit world— perhaps several warriors, on a number of occasions, used this sacred cave to commemorate and strengthen their medicine power during vision quests. An earlier visitor left shield-bearing warriors and handprints to impress the spirits, but later a Blackfoot warrior painted his impressive war record as homage to the guardian spirits that blessed him with their protection.

Through analogy with robe art, we know that the Crossfield Coulee pictographs document the coups of a warrior. Although a record of an actual event experienced by a real person, the pictographs remain intimately tied to the spirit world.

15.14 This group of vanquished enemies and tally of captured weapons from Blackfeet Chief Running Rabbit's robe is very similar to Crossfield Coulee pictographs. (Original in Royal Ontario Museum, Toronto.)

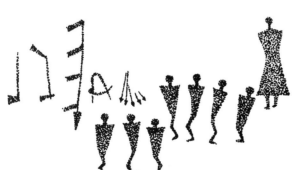

16 / Vertical Series Tradition

The rock art of the Vertical Series tradition is among the most enigmatic and intriguing on the Northwestern Plains. It consists mostly of repeated nonrepresentational symbols arranged in multiple vertical columns or series—the characteristic that gives this tradition its name (fig. 16.1). The repetition of simple geometric shapes and their consistent arrangement into rows or columns give the strong impression that they are part of a structured system of communication. Perhaps these symbols form an incipient ideographic notation system—an early precursor to true writing.

The possibility that Vertical Series rock art is ideographic writing makes it unique on the Northwestern Plains, if not in North America. Unfortunately, it is poorly known and remains largely unstudied; only a handful of sites have been recorded, and direct ethnographic evidence is scant. Furthermore, the age of this art has yet to be firmly established, and the few known sites are widely scattered across the Northwestern Plains. All of these factors make it difficult to ascertain ethnic origins and cultural function, but some limited clues suggest that this tradition may have developed from the pictographic system of the Biographic tradition. If so, Vertical Series rock art is probably a late postcontact development. These many unknowns serve to deepen its mysterious character.

Vertical Series rock art occurs as both pictographs and petroglyphs, but the former are more common. All the pictographs are red or reddish purple, except for two yellow dots associated with red pictographs at a South Dakota site. In most cases, the red pigment was probably natural ochre, although it is possible that a manufactured paint obtained through trade from Europeans was used in some cases (Sundstrom 1987). At most sites,

16.1 Symbols arranged in vertical columns, such as these crosses and crescents, characterize Vertical Series tradition rock art.

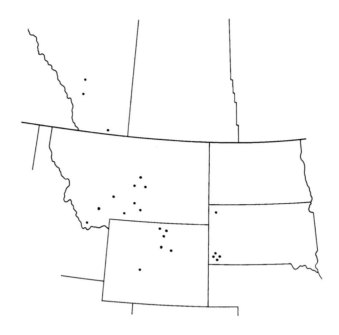

Map 16.1. Vertical Series Tradition Rock Art

Regional distribution

liquid pigment was applied with the fingertips, but some thin, detailed lines were probably painted with a bone or stick paintbrush. Vertical Series petroglyphs are lightly incised or scratched. Examples of petroglyphs and pictographs have not been recorded together at the same Vertical Series site, and no instance of incisions enhanced with pigment has been reported. This rock art shows little variation in method or emphasis on technique, suggesting that its medium may have been less important than the message it conveyed. This is certainly consistent with what would be expected for rock art that functioned as a communication system.

Vertical Series sites usually occur on sandstone outcrops and cliffs or in shallow rockshelters, but one in southwestern Montana is painted on a limestone boulder, and another at Okotoks in southwestern Alberta is painted on a large quartzite glacial erratic (fig. 16.2). Detailed information on the environmental and landscape context of these sites is lacking, but they occur from the open prairie to mountainous terrain. There is no clear association of sites with a specific physical context, although the sample of sites is small. This lack of pattern suggests that site location may not have played as large a role in this tradition as it did in others.

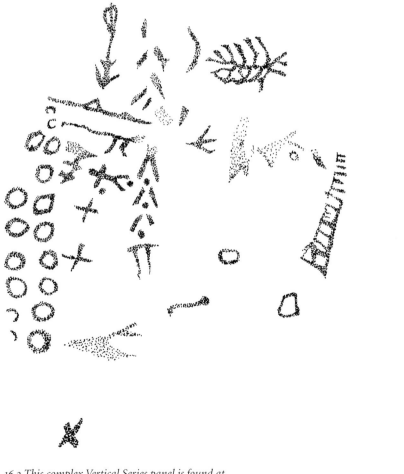

16.2 This complex Vertical Series panel is found at Okotoks Erratic in the mountain foothills southwest of Calgary, Alberta.

History of Research

Few Northwestern Plains Vertical Series rock art sites have been documented, and even fewer attempts have been made to unravel their meaning. The earliest researchers to record this rock art were Mulloy (1958) at Pictograph Cave, and Selwyn Dewdney, who visited and recorded two Vertical Series sites near Calgary in the early 1960s. Secrist (1960) partially recorded one site in central Montana at this same time. None of these researchers identified these sites as part of a distinct

16.3 This large rectilinear figure with adjacent column of crosses led Stu Conner to first identify Vertical Series art as a distinct entity.

tradition, nor did they speculate on the function or meaning of the unusual symbols.

Vertical Series rock art was first recognized as a separate "style" in the early 1970s by Stuart Conner (fig. 16.3). Based on rock art found at several sites in central Montana, he defined this style as consisting of vertical series of repeated geometric designs (Conner and Conner 1971). Subsequently a number of additional sites with Vertical Series rock art were recorded in Montana and Wyoming. In the 1980s, Linea Sundstrom (1984) identified several more Vertical Series sites in the South Dakota Black Hills. On the basis of these sites, she expanded the definition of the Vertical Series style to include panels where the designs are not arranged into vertical columns but still consist of similar geometric symbols and images (Sundstrom 1987). Subsequent to Sundstrom's work, we have recognized additional Vertical Series rock art in site reports from southern Alberta (Klassen 1994a), Montana (Greer and Greer 1996b; Jasmann 1962), and Wyoming (Mack 1971).

Sundstrom (1987, 1990) also produced the first and only systematic attempt at interpreting Vertical Series rock art. She proposed that the symbols function as a type of ideographic communication system, and that this system was affiliated with Historic period Sioux. Our summary is heavily indebted to Sundstrom's work on Vertical Series rock art and largely follows her lead in defining the formal characteristics of this tradition and interpreting it as a communication system. Nonetheless, we identify a number of new Vertical Series sites, and we incorporate the new data from these sites to expand upon some of Sundstrom's ideas concerning the origin and function of this art.

The Rock Art

The designs of Vertical Series rock art are almost exclusively nonrepresentational in nature, consisting primarily of simple

16.4 *Crosses, crescents, H shapes, E shapes, circles and other abstract symbols appear at Vertical Series tradition sites.*

geometric shapes. A few relatively complex designs may be highly abstracted animals and material culture objects, but they are so abstract that definitive identification is impossible. Only a very few recognizable representational designs occur.

Nonrepresentational Designs

Most of the simple geometric designs that characterize this tradition are highly conventionalized images, repeated in nearly exact form at widely separated sites (figs. 16.1, 16.4). Some of these are geometric shapes—triangles, crosses, crescents, tridents, dots, dashes, open and closed rectangles, and small circles. Others superficially resemble capital letters of the alphabet, including I, H, L, U,

C, E, and T shapes, though the orientation of many—upside down, on their sides, or backwards—bears no relationship to the alphabet. These designs also frequently include small "tails" and other elaborations that clearly distinguish them from actual letters. Other simple geometric shapes are rayed circles, quartered circles, and a design consisting of two short parallel lines, sometimes with a dot or dash at each end of the pair.

More complex geometric shapes also occur, including those that incorporate several simple shapes into larger more complex images (fig. 16.5). Many such shapes appear to be unique and are found at only one site. Others occur in slightly different form at widely separated sites. The best example is two nearly identical complex images, one found in northwestern South Dakota and the other in north-central Wyoming. At a southwestern Montana site, two unique designs associated with a panel of characteristic Vertical Series

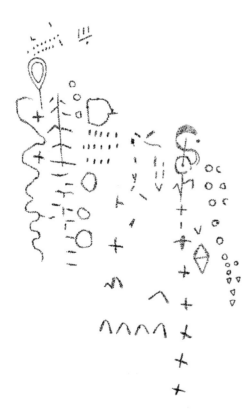

16.5 Occasionally, as in this North Cave Hills petroglyph, Vertical Series art is composed of repeated simple shapes grouped into more complex figures.

designs are a vertical serpentine design and a vertical line crossed by horizontal and diagonal lines (fig. 16.6).

Many geometric designs may be abstractions derived from representational images of objects or animals. For example, one design may be a simplified version of the guns commonly depicted in Biographic tradition rock art (fig. 16.2). The C-shaped symbols have the appearance of horse tracks, a common Biographic art design. Other designs are vaguely anthropomorphic and zoomorphic in nature. For example, some researchers consider one design to be an abstracted bison head.

Representational Designs

Only a few clearly representational designs are associated with Vertical Series rock art. In particular, images at several sites are recognizable as representations of turtles. They occur alongside more typical Vertical Series designs, but their association with Vertical Series rock art is uncertain and may be simply coincidental. Likewise, a group of Vertical Series designs carved above a horse may or may not be associated with the horse (fig. 16.7). Other representational designs associated with this Vertical Series rock art may yet be identified, but they clearly played a very minor role in this tradition.

16.6 One of the earliest recorded Vertical Series tradition sites is this southwest Montana pictograph.

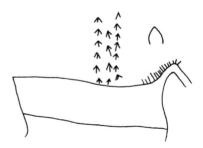

16.7 This Wyoming petroglyph shows a horse associated with a group of Vertical Series motifs.

Compositional Arrangements

The most characteristic features of Vertical Series rock art include the repetition of simple geometric shapes and their arrangement into multiple vertical columns. Most nonrepresentational designs of this tradition are small, similar in size, and highly conventionalized—design traits quickly repeated and easily recognized by everyone familiar with the rock art of this system (fig. 16.8). This necessitated their careful, precise execution, so that each rendition of a particular design was nearly identical to the next, much like standardized letters of the alphabet. Like letters, however, there was some room for individual variation in the design form.

The compositional arrangement of designs seems to follow certain specific rules of combination. Specifically, repeated designs are ordered into multiple linear columns and rows. Anywhere from two to more than two dozen individual designs may be found arranged in a single vertical column. In most cases, these columns consist of multiple examples of the same design. Sometimes,

however, several variations on the same design, or two or more completely different designs, are included in the same series. Often several vertical columns, each composed of a different series of designs, are arranged side by side. In at least one case, several vertical series are arranged side by side beneath two horizontal lines (fig. 16.2).

These simple geometric designs are also occasionally arranged into horizontal linear rows. At a site near Lander, Wyoming, numerous horizontal series of simple geometric shapes have been recorded, with some series composing nearly two dozen repeated designs. At a site near Calgary, horizontal and vertical series of designs have been combined (fig. 16.1).

Some designs associated with this tradition are occasionally found in semilinear or nonlinear groups. For example, numerous triangles at a South Dakota site are arranged in four groups, and the arrangement of designs in each group is only marginally vertical and linear. At another South Dakota site, a group of repeated designs appears to be a random arrangement, while a number of rectilinear designs at a site in Wyoming are arranged randomly alongside a vertical series of cross designs. A few simple designs associated with this tradition are also found at some sites as individual images.

Unlike the simple designs, most complex geometric and representational designs are found as individual images or as a vertical series of two or three designs (fig. 16.3). In most cases, these individual images and short series are associated with more typical Vertical Series elements (fig. 16.9). Finally, several Wyoming sites have relatively simple geometric designs arranged as one or more semicircles around a central, more complex design. The central design at one site may represent the head of a buffalo. These semicircular compositions bear a certain resemblance to the spiraling arrangement of designs found on painted hide winter counts.

16.8 Vertical Series art frequently consists of structured columns of simple repeated figures. Middle series is petroglyphs, others are pictographs.

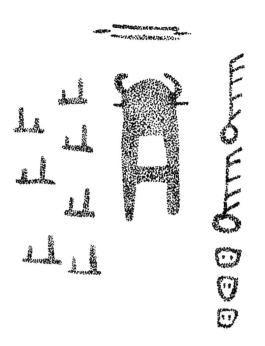

16.9 The central design in this Wyoming pictograph resembles others at sites in Montana, South Dakota, and Alberta.

Unlike traditions consisting of primarily representational designs, the compositional arrangements of Vertical Series rock art do not incorporate the elements associated with scenes or represent activities. As such, inter-action, perspective, ground lines, and other factors associated with representational art are not relevant to this tradition. At the same time, Vertical Series rock art does not consist of the relatively random and unstructured composition generally associated with most nonrepresentational rock art traditions. Rather, the composition of this rock art appears to reflect the intentional arrangement and organization associated with structured communication systems, where certain conventional rules of combination among elements—essentially a form of syntax or grammar—are employed. Although we can recognize the presence of some sort of syntax, it is difficult, if not impossible, to define exactly what those rules were.

Dating and Chronology

Determining the age of the Vertical Series tradition is difficult and problematic, as neither the rock art itself nor its context provides much in the way of dating clues. Since the tradition consists primarily of nonrepresentational images, securely datable subject matter is absent; although some designs may appear to be abstractions of historic items, such as guns and horse tracks, this is not firmly established. No site is associated with dated deposits or has been directly dated by any other scientific method. In the end, the best evidence for the age of this tradition comes from similarities between some Vertical Series designs and those found on painted hides and clothing, and the possible relationship between certain elements of the Vertical Series and Biographic traditions.

Several of the simple geometric designs commonly used in Vertical Series rock art, including small crosses, T shapes, upside-down and sideways U shapes, and C shapes, are also frequently found as painted images on items of material culture, such as robes, clothing, and tipis. Considering their simplic-ity, the occurrence of these designs in different media may simply be coincidence, especially since the characteristic vertical linear arrange-ment of these designs in the rock art is not observed on other painted items. Only a single robe is known that has repeated symbols painted in a similar vertical arrangement. Another painted bison robe with a similar series of vertical figures appears to be a fake of non-Indian manufacture (Keyser 1996). Nonetheless, the close formal correspondence between individual designs on both rock art panels and painted material culture implies some cultural and temporal relationship between them.

A somewhat stronger case can be made for the more unusual designs that are also found in both contexts (fig. 16.10). For example, crescent shapes, "bison heads,"

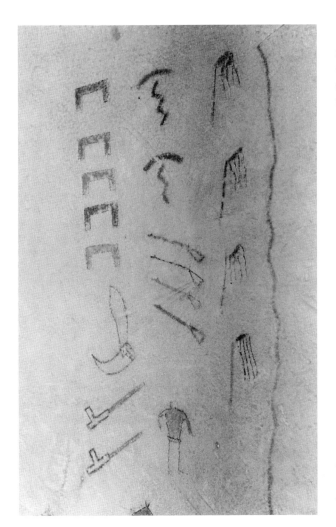

The symbols painted on this Blackfeet robe (now in the Glenbow Museum, Calgary, Alberta) probably represent a tally of coups. The symbols and their arrangement are similar to Vertical Series rock art.

16.10 Some Vertical Series tradition motifs are quite similar to images painted on robes and in winter counts.

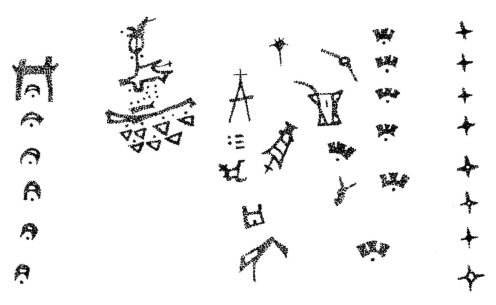

quartered circles, and turtle designs all appear on painted robes, clothing, and winter counts. It seems unlikely that the use of these relatively complex and idiosyncratic designs in both rock art and on painted items is mere coincidence, and since most winter counts and tipi covers were made in the 1800s, it implies that Vertical Series rock art panels with similar designs also date from this time. More importantly, limited evidence suggests that Vertical Series rock art may be an ideographic communication system that developed from the pictographic system of Biographic art. Since the Biographic tradition can be clearly linked to the postcontact period, this in turn suggests that the Vertical Series tradition developed during the 1700s and 1800s. Finally, Sundstrom (1987) has speculated that the pigment used at some sites is a "manufactured" paint obtained through trade with Europeans, although this has not been confirmed.

The weight of extant evidence points to an Historic period origin for Vertical Series rock art. In this scenario, the Vertical Series tradition developed from the Biographic tradition at some point in the 1700s, or even perhaps as late as the early 1800s, and continued to be produced throughout the nineteenth century. Much work must be done to validate this tentative chronology. Further comparison with Biographic rock art and ethnographic materials is needed, and pigment samples should be analyzed for non-native chemical constituents, and also radiocarbon dated if possible.

Distribution and Regional Relationships

At present, fewer than two dozen Vertical Series rock art sites have been recorded, making this tradition one of the most poorly represented on the Northwestern Plains. At the same time, however, it is one of the most widely distributed, with sites scattered from north of Calgary, Alberta, to central Wyoming, and from western Montana to the Black Hills of South Dakota (Map 16.1). Ten of the known sites are concentrated in central and south-central Montana, and in the Bighorn Mountains of north-central Wyoming. Following Sundstrom's description of the style, small sites have recently been recognized at Writing-on-Stone and in the North Cave Hills. This widespread but discontinuous distribution is just one of the many puzzling aspects of this rock art.

The Vertical Series tradition seems unrelated to rock art found in adjacent regions. Although certain elements from rock art in other areas resemble some of the simple Vertical Series designs, the more complex geometric designs are unique to this tradition, and the characteristic vertical linear arrangement of repeated designs is found nowhere else. Thus it appears that the distinctive aspects of the Vertical Series tradition developed independently on the Northwestern Plains.

Cultural Affiliations

In her analysis of Vertical Series rock art, Sundstrom (1984, 1990) suggests that this tradition is affiliated with the Teton Dakota or other Sioux groups. She bases this assertion primarily on the similarity between certain rock art designs and those used in ethnographically recorded examples of Sioux art. Furthermore, she demonstrates the existence of a probable ideographic communication system in Sioux culture, which provides an analogy for the rock art. She also believes that the estimated age and geographic distribution of the tradition corresponds closely with that of the historic territory of the Teton Dakota. Finally, she notes that some of the designs associated with Vertical Series also appear in rock art in areas previously occupied by Siouan groups.

The possibility that at least some examples of Vertical Series rock art are related to Sioux groups cannot be denied, but the hypothesis that all Vertical Series rock art sites are Siouan in origin has certain weaknesses. The uncertain age of the tradition makes it difficult to confidently associate it with the historically documented territory of any one cultural group. Several of the sites also occur well beyond the territory historically occupied by the Teton Dakota. Rather, the widespread but discontinuous distribution of sites strongly indicates that this tradition occurs within the territory of several different groups.

Furthermore, the tradition is not clearly uniform, and certain distinct formal variations exist from site to site. In particular, those in southern Alberta, although sharing important characteristics with all Vertical Series sites, display several unique designs and show distinct variations in the way that some designs are arranged (figs. 16.1, 16.2, 16.4). Finally, ethnographic evidence indicates that many other Northwestern Plains groups, particularly the Blackfeet, Crow, and Hidatsa, also employed aspects of an ideographic system similar to that of the Teton Dakota (Brownstone 1993; Lessard 1991:73–74; Wissler 1912).

Given the distribution and variation of this tradition, it seems quite likely that many cultural groups, including several Sioux groups, were involved in the production of Vertical Series rock art.

Interpretations

Although a number of authors have recognized the unusual formal characteristics of Vertical Series rock art, only Linea Sundstrom (1984, 1987, 1990) has attempted to investigate its significance. Her observation that the rock art consists of simple, repeated designs combined into consistent patterns led her to hypothesize that the Vertical Series tradition functioned as a kind of ideographic communi-

cation system. Before exploring this possibility in greater detail, it is necessary to briefly explain the nature of ideography and simple writing.

Simple writing includes both pictographic and ideographic systems. Unlike other forms of pictorial communication (i.e., representational painting), simple writing systems consist of recurring, conventionalized symbols with standardized meanings, which, when combined into consistent patterns, can be understood in the same way by all those using the system. An ideographic writing system, for example, consists of two related components: repeated symbols (ideograms) organized according to a specific syntax, or rules of combination.

Like true pictography, ideography is a nonphonological writing system that lacks a relationship between the written symbols and the actual sounds of a language. In other words, pictograms or ideograms represent the idea of a thing, but not the specific sounds that make up the spoken word for it. For example, alphabetic writing systems, such as English, and syllabic writing systems, such as Japanese kana, are both phonological. In both cases, symbols of the written language correspond to individual sounds in the spoken language. These symbols are then combined to make the sounds of a complete word. Written Chinese, on the other hand, is a nonphonological system, as each symbol corresponds to a word that may be a combination of several sounds.

Many simple nonphonological writing systems combine both pictograms and ideograms. Pictograms exhibit a recognizable picture of things as they exist in the real world. Ideograms, on the other hand, are abstract images that do not display any obvious pictorial link with real entities. For example, both ♀ ♂ and ♂ ♀ are symbols commonly used to represent "man" and "woman," but the first pair are pictograms, while the second pair are ideograms. While the pictograms actually

resemble the entities they are meant to represent, the ideograms bear no such pictorial resemblance. Because ideograms do not depict actual things, their meanings are also not restricted to "things"—they can also be used to represents concepts and ideas. For example, a red octagon has come to represent the idea of "stop," and a red circle crossed by a diagonal slash represents the negative concept associated with "no" or "do not." In reality, many symbols in nonphonological writing systems fall somewhere along the continuum that runs between true pictograms and true ideograms, and the distinction between the two forms of symbols is often blurred. Many ideograms, in fact, may have developed from pictograms through a process of abstraction and conventionalization. The ♀ symbol for female is just such a case, since it originated as a pictogram representing a woman's hand mirror, before it was simplified to its present ideogram form.

An important component of a simple writing system is that each pictogram or ideogram must be recognized as having the same meaning by all those using the system. Another aspect of a simple writing system involves the combination of interchangeable symbols into meaningful sequences. In a true ideographic system, ideograms are combined into different sequences following certain rules of syntax. These rules dictate which ideograms can be used with which, and how these symbols are spatially arranged and associated. In this way, an ideographic sequence can be read by anyone familiar with the meaning of the individual symbols and with knowledge of the syntax. Thus, an ideographic system can communicate standardized information to multiple individuals.

In previous chapters, we discuss how pictograms and certain elements of a pictographic system are recognizable on the Northwestern Plains, both in Biographic tradition rock art and in painted Robe and Ledger art. Likewise, ideograms are recogniz-

able in the ethnographic art of several Plains cultures, particularly the Hidatsa, Crow, Blackfeet, and Sioux (see fig. 15.5). Most of these ideograms relate to war exploits and were used as part of an individual's war record (Wissler 1912). For example, the open rectangle indicates that an individual led a war party, while the vertical zigzag ending in a semicircle represents war party scout service. The single circle indicates a war party entrenched for defense, a double circle represents a captured shield, and the upside-down U shape signifies a horse captured in battle. Warriors often painted their bodies and their horses with these symbols, and they were also used to decorate tipis, robes, and clothing. Late in the Historic period, some beadwork artists also used them to decorate a variety of items.

Several of these ideograms can be recognized as conventionalized abstractions derived from representational images. For example, the captured shield symbol obviously bears a resemblance to the physical object, while the symbol for a captured horse probably derives from the horse's unique track. In both cases, however, these symbols would be difficult to recognize as such without some reference to ethnographic information. This is particularly true of the scout-service symbol, which is derived from the zigzag path of a scout returning to the waiting war party members who stand or kneel in a semicircular pattern. Among the Crow and Sioux, the design is further elaborated with a small triangle at the top of the zigzag representing a pile of bison chips the returning scout kicked over to signal the truth of his report. Without extensive knowledge of the ethnographic context of this symbol, it would be impossible to determine its significance.

Horse-capture ideograms documented by Clark Wissler (1912) demonstrate the process by which ideograms develop from pictograms (fig. 16.11). Both the X and Y shapes represent the capture of a horse from an enemy camp, and both derive from the representation of a

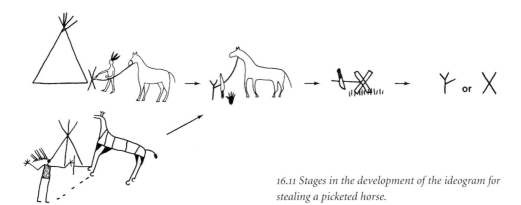

16.11 Stages in the development of the ideogram for stealing a picketed horse.

picket used to tie up a horse. Traditionally, Plains Indians would tie their horses to a picket made from either a pair of crossed sticks (an X shape) or a branched stick (a Y shape) pounded into the ground. A sequence of steps led to the development of these symbols. Initially, the capture of a horse is represented by a full pictographic representation of a human holding a knife and cutting the rope used to tie a horse to the picket. In the next stage, the human figure in the scene is abbreviated to a hand and knife, while the rest of the scene remains much the same. In the final step, only the picket itself, represented as either an X or as a Y (the latter with a short diagonal line attached to it representing the cut rope), is shown. At this stage, the image has become an ideogram—a simple image which bears only an abstract resemblance to the activity it represents. If we were familiar only with the final step in this progression— the simple ideograms—it would be impossible to identify its meaning. However, documented examples depicting each stage of this series can be found on painted robes and other items, enabling us to recognize the steps of this transformation, and to identify the end product as a symbol signifying the capture of a horse.

The preceding example clearly illustrates the importance of ethnographic information for correctly identifying and deciphering ideograms. Otherwise these abstract symbols are meaningless to us and only understood by those familiar with the system. Likewise, we must turn to ethnographic evidence in order to identify Vertical Series rock art ideograms. Indeed, comparison with ethnographically documented ideograms enables us to specifically identify the probable meaning of certain Vertical Series designs. For example, the ◯ and ⌒ designs probably had similar meanings to those of the same symbols in Robe and Ledger art. The ⌒ design, in particular, was common in the war records of several different groups to denote horses, horse raids, and coups relating to horses.

Sioux winter counts are another useful source of ethnographic evidence for the

16.12 The uppermost symbol in the middle column of this panel, composed of three elements, resembles the winter count symbol for abundant bison meat.

meaning of Vertical Series designs (Sundstrom 1987). T-shaped symbols in winter counts represent the concept of being hit or struck by a weapon or bullet in the context of counting coup. Therefore, similar T-shaped rock art designs are perhaps related to the recording of coups. On winter counts, a design which resembles an H shape was used to designate years of abundant food, and appears to have been derived from the representation of a meat-drying rack. Likewise, the H symbol in Vertical Series rock art, in a variety of forms, may represent "plenty" or "abundant food" (fig. 16.12). The passage of time was sometimes represented on winter counts by designs resembling crescent moons, and similar designs in the rock art may represent moons or months as well (fig. 16.10). Finally, the cross shape denotes a star, or the morning star, in many examples of Plains painting. A similar meaning can perhaps be ascribed to the cross design in rock art, or perhaps this star symbol may be an indicator of time.

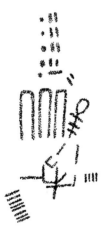

16.13 A newly recorded Vertical Series rock art panel in southwestern Montana.

Although we lack direct evidence linking Vertical Series rock art designs to similar winter count designs or other painted images, these interpretations seem plausible on the basis of ethnographic analogy. Nonetheless, the significance of most Vertical Series symbols remains a mystery (fig. 16.13). Undoubtedly they also held similar ideographic meanings, but unless a systematic and comprehensive examination of the ethnographic record reveals their significance, we will likely never know what they represented.

If Vertical Series rock art indeed functioned as an ideographic system, it begs the question of what information it was intended to communicate. Perhaps it operated as an elaborate record-keeping system with each column of symbols recording the number and types of coups, war honors, and accomplishments of a particular warrior. In some cases a more representational image associated with the Vertical Series art may even have intended to identify the warrior, much like name glyphs in Biographic art.

Another possible interpretation is that some Vertical Series rock art had a calendrical function. Columns of figures may have recorded the passage of time, or chronicled a sequence of particular events occurring at specific times. Vertical Series rock art may even have formed a more complex communication system, perhaps dealing with religious matters or communicating information on a variety of aspects concerning the lives or cultures of its creators. Overall, however, the evidence clearly supports the interpretation that Vertical Series rock art functioned as a rudimentary ideographic writing system—an unprecedented achievement in Northwestern Plains rock art.

Grooves and Tallies:
Aboriginal Mystery or Celtic Messages?

Tool grooves and tally marks are among the most controversial Northwestern Plains rock art images. Associated with several rock art traditions, the origin, purpose, and age of these enigmatic marks remain uncertain. While some claim that they originated with Celtic travelers and are actually Ogam "writing" from lost Europeans of pre-Columbian times, this is not supported by any archaeological evidence. Instead, based both on experimental and ethnographic data, archaeologists interpret them as a mysterious product of Plains Indian ritual and symbolism.

Tool grooves are abraded linear grooves varying in shape from long and slender to nearly oval. They are frequently very deep, and semicircular to V-shaped in section. Although sometimes found singly, more often they occur in clusters of two to several dozen parallel grooves. Generally each is separate from the others, but in rare cases the groove edges overlap. Most are roughly vertical in orientation and carved on sandstone cliff faces. Occasionally they are carved on horizontal surfaces or along the edges of sandstone boulders and outcrops.

Most researchers have assumed that tool grooves are the result of shaping or sharpening bone implements on sandstone surfaces, and experiments have shown that typical tool grooves are easily replicated by sharpening the ends of a variety of bone and antler tools (Feyhl 1980). Some tool grooves associated with petroglyph sites were likely used to sharpen the bone tools used to carve the rock art. Yet, tool grooves also occur at painted sites, or in far greater numbers than would be warranted by the number of associated petroglyphs. In these instances, they may have been used to make or shape tools used for other purposes.

Not all tool grooves served a solely utilitarian function, however. They are often found in difficult to reach, out-of-the-way places, far from the nearest petroglyph panel, situated in small alcoves, above ledges, or on unusual landforms or isolated outcrops. Consistently similar clusters and arrangements also occur, sometimes incorporated into rock art panels or directly associated with other symbolic markings.

These unusual placements and groupings suggest that some tool grooves were made in ritualized activities and had symbolic significance. We know that many of the areas and landforms where tool grooves are found are considered sacred places, where spirit powers are concentrated. Some researchers have suggested that ritual abrading of the rock surface with a weapon was a way of transferring the power contained within the rock to the tool and the person using it. Others suggest that these grooves were used to mark the location of sacred places, vision quest sites, and burials. Near a bison jump in southern Alberta, numerous deep tool grooves are found on sandstone outcrops atop a prominent hill. The local Piegan remember this hill as an ancient burial ground, and one informant suggested that each group of grooves marks the location where an elder was laid to rest.

This cluster of "tool grooves," deeply abraded into a sandstone outcrop in southern Alberta, may have resulted from ritual activities associated with nearby sites including a buffalo jump and a burial area.

Unlike tool grooves, tally marks occur as both petroglyphs and pictographs. Generally they are groups of short vertical lines arranged in a horizontal row of roughly parallel marks. Sometimes they also occur as horizontal marks arranged in a vertical column. Painted tally marks are generally finger-width red ochre lines, while carved examples are narrow incisions. Groups vary from a few lines to dozens of marks, and occasionally a row is crossed or joined by perpendicular or diagonal lines. Tally marks are occasionally associated with long horizontal lines or series of dots.

Although they occur at rock art sites of several traditions, painted tally marks are most frequently associated with Columbia Plateau pictographs. One Columbia Plateau site in western Montana consists solely of hundreds of tally marks carefully painted on long, thin, horizontal veins of milky white quartzite. Clearly their placement was part of an important ritual. Incised tally marks, on the other hand, are most common at Ceremonial tradition sites. At some of the most fascinating of these sites, incised tally marks are scattered across large sandstone pillars or outcrops. At one site near Writing-on-Stone, more than 100 tally marks are arranged in horizontal rows,

almost covering the entire surface of a freestanding sandstone column. Several of these groups are crossed with diagonal lines, or underlined by a long, deep horizontal groove.

Like tool grooves, tally marks are related to sacred sites. On unusual sandstone pillars, or medicine rocks thought to embody the spirits of the "Below Ground People," the marks were likely associated with vision quests or other ritualized activity. At Columbia Plateau sites, the painted marks were associated with vision questing. Early informants reported that they enumerate spirit helpers, visits to sites, and sometimes days spent fasting at the site.

Other tally marks were probably used in some sort of notational or counting system. Their arrangement closely resembles the tallies of weapons, horses, and humans noted in Biographic rock art, which were used to represent the number of objects captured in battle or the number of coups counted on enemies. Similar groups of vertical lines arranged in horizontal rows on painted robes are known to have functioned in precisely this way. Finally, some tally marks may have served a calendrical purpose, and may have been used to mark the passage of time, much like the winter counts painted on bison hides. If further study identifies any sequencing, ordering, and hierarchical grouping of these marks, it may yet be determined that tally marks represent a far more complex numerical system than previously thought (Lewis 1986a).

17 / Sites Developed for the Public

In recent years, public interest in Indian culture and history has steadily increased across the Northwestern Plains, along with a greater demand to see rock art and other archaeological sites. Better-known localities now receive thousands of visitors each year. The popularity of hiking, river rafting, canoeing, and off-road vehicles also makes many previously isolated sites more accessible.

Unfortunately, this increased interest and access has often led to serious impacts. Many sites have been deliberately vandalized and deterioration from overvisitation and ill-conceived attempts to record or preserve sites has become a serious problem. The ongoing revitalization of Native religion and cultural traditions has also led to a greater interest in visiting rock art sites for spiritual purposes.

State, provincial, and federal agencies charged with rock art site management must somehow protect and conserve this ancient cultural heritage, yet still try to meet demands of different groups to visit and use these sites. While researching this book, we encountered archaeologists and managers at all levels of government who expressed concerns about providing the locations of unprotected sites to the public. Many landowners requested that we keep confidential the locations of sites on private land. Furthermore, isolated and pristine settings are of critical importance for the spiritual use of such sites by Native groups.

From our perspective as archaeologists and rock art enthusiasts, we believe that site protection, respect for landowners, and consideration for spiritual practices are of overriding importance. Those with legitimate research or spiritual interests can obtain site locations from the government agencies responsible for them.

We also recognize the public's great interest in seeing rock art, and support and encourage the active appreciation of this fascinating cultural heritage. Therefore, we provide here specific locations for only those sites on public lands that allow visitation in a protected setting. In the following fourteen locations, the public can see rock art in an interpreted context and in its original setting (see Map 1.1). We also list a number of petroglyph boulders and rock art panels that can now be seen in the museums or parks to which they have been removed. We have cited distances first in kilometers for Canadian sites.

Where to See Northwestern Plains Rock Art

Alberta

Petroglyphs and pictographs may be viewed in their natural setting at three sites in Alberta, including Writing-on-Stone, the largest and most significant rock art location on the Northwestern Plains. Petroglyph boulder

ribstones have been moved to municipal museums in the towns of Wetaskiwin (233 km/ 145 miles north of Calgary on Highway 2A), Stavely (110 km/68 miles south of Calgary on Highway 2), and Etzikom (216 km/134 miles south of Calgary and 140 km/87 miles east of Lethbridge on Highway 61). Another petroglyph boulder is on display in Dinosaur Provincial Park (185 km/115 miles east of Calgary and 50 km/30 miles north of Brooks).

Writing-on-Stone Provincial Park. With nearly 100 separate sites representing at least five different rock art traditions, the Writing-on-Stone area of south-central Alberta contains the most significant collection of rock art on the Northwestern Plains. The extensive sandstone cliffs along the Milk River provide abundant surfaces for petroglyphs, while hoodoo formations and the nearby Sweetgrass Hills form a spectacular setting. A few sites of the En Toto Pecked, Hoofprint, and Vertical Series traditions are found here, but Writing-on-Stone is best known for its large collection of Ceremonial and Biographic tradition sites. Several of the finest shield-bearing warrior panels and the most complex battle scenes on the Plains are found within the park.

For their protection, most sites are within the restricted area of the park. Guided interpretive walks to a number of these take place daily from the end of May until the beginning of September. Free tickets for these walks are available from the park Visitor Centre, but numbers are limited. Longer hikes to some of the more isolated sites, involving a wade across the Milk River, are occasionally scheduled in July and August. A few sites, including the famous Battle Scene panel, are accessible to the public year-round via a short walking trail. Signs and maps throughout the park direct visitors to the trails and tours.

A large outdoor interpretive display is located near the campground, and interpretive signs and a self-guiding trail are found else-where in the park. Brochures and information are available at the Visitor Centre, open daily from late May to early September, and the Park Office, open weekdays year-round. Facilities within the park include an unserviced campground, drinking water, showers, pit toilets, firewood, picnic tables, picnic shelters, and a sewage dump. Writing-on-Stone is located approximately 330 km (205 miles) southeast of Calgary. To get to Writing-on-Stone Provincial Park, take Highway 4 southeast from Lethbridge, or I-15 north from Great Falls, to the town of Milk River, situated 20 km (12 miles) north of the Alberta-Montana border. From Milk River, follow Secondary Highway 501 east for 32 km (20 miles), and then take Secondary Highway 500 south for another 10 km (6 miles) to the park entrance. The route from Milk River is paved and well signed. Phone: (403) 647-2364.

Grotto Canyon. Located near the eastern edge of the Rocky Mountains in southwestern Alberta, Grotto Canyon is one of the more intriguing sites on the margins of the North-western Plains. The site includes a number of unusual pictographs which do not fit easily within any of the rock art traditions of the region. Generally considered an example of Columbia Plateau rock art, the motifs at Grotto Canyon seem to show influences from Southwest rock art, including what may be the northernmost "Kokopelli" figure. The pictographs are found on a vertical limestone cliff in a narrow, winding canyon. The site can be accessed by a moderately easy trail.

To get to Grotto Canyon, start from Canmore, Alberta, on the Trans-Canada Highway 105 km (65 miles) west of Calgary, and take Highway 1A east for 10 km (six miles) to the Grotto Mountain picnic area. From the parking lot, follow the signed Grotto Creek trail for approximately 2 km (1 mile) until the narrowest point of the canyon is reached, near the end of the canyon. The site is found on a

smooth face at the base of a high cliff on the west side of the canyon. Grotto Canyon is popular with rock climbers, and the main climbing area is found just south of the site. Facilities at the trailhead include picnic tables, drinking water, and toilets.

Okotoks Erratic Provincial Historic Site. The Okotoks Erratic, a huge quartzite boulder split into two house-sized pieces, is the largest glacial erratic on the Northwestern Plains. The Blackfeet revered it as a medicine rock and left offerings and said prayers whenever they passed by the Okotoks ("Big Rock" in the Blackfeet language). Much of the southern face of the Okotoks Erratic is smeared with red ochre, while examples of Foothills Abstract and Vertical Series rock art motifs are painted beneath several small overhangs. An interpretive display is located in the parking lot at this site.

The Okotoks Erratic Provincial Historic Site is located approximately 40 km (25 miles) south of Calgary, in southwestern Alberta. From the town of Okotoks, take Highway 2A south for approximately 2 km (1 mile) to Highway 7, and then travel west on Highway 7 for 6.5 km (4 miles) to the Historic Site parking lot on the north side of the highway. From the parking lot, the Okotoks Erratic is plainly visible to the north and can be reached by a short walk. Climbing on the rock is not permitted.

Saskatchewan

Two Saskatchewan rock art sites are developed for public visitation. In addition, a small petroglyph boulder is displayed on a pedestal at the entrance to the Saskatchewan Museum of Natural History in Saskatoon.

St. Victor's Petroglyphs Provincial Historic Park. This small site contains an excellent collection typical of Hoofprint motifs, including carved bison tracks, bear paws, human heads and hands, and turtles. The petroglyphs are found on the horizontal surface of a sandstone caprock, set on the top of a hill with panoramic views of the surrounding rolling prairie. Because the shallow petroglyphs are carved into a horizontal surface, the best time to see them is in the early evening on a sunny day. Access to the site is via a raised walkway, which protects the fragile rock surface from foot traffic. Interpretive signs and brochures are available at the site, and a cast of some of the glyphs has been provided for making rubbings.

St. Victor's Petroglyphs Provincial Historic Park is located about 200 km (125 miles) southwest of Regina, near the town of Assiniboia and the village of St. Victor. From Regina, take the Trans-Canada Highway 71 km (44 miles) west to Moose Jaw, and then head south on Highway 2 for 105 km (65 miles) to Assiniboia. Continue south of Assiniboia on Highway 2 for 17 km (10 miles), and then head east on the signed road to St. Victor. The site is about 3 km (2 miles) south of St. Victor. Picnic tables and toilets are located at the parking lot. Phone: (306) 787-2700.

Herschel Petroglyphs Municipal Heritage Site. At the Herschel site in west-central Saskatchewan, one large and three small carved limestone boulders are found in their original rolling prairie setting. Consisting of lines, cupules, and a few bisected circle designs, the petroglyphs on the boulders are probably part of the widespread Hoofprint tradition. A group of tipi rings is also located at the site.

The Herschel Petroglyphs Municipal Heritage Site is located about 150 km (93 miles) southwest of Saskatoon, near the town of Herschel. Take Highway 7 southwest of Saskatoon for 115 km (71 miles) to the town of Rosetown. Follow Highway 4 north for 12 km (7.5 miles), and then turn west on Highway 31 and continue for 23 km (14 miles) to the village of Herschel. From Herschel, take the grid road west for 2.5 km (1.5 miles) to the signed entrance to the site. No facilities are

available at the site, but a small museum, gallery, gift shop, tea room, and washrooms are located at the Herschel Interpretive Centre, open year-round on Monday, Wednesday, and Friday afternoons, and also Sunday afternoons in May through August.

Montana

Montana has six rock art sites developed for public viewing, with each representing a different rock art tradition. These are the Kila, Sleeping Buffalo, Gibson Dam, Missouri Headwaters, Wahkpa Chu'gn, and Pictograph Cave sites. Additionally, a petroglyph boulder has been moved to the grounds of the Charles M. Russell Museum in Great Falls, and a salvaged portion of a site southeast of Billings is currently housed in the Montana Historical Society Museum in Helena.

Kila Pictographs. The Kila pictographs are two small sites, separated by about a half mile, in a mountain valley of northwestern Montana. The pictographs include good examples of Columbia Plateau tradition rock art, including animals, stick-figure humans, possible canoes, and numerous tally marks. Distinct paintings of detailed bison indicate a Plains influence at this eastern example of Plateau rock art. A horse at the easternmost site also exhibits characteristics of Biographic rock art, a few examples of which were painted by the Flathead and Kutenai in this area of Montana. The Kila pictographs are in excellent condition, thanks to protective fencing built by the Montana State Highway Department many years ago, and the distinct, bright red motifs are easily photographed.

The Kila sites are located near Kalispell, Montana, approximately 226 miles (363 km) northwest of Great Falls. No highway signs mark the sites, so they are easy to miss. From Kalispell, follow Highway 2 west approximately 12 miles (19 km), to a point about 3 miles (5 km) west of the town of Kila. The easternmost site is located just before milepost

108 on Highway 2, about 2 miles (3 km) west of the Kila turnoff. A turnout on the north side of the road provides parking, and a slight uphill walk brings visitors to the protective fence in front of the pictographs. The second site is found about one-half mile farther west, where the highway begins to ascend a long slope out of the valley bottom. The site is accessible from a small gravel parking area on the north side of the highway at the top of a slight grade. The nearby pictographs are screened by a grove of trees and protected by a fence.

Sleeping Buffalo Petroglyph Boulder. Naturally resembling a reclining bison, the Sleeping Buffalo petroglyph boulder has been carved with lines representing a backbone, ribs, horns, and facial features (see fig. 12.2). Once greatly revered by the Native groups in the area, the Sleeping Buffalo still receives occasional offerings from local Indians. Although it was moved from its original location above the Milk River many years ago, it has been placed in a relatively natural setting. The Sleeping Buffalo was originally associated with Hoofprint petroglyphs on adjacent boulders, three of which have also been moved to this location. All the carvings on the boulders are considered to be part of the Hoofprint tradition.

The Sleeping Buffalo petroglyph boulders are located in north-central Montana about 113 miles (180 km) east of Havre, near the town of Malta. From Malta, travel 25 miles (40 km) east on Highway 2 to the turnoff for the Sleeping Buffalo Hot Springs Resort. The boulder is located just north of the road under a small wooden shelter. You may notice offerings of tobacco (cigarettes) or colored cloth at the site. Please do not disturb these items.

Gibson Dam Pictographs. Numerous pictographs from the Foothills Abstract tradition are found near Gibson Dam, located at the eastern edge of the Rocky Mountains in

west-central Montana. Situated in a canyon in the upper Sun River drainage, the site is a good example of typical Foothills rock art. The paintings include many characteristic motifs of this tradition, including abstract designs, simple animals, human handprints, and large red ochre smears. Interpretive information, including a story from a Blackfeet elder, is provided on signs erected by the U.S. Forest Service.

The Gibson Dam site is approximately 60 miles (100 km) west of Great Falls, and northwest of Augusta, Montana. From Great Falls, take I-15 northwest, and then head west to Augusta via Highway 89, Highway 200, and Route 21 (approximately 32 miles, or 50 km). From Augusta, follow the signed gravel road (which is paved for the last few miles within the National Forest) to the bridge below Gibson Dam, a distance of approximately 23 miles (37 km). Just across the bridge you will find a trail leading downstream a short distance to the pictographs painted on a high cliff and the adjacent interpretive signs. The alternate route from Choteau is not recommended.

Missouri Headwaters State Park. A few faded pictographs in a small rockshelter in the Missouri Headwaters State Park are interpreted for the public. The red paintings show a possible shield-bearing figure (illustrated on a nearby sign erected by the Montana State Parks Department) and several faded abstract designs. These figures are so simple that they might relate to the Columbia Plateau, Foothills Abstract, or the Ceremonial traditions. In any case, their location in this low riverside rockshelter indicates that they were probably painted as part of a vision quest or shamanistic ritual.

The site is located in the Missouri Headwaters State Park approximately 172 miles (277 km) west of Billings, and just east of Three Forks. From Interstate Highway 90, take the Three Forks exit north to State Highway 205. On highway 205 go east 3 miles (5 km) to the junction of State Highway 286. Turn north and follow this highway along the river valley for 2.75 miles (4.5 km) to the Fort Rock Historic Site parking area (past the main information kiosk). From the covered interpretive display, walk south on the trail approximately 300 yards (300 m) to the interpretive sign in front of a small rockshelter.

A small entrance fee is charged to visit the park, which is open year-round. A campground, picnic area, interpretive display, and trails are found in the park.

Wahkpa Chu'gn Bison Kill. The Wahkpa Chu'gn Bison Kill, located near the western city limits of Havre, Montana, is a Late Prehistoric period site used for nearly 2000 years by ancient hunters. Part of the ritual use of this site involved a small petroglyph boulder on which a bison hoofprint was carved, a motif belonging to the Hoofprint tradition.

Access to the site is via an entry gate behind the shopping mall on Highway 2 at the western edge of Havre. Visitors to Wahkpa Chu'gn must pay a nominal fee, which includes a guided tour of the site. Included in the tour is a stop at the hoofprint boulder and a discussion of how it may have been used in rituals associated with the bison kill. Tours are held daily except Mondays from mid-May to Labor Day. Off-season tours are available by appointment. Phone: (406) 265-6417 or (406) 265-7550.

Pictograph Cave State Historic Park. Pictograph Cave, a large rockshelter near Billings, contains numerous Late Prehistoric and Historic period pictographs representing rock art of the Ceremonial, Biographic, and Vertical Series traditions. Both Pictograph Cave and a nearby rockshelter also contain habitation sites. Pictograph Cave is one of the

most significant archaeological sites on the Northwestern Plains. It was one of the first systematically excavated sites in the region, and the pictographs are among the earliest recorded in the area. Much of the rock art has faded and exfoliated since the pictographs were originally documented during site excavations in the late 1930s, but some notable pictographs are still visible. The best of these is a line of guns, each with a muzzle blast represented by a painted cloud at the end of the barrel. Other significant motifs include shield-bearing warriors, various human and animal figures, and a panel of Vertical Series symbols. An interpretive sign at the mouth of the cave helps visitors identify many of the remaining pictographs.

Pictograph Cave State Historic Park is located 7 miles (11 km) southeast of Billings, in south-central Montana. To access the site, take exit 452 south from Interstate 90, and just south of the overpass turn right onto Coburn road. Follow the road for 5 miles (8 km), of which the last 2.5 miles (4 km) are gravel, to the park. Short but steep walking trails lead from the parking lot to the caves, where interpretive signs describe the rock art and the prehistoric occupation of the rockshelters. An interpretive area is also located near the parking lot, and a small interpretive brochure is available to visitors for a nominal charge. A picnic area, drinking water, and restrooms are available in the park, which is open during the day from mid April to mid October. A small fee is charged to visit the park. Phone: (406) 245-0227 (in season), or (406) 247-2940.

Wyoming

Public interpretive facilities are available at three Wyoming rock art sites, including Castle Gardens, one of the largest and most important sites on the Northwestern Plains. The Medicine Lodge Creek and Legend Rock sites are also open for visitation, with at least four different art traditions represented at these sites.

Medicine Lodge Creek State Archaeological Site. A large sandstone cliff at the Medicine Lodge Creek site, located in north-central Wyoming, is pecked and carved with examples of En Toto Pecked and Ceremonial tradition petroglyphs. More than 600 petroglyphs are found on the cliff, including some of the largest carved shields and animals on the Northwestern Plains. The locality has been the site of several major excavations from the 1970s onwards. Some of the petroglyphs are best seen through binoculars, due to their height above the current ground surface following archaeological excavation of the area. Interpretive signs at the base of the petroglyph cliff and displays in a small Visitor Center provide information about the images.

Medicine Lodge Creek State Archaeological Site is located approximately 164 miles (262 km) northwest of Casper and 37 miles (57 km) northeast of Worland, near the small town of Hyattville. From Worland, take Highway 20/16 north for 19 miles (30 km) to Manderson, then follow Highway 31 east for 22 miles (35 km) to Hyattville. Just before Hyattville, turn north at the Cold Springs-Alkali corner, and follow the signed road northeast for 6 miles (10 km). The last mile (2 km) of the road is gravel. The petroglyphs are found beside a parking area about a half mile (700 m) north of the park entrance. A campground and other facilities are found in the park, while opportunities for wildlife viewing, a nature trail, and archaeological interpretation are also available. The site is open from early May to early November, but the small Visitor Center closes after Labor Day. Phone: (307) 469-2234.

Legend Rock State Petroglyph Site. Petroglyphs at the Legend Rock site in northwestern Wyoming include examples of motifs from the Dinwoody and Early Hunting traditions. The petroglyphs at the site are pecked through a dark brown patina that coats the light-colored sandstone cliffs,

resulting in many high-contrast images. Those petroglyphs which have not become completely repatinated provide excellent opportunities for photography.

Legend Rock State Petroglyph Site is located approximately 160 miles northwest of Casper. It can be reached by a good access road and is found approximately 30 miles (50 km) north-west of the town of Thermopolis. However, to protect the petroglyphs from vandalism, the site is not open to the public except by prior arrangement. Visitation to the site must be arranged through park staff at the headquarters of Hot Springs State Park in Thermopolis. Facilities at the site include picnic tables and restrooms. Phone: (307) 864-2176.

Castle Gardens. Few rock art sites on the Northwestern Plains rival the size and significance of Castle Gardens, found on an isolated group of sandstone outcrops deep within the dry sagebrush prairies of central Wyoming. More than seventy panels have been recorded at this site, with most of the rock art attributed to the Ceremonial tradition. Some of the most impressive shields and shield-bearing warriors on the Northwestern Plains are found at Castle Gardens, and polychrome pigments have been used in conjunction with several of these petroglyphs. Motifs on a few panels also resemble rock art from the Dinwoody and Biographic traditions. Unfortunately, Castle Gardens has suffered from a higher degree of vandalism than most sites, despite the use of fences to protect many panels, and some panels have even been stolen. However, the Great Turtle Shield, stolen in 1940, is now held at the Wyoming State Museum.

Castle Gardens is located west of Casper and south of Moneta, on Bureau of Land Management land. To get to the site, take Highway 20/26 west of Casper for 77 miles (124 km) to the town of Moneta, and then continue 25 miles (40 km) south on a well-maintained dirt road to the site. An interpretive sign at the parking lot directs visitors to several remarkable panels. Other than a primitive picnic area, no facilities are located at the site.

North Dakota

North Dakota has a single interpreted rock art site—Divide County Writing Rock—located in the extreme northwestern corner of the state. Petroglyphs on two small glacial erratic boulders at the site consist of a maze, cupules, and Thunderbirds. Occasionally the cupules are clustered or encircled by a carved line, and within the maze at least two Thunderbird figures can be identified. Similar Thunderbirds are found on dated portable art throughout the Late Prehistoric period. Like several other petroglyph boulders, the Divide County Writing Rock site appears to be part of the Hoofprint tradition. Pioneer informants reported that the site was visited by members of the Plains Ojibwa, Assiniboin, and Sioux tribes.

Access to the site is via county road from Fortuna, North Dakota, approximately 70 miles (110 km) north of the city of Williston. From Fortuna take State Highway 5 west toward the Montana border for 4 miles (6 km). From there, take the paved county road south to the community of Alkabo. From Alkabo the site is 6 miles (10 km) south and 1 mile (1.5 km) east. The site is situated atop a prominent hill and commands an impressive view of the surrounding countryside. The North Dakota Historical Society owns 10 acres on which the site is located, and has constructed a protective shelter for the two boulders. Tipi rings can be seen in the surrounding area.

South Dakota

In South Dakota, several petroglyph boulders representing the Hoofprint tradition have been moved from their original site locations to museums or city parks. At some point it is

likely that some of these will be replaced at or near their original locations. We list them here for travelers who may find themselves near these communities and want to view the rock art. A call ahead to the host institution would be well advised.

Britton. City Museum. Approximately 20 miles (30 km) north and 40 miles (60 km) east of Aberdeen.

Ipswich. Public Library grounds. Approximately 25 miles (40 km) west of Aberdeen.

Mobridge. Klein Museum (1 boulder) and City Park (three boulders). Approximately 100 miles (160 km) west of Aberdeen, on Missouri River.

Gettysburg. Local Historical Museum. Approximately 55 miles (90 km) north of Pierre.

Pierre. State Historical Museum grounds.

Sioux Falls. Pettigrew House Museum grounds.

Conserving and Protecting Sites

The magnificent images of Northwestern Plains rock art have been greatly altered in the last century. Natural weathering and even the collapse of cliffs on which the images were painted and carved have taken their toll, but the greatest threat to rock art comes from people. For every site unwittingly destroyed in past decades by the construction of reservoirs, roads, and other developments, a dozen others have been damaged by vandals or thieves—defaced by initials and dates carved or spray-painted across the rock art, or attacked with axes, saws, or chisels. Even bulldozers have been used to cut the soft sandstone panels in order to carry off pictographs and petroglyphs. These actions have irrevocably damaged a priceless cultural heritage.

Sadly, no area of the Northwestern Plains is untouched; even remote sites are likely to have some modern graffiti. At well-known sites,

such as Writing-on-Stone and Castle Gardens, virtually every panel bears some degree of defacement. Even worse, some of the most significant panels at Castle Gardens have been removed with chisels, and many were probably destroyed in the process. Every rock art site in the region remains at risk from vandalism. To protect these rock art sites, public awareness of the value and significance of rock art must be promoted. Site locations should be kept confidential whenever possible. Anyone witnessing or knowing of acts of vandalism should report them to the appropriate government agencies; defacing, damaging, or removing rock art violates state, provincial, and federal laws. Signs of progress exist—the culprit who stole the Great Turtle Shield from Castle Gardens in 1940 was recently identified, and he was forced to donate it to the Wyoming State Museum.

Relatively few people are aware that any direct contact with rock art can damage both its aesthetic and its scientific value. Extremely fragile, rock art panels can be damaged merely by touching the surface or by using inappropriate recording techniques. Physical contact from making tracings and rubbings can also easily damage them, particularly those on soft sandstone surfaces. Chalking petroglyphs to improve their contrast for photography was once widely practiced, and some people make latex molds of petroglyphs to produce plaster reproductions. These things should never be done! Chalk and latex residues impair the aesthetics of the rock art, and usually the surface can never be completely cleaned or restored. Irreversible damage by latex has occurred at the St. Victor petroglyphs, where ill-conceived molding attempts have permanently stained the surface of the main panel.

Recent research has shown that both chalk and latex residues affect the rock varnish on petroglyphs, making it unsuitable for dating efforts. Contact with rock art can also reduce

its value to contemporary Indian communities who use sites for religious purposes; modern foreign materials left at a site can actually contaminate it for the spiritual users. The best approach overall is for viewers to respect the sites' value by simply not touching the rock art surfaces at all and by not leaving anything behind at the sites.

Black and white or color photography is the best way to record rock art. One need not be an expert photographer to take excellent photographs of pictographs and petroglyphs, but only possess patience and the willingness to take time to see the rock art under various lighting conditions. Different images are visible at different times of day. Adjusting films and filters will help capture faint images, especially pictographs. Careful composition and flash photography also enhance photographic quality. The results will more than justify the time spent in acquiring an excellent photograph.

18 / Summary and Conclusions

The Northwestern Plains is one of the richest rock art regions in North America. More than 1200 known sites are scattered across a vast region stretching from Calgary, Alberta to Fort Collins, Colorado, and from the Rocky Mountains to the Black Hills (see Map 1.1). The great time span of Northwestern Plains rock art extends from less than 100 to more than 5000 years. Many of the most important sites in the region also display evidence of rock art created over thousands of years.

The rock art sites of the Northwestern Plains also display a remarkable diversity of form and subject matter. Even a casual observer would quickly recognize disparities among the elaborate shields of Castle Gardens, the giant spirit figures of Dinwoody, the fighting warriors of Writing-on-Stone, and the hoofprints at St. Victor. Dozens of other sites display altogether different designs and figures. Stylistic diversity, rather than sheer numbers of sites and span of time, distinguishes the Northwestern Plains as one of the world's premier rock art areas. Its diversity contrasts markedly with the stylistic homogeneity characteristic of Canadian Shield rock art to the northeast and Columbia Plateau rock art to the west. Of all the culture areas of North America, only the American Southwest has a greater variety of rock art traditions than the Northwestern Plains (Wellmann 1979a; Schaafsma 1980; Whitley 2000; Turpin 1990).

Given the long history of artistic expression, and the many different Native groups that have moved through the Northwestern Plains or made the area their home for generations or millennia, the variety of its rock art is not surprising. Such diversity supports its separation into ten distinct traditions spanning more than 5000 years. This variety tends to contradict claims that most of the region's pictographs and petroglyphs originated with the area's most recent inhabitants in the last three centuries (Grant 1967:135, 1983:49; Gebhard 1969:22; Wellmann 1979a:129).

Rock art recorded and reflected nearly every aspect of Plains Indian life. Hunting scenes show a full range of ungulate prey being killed during both communal hunts and individual pursuit. Some hunting scenes likely served to instruct young hunters in the correct practices and rituals that would ensure success. Ancient vision images document individuals contacting the spirit world in their quest to obtain medicine power and a personal guardian. Mythology is portrayed in the Dinwoody carvings of Water Ghost Woman, Split Boy, and Oka-moo-bitsch the Cannibal Owl. Relationships between men and women were pecked into stone, and a few sites may even include family portraits.

Rock art produced by shamans was used to predict the future, ward off evil, cast spells, cure the sick, and heal the wounded. Some

shaman imagery shows the transformation of men into their bear spirit alter ego. Abstract designs and mazes may represent trance experiences, while handprints clustered at some sites suggest ritual initiation into secret societies. Hoofprints and large carved animals were used to increase the fertility of elk and bison, and some mark caves where the bison emerged each year to replenish the people's food supply. One such site likely records the coming of Buffalo Woman leading the Buffalo Nation from the underworld to become the Lakota Sioux. Ceremonial compositions document the importance of personal relationship with the spirit world. Many show the acquisition of a lifelong guardian spirit and advertise a person's individual medicine power.

Some sites record the coming of the horse, the arrival of the first guns, and famous battles. The bravest deeds and important coups of chiefs and warriors were recorded on rock; scenes illustrating individual combat, horse raids, and sexual conquests are carved and painted throughout the area. Many record the life histories of important warriors, some of which can still be understood more than a century later. The meaning of encoded messages at other sites is now lost, but they remain mute testimony to the creativity and complexity of Plains visual communication. Religion, mythology, history, daily life, ceremonies, rituals, personal accomplishments, spiritual powers—all are represented by the carvings and paintings which illustrate the culture and history of Plains Indian life.

Frequently Northwestern Plains rock art occurs in large concentrations in landscapes characterized by towering cliffs, strangely eroded stone outcrops, mysterious hoodoos, and deep caves and rockshelters. Known to many Plains Indians as medicine rocks, these are places where spirit powers are concentrated. Many of these sacred landscapes were favored locations for vision quests, ceremonies, and the making of rock art. Often such areas contain dozens of rock art sites, the largest of

which have hundreds of petroglyphs and pictographs. For example, 93 sites with nearly 2000 recognizable images are carved and painted along a 10 mile (16 km) stretch of the Milk River at Writing-on-Stone. The largest site there has more than 350 separate figures and designs. Similar densities of sites and designs occur in the North Cave Hills, along the Smith River, and at Whoopup Canyon, Weatherman Draw, Dinwoody Lakes, and Castle Gardens. The abundant rock art at these sacred places illustrates the special significance these landscapes held for generations of Plains Indian people—and it reminds us that these landscapes are still imbued with medicine power for the Native inhabitants of the region.

Regional Macrotraditions

Even with their great diversity of imagery and function, most Northwestern Plains rock art traditions show relationships with other rock art traditions, both on the Northwestern Plains and elsewhere in North America. And just as several related rock art styles make up a tradition, several related traditions make up a rock art macrotradition. We believe that all ten of the Northwestern Plains rock art traditions (along with the Robe and Ledger art tradition) can be grouped into four major regional rock art complexes, which we call the Western Archaic, Eastern Woodlands, Northwest Montane, and Northwestern Plains macrotraditions (fig. 18.1).

Western Archaic Macrotradition

The widespread Western Archaic rock art macrotradition includes the four predominant rock art traditions across the southern half of the Northwestern Plains, including the region's earliest rock art images. The petroglyphs of the Early Hunting, Dinwoody, En Toto Pecked, and Pecked Abstract traditions show their closest affinities to other pecked rock art styles and traditions found from the southern Plains of eastern New Mexico and

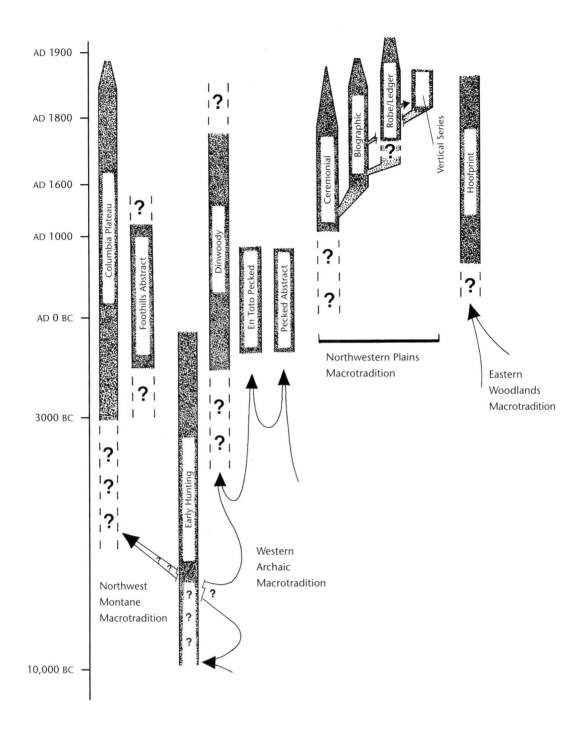

AD 1900

AD 1800

AD 1600

AD 1000

AD 0 BC

3000 BC

10,000 BC

Columbia Plateau

Foothills Abstract

?

?

?

Dinwoody

En Toto Pecked

Pecked Abstract

?

?

?

?

?

?

?

Early Hunting

?

?

?

Northwest
Montane
Macrotradition

?

Western
Archaic
Macrotradition

Ceremonial

Biographic

Robe/Ledger

Vertical Series

?

?

?

Northwestern Plains
Macrotradition

Hoofprint

?

Eastern
Woodlands
Macrotradition

18.1 Stylistic relationships for Northwestern Plains rock art

Colorado, through the Colorado Plateau and the Southwest, into the Great Basin and as far north as the Columbia River. Throughout its range, early dates for this widespread and ancient rock art macrotradition range from Paleoindian times (possibly even pre-Clovis [Whitley and Dorn 1993]), to the Late Archaic period. On the Northwestern Plains, the oldest Early Hunting petroglyphs may be of Paleoindian age, and the youngest date to the Late Archaic. The Dinwoody tradition, on the other hand, began in the Middle Archaic at least 3000 years ago and continued into Historic times. The En Toto Pecked and Pecked Abstract traditions began in the Late Archaic period and ended in the Late Prehistoric period before A.D. 1000.

In addition to their relatively great age and stylistic relationship to archaic rock art found south and southwest of the region, these four traditions share their method of manufacture. All are petroglyphs pecked into the hard sandstones that characterize the geological formations of Wyoming and southwestern South Dakota. Their scarcity north of Wyoming may owe to the prevalence of softer and more easily eroded sandstones that characterize the sedimentary rocks underlying the plains of Montana and Alberta. A few scattered sites, such as the En Toto Pecked figures on a remnant of ancient hardened cliff at Writing-on-Stone and the Pecked Abstract site at Slayton Junction north of Billings, hint that these traditions once may have been more widespread but the images now have been mostly lost to erosion. The absence of paintings in all of these traditions may reflect both their great age and the likelihood that most pictographs would have faded away after thousands of years. Some evidence for this suggestion is the microscopic charcoal ground into some of the oldest petroglyphs (animal figures probably of the Early Hunting tradition) at Legend Rock in Wyoming (Francis et al. 1993:721–22), which implies that the figures were originally filled in with charcoal that one

can no longer see. Archaic period pictographs dating 3000 and 4000 years old appear in other arid areas of the United States, however (Chaffee et al. 1994), so it seems likely that some paintings would have survived had they originally been commonplace.

These Western Archaic macrotradition petroglyphs had diverse functions. The elaborate Early Hunting scenes were apparently carved in conjunction with hunting rituals and used either as teaching tools in group rituals structured to pass knowledge across generations, or as hunting magic to appease spirits who controlled the game. Pecked Abstract and Dinwoody tradition shamans' images were carved by those who entered altered states of consciousness to communicate with and journey into the spirit world. The Pecked Abstract images, with their preponderance of wavy lines, starbursts, spirals, and grids, may represent neuropsychological "phosphenes" seen in these trances, while the Dinwoody carvings show the bizarre spirit beings who populate the Northern Shoshone netherworld. The animals and human figures arranged in small "family" groups that characterize En Toto Pecked petroglyphs were made for unknown purposes, but the two dozen sites where this rock art is known include almost as many identified female figures as all the rest of Northwestern Plains rock art.

Eastern Woodlands Macrotradition

The Hoofprint rock art tradition represents a westward extension of Eastern Woodlands rock art imagery onto the Northwestern Plains. Most common along the eastern margins of the Plains, the petroglyphs of this tradition consist of integrated panels of ungulate hoofprints, simulated human handprints and footprints, human faces, and occasional bison. Similar to religious imagery of the Sioux and Cheyenne, Hoofprint rock art was carved as part of hunting and world renewal ceremonies. The earliest Hoofprint sites may be as old

as the Besant culture of the Late Archaic period, but most panels were made and used during the Late Prehistoric period. Hoofprint tradition petroglyphs are closely related to rock art spread widely throughout eastern North America, and similar sites are found as far east as Pennsylvania, West Virginia, and Georgia. Hoofprint art was probably brought to the Northwestern Plains by migrating groups of Siouan speakers who moved into the region from the Eastern Woodlands.

Northwestern Plains Macrotradition

One of North America's most important rock art macrotraditions consists of the well-known Ceremonial tradition along with the Biographic, Robe and Ledger art, and Vertical Series traditions. All four traditions of the Northwestern Plains macrotradition share aspects of technique, form, and subject matter, and they show continuities in motifs, meaning, and function. The ages of the traditions also overlap, in some cases for more than a century, and all were produced by the same people. Beginning during the Late Prehistoric, the Ceremonial tradition eventually gave rise to the closely related Biographic and Robe and Ledger art traditions, which flourished in the Protohistoric and early Historic periods. The macrotradition culminated with the development of the Vertical Series tradition in the Historic period. Although centered on the Northwestern Plains, the traditions making up this macrotradition stretch across much of the Great Plains.

Ceremonial rock art may have originated as long ago as the Late Archaic period, but the great majority of Ceremonial tradition sites were carved and painted between A.D. 1000 and 1750. Extending from southern Alberta to central Kansas, the widespread Ceremonial rock art tradition occurs as both petroglyphs and pictographs. Consisting primarily of juxtaposed compositions recording vision quest images, this tradition is best known for its carefully incised images

of V-neck humans, shield-bearing warriors, and boat-form animals, many with lifelines. Some polychrome shield-bearing warrior pictographs are among the most striking rock art images in the region. Although both the basic boat-form animal and shield-bearing warrior motifs may have been borrowed from neighboring areas to the west, the V-neck human originated in the region and is unique to the rock art of the Plains. This motif and the use of life-lines for both humans and animals help distinguish this tradition from others in western North America.

The Ceremonial tradition continued well into the Historic era. Sometime in the Late Prehistoric period, concepts of action and narration were introduced to Ceremonial rock art. Eventually the pictographic conventions of the Biographic tradition were developed to record individual deeds of valor using many of the same designs and elements found in Ceremonial rock art. Around 1730, horses and guns were introduced into Plains societies, and the following century saw radical changes in Plains Indian cultures. Reflecting these far-reaching changes, the Biographic tradition flourished and quickly became the predominant artistic expression across the region. At its height, Biographic rock art was made from Calgary, Alberta, to south of the Rio Grande in Mexico and from the Rocky Mountains to the Black Hills. Biographic rock art mostly portrays the exploits of warriors—scenes of combat, horse raiding, hunting, and sometimes sexual conquest—by which a Plains Indian warrior achieved status and personal worth. As the narrative complexity of Biographic rock art increased, some scenes reached the level of true pictography.

Ceremonial and Biographic imagery was so important in Plains society that it was not restricted to rock art. Similar designs were painted on robes and clothing at least as far back as the 1700s. Some robe art mirrors the imagery of the Ceremonial tradition, but with

the rise of Biographic rock art, similar narrative imagery began to dominate the figures painted on robes, clothing, and tipi covers. The earliest Biographic robe art shows V-neck and rectangular-body human figures composed into narrative scenes identical to those in early Biographic rock art. After 1830, biographic imagery began to be drawn on paper provided by soldiers, traders, and missionaries, giving rise to ledger art. Later robe and ledger drawings show significant influences from Euro-American artists, including the introduction of portraiture and perspective, and the illustration of realistic horses and costume details. Biographic art in all three media (rock art, robe art, and ledger art) continued to develop in this vein throughout the late 1800s and early 1900s, and the latest Biographic rock art rivals the finest ledger drawings.

Biographic art also spawned the Vertical Series rock art tradition. As Biographic imagery developed into pictography, and was adapted to serve a calendric function in winter counts, some pictures began to represent ideas not directly obvious from the image itself—in other words, some designs became ideographic symbols. In Vertical Series rock art, various ideograms are organized into columns or series following what appears to be a rudimentary syntax or grammar, and forming a relatively complex communication system. Although Vertical Series rock art is widespread on the Northwestern Plains, it is uncommon and still poorly known. Only limited ethnographic evidence is available to decipher the meaning of individual symbols, and so few sites have been identified and recorded that it is difficult to recognize how the syntax is organized. The Vertical Series tradition was formally recognized only a decade ago, and research in the coming years may unlock more of its secrets.

Northwest Montane Macrotradition

The Columbia Plateau and Foothills Abstract traditions are both found along the far western margins of the Northwestern Plains. Although distinct in many ways, these ancient and long-lived rock art traditions are linked to other primarily painted rock art throughout the mountains, basins, and plateaus stretching from the Pacific Coast to the Rocky Mountain foothills. Along with the Columbia Plateau and Foothills Abstract traditions, the Klamath Basin and Northwest Coast traditions can be loosely grouped into a Northwest Montane macrotradition.

The Columbia Plateau tradition, one of the most common and widespread in the Far West, extends out onto the fringes of the Northwestern Plains. Eastern Columbia Plateau style rock art is found at scattered sites in the Rocky Mountain foothills and the interior mountain valleys from north of Calgary to Yellowstone Park. Although generally simple in form and composition, Columbia Plateau rock art at these sites eloquently records the vision quest experiences of both men and women of interior plateau cultures, and the divination, curing, and hunting magic rituals of their shamans.

Despite the vast distribution of the Columbia Plateau rock art tradition, its imagery shows amazing internal consistency in technique, form, and subject matter across the entire region, and from Archaic to Historic times. Although its earliest forms appear to have been influenced by ancient hunting scenes of the Western Archaic macrotradition, over at least the last 2000 years this rock art developed into one of North America's most homogeneous stylistic traditions (Keyser 1992). From the Late Archaic to the Historic period, Columbia Plateau rock art maintained a characteristic form and function across the entire intermontane plateau of northwestern North America.

On the far western fringe of the Columbia Plateau, several traditions show limited relationships to the Columbia Plateau tradition, including rock art from the Klamath Basin (Swartz 1978). Scattered among the

better-known petroglyphs of the Northwest Coast (Hill and Hill 1974) is a little known but significant pictograph component (Leen 1985), which also has links to some Columbia Plateau rock art. Limited influences from Northwest Coast and Klamath Basin traditions have led to stylistic variants within Columbia Plateau rock art. As a result, regional styles can be identified within the Columbia Plateau tradition, but the differences are not significant enough to warrant classification into separate traditions.

On the east, pictographs of the Foothills Abstract tradition are common in the Rocky Mountain foothills and outlying ranges of Montana and southern Alberta. Despite its proximity to Columbia Plateau rock art, Foothills Abstract imagery shares only a few general similarities with the Columbia Plateau tradition, except that both consist predominantly of red finger-painted pictographs, and both include stick-figure humans, block body animals, and tally marks. Rock art from both traditions also was made as part of vision quests and shamanic rituals. In detail, however, the two traditions are clearly distinct. Foothills Abstract tradition paintings display formal characteristics and subject matter unlike either Columbia Plateau rock art or any other Plains tradition—bear imagery, abstracted animal and human figures, masks, shaman figures shown with their supernatural lizard and turtle helpers, finger lines, extensive panels of handprint impressions, and numerous panels completely covered with a wash of red pigment and visible from great distances. Some of these sites were probably the location of public ceremonies based on shamanic rituals, while other sites are small, isolated, vision quest locations used by individuals seeking personal power. This northern Rocky Mountain pictograph tradition dates to the Archaic and early Late Prehistoric periods. Little is known of its antecedents or descendants, but some research has shown stylistic differentiation between the southern and northern sites of the Foothills Abstract tradition (Greer and Greer 1996a). Further research may one day link this rock art more closely to the other traditions of the Northwest Montane macrotradition.

Conclusion

Rock art helped Plains Indians structure their world and maintain their place within the cosmic order. By linking the people to the powers of the spirit world, it aided individuals in their quest for status and assisted groups in their struggle for survival. By recording significant events and the accomplishments of individuals, it helped pass tribal lore to future generations and maintained cultural traditions. While some drawings may have been created expressly as art, the beauty and artistic quality of many images are an unintended result of the artist's intimate relationship with the spirits, the natural world, and the landscape. Nonetheless, many rock art sites are galleries of fine art, with images as beautiful and evocative as any in the world. As we begin to understand why ancient artists felt compelled to create such expressive images, they become even more impressive and fascinating to us.

Though mystery surrounds many pictographs and petroglyphs, our knowledge and understanding of Northwestern Plains rock art increases every year. In the last decade, archaeologists and amateurs have discovered and recorded numerous pictographs and petroglyphs, more than doubling the number of known sites. Even as we were writing this book, dozens of previously unrecorded sites were found throughout the region, and systematic surveys will undoubtedly produce many more. For instance, an ongoing provincewide inventory of Alberta rock art has added more than thirty-six sites to the provincial total since 1992, an increase of nearly 40 percent. Amazingly, the majority of these sites were identified at Writing-on-Stone,

one of the most intensely studied and surveyed rock art localities on the Northwestern Plains. In central Montana, four years of survey has more than quadrupled the number of sites known from the Smith and Judith river drainages in 1988. Similar increases in known sites have been reported recently from the Black Hills, Bighorn Basin, and Wind River drainage.

Even today, large areas of eastern Montana and central and eastern Wyoming have never been adequately surveyed for rock art. These vast areas promise to reveal untold rock art riches when they are carefully and systematically examined. New discoveries and the dedicated work of many researchers will continue to reveal the beauty and meaning of Northwestern Plains rock art.

Bibliography

Arthur, George W.

1960 Pictographs in Central Montana, Part III: Comments. *Anthropology and Sociology Papers*, no. 21, pp. 41–44. Missoula: Montana State University.

Barbeau, Marius

1960 *Indian Days on the Western Prairies.* National Museum of Canada Bulletin no. 163, Anthropological Series, no. 43.

Barry, P. S.

1991 *Mystical Themes in Milk River Rock Art.* Edmonton: University of Alberta Press.

Beck, W.; D. J. Donahue; A. J. T. Jull; G. Burr; W. S. Broecker; G. Bonani; I. Hajdas; and E. Malotki

1998 Ambiguities in direct dating of rock surfaces using radiocarbon measurements. *Science* 280:2132–35.

Bierce, Ambrose Gwinett

1866 Route maps of journey from Fort Laramie, Dakota Territory, to Fort Benton, Montana Territory. MS on file in William Robertson Coe Collection, Yale University, New Haven CT.

Black, Kevin D.

1991 Archaic continuity in the Colorado Rockies: The Mountain Tradition. *Plains Anthropologist* 36(133):1–29

Bouchet-Bert, Luc

1999 From spiritual and biographic to boundary-marking deterrent art: A reinterpretation of Writing-on-Stone. *Plains Anthropologist* 44(167):27–46.

Brink, Jack

1979 Archaeological investigations at Writing-on-Stone. In *Archaeology in Southern Alberta.* Archaeological Survey of Alberta, Occasional Paper, no. 12/13, pp. 1–74.

1980 The 17% solution: New pictographs at the Zephyr Creek site, Alberta. *Canadian Rock Art Research Associates Newsletter*, no. 13, pp. 5–15.

1981 Rock art sites in Alberta: Retrospect and prospect. In *Alberta Archaeology: Prospect and Retrospect.* Lethbridge: Archaeological Society of Alberta, pp. 69–81.

Brownstone, Arni

1993 *War Paint: Blackfoot and Sarcee Painted Buffalo Robes in the Royal Ontario Museum.* Toronto: Royal Ontario Museum.

Buckles, William G.

1964 An analysis of primitive rock art at Medicine Creek Cave, Wyoming, and its cultural and chronological relationships to the prehistory of the Plains. Master's thesis, University of Colorado, Boulder.

1989 Petroglyphic research and Ogam in
 Southeastern Colorado: Strategies
 for resolving controversies. In *Rock
 Art of the Western Canyons*, Colo-
 rado Archaeological Society,
 Memoir no. 3, pp. 113–55.

Buker, Leon W.
1937 Archaeology of the southern Black
 Hills. *American Antiquity* 3:79–80

Cassidy, Stephen C.
1992 Do the Cranbrook petroglyphs
 speak? In *Ancient Images, Ancient
 Thoughts: The Archaeology of
 Ideology*, ed. A. S. Goldsmith, pp.
 331–36. Calgary AB: The Archaeo-
 logical Association of the University
 of Calgary.

Castañeda de Nágera, Pedro de
1990 *The Journey of Coronado.* Mineola
 NY: Dover Publications.

Catlin, George
1844 *Letters and Notes on the Manners,
 Customs, and Conditions of North
 American Indians.* (Reprint, New
 York: Dover Publications Inc., 1973.)

Chaffee, Scott D.; Lawrence L. Loendorf;
 Marian Hyman; and Marvin W.
 Rowe
1994 Dating a pictograph in the Pryor
 Mountains, Montana. *Plains
 Anthropologist* 39(148):195–201.

Cline, Walter
1938 Religion and world view. In *The
 Sinkaietk or Southern Okanogan of
 Washington*, ed. Walter Cline, R. S.
 Commons, M. Mandelbaum, R. H.
 Post, and L. V. W. Walters, pp. 133–
 44. General Series in Anthropology,
 no. 6, Menasha WI.

Cole, Sally J.
1987 An analysis of the Prehistoric and
 Historic rock art of West-Central
 Colorado. Bureau of Land Manage-
 ment, *Cultural Resource Series*, no.
 21. Colorado State Office, Denver.
1990 *Legacy on Stone: Rock Art of the
 Colorado Plateau and Four Corners
 Region.* Boulder CO: Johnson
 Books.

Conner, Stuart W.
1962a A preliminary survey of prehistoric
 picture writing on rock surfaces in
 central and south central Montana.
 Anthropological Papers, no. 2.
 Billings MT: Billings Archaeological
 Society.
1962b The Fish Creek, Owl Canyon and
 Grinvoll Rock Shelter pictograph
 sites in Montana. *Plains Anthropolo-
 gist* 7(15):24–35.
1964 Indian rock petroglyphs. *Trowel and
 Screen* 5(2).
1980 Historic Period indicators in the
 rock art of the Yellowstone. *Archae-
 ology in Montana* 21(2):1–13.
1984 The Petroglyphs of Ellison's Rock
 (24RB1019). *Archaeology in Montana*
 25(2&3):123–145.
1989a Comments concerning the
 petroglyphs at sites 24RB1153,
 24RB1171, 24RB1176, and 24RB1181.
 In Archaeological Investigations for
 Peabody Coal Company's Big Sky
 Mine, Area B. Butte MT: GCM
 Services.
1989b Protohistoric horse petroglyphs
 (24CH757) in Eagle Creek Canyon.
 Archaeology In Montana 30(1,2):
 99–110.

Conner, Stuart W., and Betty Lu Conner
1971 *Rock Art of the Montana High Plains.*
 Santa Barbara CA: The Art Galleries,
 University of California.

Copp, Stan
1980 A dated pictograph from the south
 Okanagan Valley of British Colum-
 bia. *Canadian Rock Art Research
 Associates Newsletter*, no. 14, pp.
 44–48.

Corner, John
1968 *Pictographs (Indian Rock Paintings)
 in the Interior of British Columbia.*

Vernon BC: Wayside Press.

Cornford, Jackie, and Steve Cassidy
1980 Cranbrook petroglyphs. *Datum: B.C. Heritage Conservation Branch Newsletter* 5(2):7–9.

Cowdrey, Mike
1995 Spring Boy rides the moon: Celestial patterns in Crow shield design. Manuscript.

Cramer, Joseph L.
1974 Drifting down the Yellowstone River with Captain William Clark, 1806: A pictographic record of the Lewis and Clark return expedition. *Archaeology in Montana* 15(1):11–21.

Darroch, John I.
1976 A hoof, hand and footprint petroglyph boulder recovery from Valley County, Montana. *Archaeology in Montana* 17(3):19–27.

Dempsey, Hugh A.
1973 A History of Writing-on-Stone. Manuscript on file with Alberta Environment and the Provincial Museum of Alberta.

Dewdney, Selwyn
1964 Writings on stone along the Milk River. *The Beaver*, Outfit 295 (Winter):22–29.

Dorn, Ronald I.
1995 Cation ratio and radiocarbon ages for Wyoming petroglyphs. Report submitted to the Bureau of Land Management District Office, Worland WY.
1996 A change of perception. *La Pintura*, Fall.
1997 Constraining the age of the Coa Valley (Portugal) engravings with radiocarbon dating. *Antiquity* 71(271):105–15.
1998 Reply to: Ambiguities in direct dating of rock surfaces using radiocarbon measurements. *Science* 280:2136–39.

Doty, James
1966 A visit to the Blackfoot camps. *Alberta Historical Review*, summer issue, pp. 17–26.

Eichhorn, Gary
1958 Petroglyphs at Porcupine Lookout, a site in Rosebud County. *Archaeology in Montana* 1(1):3–5.

Elrod, Morton J.
1908 Pictured rocks: Indian writings on the rock cliffs of Flathead Lake, Montana. *Bulletin of the University of Montana*, no. 46, Biological Series no. 14, Missoula MT.

Erwin, Richard P.
1930 Indian rock writing in Idaho. *Annual Report* no. 12, Idaho Historical Society, Boise.

Ewers, John C.
1939 *Plains Indian Painting: A Description of an Aboriginal American Art.* Palo Alto CA: Stanford University Press.
1955 The Horse in Blackfoot Culture. *Bureau of American Ethnology, Bulletin* no. 159. Washington DC.
1968 Introduction. In Karen D. Petersen, *Howling Wolf: A Cheyenne Warrior's Graphic Interpretation of His People.* Palo Alto CA: American West Publishing Company.
1983 A century and a half of Blackfeet picture-writing. *American Indian Art Magazine* 8(3):52–61.

Feyhl, Kenneth J.
1980 Tool grooves: A challenge. *Archaeology in Montana* 21(1):1–31.

Fowler, Roy
1950 Pictographs of the Alberta foothills. *Canadian Cattlemen* 13(9):44–45.

Francis, Julie E.
1991 An overview of Wyoming rock art. In *Prehistoric Hunters of the High Plains*, ed. G. C. Frison. 2d ed. San Diego CA: Academic Press.
1994 Cation-ratio dating and chronologi-

cal variation within Dinwoody-Tradition rock art in Northwestern Wyoming. In *New Light on Old Art: Recent Advances in Hunter-Gatherer Rock Art Research,* ed. D. S. Whitley and L. L. Loendorf, pp. 37–49. Los Angeles: Institute of Archaeology, University of California.

Francis, Julie E.; Lawrence L. Loendorf; and Ronald I. Dorn

1993 AMS radiocarbon and cation-ratio dating of rock art in the Bighorn Basin of Wyoming and Montana. *American Antiquity* 58(4):711–37.

Fredlund, Lynn

1993 *Archeological Investigations and Rock Art Recordation at Recognition Rock (24RB165) Rosebud County, Montana.* Butte MT: GCM Services, Inc.

Frison, George C.

1978 *Prehistoric Hunters of the High Plains.* New York: Academic Press.

1991 *Prehistoric Hunters of the High Plains.* 2d ed. San Diego CA: Academic Press.

Gebhard, David S.

1951 The petroglyphs of Wyoming: A preliminary paper. *El Palacio* 58:67–81.

1963 Rock drawings in the western United States. *Jahrbuch für Prähistorische und Ethnographische Kunst* 20:46–54.

1966 The shield motif in Plains rock art. *American Antiquity* 31(5):721–32.

1969 *The Rock Art of Dinwoody, Wyoming.* Santa Barbara: The Art Galleries, University of California.

Gebhard, David S., and Harold A. Cahn

1950 The petroglyphs of Dinwoody, Wyoming. *American Antiquity* 15:219–28.

1954 Petroglyphs in the Boysen Reservoir area. In William T. Mulloy, *Archaeological Investigations in the Shoshone Basin of Wyoming.* University of

Wyoming Publication, no. 18, pp. 66–70.

Gebhard, David; Fred Heaton; and Jonathan Laitone

1987 The rock drawings of Castle Gardens, Wyoming. Report submitted to the Bureau of Land Management, Cheyenne WY.

Gould, C. N.

1900 Indian pictographs on the Dakota sandstone. *Science* 11:630–31.

Grant, Campbell

1967 *Rock Art of the American Indian.* New York: Thomas Y. Crowell Co.

1983 *The Rock Art of the North American Indian.* Cambridge U.K.: Cambridge University Press.

Grant, Campbell; James W. Baird; and J. Kenneth Pringle

1968 *Rock Drawings of the Coso Range.* China Lake CA: Maturango Museum.

Greene, Candace

1994 Cheyenne pictographic art: Structure and meaning. Manuscript.

Greer, Mavis

1995 Archaeological Analysis of Rock Art Sites in the Smith River Drainage of Central Montana. Ph.D. dissertation, University of Missouri-Columbia.

Greer, John, and Mavis Greer

1995a Pictograph sites on the Judith River of Central Montana. In *Rock Art Papers,* ed. Ken Hodges, pp. 1–12. San Diego CA: San Diego Museum.

1995b An evaluation of abstract figures in Central Montana Rock Art. Manuscript.

1995c Shaman activity portrayed in the pictographs of Central Montana. Manuscript.

Greer, Mavis, and John Greer

1994a The Sun River pictographs in Central Montana. In *American Indian Rock Art,* ed. F. G. Bock, pp.

25–33. San Miguel CA: American Rock Art Research Association.

1994b Rock art along the Smith River in Central Montana: Report on the 1993 field season. Manuscript.

1996a Central Montana rock art. *Archaeology in Montana* 37(2):43–56.

1996b Montana rock art: 1996 field season. Report no. MT-2850G; prepared for USDA Forest Service, Montana.

1999 Handprints in Central Montana rock art. *Plains Anthropologist* 44(167):59–71.

Grey, Don, and Glen Sweem

1961 Regional pictograph styles. *Wyoming Archaeologist* 4(11):2–13.

Grinnell, George Bird

1962 *Blackfoot Lodge Tales: The Story of a Prairie People.* Lincoln NB: University of Nebraska Press.

Habgood, Thelma E.

1967 Petroglyphs and pictographs in Alberta. *Archaeological Society of Alberta Newsletter,* nos. 13 and 14, pp. 1–40.

Haines, Francis

1938 Where did the Plains Indians get their horses? *American Anthropologist* 40:112–17.

Hallowell, Irving A.

1926 Bear ceremonialism in the Northern Hemisphere. *American Anthropologist* 28:1–175.

Hann, Don; James D. Keyser; and Phillip Minthorn Cash Cash

2000 Columbia Plateau rock art: A window to the spirit world. In *The Ethnography of Rock Art,* ed. David Whitley. Walnut Creek CA: Altamira Press.

Heidenreich, Adrian C.

1985 *Ledger Art of the Crow and Gros Ventre Indians: 1879–1897.* Billings MT: Yellowstone Art Center.

Heizer, R. F., and M. A. Baumhoff

1962 *Prehistoric Rock Art of Nevada and Eastern California.* Berkeley CA: University of California Press.

Hendry, Mary Helen

1983 *Indian Rock Art in Wyoming.* Lincoln NB: Augstums Printing Services, Inc.

Hill, Beth, and Ray Hill

1974 *Indian Petroglyphs of the Pacific Northwest.* Seattle: University of Washington Press.

Holm, Bill

1984 Four Bears' Shirt: Some problems with the Smithsonian Catlin collection. Paper presented at the Plains Indian Seminar, Buffalo Bill Historical Center, Cody WY.

Horse Capture, George P.; Anne Vitart; Michael Waldberg; and W. Richard West, Jr.

1993 *Robes of Splendor.* New York: The New Press.

Hotz, Gottfried

1991 *The Segesser Hide Paintings: Masterpieces Depicting Spanish Colonial New Mexico.* Santa Fe: Museum of New Mexico Press.

Howard, James H.

1960 Dakota winter counts as a source of Plains history. *Bureau of American Ethnology Bulletin,* vol. 173, no. 6, pp. 335–416. Washington DC.

1976 Yanktonai ethnohistory and the John K. Bear winter count. *Plains Anthropologist* 27(73).

Hoy, Judy

1969 Petroglyph boulders in Phillips County, Montana. *Archaeology in Montana* 10(3):45–65.

Jasmann, Alice O.

1962 Seven pictograph sites in southwestern Montana. *Archaeology in Montana* 3(3):1–19.

Johnson, Ann. M.

1975 Hoofprint boulder. *Archaeology in Montana* 16(1):43–47.

Jones, Tim, and Louise Jones

 1982 The St. Victor petroglyphs: Description and condition report. Manuscript on file with the Saskatchewan Museum of Natural History, Regina.

Keyser, James D.

 1975 A Shoshonean origin for the Plains shield-bearing warrior motif. *Plains Anthropologist* 20(69):207–15.

 1977a Writing-on-Stone: Rock art on the Northwestern Plains. *Canadian Journal of Archaeology* 1:15–80.

 1977b Audrey's Overhang: A pictographic maze in central Montana. *Plains Anthropologist* 22(77):183–87.

 1978 The Zephyr Creek pictographs: Columbia Plateau rock art on the periphery of the Northwestern Plains. In *Archaeology in Alberta 1977.* Archaeological Survey of Alberta, Occasional Paper, no. 5, pp. 97–104.

 1979a The Central Montana abstract rock art style. In *CRARA '77, Papers from the Fourth Biennial Conference of the Canadian Rock Art Research Associates.* British Columbia Provincial Museum, Heritage Record no. 8, pp. 153–77.

 1979b The Plains Indian war complex and the rock art of Writing-on-Stone, Alberta, Canada. *Journal of Field Archaeology* 6(1):41–48.

 1981 Pictographs at the DesRosier Rockshelter. *Plains Anthropologist* 26(94):271–76.

 1984 The North Cave Hills. In *Rock Art of Western South Dakota.* Special Publication of the South Dakota Archaeological Society, no. 9, pp. 1–51.

 1987a A lexicon for historic Plains Indian rock art: Increasing interpretive potential. *Plains Anthropologist* 32(115):43–71.

 1987b A graphic example of petroglyph superimpositioning in the North Cave Hills. *Archaeology in Montana* 28(2):44–56.

 1989 Ledger book art: A key to understanding Northern Plains rock art. In *Rock Art of the Western Canyons,* Colorado Archaeological Society Memoir, no. 3, pp. 87–111.

 1990 Rock art of North American Northwestern Plains: An overview. *Bollettino del Centro Camuno di Studi Preistorici* 25/26:99–122.

 1991 A thing to tie on the halter: An addition to the Plains rock art lexicon. *Plains Anthropologist* 36(136):261–67.

 1992 *Indian Rock Art of the Columbia Plateau.* Seattle: University of Washington Press.

 1993 Remnants of a vanished culture: Columbia River rock art. *Columbia: The Magazine of Northwest History* 7(1):28–36.

 1994 *Indian Petroglyphs of the Columbia Gorge: The Jeanne Hillis Rubbings.* Portland OR: J. Y. Hollingsworth Co.

 1996 Painted bison robes: The missing link in the Plains Biographic art style lexicon. *Plains Anthropologist* 41(155):29–52.

 2000 *The Five Crows Ledger: Biographic Warrior Art of the Flathead Indians.* Salt Lake City: University of Utah Press.

Keyser, James D., and Timothy J. Brady

 1993 A war shirt from the Schoch Collection: Documenting individual artistic expression. *Plains Anthropologist* 38(142):5–20.

Keyser, James D., and Mike Cowdrey

 2000 Northern Plains Biographic rock art: Ethnography written on stone. In *The Ethnography of Rock Art,* ed. David Whitley. Walnut Creek CA: Altamira Press.

Keyser, James D., and George C. Knight

1976 The rock art of Western Montana. *Plains Anthropologist* 21(71):1–12.

King, Donald R.

1965 The Milk River petrograph sites, Alberta. Manuscript on file with the Glenbow Archives, Calgary AB.

Klassen, Michael A.

1994a Spirit images and medicine rocks: Results of the 1992–93 Alberta Rock Art Survey. Paper presented at the Canadian Archaeological Association annual meeting, Edmonton AB.

1994b Survey of Plains hide paintings in museum collections. Manuscript.

1995 Icons of power, narratives of glory: Ethnic continuity and cultural change in the contact period rock art of Writing-on-Stone. Master's thesis, Trent University, Peterborough ON.

1998a Icon and narrative in transition: contact-period rock-art at Writing-on-Stone, southern Alberta, Canada. In *The Archaeology of Rock-Art,* ed. C. Chippindale and P. S. C. Taçon, pp. 42–72. Cambridge UK: Cambridge University Press.

1998b Between Plains and Plateau: Fusion and tension in the rock art of the Alberta foothills. Paper presented at the 63rd Annual Meeting of the Society for American Archaeology, Seattle WA.

Klassen, Michael A.; James D. Keyser; and Lawrence L. Loendorf

2000 Bird Rattle's petroglyphs at Writing-on-Stone: Continuity in the Biographic tradition. *Plains Anthropologist* 45(172):189–201.

Leechman, Douglas; Margaret Hess; and Roy L. Fowler

1955 Pictographs in southwestern Alberta. National Museum of Canada, Annual Report 1953–1954, *Bulletin,* no. 136, pp. 36–53.

Leen, Daniel

1985 A preliminary inventory of Haisla and Kitkiata rock art. Report submitted to the Kitimat Heritage Advisory Commission, Kitimat BC.

Lessard, F. Dennis

1991 Pictographic Sioux beadwork: A re-examination. *American Indian Art Magazine* 16(4):70–74.

Lewis, Thomas H.

1986a Counts, coups, and tally marks: Evidence of notational systems in the pictographic/petroglyphic record. *Northwest Science* 60(4): 243–49.

1986b Hunting and battle scenes at Nordstrom-Bowen site (24YL419) in the Bull Mountains, Montana. *The Wyoming Archaeologist* 29(3–4):165–70.

Lewis-Williams, J. D., and T. A. Dowson

1988 The signs of all times: Entoptic phenomena in Upper Palaeolithic art. *Current Anthropology* 29(2):201–45.

Loendorf, Lawrence L.

1984 Documentation of rock art, Petroglyph Canyon, Montana 24CB601. *Contribution,* no. 207, Department of Anthropology and Archaeology, University of North Dakota, Grand Forks ND.

1988 Rock Art chronology and the Valley of the Shields site (24CB1094) in Carbon County, Montana. *Archaeology in Montana* 29(2):11–24.

1990 A dated rock art panel of shield-bearing warriors in south central Montana. *Plains Anthropologist* 35(127):45–54.

1992 AMS 14 carbon and CR age estimates for two Montana rock art sites. *Archaeology in Montana* 33(2):71–83.

1994 Rock art and the Water Ghost Woman on the Wind River, Wyoming. Manuscript.

1995 Points of power: Representations and typology in Wyoming petroglyphs. Paper presented at the 53rd Plains Conference, Laramie WY.

Loendorf, Lawrence L., and Stuart W. Conner

1993 The Pectol Shields and the shield-bearing warrior rock art motif. *Journal of California and Great Basin Anthropology* 15(2):216–24.

Loendorf, Lawrence L., and Julie Francis

1987 Three rock art sites on the middle fork of the Powder River, Wyoming. *Archaeology in Montana* 28(2):18–24.

Loendorf, Lawrence L., and Audrey Porsche

1985 The rock art sites in Carbon County, Montana. *Contribution* 224, Department of Anthropology, University of North Dakota, Grand Forks.

Loendorf, Lawrence L.; K. Hackett; J. D. Benko; D. M. Penny; et al.

1990 The Cottonwood Creek rock art survey. Manuscript on file with the Bureau of Land Management, Montana State Office, Billings.

Mack, Joanne M.

1971 Archaeological investigations in the Bighorn Basin, Wyoming. *The Wyoming Archaeologist* 14(2–4):17–113.

MacLean, John

1896 Picture-writing of the Blackfeet. *Transactions of the Canadian Institute* 5:114–20.

Magne, Martin P. R., and Michael A. Klassen

1991 A multivariate study of rock art anthropomorphs at Writing-on-Stone, southern Alberta. *American Antiquity* 56(3):389–418.

1992 Were the Shoshone at Writing-on-Stone? In *Ancient Images, Ancient Thought: The Archaeology of Ideology,* ed. A. S. Goldsmith, pp. 449–59. Calgary AB: Archaeological Association of the University of Calgary.

Mallery, Garrick

1877 A calendar of the Dakota Nation. *Bulletin of the United States Geographical Survey* III(1).

1893 *Picture-Writing of the American Indians.* Annual Report no. 10, Bureau of American Ethnology, Washington DC.

Malouf, Carling

1961 Pictographs and petroglyphs. *Archaeology in Montana* 3(1):1–13.

Malouf, Carling I., and Thain White

1952 Recollections of Lasso Stasso. Montana State University *Anthropology and Sociology Papers* no. 12.

1953 The origin of pictographs. Montana State University *Anthropology and Sociology Papers* no. 15, pp. 30–33.

Maurer, Evan M., ed.

1992 *Visions of the People.* Minneapolis MN: Minneapolis Institute of the Arts.

McClintock, Walter

1936 Painted tipis and picture-writing of the Blackfoot Indians. *Masterkey* 10:120–33, 168–79.

McClure, Richard H.

1980 Anthropomorphic motifs and style in Plateau rock art. Paper presented at the 33rd Northwest Anthropological Conference, Bellingham WA.

Mishkin, Bernard

1940 *Rank and Warfare Among the Plains Indians.* Seattle: University of Washington Press.

Molyneaux, Brian L.

1977 Formalism and contextualism: An historiography of rock art research in the New World. Master's thesis, Trent University, Peterborough ON.

Mulloy, William T.

1958 A preliminary historical outline for the Northwestern Plains. *University of Wyoming Publications* 22(1).

Nagy, Imre J.

 1994 A typology of Cheyenne shield designs. *Plains Anthropologist* 39(147):5–36.

Over, William H.

 1936 The archaeology of Ludlow Cave and its significance. *American Antiquity* 2:126–29.

 1941 *Indian Picture Writing in South Dakota.* Vermillion: University of South Dakota Museum.

Panofsky, Erwin

 1955 Iconography and iconology: an introduction to the study of Renaissance art. In *Meaning in the Visual Arts,* pp. 26–54. Chicago: University of Chicago Press.

Park, John A.

 1990 The Simanton Petroglyph Hill site (24PH2072): A ceremonial complex in Northern Montana. *Archaeology in Montana* 31(2):41–49

Parsons, Mark L.

 1987 Plains Indian portable art as a key to two Texas Historic rock art sites. *Plains Anthropologist* 32(117):257–74.

Penney, David W.

 1992 The horse as symbol: Equine representations in Plains pictographic art. In *Visions of the People,* ed. Evan M. Maurer, pp. 69–79. Minneapolis: Minneapolis Institute of the Arts.

Petersen, Karen D.

 1968 *Howling Wolf: A Cheyenne Warrior's Graphic Interpretation of His People.* Palo Alto CA: American West Publishing Company.

 1971 *Plains Indian Art from Fort Marion.* Norman: University of Oklahoma Press.

Point, Nicolas, S.J.

 1967 *Wilderness Kingdom.* New York: Rinehart and Winston.

Porsche, Audrey, and Larry Loendorf

 1987 The dual function of rock art on the Northern Plains. *Archaeology in Montana* 28(2):57–60.

Rajnovich, Grace

 1994 *Reading Rock Art: Interpreting the Indian Rock Art of the Canadian Shield.* Toronto ON: Natural Heritage/Natural History Inc.

Ray, Verne F.

 1939 *Cultural Relationships in the Plateau of North-western America.* Los Angeles CA: Publications of the Frederick Webb Hodge Anniversary Publication Fund.

Renaud, Etienne B.

 1936 Pictographs and petroglyphs of the High Western Plains. *Archaeological Survey Series,* Eighth Report. Department of Anthropology, University of Denver CO.

 1937 Pictographs and petroglyphs of Colorado. *Southwestern Lore,* nos 2–3:57–60, 74–79, 12–19, 35–40, 45–48.

Robertson, Valerie

 1993 *Reclaiming History: Ledger Drawings by the Assiniboine Artist Hongeeyeesa.* Calgary AB: Glenbow-Alberta Institute.

Rodee, Howard D.

 1965 The stylistic development of Plains Indian painting and its relationship to ledger drawings. *Plains Anthropologist* 10(30):218–32.

Schaafsma, Polly

 1971 Rock art of Utah. *Papers of the Peabody Museum of Archaeology and Ethnology* 65.

 1975 *Rock Art in New Mexico.* Albuquerque: University of New Mexico Press.

 1980 *Indian Rock Art of the Southwest.* Albuquerque: University of New Mexico Press.

 1985 Form, content, and function: Theory and method in North American rock art studies. *Advances*

in Archaeological Method and Theory
8:237–77.

Schlesier, Karl H.

1994 Commentary: A history of ethnic
groups in the Great Plains, A.D. 150–
1550. In *Plains Indians, A.D. 500–
1500: The Archaeological Past of
Historic Groups,* ed. K. H. Schlesier,
pp. 308–81. Norman: University of
Oklahoma Press.

Schuster, Helen H.

1987 Tribal identification of Wyoming
rock art: Some problematic consid-
erations. *Archaeology in Montana*
28(2):25–43.

Secoy, Frank Raymond

1953 *Changing Military Patterns of the
Great Plains.* Seattle: University of
Washington Press.

Secrist, Kenneth G.

1960 Pictographs in Central Montana:
Part I, Fergus County. *Anthropology
and Sociology Papers,* no. 20.
Missoula: Montana State University.

Shimkin, Demitri B.

1947a Childhood and development among
the Wind River Shoshone. *University
of California Anthropological Records*
5(5):289–326.

1947b Wind River Shoshone literary forms:
An introduction. *Journal of the
Washington Academy of Sciences*
37(10):329–52.

Shumate, Maynard

1960 Pictographs in Central Montana,
Part II: Panels near Great Falls.
Anthropology and Sociology Papers,
no. 21:1–40. Missoula: Montana
State University.

Slifer, Dennis, and James Duffield

1994 *Kokopelli: Flute-Player Images in
Rock Art.* Santa Fe NM: Ancient City
Press.

Smith, Harlan I.

1908 An archaeological reconnaissance in
Wyoming. *American Museum*

Journal 8:22–26, 106–10.

1923 An album of prehistoric Canadian
art. *Victoria Memorial Museum
Bulletin,* no. 37. Ottawa ON: Canada
Department of Mines.

Sowers, Ted C.

1939 *Petroglyphs and pictographs of
Dinwoody.* Archaeological Project,
Work Projects Administration,
University of Wyoming Library,
Laramie.

1940 *Petroglyphs of west central Wyoming.*
Archaeological Project, Work
Projects Administration, University
of Wyoming Library, Laramie.

1941 *Petroglyphs of Castle Gardens.*
Wyoming Archaeological Survey,
University of Wyoming, Laramie.

Steinbring, Jack, and Tony Buchner

1993 The southwestern Saskatchewan
rock art project: A multidisciplinary
approach. Manuscript.

Steward, Julian H.

1929 Petroglyphs of California and
adjoining states. University of
California, *Publications in American
Archaeology and Ethnology* 24(2).

Stewart, James J.

1989 Distributional analysis of a
petroglyph motif from Legend Rock
petroglyph site (48HO4),
Hotsprings County, Wyoming. In
*Legend Rock Petroglyph Site
(48HO4), Wyoming: 1988 Archaeo-
logical Investigations,* ed. D. N.
Walker and J. E. Francis, pp. 209–55.
Laramie: Office of the Wyoming
State Archaeologist.

Sundstrom, Linea

1981 Rock art of the southern Black Hills.
South Dakota State University,
*Laboratory of Archaeology Publica-
tions in Anthropology,* no. 2.

1984 The Southern Black Hills. In *The
Rock Art of Western South Dakota.*
South Dakota Archaeological

Society, Publication no. 9, pp. 53–142.

1987 Vertical series rock art and its relation to Protohistoric Plains Indian symbolism. *Archaeology in Montana* 28(2):3–17.

1989 Archaic hunting practices depicted in a Northwestern Plains rock art style. *Plains Anthropologist* 34(124):149–69.

1990 *Rock Art of the Southern Black Hills: A Contextual Approach.* New York: Garland Publishing, Inc.

1993 *Fragile Heritage: Prehistoric Rock Art of South Dakota.* Vermillion: South Dakota Historical Preservation Center.

1995 Buffalo Women: Changing contexts of a Siouan rock art tradition. Paper presented at the 60th Annual Meeting of the Society of American Archaeology, Minneapolis MN.

Sundstrom, Linea, and James D. Keyser

1998 Tribal affiliation of shield petroglyphs from the Black Hills and Cave Hills. *Plains Anthropologist* 43(165):225–38.

Swaim, Charles R.

1975 A survey of the Trail Lake petroglyphs. Master's thesis, University of Wyoming, Laramie.

Swartz, B. K.

1978 *Klamath Basin Petroglyphs.* Socorro NM: Ballena Press.

Swauger, James L.

1974 *Rock Art of the Upper Ohio Valley.* Graz, Austria: Akademische Druck und Verlagsanstalt.

Szabo, Joyce M.

1994 Shields and lodges, warriors and chiefs: Kiowa drawings as historical records. *Ethnohistory* 41:1–24.

Taçon, Paul S. C.

1990 The power of place: Cross-cultural responses to natural and cultural landscapes of stone and earth. In

Perspectives of Canadian Landscape: Native Traditions, ed. J. Vastokas, pp. 11–43. Toronto ON: York University, Robarts Centre for Canadian Studies.

Taylor, Colin

1994 *The Plains Indians.* New York: Crescent Books.

Taylor, Dee C.

1973 Archaeological Investigations in the Libby Reservoir Area, Northwestern Montana. University of Montana, *Contributions to Anthropology* no. 3.

Taylor, J. M.; R. M. Myers; and I. N. M. Wainwright

1974 Scientific studies of Indian rock paintings in Canada. *Bulletin of the American Institute for Conservation* 14(2):28–43.

1975 An investigation of the natural deterioration of rock paintings in Canada. In *Conservation in Archaeology and the Applied Arts,* pp. 87–91. London UK: International Institute for Conservation of Historic and Artistic Works.

Teit, James A.

1928 *The Salishan Tribes of the Western Plateau.* Bureau of American Ethnology, Annual Report, no. 45. Washington DC.

Thompson, David

1962 *David Thompson's Narrative 1784–1812.* Edited by Richard Glover. Toronto ON: The Champlain Society.

Tipps, Betsy L., and Alan R. Schroedel

1985 The Riverton Rock Art Study, Fremont County, Wyoming. Report on file with the U.S. Bureau of Reclamation, Billings MT.

Tratebas, Alice M.

1993 Stylistic chronology versus absolute dates for Early Hunting style rock art on the North American Plains. In *Rock Art Studies: The Post-Stylistic*

Era or Where Do We Go From Here?
ed. Michel Lorblanchet and Paul G.
Bahn, pp. 163–77. Oxford UK:
Oxbow Books.

1997 Early petroglyph traditions on the
Northern Plains. Paper presented at
the 55th Annual Plains Anthropo-
logical Conference, Boulder CO.

Turpin, Solveig A.

1989 The end of the trail: An 1870s Plains
combat autobiography in southwest
Texas. *Plains Anthropologist*
34(124):105–10.

1990 Rock art and hunter-gatherer
archaeology: A case study from SW
Texas and Northern Mexico. *Journal
of Field Archaeology* 17(3):263–81.

1992 Hunting camps and hunting magic:
Petroglyphs of the Eldorado Divide,
West Texas. *North American
Archaeologist* 13(4):295–316.

Vastokas, Joan M.

1987 Native art as art history: Meaning
and time from unwritten sources.
Journal of Canadian Studies
21(4):5–36.

1990 Landscape as experience and symbol
in Native Canadian culture. In
*Perspectives of Canadian Landscape:
Native Traditions,* ed. J. Vastokas, pp.
55–82. Toronto ON: York University,
Robarts Centre for Canadian
Studies.

1992 *Beyond the Artifact: Native Art as
Performance.* North York ON: York
University, Robarts Centre for
Canadian Studies.

Vastokas, Joan M., and Romas K. Vastokas

1973 *Sacred Art of the Algonkians: A Study
of the Peterborough Petroglyphs.*
Peterborough ON: Mansard Press.

Vatter, Ernst

1927 Historienmalerei und heraldische
bilderschrift der Nordamerikanischen
präriestämme: Beiräge zu einer
ethnographischen und stilistischen

analyse. *IPEK: Annual Review of
Prehistoric and Ethnographic Art*
4:46–81. Leipzig, Germany:
Klinkhardt & Biermann Verlag.

Walker, Danny N.

1992 The River Basin Survey rock art at
Boysen Reservoir, Fremont County,
Wyoming. Report on file with the
Wyoming State Archaeologist's
Office, Laramie.

Walker, Danny N., and Julie E. Francis

1989 *Legend Rock Petroglyph Site
(48HO4), Wyoming: 1988 Archaeo-
logical Investigations.* Laramie:
Office of the Wyoming State
Archaeologist.

Warburton, Miranda, and Philip Duke

1995 Projectile points as cultural symbols:
Ethnography and archaeology. In
*Beyond Subsistence: Plains Archaeol-
ogy and the Postprocessual Critique,*
ed. P. Duke and M. C. Wilson, pp.
211–28. Tuscaloosa: University of
Alabama Press.

Wedel, Waldo R.

1959 An introduction to Kansas Archeol-
ogy. *Bureau of American Ethnology,
Bulletin,* no. 174. Washington DC.

1969 A shield and spear petroglyph from
Central Kansas: Some possible
implications. *Plains Anthropologist*
14(44):125–29.

Wellmann, Klaus F.

1979a *A Survey of North American Rock
Art.* Graz, Austria: Akademische
Druck und Verlagsanstalt.

1979b A quantitative analysis of superim-
positions in the rock art of the Coso
range, California. *American
Antiquity* 44(3):546–56.

Werner, Jewell F.

1981 Some notes on pictographs from the
Jefferson River headwaters. *Archae-
ology in Montana* 22(3):75–82.

Whitley, David S.

1992a Shamanism and rock art in far

western North America. *Cambridge Archaeological Journal* 2(1):89–113.

1992b The Numic vision quest: Ritual and rock art in far western North America. Manuscript.

1994a Ethnography and rock art in the far West: Some archaeological implications. In *New Light on Old Art: Recent Advances in Hunter-Gatherer Rock Art Research,* ed. D. S. Whitley and L. L. Loendorf, pp. 81–93. Los Angeles CA: Institute of Archaeology, University of California.

1994b Shamanism, natural modeling and the rock art of far western North American hunter-gatherers. In *Shamanism and Rock Art in North America,* ed. Solveig Turpin, pp. 1–43. Special Publication 1. San Antonio TX: Rock Art Foundation, Inc.

2000 *The Art of The Shaman: Rock Art of California.* Salt Lake City: University of Utah Press.

Whitley, David S., and Ronald I. Dorn

1995 New perspectives on the Clovis vs. pre-Clovis controversy. *American Antiquity* 58(4):626–47.

Will, George F.

1909 Some observations made in Northwestern South Dakota. *American Anthropologist* 11(2):257–65.

Wintemberg, W. J.

1939 Petroglyphs of the Roche Percée and vicinity, Saskatchewan. *Transactions of the Royal Society of Canada,* 3d series, sec. II, vol. 33, pp. 175–84.

Wissler, Clark

1912 Ceremonial bundles of the Blackfoot Indians. *Anthropological Papers of the American Museum of Natural History* 7(2).

1913 Societies and dance associations of the Blackfoot Indians. *Anthropological Papers of the American Museum of Natural History* 11(4).

Wormington, H. M., and Richard G. Forbis

1965 *An Introduction to the Archaeology of Alberta, Canada.* Denver CO: Denver Museum of Natural History.

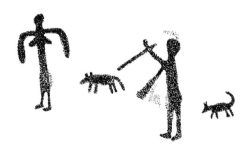

Index

Abrading: in Ceremonial tradition, 194; defined, 6; in Dinwoody tradition, 107, 117; in Hoofprint tradition, 178; in tool grooves, 295

Absolute dating. *See* Dating: absolute

Abstract, defined, 9, 167–68

Algonkian language group, 15, 57, 186, 243

Amateur rock art researchers, 29, 85–86, 110–11

AMS radiocarbon dating. *See* Dating: radiocarbon

Analogy, 32–34, 244, 280

Antelope, in rock art, 35, 78, 80, 116, 179–80, 191, 192, 200–2

Anthropomorph: as component of rock art, 89, 102, 111–16, 154–56; defined, 8–9

Arapaho, 57, 58; as makers of robe or ledger art, 258, 270; as makers of rock art, 212, 243

Archaeological culture, 44

Archaic period, 43–49, 147–48, 150; rock art, 82, 119–21, 134, 136, 139, 141, 144–45, 163–65, 185, 206

Arikara, 58, 59, 63, 65; as makers of robe or ledger art, 258, 270

Armor. *See* Horses: armor

Assiniboin, 51, 53, 57, 58, 186; as makers of robe or ledger art, 258, 270

Athapaskan language group, 57, 136, 167

Atlatl: as chronological indicator, 20, 82, 207; in rock art, 8, 13, 79–83, 185, 203, 207

Audrey's Overhang, 8–9, 158

Bannock, 59

Battle scenes: in robe and ledger art, 257, 260; in rock art, 224, 225, 237, 252, 254–56

Bear paw, in rock art, 109, 132, 157, 160, 168–70 passim, 172, 180, 185, 201, 218

Bears, 9, 171–75; in rock art, 131–32, 151, 157–60 passim, 162, 165, 167, 168, 197, 199–201, 203, 206, 208, 218, 231, 232. *See also* Bear paw

Besant archaeological complex, 48–49, 147, 310

Big Dog, 223

Biographic tradition, 11, 12, 14, 15, 34, 70–72, 118, 165,

167, 221, 222, 224–57, 288–90; dating of, 17–22, 52, 54, 238–41, 246–53; influence on Columbia Plateau tradition, 101; painted on trees, 227; relationship to Ceremonial tradition, 195, 207, 221–22, 224–33, 236–37, 242, 249; relationship to macrotraditions, 308, 310–11; relationship to Robe and Ledger Art tradition, 230, 241, 243–53, 271; relationship to Vertical Series tradition, 243, 253, 281, 286, 288, 290, 292, 294

Bird: in rock art, 33, 96–98, 112–14, 136, 137, 156–57, 170, 172, 181, 200–3, 214, 216, 246; tracks in rock art, 26–27, 157, 177, 180, 185, 188

Bird Rattle, 238–39, 241, 254–56

Bison, 186–89, 307; hunting, 43, 46–54, 59, 63–65, 101, 188; kills, 40, 46, 47, 50, 65, 159, 165, 167, 183, 188, 194; in rock art, 17, 78, 96, 102, 116, 120, 131, 157–58, 170, 177–81, 183, 187, 192, 200–5, 214, 231, 232, 236, 250, 286, 288, 293

Blackfeet, 32–33, 51, 53, 55, 57, 58, 60–62, 70–72, 101, 164, 166, 174, 186, 189, 218, 222–23, 291–92, 295, 299; as makers of robe or ledger art, 71, 258, 259, 261, 263, 269–74, 278–80, 289; as makers of rock art, 33, 70–72, 211–12, 228, 243, 252, 255–56, 279–80

Black Hills, 2, 24, 34, 36, 55, 75, 77, 78, 81, 85, 89, 135, 136, 139–43, 145–47, 150, 178, 184, 191, 241–46, 248

Blood (division of Blackfeet). *See* Blackfeet

Boat, in rock art, 20, 233, 234

Boat-form style, 166, 197, 200–2, 208–11, 222, 231, 239, 247, 250, 310

Bodmer, Karl, 261, 271

Bow and arrow, 50; as dating indicator, 20, 99, 117, 120, 132, 134, 207; in robe and ledger art, 259, 260, 262, 264, 266, 269, 272–74; in rock art, 26, 95, 130, 131, 198, 199, 203, 205, 216, 224, 229, 233, 235, 240, 248, 249, 252, 255

Bow-spear, in rock art, 20, 198, 204, 205, 216, 221

Boysen Reservoir sites, 110–11, 115, 116, 121

Brands, in rock art, 19, 22, 230–32, 237, 242

Buckles, William G., 178

Paleoindian, 43–46, 82–84

Pandzoavits, 125–26

Park, John A., 188

Patina. *See* Rock varnish

Pawnee, 58, 59, 61, 63; as makers of robe or ledger art, 258, 271

Pecked Abstract tradition, 11, 13, 14, 31, 139–50; comparison with other rock art traditions, 146; dating of, 48, 49, 52, 144–45; relationship to macrotraditions, 307–9

Pelican Lake archaeological culture, 48–49, 147, 167

Pend d'Oreille, 59, 62, 166; as makers of rock art, 101, 164. *See also* Salish

Penisform, 181–82, 185

Petroglyph, 5–6, 43, 75, 107, 112, 127, 131, 178, 192, 225

Petroglyph Canyon site, 2, 130–34, 137

Phosphene. *See* Entoptic

Pictogram, 32, 263, 291–94. *See also* Ideograms; Picture writing

Pictograph, 43; application technique, 7, 159–61, 194, 225, 282–83; defined, 6–8; preservation of, 7–8. *See also* Pigment

Pictograph Cave site, 2, 20, 195, 209, 284, 301–2

Picture writing, 32, 224–56, 263–68, 278, 291–94

Piegan. *See* Blackfeet

Pigment, 6–7, 93, 194, 218, 281–83; European trade item, 290

Plains Cree, 22, 53, 57, 58, 101, 186, 189, 222–23, 255–56, 280; as makers of robe or ledger art, 258, 270; as makers of rock art, 228, 243

Plains Ojibwa, 57, 58, 186

Polychrome pictographs, 6, 93, 193, 194

Ponca, 57, 58, 271

Projectile points, in rock art, 9, 111, 117, 183, 185

Protohistoric period, 43, 52–54, 252–53; in rock art, 183–84, 238–41, 247

Radiocarbon dating. *See* Dating: radiocarbon

Rectilinear, defined, 9, 11

Red Canyon site, 2, 181

Relative chronology. *See* Dating: relative

Renaud, Etienne B., 76, 146, 195

Representational, defined, 9

Ribstone. *See* Glyphstone

Robe and Ledger art tradition, 15, 228, 257–80; as comparison for studying rock art, 18–19, 22, 259–80, 288; dating of, 54, 260–62, 268–70; earliest robe and ledger art, 260, 268; latest robe and ledger art, 261, 268–70; related to other rock art traditions, 230, 241–53, 257–59, 263–66, 271, 278, 307–8, 310–11

Roche Percée site, 178, 180–81, 183, 188

Rock art: aspects unique to Northwestern Plains, 110, 166, 210, 281, 310; attributed to non-Indians, 5, 295; conservation and protection of, 304–5; defined, 5–15; earliest academic interest in, 28–29; earliest on Northwestern Plains, 3, 45, 47; early references to, 76, 93, 110, 178, 194, 227; first reported on Northwestern Plains, 3; latest on Northwestern Plains, 228, 233, 238–39, 241, 277–78; manufacturing techniques, 5–7; preservation of, 7–8, 16; on trees, 227. *See also* Dating; Pictograph; Petroglyph; Pigment

Rock art style: defined, 13–15; used for interpretation, 30–31, 76–79, 84–85

Rock art tradition: defined, 13–15, 307–12

Rock varnish: described, 23, 76; used in rock art dating, 23–25

Sacred places/landscapes, 3, 55–56, 62, 69, 188, 241; and rock art, 35–39, 56, 67, 102, 104, 105, 150, 171, 188, 196, 213, 215, 219, 253, 280, 295–96, 307. *See also* Medicine Rocks

Sahaptian language group, 14, 57, 59

Saint Victor petroglyphs, 2, 178–83, 185–86, 299, 304, 306

Salish, 38, 51, 101; as makers of rock art, 14

Salishan language group, 14, 57, 59, 101

Sarcee, 53, 57–59, 62; as makers of robe or ledger art, 258, 270

Schaafsma, Polly, 146

Schematization/schematic, defined, 12

Scorpion, in rock art, 132

Secrist, Kenneth G., 284

Semiotics, 31–32

Seriation. *See* Dating: by seriation

Sex acts, in rock art, 181, 182, 197, 199, 237, 250

Shaman and shamanism: defined, 35; general, 31, 33, 46, 47, 49, 61, 66, 86–87, 122, 137, 155, 168–70, 172, 196, 219–20; shamans as makers of rock art, 14, 31, 33, 35, 88–91, 102–4, 106, 123–26, 138, 139, 148–50, 151, 153, 167–75, 188–89, 213, 220, 306–7

Shield, 6, 17, 20, 22, 30, 67, 168, 194, 195, 203, 206–8, 210, 214, 215, 222, 224, 225, 230, 232, 233, 239, 248–50, 252, 274, 275. *See also* Shield-bearing warrior

Shield-bearing warrior, 8, 13, 20, 23, 26–27, 52, 95, 120, 133, 163, 166, 191–93, 196–98, 203–12, 215, 218–19, 222, 223, 228, 229, 238, 240, 246, 247, 268, 279–80

Shoshone, 20, 34, 51, 53, 58, 59, 89, 101, 107, 121–26, 166, 195, 211, 222; as makers of robe or ledger art, 258, 270; as makers of rock art, 14, 122–23, 137, 212, 243